WOMEN MAKING Art

"Transgressing the feminine, the writers take us through the lives of women artists, who intentionally or not, push the boundaries in photography, dance, architecture, music, writing, art, and film. Told through the lives of the artists in the period since 1960, we confront their double ideological markings—that of being female and that of creating art as a woman. Problematizing gender, *Women Making Art* explores the cultural codes of female identity and art-making. This book is a rich and compelling collection exploring the lives of women artists and their power to shape and re-shape the myths by which we live."

Sherry Shapiro, Associate Professor of Dance, Meredith College;
Editor of Dance, Power, and Difference

"Deborah Johnson and Wendy Oliver have co-edited a remarkable book about very successful women who have defied stereotyping in their lives and in their art. This highly compelling collection of essays will be of interest to those who look for role models and also to those who view artistic processes as a possible model for cognition. The deliberation and self-awareness involved in making art may be a surprise to those outside the art field."

Ellen K. Levy, Artist and Distinguished Visiting Fellow
in Arts and Sciences, Skidmore College

"*Women Making Art* makes an important contribution to the history of feminist consciousness in art. Its essays examine dance, poetry, music, architecture, performance art, literature, photography, and film by women from the 1960s through the 1990s. Whether by exposing oppression, celebrating achievement, or proposing radical change, they suggest how female experience has engendered new forms of aesthetic, political, and spiritual expression in art."

Jann Pasler, Professor of Music,
University of California, San Diego

WOMEN MAKING Art

ERUPTIONS
New Thinking across the Disciplines

Erica McWilliam
General Editor

Vol. 7

PETER LANG
New York • Washington, D.C./Baltimore • Boston • Bern
Frankfurt am Main • Berlin • Brussels • Vienna • Oxford

WOMEN MAKING Art

Women in the Visual, Literary, and Performing Arts since 1960

EDITED BY

Deborah Johnson
& Wendy Oliver

PETER LANG
New York • Washington, D.C./Baltimore • Boston • Bern
Frankfurt am Main • Berlin • Brussels • Vienna • Oxford

Library of Congress Cataloging-in-Publication Data

Women making art: women in the visual, literary, and performing arts
since 1960 / edited by Deborah Johnson and Wendy Oliver.
p. cm. — (Eruptions; vol. 7)
Includes bibliographical references and index.
1. Feminism and the arts—United States. 2. Arts, Modern—20th century—
United States. 3. Women artists—Psychology. I. Johnson,
Deborah (Deborah J.). II. Oliver, Wendy. III. Series.
NX180.F4 W6575 700'.82—dc21 99-046197
ISBN 0-8204-4438-3
ISSN 1091-8590

Die Deutsche Bibliothek-CIP-Einheitsaufnahme

Women making art: women in the visual, literary, and performing arts
since 1960 / ed. by: Deborah Johnson and Wendy Oliver.
–New York; Washington, D.C./Baltimore; Boston; Bern;
Frankfurt am Main; Berlin; Brussels; Vienna; Oxford: Lang.
(Eruptions; Vol. 7)
ISBN 0-8204-4438-3

Architectural painting of "The Peak Club" site, by Zaha Hadid of London,
England. Hadid's design was the winning entry in an architecture
competition in Hong Kong in 1983.

Cover design by Lisa Dillon
Author photograph by Richard Elkington

The paper in this book meets the guidelines for permanence and durability
of the Committee on Production Guidelines for Book Longevity
of the Council of Library Resources.

© 2001 Peter Lang Publishing, Inc., New York

Printed in the United States of America

Contents

Illustrations

Acknowledgments

This volume has been a labor of love, but even more so, a labor of commitment over several years. It has been a journey across varied terrain, steep and level, rocky and smooth. Throughout this period, our paths crossed those of colleagues in many fields who encouraged, cajoled, and challenged us toward completion. Those scholars and friends with whom we have exchanged ideas cannot all be acknowledged here, but we hope they will be rewarded by the appearance of this book. It is our hope, above all, that this volume helps all of us to bring the message and achievements of creative women in the second half of the 20th century into the classroom, as well as into the living room.

As the journey progressed, our paths were mercifully cleared by those who worked and lived closest to us. We would like to acknowledge the patience of our families, Cyrus O'Neil, Shannon and Lincoln Oliver-O'Neil, and Robert, Leah, and Chloe Johnson Serinsky, and the faculties of our academic departments of Art and Art History and Theater at Providence College. The administration of Providence College has been implicitly supportive of our work. This has been particularly true of the Women's Studies Program, a program we helped to found, whose atmosphere of collegiality provided a context in which to think about, discuss, and teach this material for the first time, and many times thereafter.

At Providence College, several individuals deserve special mention for their work toward completion of this book: students Cristina Bauer, Meredith Campbell, Kristen Molinski, Megan Porcaro, and Mary Tinti performed innumerable tasks relating to the physical production of the text as well as to its content; and Matt Bechtel, Bob Booth, Richard Elkington, Cathy Pantano, and Harriet Pappas provided technical support, often at a moment's notice.

Among our colleagues, scholars and artists alike, we would like to extend our gratitude, in particular, to Lynda Benglis, Amelia Jones, Ellen Levy, Jann Pasler, Sherrie Shapiro, Grace Welty, and Donald Woodman; in addition, the staff of Peter Lang Publishing, Inc., have been conscientious guides and careful editors, and we are glad for that. We offer our deepest thanks to the artists who are the subjects of this study for providing such rich material, and for facilitating the acquisition of photographs, rights, and other pertinent information. Finally, we thank our contributing authors who have taken such a fascinating lens to these artists. We are grateful for their generosity, accountability, and especially, their insights.

Deborah Johnson
Associate Professor of Art History
 & Women's Studies
Providence College
Providence, Rhode Island, USA

Wendy Oliver
Associate Professor of Dance &
 Women's Studies
Providence College
Providence, Rhode Island, USA

Preface

This book began out of friendship, discussion of common interests, and as an extension of a course which we developed together in the early 1990s. As colleagues in the Women's Studies Program at Providence College in Providence, Rhode Island, and specialists in the areas of art and dance, we developed a course which integrated many different arts in the spirit of interdisciplinary learning. Specifically, we looked intensively at the work of contemporary (mostly American) women artists in ten different fields: dance, poetry, music, visual art, photography, performance art, literature, architecture, film, and theater. Our goals were to introduce our undergraduate students to several important women artists, to develop an understanding of recent history and criticism in the arts, and to assess the relationship among the arts within the period since 1960. We did this primarily through in-depth study of a single work in each media, using guest speakers to provide insight on areas outside our own expertise. Student-led discussion was also an important aspect of the course.

This course has offered us and our students the opportunity to discover a myriad of new interconnections among the arts, feminist thought, and cultural history. The synergistic effect of these elements has been compelling for us, and when we realized that there was no existing text that had the same effect, we decided to create this book. Mirroring the organization of the course, we invited scholars from the varied arts disciplines to write chapters focused primarily upon a single work or collection by a well-known female artist. This, we felt, would allow for a thoughtful and sophisticated engagement with each work, rather than taking a survey approach, where depth is necessarily sacrificed to breadth.

Our choice of artists was made after research and conversations with scholars in each of the relevant fields. Because we were selecting only one artist per field, it might be supposed that the choices would be difficult to

make. However, we were not concerned with selecting the *one best* female poet (or composer or choreographer) since 1960, but instead, someone whose impact was unique, lasting, and significant. We wanted to include artists who were held in high regard by their peers and recognized by historians and critics. Another criterion for inclusion was that the work of the artist be readily available in some format so that readers could experience it firsthand, since all the essays in the world cannot substitute for personal engagement with an art work.

The choice of work or works presented for a given artist was ultimately each individual author's. Many of the works selected have won prizes or honors in their fields, and all are well known within their respective art communities, if not more broadly. The chapters are arranged in chronological order by work (i.e., Yvonne Rainer's *Trio A*, 1966, to Paula Vogel's *How I Learned to Drive*, 1997).

In chapter 1 on choreographer Yvonne Rainer and *Trio A* (1966), Wendy Oliver discusses how minimalism, postmodern dance, and feminism share common ground. It problematizes the dancing body and examines Rainer's solution to avoiding or averting "the male gaze."

Annie Perkins's chapter on poet Gwendolyn Brooks analyzes several poems from the 1970s and 1980s, including "Gang Girls," "To Sisters Who Kept Their Naturals," "In Memoriam: Edgar William Blakely," "Walter Bradford, Music for Martyrs," "A Welcome Song for Laini Nzinga," "The Life of Lincoln West," and "The Boy Who Died in My Alley." By exploring a gallery of real and imagined figures, Perkins examines issues of race and gender through the lens of Brooks's beautifully wrought poems, and shows them to be, above all, an affirmation of the Black experience.

In chapter 3, William Osborne discusses musician Pauline Oliveros' landmark work *Sonic Meditations* (1971). He explains her theory of "deep listening," and shows how her feminism and philosophical orientation are a prominent aspect of her work.

Next, Deborah Johnson explores the little-discussed religious aspect of artist Judy Chicago's famous work *The Dinner Party* (1975–79). She proposes that both feminist and religious interpretations of the work are interconnected, given the background of the artist and the scope of the project.

Then, Maura Reilly analyzes *Untitled Film Stills* (1977–81) by photographer Cindy Sherman. These photos are of Sherman herself, acting out various solo scenarios, or evocative moments, from the lives of the female characters she plays. Reilly discusses and clarifies the difficulties inherent in mocking what one is mimicking.

In chapter 6, Loretta Lorance writes about one of the world's most prestigious architecture competitions and how it was won by Zaha Hadid in 1982. Hadid's award-winning work, *The Peak Club,* although never built, led to an increasingly acclaimed career as a postmodern architect who now has several public buildings to her credit.

In her article on Laurie Anderson's performance art piece, *Langue d'Amour* (1984), Susan McClary focuses on the musical aspect of her work. McClary finds that Anderson has discovered a particularly feminine (although not essentialist) way of creating music in time and space.

The last three chapters share the common thread of work that specifically examines the oppression of women. In chapter 8, Phillipa Kafka writes of Amy Tan's novel, *The Kitchen God's Wife* (1991), showing the complex interweaving of relationships among Chinese American women, the mystical traditions of China, and the more "scientific" western traditions. Despite the ever-present cruelty towards women in the book, Kafka finds Tan to be hopeful about the future.

Author Denise Bauer also deals with the oppression of women in her essay on *The Piano* (1993), a film directed by Jane Campion. Bauer discusses both the content and filmic techniques which combine to make " a feminist tale of resistance."

Finally, Sarah Stevenson's examination of playwright Paula Vogel's *How I Learned to Drive* (1997) explains Vogel's depiction of how a survivor of sexual abuse becomes alienated from her body. Stevenson points to the themes of fragmentation, multiplication, and division that occur as the play moves among different time periods.

Taken as a whole, these essays show us a spectrum of compelling and sometimes surprising ways in which women's (art)work is constructed and displayed, read, or performed. It is our hope that this volume will attest not only to the significance of the art it presents, but also to the richness of interpretations and analyses made by our authors. We hope to share with you the delightful synergy of this cross-disciplinary juxtaposition as we expand the dialogue between women's studies and the arts.

DJ
WO

Introduction

Historical rupture, when used as an explanation for the abandonment of old ways for new, is a spurious concept: it often preempts serious discussion and is infinitely manipulatable to serve the speaker's particular biases. That having been said, the environment in which young female artists found themselves after 1960 was so different from that of their predecessors that the term "rupture" seems to apply. The generation coming of age around 1960 would have been the first generation of young female artists in the history of civilization with more-or-less full access to education and training. They came with assumptions about equal worth that led them, by the end of the decade, to return the fight for equality to the streets for the first time since 1920 and the winning of suffrage. They came with the pragmatic ability to make conscious decisions around marriage, and for the first time in history, birth control, so that the status of wife and mother was a choice, not a trap.

Nonetheless, to chronicle the lives and work of women artists in the past forty years is also to chronicle the ways in which the positive results of this rupture have been internalized only to varying degrees. It is still only tentatively that the demands of female identity and artistic identity are seen by the artist and those around her as reconcilable. Moreover, it is only recently that we have begun systematically to document, and importantly, teach and learn our history as women so that our past does not need to be reconstituted by each new generation. We have now begun to build on and grow from the shoulders of our foremothers, who serve as reference, inspiration, role models, mentors, and context; we may choose to learn from their mistakes and draw from their strengths. If the generation coming of age around 1960 came with the gift of a uniquely new foundation, the generations since 1960 have given us the gift of community: an historical past.

When we examine the immediate historical past, the concept of rupture as a dramatic, even violent, break around 1960 begins to appear predictably suspect. American women had entered the professional world in quantitatively significant numbers at least by the turn of the century. In 1890 over 10 percent of all American graduate students were women, and by 1910 the American Census Bureau logged over 9,000 female physicians (Johnson 137). At this same time, the author Thomas Hardy invented a new female character: she smoked, drank, moved about and spoke her mind freely, and while still clearly fictional, she nonetheless reflected populist perceptions of shifting female ambitions. By the 1920s, in a case, perhaps, of life imitating art, the phenomenon of the flapper personified the free-thinking, free-moving, free spirit of the New Woman.

The New Woman had been anticipated in art not only by the fantasies of Hardy, but in the lives and works of American dancers who, early in the century, laid the foundation for modern dance. Of all the arts, dance (if not choreography) was unique in its domination by women. It led the way in providing avenues for female expression and redefinition, and often served as a reflection of progressive feminist sociopolitical trends. Dancers Loie Fuller, Isadora Duncan, Ruth St. Denis, and Josephine Baker, for example, took freedom of movement and celebration of sensuality as the primary theme of both their lives and work. They were soon joined by other women artists who brought a more pensive—though not more authentic—edge to this liberated type. Clothing designer Coco Chanel literally released women from their bustles, brassieres, and form-fitting costumes to promote a life of greater comfort and mobility; painter Georgia O'Keeffe facilitated her career by eschewing the roles of traditional wife and mother, and adopting, instead, atypical identities as the "other woman," as lesbian, and as living separate from her otherwise beloved husband; Edna St. Vincent Millay, in 1923 the first woman to win a Pulitzer Prize for poetry, documented her liberated lifestyle and the sybaritic underpinnings of the Jazz Age in her work; meanwhile, author Virginia Woolf called for the psychological, social, and temporal space for women to create, giving words to the lives O'Keeffe, Millay, and Chanel were creating for themselves.

The Great Depression of the 1930s brought with it a wave of overt backlash toward this expansion of the social, familial, and creative roles of women. Moreover, the pressure of a large, organized group of feminist activists—mobilized since the 1890s—had dissipated with the attainment of its primary goal, suffrage, in 1920. Women were now expected to turn over newly acquired jobs to unemployed men, while the first woman cabi-

net member, Secretary of Labor Frances Perkins in the Roosevelt admin-istration, ironically called for a return of women to their "proper sphere," the home. Nonetheless, it was Franklin and Eleanor Roosevelt's establish-ment of federal relief programs at this time (the Works Progress Adminis-tration or WPA) that would train the first generation of professional women artists.

Throughout the Depression, women comprised, on average, 41 per-cent of all artists on work relief, and from all accounts, documentable and anecdotal, the awarding of federal relief status and commissions was sur-prisingly gender-blind (Johnson 140). Virtually all of the women artists who continued to work seriously into the 1940s credited the professionalizing experiences of these programs with providing them not only an opportunity to create, but to create on a scale that would have been impossible in the context of routine American arts patronage of the period. In the visual arts alone, Isabel Bishop, Alice Neel, Louise Nevelson, Lucienne Bloch, and Lee Krasner, among others, won their first major commissions through the mural program of the WPA (Johnson 140).

Women in the WPA were employed not only as artists, but perhaps more importantly, as program administrators. Photographer Berenice Abbott was supervisor of the photography division; African-American artists Augusta Savage and Gwendolyn Bennett were directors of New York's Harlem Art Center, a pulse point for the Harlem Renaissance; Ruth Reeves was director of the Government Index of American Design, a permanent archive of American folk arts directly benefiting anonymous work by women and African-Americans; Lee Krasner, Elizabeth Olds, and Helen Lundeberg were local supervisors; and Audrey McMahon was New York regional director. This position, in particular, gave its director supreme authority over North America's biggest and most productive art-producing region: almost half of all American artists at this time lived in New York (Johnson 140).

The result of the government position on the status of women during the Depression years was an official mixed message that persisted well into the 1940s. For example, even as women were nationally mobilized to reenter the work force during the labor shortage of World War II, mar-ried women could not hold their own earnings in 11 states; they could not make contracts in 16 states; they could be divorced if not a virgin upon marriage; they could be sued for damages in cases of adultery; they could not sue for child support; they did not have guardianship rights; and they could not serve on juries (Johnson 140). Not surprisingly, this mixed message was everywhere in the popular culture, as well, and perhaps

nowhere so blatantly as in films of the 1930s and 1940s. While romance as a theme had dominated film since its inception, romance was now tightly circumscribed within a framework of gender role issues and expectations. The formula was bifurcated into films like *Stella Dallas*, in which women were punished for failing to meet their socially prescribed responsibilities as wife and mother, in a genre known as "weepies"; while at the other end of the spectrum was the theme of "the woman behind the man," treated comedically in films like *Bringing Up Baby*. In these films, the clever heroine guides the bumbling hero (typically played by real-life maverick Katharine Hepburn and a stammering Cary Grant or Spencer Tracy, respectively) toward the rewards apparently due him, but actually won through her subtle orchestration. Despite their differences, the underlying message in both types was ultimately the same, of course: women must not disrupt the social order, either by living outside its imposed roles, or by stealing the thunder of their male counterparts.

With the termination of the federal arts projects in 1943 in response to World War II, women artists who had enjoyed a foundation of acceptance and government patronage were left with neither. The situation for female visual artists during and after the war actually worsened with the emergence of the soon-to-be internationally renowned art movement, Abstract Expressionism. There was much about Abstract Expressionist art that was remarkable, such as the ways in which its ambitiousness of scale and language demanded and received attention of a sort unprecedented for American art. In many international surveys of the history of art, it is still often the first example of American art to be included. Nonetheless, as a socio-artistic phenomenon, it was programmatically xenophobic and male chauvinist. Undoubtedly related to feelings generated by the war, it was presented and read as a self-consciously American expression. The mention of influence from outside this sphere—from Asia, for example—was ignored or suppressed, and even today is only tentatively acknowledged. Women artists who had been the professional colleagues of men only a few years earlier were now admitted to this group and its meeting places primarily as audience. In a parallel to the attenuated machismo inspired by war and the Expressionists' archetypally aggressive style, artists like Lee Krasner were "treated like cattle," told that the movement "didn't need dames," and upon production of a painting that met with approval, informed that it was "good enough to have been painted by a man" (Johnson 141–2).

A significant exception to the marginalization of women artists in this period, and of a woman artist who bridged the pre- and post-war years

with reputation intact was dancer/choreographer, Martha Graham. A student and member of the Denishawn Dance Company founded by Ruth St. Denis, Graham established her own troupe in New York in 1929, only to face immediately the deprivations of the Depression years. Nonetheless, she won an audience that reached to the presidency of the United States, and was in a position to decline the invitation of Hitler to perform at the 1936 Olympic Games (Graham 151). As early as 1926, she said her audience "came because I was such a curiosity—a woman who could do her own work" (Graham 110). They also came because that work was groundbreaking—especially in the ways in which it smashed expectations of the dance and woman's role in it, and thus contributed its own clear voice to the polarized cacophony around women's proper sphere. In contrast both to classical ballet and her teacher, St. Denis, Graham had little use for "feminine" grace and lyricism as enacted by the female dancer, or even as it appeared in traditional dance dress. Often designing her own costumes of stark lines and dark colors, the movement she choreographed was radically energized, angular, and staccato. Graham made the transition into the war years seamlessly, and, in fact, created most of her significant works during the decade of the 1940s. As was the case for so many of her artist-sisters, this was at the expense of a comfortable personal life: her marriage (to dancer Erick Hawkins) fell apart after only a year, and she was to remain completely devoted to dance for the rest of her long life.

Graham described her failed marriage as a lesson in never trying "to hold on to something" (Graham 174). However, there is little question that the balancing act of "the public" and "the private" was often too much for a woman artist to bear, and one or the other suffered. The first philosopher to explore systematically this wrenching dichotomy in women's lives was Simone de Beauvoir. It is not coincidental that de Beauvoir and Graham shared the same generation, a watershed period in which the collision of old ideas with new established the condition of pre-rupture. Credited with the founding of the modern feminist movement and of feminist theory, de Beauvoir laid out, over several volumes, virtually all of the issues that have since occupied feminist theorists; none has been more effective in establishing an understanding of the female condition than her 1949 masterpiece, *The Second Sex*. It appeared only two years after women won the right to vote in France.

From the dawn of civilization, wrote de Beauvoir, woman has been subordinated to man. In addressing the question of "why" in an existentialist frame, de Beauvoir came to three important conclusions: that man has named himself "self" (the Sartrean "being-for-itself," or consciousness);

that woman has been named "other" (Sartrean "being-in-itself," or body); and that, as such, woman implicitly threatens the preeminence of man's "self-hood" by her "otherness." Thus, man/self must keep woman/other under control, and invented strictly proscribed social roles as his primary modus operandi. In this way, woman has also come to internalize and enact man's myth about her, and in so doing, has tacitly accepted her status as "other."

De Beauvoir examined the most influential contemporary explanations for women's oppression in turn, and rejected them all. Marx's promise, for example, that female oppression was fundamentally economic and would collapse upon itself with the demise of capitalism is countered with evidence of the existence of sexism in pre- and noncapitalist societies. In another example, de Beauvoir adjures that women do not have Freudian penis envy, but power envy, which the penis emblematizes. The undeniability of biological difference, however, gave her pause and a plat- form for some of her most significant—and controversial—arguments. That men are biologically oriented to the "outside of themselves" through the apparatus of the penis is suggested by the mechanisms of urination and ejaculation. Women, by contrast, are "contained within." Biological fac- tors were particularly compelling in the case of a woman's very real con- nection to a baby growing inside her. For de Beauvoir, the biological link between a mother and her baby establishes a practical precedent after birth, psychologically and otherwise, and makes it difficult, if not impos- sible, for a woman to become and remain a "self." Nonetheless, de Beauvoir did not accept that this provided an adequate explanation of the reasons for women's "otherness." An existentialist to the end, she believed that we are social beings who make decisions—passively or actively—as to how to live our lives. Since "it is not in giving life but in risking it that we are raised above the animal," "being-in-itself" can become "being-for itself" only through acts of consciousness (de Beauvoir 72). This is an argument that, perversely, has been used against women to justify notions of male public sphere and female private sphere biologically.

De Beauvoir was a theorist content with raising and arguing questions, often in brilliant dialectic. Thus, somewhat illogically, she has been criti- cized for her failure to come to definitive conclusions concerning the im- portance of biology, for example. More significantly, her biological argu- ments have been seen as distracting from the evolution of practical strategies for liberation, and even as a source of highly controversial es- sentialist theory of the 1970s. That de Beauvoir believed biology is deter- minant of some aspects of the female condition is undeniable. However,

her own acknowledged distaste for the body and ultimate belief in existential consciousness preclude the supposition that she posited the body (the dreaded "being-in-itself") either as destiny, or as essential womanhood.

The Second Sex was surprisingly popular, appearing in translation in several languages within a decade and indicating that the postwar generation was receptive to change. In the art world, in particular, change was, in fact, in process at this same time. At Black Mountain College, a small and ultimately short-lived liberal arts school in North Carolina that had opened in 1933, the arts were at the center of new ideas regarding creativity, pedagogy, and ultimately, life, that would have wide-ranging implications for the next forty years. Loosely based on the model of the Bauhaus in Germany, and even employing several of its war-expatriated faculty, Black Mountain promoted the particular notion of the interdependence of all the arts and served as site for a full range of radical experimentation. Perhaps none was as significant or as fundamentally interdisciplinary as that among teachers John Cage, Merce Cunningham, and student Robert Rauschenberg. In their collaborative projects of the late 1940s and early 1950s, the interaction of music, dance, and the visual arts served to destroy boundaried definitions of technique and medium and marked the beginnings of performance art. Each artist also relied heavily on resources and references not only from popular culture, but from real life.

While elitist distinctions around high or "fine" art have broken down intermittently throughout history, this break has been seen as particularly characteristic of the period since 1960. Nonetheless, we can trace the source of the break as far behind us in the modern epoch as the 1860s and the introduction of "vulgar," that is, quotidian, subject matter in painting. Surely by the period between the world wars, predating the experimentation at Black Mountain, everyday materials and events began to appear more or less consistently in the arts. This was especially true with regard to the subject of the day-to-day lives of women, already under political and social scrutiny. Willa Cather, a pioneer of this genre and Pulitzer Prize winner by 1922, saw her novel *A Lost Lady* made into a silent film in 1925, and remade as a talkie in 1934. Nonetheless, it may have been particularly the artists of the Harlem Renaissance, both men and women in the years following World War I, who were at the forefront of this trend in programmatic efforts to deconstruct and reconstruct assumptions about the African-American community at the dawn of the twentieth century. Author Zora Neale Hurston, for example, revealed in her works the life and aspirations of the "New Negro lady," not only

educated and genteel, but also the down-to-earth dialect and often pain-ful, sometimes gritty experiences of the working class Black woman. In the visual arts, the Mexican painter of the 1930s and 1940s, Frida Kahlo, created what many have characterized as the first female iconography in the history of art. Within female-specific imagery, she compulsively chronicled her life as victim: of identity crisis, of a damaged body, and of an unfaithful husband.

Nonetheless, neither Hurston, nor Kahlo, nor the many artists who began to examine women's lives in this period did so through a lens of gender construction, as de Beauvoir in 1949. This is true even of Graham, whose heroines existed in such stark opposition to the actual options open to women, literally and psychologically, that they could be regarded only as fantasies. Perhaps the first artist to characterize the lives of women as defined and impeded by their imposed roles *as* women was sculptor Louise Bourgeois. Virtually ignored until the 1960s, she later confessed: "I have had a guilt complex about pushing my art, so much so that every time I was about to show I would have some sort of attack. So I decided it was better simply not to try...the work was done and hidden away" (Munro 156). Nonetheless, if Virginia Woolf in 1929 had rational-ized the need for and militantly demanded a "room of one's own" as a prerequisite of full, creative personhood for women in the future, Bour-geois was imaging this room in the reality of the 1940s. In drawings and sculptures beginning in 1946, she presents the archetype of a nude fe-male figure whose head is encased and obscured within the framework of a middle-class suburban house. As Bourgeois clearly pictorialized, women were hopelessly trapped by domestic responsibilities, definitions, and millennia-old assumptions regarding "proper sphere"; they were utterly without autonomous human identity.

This situation and its critique changed surprisingly little over the course of the next twenty-five years. It is remarkable, however, that any critique existed at all, since, as sculptors Judy Chicago and Eva Hesse recalled, women were discouraged by both teachers and colleagues from linking their experience as women with their art practice. Nonetheless, in the early 1960s, sculptor Marisol (Escobar) also presented the female figure as literally entrapped within huge blocks of wood, metaphorically con-tained and confined by social expectations. The form was repeated in 1972 by Sandy Orgel, who, in an installation piece for *Womanhouse*, embedded a nude female mannequin within the shelves of a linen closet. Marisol may have persisted in seeing the problem as specific to her; these works are almost always self-portraits. *Womanhouse*, on the other hand,

was an apex of communal gender consciousness. The years between the Marisol and Orgel works return us to the issue of social and artistic rupture in the 1960s.

With the founding of the National Organization for Women (NOW) in 1966, the fight for equal rights became fiercely political for the first time since before 1920. NOW served as a watchdog organization to monitor and correct gender bias, and in so doing, brought women's issues back into the legislature and courts of law. The job of returning these issues to popular consciousness had been accomplished in 1963 when one of the founders of NOW, Betty Friedan, published *The Feminine Mystique*. In words which recall Bourgeois's middle-class Everywoman trapped in a literal construct of apparent domestic bliss, Friedan recorded the phenomenon of hundreds of thousands of women whose lives had no independent identity outside of "wife to" and "mother of." Friedan claimed that these women's voices rose to a single question: "Is this all?" It was "the problem which has no name," and corresponded with the first widespread population of college-educated American women whose potential dissipated with middle-class marriage. Like *The Second Sex*, *The Feminine Mystique* attracted a surprising amount of attention in its articulation of basic (but unspoken) truths, served as a clarion call for a new wave of feminist activism, and laid the foundation for further feminist theory on the social construction of gender.

The painful collision of aspiration and reality that characterized the lives of privileged white women in the twentieth century was still relevant in 1988 when dramatist Wendy Wasserstein produced *The Heidi Chronicles*. It is the story of three decades in the life of this class of woman, and charts her passage through feminist awakening and activism in college in the 1960s, to careerism and materialism in the 1970s, and confusion and irresolution in the 1980s. This finale was a chilling parallel, rather than distanced reminiscence or literary parable, of the actual mood of the historical moment. Heidi's embodiment of female truths was seen as poignant and powerful enough to win the Pulitzer Prize the following year. It has been said, however, that Bourgeois, Friedan, and Wasserstein, in their focus on white culture of the upper classes, document problems that women of lesser privilege, and women of color, wish they had. In fact, nonwhite and/or poor women encountered tremendous difficulties in their attempts to link their particular agendas with that of mainstream feminism. Scholar, social critic, poet, and photographer bell hooks was among the first to address systematically the overlapping vested interests of race, gender, and sexual orientation. While charged with

"privilege" herself, hooks is remarkable in her ability to speak in several voices while remaining rooted in the foundations of her poor, Black up-bringing. Her 1981 publication, *Ain't I a Woman: Black Women and Feminism*, was ranked by *Publishers' Weekly* in 1992 among the twenty most important books on women of the previous twenty years.

Despite their very real differences, Wasserstein and hooks shared both their feminist politics and their interest in art. In addition to their roles as artists themselves, Wasserstein created Heidi as an art historian, and hooks is a persuasive art critic. Both came to maturity in the decade of the 1970s, arguably the most prolific period in the history of women artists, specifically, and among the most significant artistic epochs of this cen-tury, in general. Throughout this decade, women played a catalytic role in redirecting mainstream art currents in virtually all creative arenas. Not only did women artists introduce new genres, techniques, and subject matter; they effectively brought to a close the phenomenon of "moder-nity" as a formalist art-for-art's-sake aesthetic that had dominated art production since about 1870. As artists now working from female expe-rience, they went far in completing the historical record, moving women out of the role of passive theme into that of active speaker. One author has written that, in the past, "it has been possible to construct a history of mainstream art without women. In the future, this will not be so, in large part because of the contributions made during this period" (Rosen, et al. 22).

Women not only introduced the new genres of performance art, instal-lation art, and site art, but were among its leaders. Performance art, perhaps the quintessential new genre of the '70s, had already begun to define itself by the mid-1960s in a space turned over to artists in New York City's Judson Memorial Church. Here, poets, dancers, visual artists, and musicians presented work that sought not only to break down barri-ers among genres and techniques, but to weave them together in ways that gave performance art its particular character. Sometimes spontane-ous, usually multi-media, the work done at Judson Memorial Church con-tinued the interdisciplinary experimentation that had begun at Black Mountain and then taken to the streets with the phenomenon of the 1950s "Happening." Like the latter, there was a presumption of social critique and political protest that was fresh, relevant, and edgy, and which blurred the centuries-old distinction between "fine" and "popular" art. It was also heavily represented, if not dominated, by women, who were increasingly engaged with issues of artifice and personae. As performance artist Cheri Gaulke has observed, "performance is not a difficult concept to us. We're on stage every moment of our lives" (Withers 160).

Throughout the 1970s, the range of aesthetic vocabulary utilized by women was wide and daring: Yvonne Rainer, for example, continued in film the minimalism she had pioneered at Judson Memorial Church in choreography and the "No Manifesto," while Judy Chicago recontextualized women's traditional "craft" media for high art with a baroque edge. Perhaps most significant, issues specific to women's bodies and experience were explored through subjects such as the goddess, female sexuality, fertility, and gender roles. This was no more apparent than in the phenomenon of body art, a subbranch of performance and among the most exciting developments in modern art and feminist theory of this period. In works by Ana Mendieta, Carolee Schneeman, Faith Ringgold, Judy Chicago, Hannah Wilke, Eleanor Antin, and Mary Beth Edelson, among others, women confronted the negative social implications projected onto the female body. These implications were outed, enacted, denounced, punished, metaphorized, and—in a strategy that would soon be linked with theories of essentialism—turned inside out as a celebratory, rather than condemnatory, component of genuine, innate "female essence."

Both the dominance of body art in the 1970s and its perceived connection to essentialism paralleled the international trend toward "écriture feminine," or "writing the female body." In fact, champions of literary "écriture feminine," such as Hélène Cixous, openly rejected the notion of female essence; however, the apotheosis of female experience found in works like Cixous's "Laugh of the Medusa" of 1976, especially as it was seen to reside in female sexuality, shared much in common with Mendieta's merging of the female body with the four primal elements of nature; Edelson's identification of the nude female with the powers of the goddess; and Chicago's celebration of female genitalia as site of female pleasure and productivity. Thus, the existence of a female essence—whether biological, psychological, or historic—was not denied, but renovated. As with feminist artists' attempts in the 1970s to apply the word "cunt" self-descriptively in a neutral or positive context (or the parallel phenomenon of the use of the word "nigger" among young African-Americans), images and ideas that had previously demeaned women were reappropriated and redefined by women themselves.

Virtually the instant theories of female essence were posited, feminists (and nonfeminists) were sharply divided into camps of support or opposition. To those in opposition, the idea that women were essentially or inevitably anything that separated them from the accepted norm, status, and power of men was not only wrong, but dangerous. The subsequent explanation—that weapons used to keep women down could be quietly wrested from male authority for women's own use—became the source of

both artistic and theoretical controversy: the possibility or impossibility of "dismantling the master's house with the master's tools" (hooks 36). Despite the production of often virulent argument and heavy-handed artistic imagery, the essentialist debate was a marker of the vitality of what is now regarded as the third wave of feminist activism (following suffrage and the founding of NOW) and feminist theory (following de Beauvoir and Friedan) in the twentieth century. It firmly put into place a body of fundamental principles upon which further practical action and feminist theory could, and did, develop.

Women redefining themselves, their imagery, and their place in history also became the driving force of the emergence of feminist art theory in this decade. Art historian Linda Nochlin, in a ground-breaking essay of 1969 entitled "Why Have There Been No Great Women Artists?," confronted the fact of women's relative absence as producers of art in the history of civilization. Nochlin was the first to raise the most significant issues feminist art critics and scholars would address over the succeeding decades: that history as a discipline has been biased, distorting, and androcentric, and, in the case of art histories, deeply vested in the notion of creativity as the purview of the solitary, sexual, male genius; that the demands of art-making have been utterly incompatible with the socially imposed demands of "femininity," marriage, and motherhood, and that this incompatibility has been protected from within the establishment of art education and patronage; and that woman's overwhelming presence as object, rather than subject, of art has masked her voicelessness and reified her as site of mute sexuality and male ownership. This last issue was taken up with persuasive force by filmmaker and critic Laura Mulvey in her 1975 essay, "Visual Pleasure and Narrative Cinema," and served to push feminist art theory to the next level of significant inquiry. Using structuralist and post-Freudian methodologies, Mulvey isolated the dominant and determinant presence of the "male gaze" in film. Because film, like most art, is the production of men, women are inevitably presented as the objects of male projections and desires. The making of art, and specifically film, is thus seen as a codified language of scopophilia which premises all acts of looking in patriarchy, and which ultimately results in an act of possession of the Other.

Much of this debate came together, for good and for bad, in the emergence of so-called postmodern feminist theory and art practice. Precipitated by the break-up of the hegemonic (if not monolithic) domination of modernism resulting from feminist art activity in the 1970s, it remains—intentionally—a difficult concept to contain and define. Postmodernism as

a term first appeared in the 1930s in the writings of European semioticians such as Jan Mukarovsky, who posited the encoding of all language, verbal and visual, with meanings that were neither apparent nor objective. This implicitly denied the control of the speaker, whether artist or writer, over meaning, and instead, privileged the "reader" as the holder of a text's final significance. These ideas continued to be taken up by European theorists, in particular the French psychoanalyst Jacques Lacan and French philosopher Jacques Derrida. Lacan, working within orthodox Freudianism, examined the mechanisms by which the symbolic order of power hierarchies is integrated by the child in the Oedipal phase of development. Derrida, the originator of deconstructionist theory, turned his attention to language as carrier of symbolic hierarchies. He proposed that language is a binary system in which meaning is determined by contrast, as in male/female, true/false, good/bad, and that superiority is usually granted the first in the pair. Language, he contended, must be dismantled—deconstructed—in order to recognize and disrupt this system.

Initially, postmodern feminism was identified with French writer/philosophers Hélène Cixous, Luce Irigaray, and Julia Kristeva. Each took Lacan and Derrida as their starting points, and applied Simone de Beauvoir's lens of woman as other to woman as ultimate Other in social hierarchy, symbolic systems, and dualistic language. The authority of authorship—male agency in all forms of language and text—was rejected, and Freud's theories were interpreted iconoclastically, not via the phallic order—woman as lacking the sexual and symbolic power of the penis—but via multiple sites of female sensuality and knowledge, characterized as *jouissance*. In the great debate of female equality vs. female difference, the French postmodernists resoundingly embraced female difference and its celebration. Moreover, they aggressively rejected all remnants of patriarchal form, as in traditional linear logic in writing, science, or mathematic methodologies. In focusing attention on radically altered form, they parted company with the essentialists, largely bound by definition to the discussion of the meaning of Woman. In fact, their emphasis on form, sometimes to the exclusion of meaning, led to the accusation that the privileging of theory over action rendered postmodern feminism useless in the fight for gender equity.

Nonetheless, postmodern and feminist theory has been built on some of the same foundations, and come to share certain issues in common: for example, language, verbal or visual, as a system constituting meaning; difference as established through contrast and the creation of an inferiorized Other; and discourse as the deconstruction of binarism and the operations

of difference in language (Scott 359–60). In America, however, feminist postmodernism has often been seen as an oxymoron. Women's issues had not been a part of the postmodern program of its originators, and the denial of authority and authorship has been identified as dangerous (or at least ill-timed) to a period in which women were still only beginning to reclaim their history and assert their voice. Moreover, the insistence on the part of the French feminist postmodernists, especially Irigaray, that we take patriarchal gender codes, exaggerate them, and fling them into the face of patriarchy has been linked to highly controversial strategies in the arts. Sherrie Levine's rephotographed images of the best-known work of historic male photographers have almost never been critically discussed as "art" rather than polemic; Laurie Anderson's technological manipulation of her vocal range is most often understood not as a de-genderizing move, but a masculinizing one; and Cindy Sherman's photographic parody of gender stereotypes is widely acknowledged as ambiguous, if not ambivalent.

As an art-specific concept, the term Post-Modernism appeared late in the 1960s in the context of architecture, and became codified in that context with the publication of Robert Venturi and Denise Scott Brown's *Learning from Las Vegas* (1972). According to these architects, we learn from the buildings in Las Vegas that multiplicity, idiosyncrasy, vulgarity, pastiche and the rejection of seamlessness, abstraction, "art for art's sake," and other hallmarks of international modernism can renovate and revitalize the visual environment. As theoreticians and practitioners, Venturi, Scott Brown, and their Post-Modern program succeeded in bringing an end to the unitary quality of architectural modernity, as feminist practice achieved for the arts, in general, at the same time. Further, architectural Post-Modernism interfaced with postmodernism as cultural practice around ideas of plurality, popular agency, quotation and its implicit critique of authoricity, even the power of jouissance. It was in the work of architect Elizabeth Plater-Zyberk that Post-Modernism/postmodernism spawned its most successful, and controversial, creation: the construction of the new city of Seaside, Florida (1984–91). Heralded as a uniquely feminist environment, Seaside was designed around the needs of families, and especially women, for easily accessed services, community support, and safety. Nonetheless, its impeccably historiated buildings, presumption of upper middle-class economy, car-free streets, and legislation of codes of maintainance have the ring of Disneyworld for real. That there may be a dark underbelly beneath the surface was metaphorized in the film *The Truman Show*, which was shot on location at Seaside.

There was a dark underbelly, as well, beneath the radical breakthroughs of the 1970s and 1980s. There is significant evidence that the latter decade, in particular, brought with it a reactionary trend like that documented in Susan Faludi's broad sociocultural study, *Backlash* (1991). In the visual arts, in 1984, when the Museum of Modern Art opened its new facilities with "An International Survey of Painting and Sculpture," only 13 of 164 artists were women. Virtually all of the artists were proponents of a "new" movement, Neo-Expressionism, which has since been characterized as an attempt on the part of the art establishment to reinstate the primacy of large-scale, emotionally explosive painting. One of the apparent purposes of this effort was to resuscitate an art economy suffering as a result of the nonmarketability of the new genres of the 1970s. Nonetheless, just as art experts sought to reify the traditions of twentieth century modernism, they breathed new life into the myth of the tortured, but macho, male genius who was thought invariably to produce this kind of work. These strategies and attitudes directly impacted on women artists' viability. During the period 1980-85, 40 percent of those classifying themselves as professional, U.S. artists were women; during the same period, a National Endowment for the Arts survey recorded the average annual income from art of men at $13,000, compared to $5,700 of women.

It was in response to MoMA's exhibition that a group of artists and art historians came together to form an activist group known as the Guerrilla Girls. Concealing their identities in gorilla costumes, they continue to post data throughout Manhattan's art districts documenting, among other issues, sexism and racism in New York galleries and museums. While very much determined to serve as a pragmatic watchdog group for the arts, they also insist upon the profound theoretical disconnection between a woman artist's professional life and gender role expectations. They have kept the fight in the streets by picketing art institutions, attracting the news media with information-based performances, and promoting their activities through sets of slides and videos.

The actions of the Guerrilla Girls have helped to highlight the extreme bias that still exists in the visual art world. Similar biases exist in the other art disciplines, as well, but despite these challenges, many women, including those in this book, have risen to the top of their chosen fields. The artists we have chosen to represent their media have won high honors for their work, including Pulitzer prizes for both Gwendolyn Brooks and Paula Vogel, and MacArthur "genius" fellowships to Yvonne Rainer and Cindy Sherman. All still living as of 1999, they are primarily from the United States. The two exceptions are Jane Campion, New Zealand filmmaker,

and Zaha Hadid, Iraqui-born architect based in London. The artists' works are spread over four decades: Yvonne Rainer's *Trio A* in the 1960s; Pauline Oliveros' *Sonic Meditations*, Judy Chicago's *Dinner Party* and Cindy Sherman's *Film Stills* in the 1970s; Laurie Anderson's *Langue d'Amour* and Zaha Hadid's *Peak Club* in the 1980s; Gwendolyn Brooks's poetry spanning the 1970s through the 1980s; and Amy Tan's *The Kitchen God's Wife*, Jane Campion's *The Piano*, and Paula Vogel's *How I Learned to Drive* in the 1990s.

The artistic works discussed in this book range not only in discipline, from the visual to the literary to the performing arts—but in language—from very abstract, such as Yvonne Rainer's dance *Trio A*, to unabashed sociopolitical commentary, as in Judy Chicago's art installation *The Dinner Party*. These two works in many ways are opposites of one another. Rainer eschewed narrative, emotional content, embellishments, and virtuosity in *Trio A*, whereas Chicago literally wove them into her work. Chicago wanted the stories and accomplishments of many women in history to be a part of her content, and she made them central to her work. Embellishment and virtuosity were present in the rich embroideries and elegant place settings, requiring highly specialized techniques in ceramics. The sheer spectacle of the work—its scale and aesthetic complexity—spoke to its impact on both emotional and intellectual levels. With *The Dinner Party,* Chicago made a multilayered commentary that had a specifically political purpose: to bring to light important aspects of women's history with the notion of reclaiming respect for women. This was a work meant not only to challenge ideas of what "art" is but also to challenge the current status of women. On the other hand, Rainer's stated purpose in creating *Trio A* was finding a choreographic equivalent for minimalism. Rainer wanted the audience to see the movement itself and the body in motion. She encouraged the viewer to avoid reading emotional or narrative meaning into her piece, much as philosopher Susan Sontag explained the phenomenon in her famous essay "Against Interpretation."

In addition to noting the range of content and media within this group of works, there are other questions that have interested us. What is political art, and which of these works is political? How are social change and artistic change related? How does gender figure into the work? What is feminist art, and which of the works is feminist? How do race, religion, class, and sexual orientation fit into the total picture?

Political art may be defined quite narrowly as art that is designed to promote a specific political cause, such as much of the street theater

performed in the 1960s and 1970s, and that of the Guerrilla Girls now. None of the artists or works in this book are as specifically focused on achieving a particular political end. However, somewhat more broadly, political art may mean work that is designed to provoke significant social change through a full and sensitive engagement with its medium, and not at the expense of aesthetic values. Much of the work discussed here falls loosely into this category. It is work that challenges us to perceive issues in a new, full way, knitting together aesthetic detail with narrative or message into a seamless whole. Poet Gwendolyn Brooks is an example of this mix of the political and the aesthetic. By praising admirable behaviors and condemning the despicable through the fictional characters of her poems, she suggests values to live by. But it is done elegantly, beautifully, never pedantically.

A third definition of political art is even broader still. This third type of political art might indicate work that is designed to push at the boundaries of current definitions of its art form. A work is then "political" in the sense that an artist makes an aesthetic change by creating an alternative to the dominant norms. The tension between the established traditions and the new work sets up a dialectic that causes reverberations in the art world and sometimes in the world at large. Pauline Oliveros' *Sonic Meditations* can be considered political because it asks that we stop what we are doing to reconsider the nature of sound. Although this composition does not, on the surface, appear to promote social change, it is actually very subversive. Oliveros asks us to listen to, and furthermore, to participate in, music that is a doorway into a new kind of awareness which she calls "Deep Listening." There is minute attention to detail that is both individual and collective. It draws on some of the principles of meditation, and in fact, is a kind of meditation itself. On her web page, Oliveros states, "Deep Listening is listening in every possible way to everything possible to hear . . . Such intense listening includes the sounds of daily life, of nature, of one's own thoughts, as well as musical sounds. Deep Listening is a life practice" (19). Oliveros' intent is nothing less than changing the way we go about our daily lives.

If we accept all these definitions of "political art," then every work examined in this text is political, since each challenges the status quo, either artistically or socially. However, there is a great difference in degree of political orientation among the works. Some artists promote a viewpoint rather explicitly through the particular content which they narrate to us. In fact, the arts involving language are more likely to be able to do this directly, and our sampling is no exception. Writers Amy Tan,

Gwendolyn Brooks, and Paula Vogel all write about experiences of oppression and survival in difficult situations. Their works make readers or viewers see wrongs that might otherwise go by quietly unnoticed, and ask us to confront those wrongs along with them. Filmmaker Jane Campion, through both her script and her filmic techniques, also examines an oppressive relationship and suggests a kind of resolution. Sculptor Judy Chicago, too, uses the written word by way of the names of the women embroidered on her tapestries and glazed onto her ceramic floor. Chicago's "narrative" is about celebrating the achievements of women rather than confronting a specific oppressive relationship, and it certainly challenges the social order by demanding attention for women's history. Performance artist Laurie Anderson, through her song lyrics, also proposes a radical revision of history by telling the Adam and Eve story from Eve's perspective.

The nonverbal works, by Rainer, Oliveros, Sherman, and Hadid challenge the social order in pushing boundaries within their respective art forms, and thus fall into the broadest category of political art. Rainer and Oliveros were both fundamental to the radical new genres of dance and music that arose in the 1960s and 1970s. Sherman abandoned traditional expectations around "aesthetic" photography in favor of the look of randomly arrested sequences from films. Hadid questioned both traditional and modernist views of architecture, creating her own internationally recognized style within a field that has been notoriously resistant to the inclusion of women.

In most of the art works discussed in this book, gender is a dominant theme or issue. For instance, in Tan's novel *The Kitchen God's Wife*, the reader is continually confronted with the reality of women's oppression in China and how that colors women's relationships, especially those with their own daughters. Chicago celebrates women, their achievements and their sexuality, in her work *The Dinner Party*. Sherman uses gender and sexuality as both the implicit and explicit content. Brooks shows us portraits of both women and men, not dwelling on gender, but including it as part of the conversation on Black unity. Vogel's touching look at an incestuous relationship between an uncle and his niece examines issues of gender and power in a unique way. Campion, in an historical look at colonial New Zealand, shows how women were excluded from decision-making, even about their own lives, and had no autonomy. Finally, Laurie Anderson reveals how the original biblical gender story, Adam and Eve, might have turned out differently, if only from the viewpoint of a female narrator. In fact, each of these works has a "new story to tell" in large part

because of the simple fact that the authorial voice is new: it is that of a woman.

In contrast, Oliveros, Rainer, and Hadid seem unconcerned with gender in their work. It seems abstract, nongendered, nonsexual, and emotionally cool. This is partly due to the nonverbal nature of their respective mediums. However, the essays on these three artists show that on a deeper level, gender *did* have a role to play in shaping these artists' aesthetics, and certainly their careers, although it is not easily read on the surface.

Are these works feminist? Must an artist *declare* herself a feminist in order to make feminist art, and, conversely, will a feminist necessarily make feminist works? Many of these works take on a feminist hue when viewed from the perspective of creating resistance to the patriarchal status quo. For instance, in the discussion of Campion's *The Piano*, the author points out that the protagonist stands up for her own rights, and by extension, the rights of women, although these "rights" are very restrictive from a late twentieth-century perspective. Similarly, Amy Tan's female characters resist the traditional Chinese patriarchal order, not by declaring themselves feminist or joining a political movement, but through actions and deeds small and large that promote women's physical and emotional survival in Chinese and Chinese-American culture. On the other hand, in examining Cindy Sherman's *Untitled Film Stills,* we find that although Sherman claims a feminist position for her work, that intent is clouded by the double message embedded in her sexualized images.

The issue of "otherness" ties all of these essays and works together. What does it mean to be outside of the dominant white, male mainstream in our culture? How have these women's worldviews made "otherness" a positive platform for social and artistic criticism and commentary? Postmodern feminists believe that being outside of the dominant cultural group is an advantage because it gives one both a clear vantage point and a position from which to criticize. If that is so, then the artists in this text certainly have optimal positions from which to promote social, political, or aesthetic change. The elements of gender, race, class, religion, age, and sexual orientation necessarily shape art, because they shape the artist, and the potential diversity within these elements is represented by the artists included here. As with political art, however, these factors may be explicitly highlighted or buried under other concerns within a given work. All ten artists are "other" (in de Beauvoir's now-famous terminology) because of their gender, and one might argue, also because each is an artist,

less involved in the day-to-day production of usable goods and services in our society than they are in creating alternative artistic visions.

Three of the ten artists, Brooks, Hadid, and Tan, are visibly "outsiders" in western culture due to their races and ethnic identities. As Annie Perkins points out in the case of Gwendolyn Brooks, her poetry foregrounds race and Black unity; her personal writings state that Black women need to work with Black men to fight racism. Phillipa Kafka stresses the difficulties and tensions between East and West in the bicultural (Chinese-American) novels of Amy Tan, with Tan's own Chinese heritage a major theme in her work. For Zaha Hadid, however, race and ethnicity are issues left unaddressed in both her work and her discussion of her work. Hadid herself has said that she prefers to ignore the question, and so far has been able to do so.

Considering the many variables that can create difference, how are the intentions and creations of these ten women linked? Perhaps the most basic common denominator among these artists is the push for *change* that suffuses their work. Whether asking us to reconsider the nature of sound, as Oliveros does, or the nature of women's place in history, as Chicago does, these artists challenge us to perceive in new ways. Most of these artists embody a radical departure from the previous traditions in their fields, and, in fact, that "radical" element is an important part of why each is so important. Although change is a characteristic in much contemporary art, it seems that in general, women "do it differently."

It appears that certain women-related themes, as evidenced in the work of Brooks, Chicago, Vogel, Sherman, Campion, Tan, and Anderson, give clues as to the gender of their creators. It is unlikely, for instance, that a man could have written *The Kitchen God's Wife*, with its in-depth look at violence against women, and its intimate focus on a mother-daughter relationship. Likewise, it seems unlikely that a man would rewrite the Adam and Eve story as Anderson did, in a way that makes Eve the focal point. And Gwendolyn Brooks's poem "To Sisters Who Kept Their Naturals," which celebrates the Afro hairstyle as an emblem of self-respect for Black women, clearly is written by not only a Black, but a Black woman.

The fact that the artists in this book are women affects the nature of what they choose to say, how they choose to say it, and their dialogue with change. This is not to suggest, however, that this dialogue can be reduced to a set of essential female elements. Each woman's unique makeup (age, race, religion, personal history, education, sexual orientation) contributes to her aesthetic philosophy and its expression through her art.

There can be no monolith called "women's art." Yet, were we to take a similar sample of ten male artists of the period, the issues embedded in their works would doubtless look very different from those presented here. The artists in this book constitute a microcosm of women's artistic, social, and political concerns since 1960, and as such, stand for the emerging and consolidating strength of women artists (and women in general) coming to voice in the last part of the twentieth century.

Works Cited

de Beauvoir, Simone. *The Second Sex*. Ed. and Trans. H. M. Parshley. New York: Vintage Press, 1974.

Graham, Martha. *Blood Memory*. New York: Doubleday, 1991.

hooks, bell. "Feminist Theory: A Radical Agenda.." In *Talking Back: Thinking Feminist, Thinking Black,* Boston: South End Press, 1989. 35–41.

Johnson, Deborah. "The Training and Professionalism of North American Women Artists in the 20th Century" in *The Dictionary of Women Artists*. Ed. Delia Gaze, Vol. 1. London: Fitzroy Dearborn Publishers, 1997. 137–146.

Munro, Eleanor. *Originals: American Women Artists*. New York: Simon and Schuster, 1979.

Oliveros, Pauline. "Deep Listening." *Pauline Oliveros Website*. 9 Aug. 1999. http://www.artswire.org/pof/peop_po.html.

Rosen, Randy, et al. *Making Their Mark: Women Artists Move into the Mainstream, 1970-85*. Cincinnati: Cincinnati Art Museum, 1989.

Scott, Joan W. "Deconstructing Equality-Versus-Difference: or, The Uses of Poststructuralist Theory for Feminism" in *Theorizing Feminisms*. Eds. Anne C. Herrmann and Abigail J. Stewart, Boulder: Westview Press, 1994. 358–371.

Withers, Josephine. "Feminist Performance Art: Performing, Discovering, Transforming Ourselves" in *The Power of Feminist Art*. Eds. Norma Broude and Mary D. Garrard, New York: Harry N. Abrams, Inc., 1994. 158–173.

Chapter 1

Disappearing Act: Yvonne Rainer, *Trio A*, and the Feminist Dilemma (1966)

Wendy Oliver

Yvonne Rainer (b.1934) came to New York City in 1956 to study acting but rather quickly decided that professional theater was not her métier. Meanwhile, she was very involved in the "art scene," and attended many plays and gallery openings. In 1957, a friend invited her to take a dance class with teacher Edith Stephen. Although very athletic as a girl, Rainer had little formal training in dance, but she agreed to go. She enjoyed the class so much that she started attending regularly. By age 25, she decided to accelerate her training by taking three classes a day: two modern dance, and one ballet. Over the next few years, she studied with Martha Graham, Merce Cunningham, Anna Halprin, and Robert Dunn, making rapid progress. She also performed with established choreographers James Waring, Aileen Passloff, and others.

In 1962, she and several other dancers, musicians, and artists, formed the Judson Dance Theater. They created interdisciplinary art that pushed boundaries by including pedestrian movement, unusual juxtaposition of elements, and an intellectual rather than emotional approach. Within this context, she pioneered her minimalist, task-oriented style of dance. One of her earlier works, Terrain *(1963), was an evening-length piece that involved six performers using chance operations within a set structure, and featured lighting design by Robert Rauschenberg.* Trio A, *her signature dance work, was choreographed three years later in 1966. This dance was performed in different versions over the next few years*

by Rainer herself, and was even appropriated, in part or whole, by other choreographers, with Rainer's tacit permission.

In 1970, Rainer formed an improvisational performance group called the Grand Union. Meanwhile, she continued work on her own choreography and began integrating film into her work. By 1975, she thought of herself as a filmmaker rather than a dancer or choreographer. She has made several feature-length films, including The Man Who Envied Women *(1985) and became internationally known as an avant-garde filmmaker. She has been awarded the Special Achievement Award from the Los Angeles Film Critics' Association, the Filmmakers' Trophy at the Sundance Film Festival, the Geyer Werke Prize at the International Documentary Film Festival, as well as a coveted MacArthur "genius" grant.*

Although Rainer choreographed for only about a decade, her impact on modern dance has been extremely significant, evidenced by the fact that her name appears in virtually all Western dance history books written since 1960.

Yvonne Rainer choreographed her classic work *Trio A* in 1966 as a radical statement about what dance could be (fig.1). Her intention was to move away from passion, technical virtuosity, and classical structure towards a minimalist statement where no one gesture was more important than any other. Her new brand of "pedestrian" choreography, as epitomized by this work, became the foundation of postmodern dance, and was admired and emulated by many choreographers of the 1960s and 1970s. Rainer literally "embodied" the idea of minimalism by choreographing and performing in sympathy with the principles of minimalist visual art in that era.

But choreographing and performing not only as a minimalist, but as a *female* minimalist, brought with it a particular dilemma. How could a performer, and particularly a female performer, dance for an audience without being objectified or glamorized in the eyes of the beholder? Rainer's answer to this question was inextricably woven into her landmark work *Trio A*. Although Rainer did not consider herself a feminist until the early 1970s[1], close examination of *Trio A* shows that aspects of her work readily lend themselves to feminist interpretation.

* * * * *

In the early 1960s, choreographer Yvonne Rainer had become part of the minimalist arts movement. During her formative years with the Judson

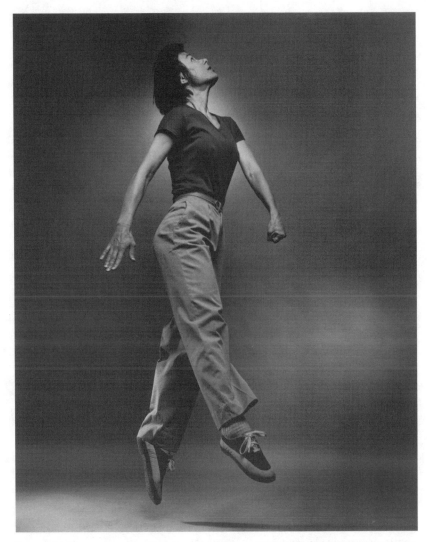

Figure 1. Yvonne Rainer in *Trio A*, reconstruction, 1981. Photograph © Jack Mitchell.

Church group (1962-64) in New York City, she participated in a lively performance workshop where dancers, visual artists, and musicians gathered to make and perform new work. Carolee Schneemann, Robert Morris, and Robert Rauschenberg were some of the visual/performance artists who were also part of this group. Rainer and her colleagues stripped away narrative, costumes, sets, mood, and music in order to focus attention on the movement itself. In modern dance, this style generally translated

to using simple, everyday movement, often performed by untrained danc-
ers. Instead of the extravagant leaps and turns of ballet, or the impas-
sioned contractions of the torso characteristic of modern dance, Rainer
chose easy, uninflected movements such as arm circles, toe taps, and
torso twists.

Even the name *Trio A* suggested a minimalist simplicity, since it seemed
to imply movement for three people without any particular theme, but
with an attention to form suggested by the letter "A," as in ABA form in
music.[2] The title is also interesting since Rainer later developed other
versions of the dance which were performed solo or in a larger group,
and were still referred to as *Trio A*, even though they were no longer
performed by three people.

Critic and historian Sally Banes has written a landmark analysis of *Trio
A* which explains how the features of the work differ radically from ballet
and most modern dance. She notes that although the dancer sometimes
assumes a balletic posture—an erect torso and head, coupled with turned
out legs and feet—that balletic position always dissolves into movement
that is most definitely unballetic. Banes cites a number of characteristics
of the dance that make it the revolutionary work it is:

> The lack of plot development in the phrasing, the antivirtuosic baring of workliness
> in certain of the movements . . . and the straightforward angles of presentation of
> the body, and the fact that at the beginning of the dance the performer faces to
> the side and the dance ends with the performer's back to the audience: all these
> features drastically violate the canons of classic theatrical dancing (*Terpsichore in
> Sneakers* 48).

Rainer herself wrote how her dislike of the artificiality of ballet led to
finding something new. In her book entitled *Work 1961-1973*, published
in 1974, Rainer explains how the larger-than-life theatrical style of dance
was no longer viable for her time. Here she discusses the dance move-
ment grand jeté (large leap), which represents the epitome of the dra-
matic gesture in dance.

> It is easy to see why the grand jeté (along with its ilk) had to be abandoned. One
> cannot "do" a grand jeté; one must *dance* it to get it done at all, i.e., invest it with
> all the necessary nuances of energy distribution that will produce the look of
> climax together with a still, suspended extension in the middle of the movement.
> Like a romantic, overblown plot, this particular kind of display—with its emphasis
> on nuance and skilled accomplishment, its accessibility to comparison and inter-
> pretation, its involvement with connoisseurship, its introversion, narcissism, and
> self-congratulatoriness—has finally in this decade exhausted itself, closed back on
> itself, and perpetuates itself solely by consuming its own tail (65–66).

Convinced that the dramatic gesture was dead, Rainer went on to consider alternatives. These included "stand, walk, run, eat, carry bricks, show movies, or move or be moved by some *thing* other than oneself" (66).

In her dances of the late sixties, Yvonne Rainer dedicated herself to finding an alternative to "self-congratulatory" choreography. In one 4½-minute statement, *Trio A* summarizes and symbolizes this anti-traditional philosophy through movement.

Trio A opens with the dancer (or dancers, depending upon the version) in profile to the audience. She bends her knees, then turns her head to her left, away from the audience. Her arms swing across her body, five times, one wrapping across her stomach, and the other behind her back, in alternation. She takes two steps upstage (away from the audience), opens her arms wide like an airplane, and makes two small circles from the shoulders.

The dance continues with smooth walking or turning accompanied by interesting and unusual hand and head gestures. For instance, at one point, the dancer's hands are clasped together an inch or two above her head. Her bent elbows alternate side to side, each in turn pulling her clasped hands down near an ear, passing lightly around the crown of the head without touching it.

On first viewing, the movement appears quirky but uncomplicated. However, on subsequent examination, the dance reveals itself as difficult to follow, perhaps due in part to its lack of traditional phrasing, and its specific avoidance of formal structures such as theme and variation. Typically, dance works before this time had stops, starts, and tempo variations, all of which served to provide varied emphases and dynamics. Rainer specifically avoided this. There are no pauses between phrases, and the tempo is moderate throughout. The quality of the movement "conveys a sense of unhurried control. The body is weighty without being completely relaxed" (*Work* 67).

Rainer also avoided a theme and variation type structure. Since no movement or movement series in the dance is a variation of another, it means that the viewer is continually taking in new visual information. This feature, coupled with the constant flow of movement at an even tempo may take the viewer into "information overload."

Sometimes, the movements suggest an image, like a tightrope walker, a person walking a dog, or a Spanish dancer. Most of the time, however, the movement seems not to refer to anything except itself. A simple squat, a back somersault, a handstand: each is danced simply, almost nonchalantly,

as part of the flow. The dancer descends to the floor frequently, only to rise each time for another episode of verticality. At one point, standing, she lifts her shoulder, shifts her ribcage, and curls downward, placing her shoulder on the floor. She begins to pivot around herself in a circle, seems to change her mind, and reverses direction.

An especially wonderful moment in the dance occurs when she jumps forward lightly from two feet onto one foot, patting the air with both palms forward as she lands. Perhaps because it is impossible to perform a jump in a totally uninflected way, this movement has a suddeness that sets it apart from the others.

Anyone who has tried this dance will note that it is not easy to do, despite the fact that it excludes "virtuosic" movement. Within the first thirty seconds of the piece, the performer is required to balance on one foot while undulating the spine. Neither of these movements is easy for a novice, and performed together they present quite a challenge. Then, a moment later, the dancer must drop downward into a deep lunge, head touching the floor, a feat requiring a great deal of flexibility—certainly more than the average "person on the street" possesses.

Performing *Trio A* requires concentration and relaxation simultaneously. Rainer wrote that in order to achieve a continuous flow, "one must bring to bear many different degrees of effort just in getting from one thing to another. Endurance comes into play very much with its necessity for conserving (actual) energy (like the long-distance runner)" (*Work* 67). The overall feeling of the piece, both in viewing it and performing it, centers around a steady-state energy flow, barely punctuated occasionally with a light jump or weight drop. This steady-state flow creates a slightly hypnotic effect.

Many critics have written about *Trio A,* describing its unique look and its important underlying concepts. Jack Anderson, a much revered dance writer, made this observation:

> The action flows by with such rapidity and lack of emphasis that one must struggle to concentrate upon following the course of the dance. In that struggle to concentrate, the audience, too, is dancing—dancing with the mind. Miss Rainer says, "The mind is a muscle," and just as the dancers are physically working certain sets of muscles, the audience is working to keep up with them (34).

It is interesting that the effect that this dance had on Anderson was unique; he chose to comment on the process of viewing the dance, as well as the dance itself. In fact, Rainer recognized that her choreography would force people to see movement in a new way: "Dance is hard to see. It must

must either be made less fancy, or the fact of that intrinsic difficulty must be emphasized to the point that it becomes almost impossible to see"(*Work 69*). Rainer chose the latter route for *Trio A* by creating complex, detailed movement that did not repeat itself, purposely creating "viewer overload." Additionally, Rainer created varied contexts for performing this work which further enriched its development.

Trio A is part of a larger work entitled *The Mind Is a Muscle* and has been performed in many incarnations over its lifetime. *Trio A's* first performance was in the Judson Memorial Church, in New York City, on January 10, 1966, to the accompaniment of wooden boards being thrown over a balcony at regular intervals. In May of 1966, it became the first of four parts, then eventually one of many parts in the full-length work *The Mind Is a Muscle*.

The several sections of *The Mind Is a Muscle* were performed either in silence or to varied sounds, including the performers counting aloud. The original *Trio A* was 4½ minutes long, performed by three dancers simultaneously, but not strictly in unison. Each performer was to use his/her own timing. *Trio B* involved "a series of runs and athletic traveling movements performed in unison by three women" (*Work* 77) on plastic bubble wrap and black rubber. "Mat" used a large rubber mat and a dumbbell, with rolling, headstands, and handstands, all executed with an even dynamic. "Stairs," also a trio, used a small set of stairs as the location for climbing, pulling, and jumping. "Act" involved varied tableaux using swings on one side of the stage, while a magician performed on the other side. There were four other sections, and all of the short pieces were interspersed with brief musical selections or poetry entitled "interludes."

The dance was passed down through generations of dancers, filmed, videotaped, performed in a 1960s retrospective, reviewed by many critics, and analyzed thoroughly by critic/historian Sally Banes. Rainer herself wrote extensively about the dance and about its relationship to the minimalism of visual arts.

In constructing a philosophical basis for her work, Rainer created a list that loosely equated several characteristics of art and dance. This list, entitled "A Quasi Survey of Some 'Minimalist' Tendencies in the Quantitatively Minimal Dance Activity Midst the Plethora, or an Analysis of *Trio A*," looked at the common ideas underlying minimalist dance and art.

Rainer was looking to "eliminate or minimize" the characteristics of "phrasing, development and climax, variation, character, performance, variety, and virtuosity" from dance, instead replacing them with "energy equality and found movement, equality of parts . . . , repetition . . . ,

neutral performance, . . . tasklike activity, singular action . . . , and human scale." Her parallel directive in visual art was to "eliminate or minimize" the "role of artist's hand, hierarchical relationships of parts, texture, figure reference, illusionism, complexity and detail, and monumentality," replacing them with "factory fabrication, unitary forms, uninterrupted surface, nonreferential forms, literalness, simplicity, and human scale" (*Work* 63).

In Rainer's system, specific visual art characteristics had dance equivalents. For example, eliminating "hierarchical relationships of parts" in visual art translated to eliminating "development and climax" in dance. In *Trio A*, this was carried out by keeping the movement constantly flowing at an even pace. No pauses were permitted. Rather than building dynamic tension leading to a release, Rainer kept a steady-state dynamic throughout. Eliminating "figure reference" in art translated to eliminating "character" in dance. In *Trio A,* the performers were not pretending to be characters, as in a play, or a Martha Graham[3] opus. They were not performing a narrative, but an abstract dance, just as minimalist visual artists were not telling stories with their works, but presenting abstract visual images.

Ironically, however, Rainer did not consider herself a "true minimalist." In an interview with Thryza Nichols Goodeve, she says that she "never wanted to be restricted to Minimalism's anti-metaphorical strategies. In fact, as a dancer I knew it was impossible: the body speaks no matter how you try to suppress it" (3). As an example of how she integrated "narrative" into her work, Rainer cites her solo, "Ordinary Dance" (1962), in which she recited a list of street names and grade school teachers from her own past while dancing. She also mentions her dance "We Shall Run" (1963), in which twelve people in street clothes ran for seven minutes in varied pathways to the music of a Berlioz requiem. To Rainer, autobiographical lists and emotionally charged music such as the requiem were "dramatic elements," even if they did not constitute a linearly developed dance/drama as it is commonly conceptualized.

Rainer says that a need to incorporate more narrative in her work was what led her to become a filmmaker in 1973. In an interview with Laleen Jayamanne, she elaborated: "What the body can say without verbal language is limited, which is why I so frequently used language in my dances . . . to tell stories, mostly. I would speak or project texts and later used more elaborate scripts, including multi-media. But I guess I grew impatient with the limitations of the body's expressivity. That is why I no longer involve myself in the kind of 'physical research' I had done through my body" (22).

Rainer says that she was drawn to fictionalizing her own autobiography, and although she was partially able to do that within her dance work, she felt that she would better be able to carry it out through film. Over the years, her seven films have included the themes of heterosexuality, domestic conflict, political violence, U.S. imperialism, social privilege, gender inequality, disease, aging, and homosexuality. Her most recent film, *MURDER and murder* (1997), parallels her own recent coming out and involvement in a lesbian relationship as well as her experience with breast cancer. Much of the material for this film, as in the earlier ones, came directly from her life experience. The contrast between *MURDER and murder* and *Trio A* is striking. Her film has been called ". . . a simple love story involving two women of their 50s . . ." and "an example of Rainer's special brand of slapstick-feminist modernism [that] is not only her most accessible film to date but also her funniest" (Goodeve 2). On the other hand, *Trio A* is the epitome of a nonnarrative work. Given that Rainer has considered autobiography to be her most compelling artistic source, it is ironic that she may be best known for a dance, *Trio A*, that has no apparent emotive, narrative, or autobiographic components.

Rainer's *Trio A* and other avant garde works of the 1960s were the beginning of a style of dance that eventually became known as "postmodern dance." Two decades later, the term "postmodern feminism" was coined. It is interesting to examine the connections between these two "postmodern" movements.

While the field of dance had both "modern"[4] and "postmodern" varieties, feminism did not label any of its strands as "modern." Rather, the advent of "the second wave" of feminism in the 1960s involved both liberal and radical feminists. Postmodern feminism did not exist until two decades later. (Two of the definitive texts of postmodern feminism were *This Sex Which Is Not One*, by Luce Irigaray, published in French in 1977, and English in 1985, and Hélène Cixous's "The Laugh of the Medusa," published in 1981.) Each discipline declared itself "post" or after modernism, implying that it encompassed newer and more radical points of view than its "modern" precursor.

"Postmodern" dance was the term coined in the 1970s for dances like *Trio A* that were centered on minimalist or formalist concerns. Minimalism, or a stripping away of extraneous elements, and formalism, an emphasis on structure over content, combined to create a new style that was extremely thought-provoking. How dances were constructed became more important than visual elements such as elaborate costumes or artistic sets. Movement itself was the centerpiece, rather than any external message

or story. The phrase "movement for movement's sake" was often heard as a descriptor for dance of this era.

Postmodern dance also embraced the "found art"[5] aesthetic of minimalist art by showing that any movement could be dance. Walking across a stage, sitting on a chair, or tying a shoe were all treated as potential performance material. Another permutation of this idea was the use of untrained performers. Just as any movement could be considered dance, any person could be a dancer, regardless of age, physical appearance, or training. Rainer taught *Trio A* to "anyone who wanted to learn it—skilled, unskilled, professional, fat, old, sick, amateur—and gave tacit permission to anyone who wanted to teach it . . ." (*Work* 77). Postmodern dance was a rejection of the elitist ideals of traditional dance, and in this rejection of its roots, it exposed the bias of earlier dance aesthetics.

Choreographers of postmodern dance proved that dance could be intellectual as well as emotional. Culturally determined stereotypes often equate men with intellect, and women with emotion. Typically, dance is categorized as emotional or expressive, rather than intellectual, therefore allying it with things female. Female postmodern choreographers including Rainer, Trisha Brown, Lucinda Childs, and others repudiated these stereotypes by leading the way in this "intellectual" dance genre. By developing complex choreographic theories, these women showcased their intellect as well as their physical selves. Rainer's philosophical writings were further "proof" of her intellectual brawn. However, this could not be interpreted as a wholesale attempt to deny the physicality of the body, since she declares in her own writing "I love the body—its actual weight, mass, and unenhanced physicality . . . My body remains the enduring reality" (*Work* 71). According to Banes, Rainer "looked for ways not to disembody the female mind, but rather, to foreground it in and unite it with the female body, while simultaneously excising emotional expression from that body"(*Dancing Women* 224).

While Rainer grounded this body/mind union in the sensory experience of dance, there is a distinction to be made between the sensory and the sensual. While embracing the "unenhanced physicality" of her body (which might be interpreted as a kinesthetic internal awareness of how her body felt as it moved), she nonetheless avoided inviting a sensual or sexual experiencing of her performance. Postmodern dance seemed to equalize the genders because it showed that women did not need to trade on their sexuality in order to make dance. This emphasis on equality between the sexes was an unstated link to the feminist movement of that time, which included such events as the publication of Betty Friedan's

The Feminine Mystique in 1963 and Gloria Steinem's *Ms.* magazine in 1971. A decade later, feminist thought had proliferated and changed, and on the forefront of the movement was postmodern feminism.

According to feminist scholar Rosemarie Putnam Tong, postmodern feminism, which came into prominence in the 1980s, "view[s] with suspicion any mode of feminist thought that aims to provide THE explanation for why woman is oppressed . . ." (193). Postmodern feminists such as Hélène Cixous, Luce Irigaray, and Julia Kristeva have proposed to write new theories about women. In order to do this, they first had to deconstruct patriarchal notions of gender. "Deconstructionists take a critical attitude toward everything that society regards as good, true, and beautiful, suggesting that it might actually be better for individuals to be "bad," "false," and "ugly" (Tong 195).

Postmodern dance paralleled this definition in that it was a deconstruction not only of modern dance, but of all dance of the twentieth century. Postmodern choreographers boldly declared, both through their work and in discussions about it, that the established norms for dance were no longer valid. By presenting images, ideas, and movements so far removed from the standard idea of dance, postmodern choreographers challenged the very meaning of the word "dance." Like postmodern theorists, postmodern choreographers were questioning the very definition of words like "good and bad," "beautiful and ugly." If pointing the feet was a hallmark of "good" dancing, then postmodern dancers would choose *not* to point their feet, or better yet, wear sneakers in order to give the feet a more ordinary look.

While postmodern feminists recognized their relegation to "second sex" status, they chose to regard this as a strength rather than a weakness. This outsider's standing in societal hierarchy gave one the advantage of being able to critique societal norms and to advocate for diversity and difference. Postmodern choreographers like Rainer, on the other hand, were not relegated to their place outside the mainstream, but had willfully chosen it. From this fringe vantage point, they were able to critique traditional dance through both their actions and their words.

However, at this point, the parallel between postmodern dance and postmodern feminism breaks down. While postmodern feminist theory has as its overarching framework the idea that there is no one truth, but rather many truths, postmodern dance does not appear to embrace this idea. Postmodern feminism shows that one can be a "good" feminist in many different ways. Postmodern dance was most concerned with making something new, and in causing audiences to see dance in a new way.

In breaking away from modern dance, postmodern dance had to prove itself legitimate and could not logically extend itself by embracing all definitions of dance. Rainer had declared that modern dance had "exhausted itself, closed back on itself, and perpetuates itself solely by consuming its own tail" (*Work* 65–66). This condemnation is antithetical to the notion that postmodern dance could accommodate any and all aesthetic approaches to dance.

One aspect of postmodern dance evident in *Trio A* was the seeming indifference to the gender of the performers. Scholar Elizabeth Dempster has noted that "the play of oppositions and the gender stereotyping embodied in the ballet and perpetuated in modern dance traditions were systematically deemphasized in the postmodern work of this era" (31). In adopting the translated principles of minimalist art, Rainer was not concerned specifically with performing in gendered ways, that is, dancing roles that could be interpreted as either male or female. In fact, many of her dances used males and females interchangeably. Her formalist, intellectual works implied that women could do mentally challenging work just as well as men. Rainer sought to deny the dancing body, and particularly the female dancing body, its usual role as audience-seducer, either through sexuality or virtuosity. By refusing to emphasize the *femaleness* of her body, Rainer was able to make a work that seemed to transcend gender.

While *Trio A* is firmly grounded in its sense of physicality, it does not appear particularly "female." The straightforward, tasklike approach to movement does not readily reveal the gender of its creator. This "gender camouflage" comes about in a way that could be interpreted as related to Simone de Beauvoir's notion of immanence and transcendence.

Simone de Beauvoir, French feminist and author of *The Second Sex*, defines the concepts of immanence and transcendence relative to one another. Immanence is the state of being in the body; transcendence is rising above the body into the realm of the abstract. By their very nature, women are defined as inextricably tied to their bodies, bound to their immanence, and are therefore unable to transcend.

> The female, to a greater extent than the male, is the prey of the species; and the human race has always sought to escape its specific destiny. The support of life became for man an activity and a project through the invention of the tool; but in maternity woman remained closely bound to her body, like an animal . . . (97).

De Beauvoir believed that because of her biology, woman would have to struggle to attain freedoms like those which came by naturally.

Transcendence is a male concept, but de Beauvoir suggested that women could accomplish it through a dissociation with what is female about their

bodies. Although contemporary feminists consider this idea misogynist and, at any rate, impossible to achieve, at the time of its original publication, 1949, de Beauvoir's ideas in *The Second Sex* represented a radically new way of envisioning freedom from traditional ideas of femininity.

In the same way, one could say that Rainer was perhaps unconsciously striving for a kind of transcendence, not by denying her body, but by denying what was particularly female or feminine about it. One can never actually transcend one's embodied femaleness, of course, but she came very close to it. Her way of dancing in *Trio A*, like de Beauvoir's philosophical ideas, illustrated a kind of freedom from traditional ideas of femininity.

Another way in which Rainer rebuffed traditional notions of femininity was her acknowledgment and subsequent repudiation of what is now known as the male gaze. Nine years before Laura Mulvey's famous article (1975) on the male gaze in filmmaking was published, Rainer had already discovered that gaze for herself and had created a way to deflect it. What Rainer knew about body language was built into her choreography to create a particular kind of audience/performer relationship.

Audiences and performers tend to relate to one another through a series of encoded signals that are based on a long, shared cultural history. Gaze, or the act of looking, is perhaps the most basic of those signals. Psychologist Judith Hall notes that "Gaze is one of the most subtle and meaningful forms of nonverbal behavior" (73). She notes that gaze is a signal of attention; it is generally considered polite to look at people when interacting. Catching someone's eye indicates starting an interaction, while avoiding someone's eye indicates avoiding an interaction.

Psychologists Argyle and Cook state "A number of studies have found that people who look more are seen as more truthful or credible . . . people who are not telling the truth usually look less . . ." (77). They also say that "gaze at strangers in public places is interpreted in special ways. It can be perceived as threat or sexual interest, depending on contextual clues" (97).

Typically, performers use gaze as a means of making contact with their audience. This involves looking out toward the audience as often as is practical. The audience, continually gazing toward the performer (in most cases), receives this generalized eye contact and interprets it as connective. This contact promotes the feeling that the performer is sharing something with the viewer, or doing something especially for the entertainment or enjoyment of the viewer. When the performer is a female and the viewer a heterosexual male, the act of making eye contact with the audience can be construed as a sexual one. Yvonne Rainer was

quite aware of this, and so short-circuited the problem by avoiding eye contact with the audience all together. In *Trio A*, the dancer's head is often in profile to the audience, or facing away; if facing the audience, the dancer's eyes look down or away. This seems like a good example of Argyle and Cook's assertion that "gaze aversion may sometimes result from the need to avoid unduly high levels of arousal" (150), although they were referring to emotional, not sexual, arousal.

This gaze aversion technique is also practiced everyday in crowded urban areas by ordinary women to avoid attracting sexual attention. Rainer, as a resident of New York City, was surely aware of the unspoken urban rules of nonverbal behavior among strangers, and particularly between those of the opposite sex. By avoiding eye contact on the street, on the subway, or in an elevator, women express their disinterest in men who may try to engage their attention. Another defensive technique involves how women walk. When women walk briskly down the street in a no-nonsense way, directly toward a real or imagined goal, they appear to ask passersby to leave them alone. While waiting for the bus, subway, or taxi, women generally choose standing postures that appear reserved, with the body in a vertical or slightly hunched alignment, rather than those which attract sexual attention, with breasts or hips emphasized.

Another cultural cue that makes women either highly visible or relatively invisible concerns clothing. Loose clothes which cover the body completely tend to make women "invisible" to men who might otherwise look sexually at them. Hall notes that "most women would probably agree that wearing unisex (which really means masculine) clothes such as trousers and flat shoes confers much greater physical freedom and lack of self-consciousness about how they walk, sit, stand, and lean over" (120). Loose-fitting pants are particularly good camouflage, as they hide the contours of the hips and legs. Flat, utilitarian shoes promote women's ability to walk or run.

In the 1960s, women's fashions dictated tight miniskirts, tight sweaters or shirts, high heels, and heavy eye makeup. These fashions seemed made to display women's bodies and curtail the speed and vigor of their walk. This display of the female form was the "look" for the women of the 1960s sexual revolution. As scholars Christy Adair and Roger Copeland have pointed out, the so-called sexual liberation of that era was not necessarily so liberating for many women, who now felt pressure to be sexually available. Copeland noted, "Many feminists began to practice what Midge Decter calls 'the new chastity.' They began to 'dress down' rather than up; they became suspicious and resentful of what has come to be known as 'the male gaze'"("Founding Mothers" 142).

In 1965, Yvonne Rainer published a statement which has since been referred to as the "No Manifesto." It says, among other things, "No to spectacle no to virtuosity no to transformations and magic and make believe . . . no to seduction of spectator by the wiles of the performer . . ." (*Some Retrospective Notes* 168). Copeland notes that

> these words were intended as an aesthetic, not a political, statement. But Yvonne Rainer's insistence upon saying "no" to so many of the voyeuristic and erotic pleasures that dance has traditionally offered begins to assume feminist implications when viewed against this ideological backdrop ("Founding Mothers" 8).

Rainer's *Trio A* avoids the "seduction of the spectator" in many of the same ways that women camouflage themselves walking down city streets where men are often ready with a catcall or suggestive comment. Her focus away from the audience, her task-like movement, her vertical, neutral body alignment, and her simple, everyday unisex clothing all lead the audience away from sexualizing the performer. Even her smooth, flowing dynamics, which refuse to make one movement more important than another, play into this scheme by deflecting attention from the dancer onto the movement itself.

This desexualization of the performer was a continuing theme for Rainer. As noted earlier, Rainer gave up choreography in 1973 to become a filmmaker, because, she says, she became less interested in abstract dance and everyday movement, and more intrigued with dramatic and psychological subject matter. "This could not always be realized to my satisfaction by configurations of bodies in space" (Bergstrom et al. 30). Although she does not specifically mention it, she must have welcomed the control of the audience viewpoint that came with her new artistic medium. She saw the sexualization and objectification of women in performance or on film as a problem to be solved. In an interview with Amy Taubin, Rainer discusses one of her earlier films, *The Man Who Envied Women*. It is

> about a man whose wife has just left him . . . The wife is never seen. We hear her voice throughout—it governs the film. I began to be uncomfortable with the visual representation of women after *Film About a Woman Who* . . . (1974) . . . So the removal of this main female character, of her image, is an extreme response to the problem that the woman in film is always a voyeuristic object, that one relates to her primarily through her physical attributes. I can't deal with her physicality in any other way right now" (81).

By eliminating the physical presence of the female protagonist in her film, Rainer not only found a way of realizing de Beauvoir's notion of transcendence, but also was able to evade the male gaze.

As a choreographer and performer, Rainer could not literally disappear from the stage. But she discovered a way to approximate that effect by distancing herself from the audience. Emotional, expressive, sensual, and sexual movements, as well as eye contact, were excluded from her vocabulary in her attempt to avoid "seducing" the audience. The dancer became, in essence, simply a medium through which the movement was conveyed, rather than a charismatic performer with whom the audience could connect.

Decades later, some feminists might be inclined to look back at *Trio A* and call it regressive. They could argue that it denied any sense of female sensuality, and in fact appears to be trying to deny natural expressivity. *Trio A* is hardly a piece that celebrates woman in any obvious way. However, in 1966, it was a feminist work precisely because it took the established norms for female social and performance behavior and turned them upside down. Instead of personal drama, sexuality, and audience connection, Rainer gave us movement for its own sake, asexuality, and audience distancing. Nine years before Laura Mulvey's famous essay on the "male gaze" in filmmaking was published in 1975,[6] Rainer had created her own novel solution to the problem of the viewer's tendency to sexualize the performer. By repudiating the "male gaze," Rainer took control of the way audiences (read: men) viewed performers (read: women).

Notes

1. During an interview with Thryza Nichols Goodeve in *Art in America,* July 1997, Rainer says, "By the early '70s, reading *Sisterhood Is Powerful* and all those outpourings of rage and outrage, I began to think of myself as a feminist. But it took a while. I was resistant . . ." (4).

2. There was also a *Trio B*, performed along with *Trio A* and several other short dances in a longer work called *The Mind Is a Muscle*.

3. Martha Graham, one of the greatest modern dance choreographers, created prolifically from the 1920s through the 1980s. She is known for creating full-length (1–2 hr.) dramatic dance works that center around a female protagonist (i.e. Joan of Arc and Clytemnestra) using plots based on various mythical or heroic figures and involving specific character roles, as in a play.

4. Modern dance arose at the beginning of the 20th century as a new, individualistic means of expression that was particularly opposed to the codification and strict stylization of ballet. Modern dance glorified the choreographer's vision, and emphasized the idea that dance was more than entertainment and pretty costumes. The development of modern dance paralleled the development of modern music and modern art, and modern dance became increasingly accepted during the period of 1920–1960.

5. The term "found art" comes from visual artist Marcel Duchamp (1887–1968), who took everyday objects, or ready-mades, and labeled them as art. Among the most famous of these ready-mades is the 1917 piece entitled *Fountain*, which was merely an unaltered urinal that he chose to display. The display of the urinal was a direct representation of Duchamp's rejection of the rules and conformities present in art. He created something that was in opposition to what had previously been deemed the artistic norm, and forced his audience to discover the art of pondering the aesthetic questions that an object can provoke rather than the aesthetic value of the object itself.

6. In her groundbreaking essay, Mulvey asserted that most films were made from a male viewpoint, with a man as spectator or subject, and a woman as the object of his scrutiny. The problem with this arrangement is that the balance of power can never be equalized; the woman on the screen necessarily exists to please the man visually. Furthermore, women generally adopt this patriarchal worldview as their own, and therefore see other women as well as themselves in this objectified way.

Works Cited

Adair, Christy. *Women and Dance: Sylphs and Sirens.* New York: New York University Press, 1992.

Anderson, Jack. "Yvonne Rainer: The Puritan as Hedonist." *Ballet Review* (1970): 31–37.

Argyle, M. and Cook, M. *Gaze and Mutual Gaze.* Cambridge, MA: Cambridge University Press, 1976.

Banes, Sally. *Dancing Women: Female Bodies on Stage.* London: Routledge, 1997.

————. *Terpsichore in Sneakers: Post-modern Dance.* Boston: Houghton-Mifflin, 1980.

Bergstrom, Janet, Sandy Flitterman, Elisabeth Lyon, and Constance Penley. "Interview with Camera Obscura Collective." *Camera Obscura: A Journal of Feminism and Film Theory* (Fall 1976): 29–31.

Copeland, Roger. "Founding Mothers: Duncan, Graham, Rainer, and Sexual Politics." *Dance Theatre Journal* (1990): 6–9; 27–30.

————. "Dance, Feminism, and the Critique of the Visual." In *Dance, Gender, and Culture.* Ed. Helen Thomas. NY: St. Martin's Press, 1993. 139–150.

de Beauvoir, Simone. *The Second Sex.* Ed. and Trans. H.M. Parshley. New York: Vintage Books, 1974.

Dempster, Elizabeth. "Women Writing the Body: Let's Watch a Little How She Dances." In *Bodies of the Text.* Eds. Ellen Goellner and Jacqueline Shea Murphy. New Brunswick, NJ: Rutgers University Press, 1994: 21–38.

Goodeve, Thyrza Nichols. "Rainer Talking Pictures." *Art in America* (July 1997): 56–59.

Hall, Judith. *Nonverbal Sex Differences: Communication Accuracy and Expressive Style.* Baltimore and London: Johns Hopkins University Press, 1984.

Jayamanne, Laleen. "Discussing Modernity, 'Third World,' and *The Man Who Envied Women*, with LJ, Geeta Kapur, and Yvonne Rainer." *Art and Text* 23.4 (Mar-May 1987): 41–51.

Mulvey, Laura. "Visual Pleasure and Narrative Cinema." *Screen 16* (Autumn 1975): 6–18.

Rainer, Yvonne. "Beyond the Mainstream." PBS television broadcast. *Dance in America.* 1980.

————. *Trio A.* (16 mm film). Producer Sally Banes. 1978.

————. "Some Retrospective Notes on a Dance for 10 People and 12 Mattresses Called 'Parts of Some Sextets' Performed at the Wadsworth Atheneum, Hartford, Connecticut, and Judson Memorial Church, New York, in March 1965." *Tulane Drama Review* 10 (Winter 1965): 168–178, reprinted in *Work* 45–51.

————. *Work 1961–1973.* Halifax: Press of Nova Scotia College of Art and Design; New York: New York University Press, 1974.

Taubin, Amy. "Daughters of Chaos: Feminist and Avant-garde Filmmakers." *The Village Voice* (30 Nov. 1982): 80–81.

Tong, Rosemarie Putnam. *Feminist Thought: A More Comprehensive Introduction.* Boulder, CO: Westview Press, 1998.

Chapter 2

The Poetry of Gwendolyn Brooks (1970s–1980s)

Annie Perkins

Gwendolyn Brooks (b.1917) (fig. 2) was born in Topeka, Kansas, and was reared in Chicago, her lifelong home. With the support and nurture of her parents, Brooks began writing poetry at age seven. She was first published at age thirteen, and by the time of her graduation from Englewood High School, had published sev-enty-five poems in the Chicago Defender.

In 1936, Brooks graduated from Wilson Junior College. In 1939, she married and settled happily into domesticity with her husband, Henry Lowington Blakely II, and later Henry III, their baby son. During this period, Brooks continued to write, first winning the 1943 Midwestern Writers' Conference Award and then publishing her first volume, A Street in Bronzeville *(1945). Her second volume,* Annie Allen *(1949), earned the 1950 Pulitzer Prize for Poetry, the first to be awarded to a Black writer. A year later, Brooks's daughter, Nora, was born.*

Balancing home, family, and writing, Brooks published within a decade Maud Martha *(1953), a novel;* Bronzeville Boys and Girls *(1956), a book of children's poetry; and* The Bean Eaters *(1960). In 1968, she received a National Book Award nomination for* In the Mecca, *written in the aftermath of the Martin Luther King assassination.*

In honor of her distinguished body of work, Brooks has received many awards, including the Frost Medal from the Poetry Society of America, the American Academy of Arts and Letters Award, the National Book Awards Medal for Distinguished Contribution to American Letters, the Sewanee Review's Aiken-Taylor Award,

and the National Medal of Arts from the President of the United States.

From 1985 to 1986, Brooks served as the twenty-ninth (and final) Consultant in Poetry to the Library of Congress. In 1988, she was inducted into the National Women's Hall of Fame. More recently, in 1994, she was a Jefferson Lecturer. Brooks holds seventy honorary doctorates and has taught at several institutions.

A poetry promoter, Brooks has sponsored poetry prizes throughout the country and has mentored and influenced scores of writers. Two tributes, To Gwen with Love *(1971) and* Say that the River Turns: The Impact of Gwendolyn Brooks *(1987), attest to the devotion and admiration she has inspired among younger writers. Her reminiscences and observations appear in two autobiographies,* Report from Part One *(1972) and* Report from Part Two *(1996). Among her recent poetry is* Children Coming Home *(1991).*

Gwendolyn Brooks—Pulitzer Prize winner, Illinois Poet Laureate, and poetry ambassador—has earned popular and critical acclaim for a body of work that spans more than five decades. Rich in ideas, complex in form, and centered in the Black experience, Brooks's poetry celebrates human aspiration and the push for empowerment nourished and sustained by respect for self, community and heritage. Through striking poetical sketches, Brooks offers an inspiriting and expansive vision which affirms the necessity for Black unity. However, readers of any race, class, gender, or nationality can identify with her gallery of women, men and children who reflect attitudes and aspirations common to humankind, and who experience life's ordinary—and extraordinary—triumphs and trials.

Critic Dan Jaffe maintains that "the purpose of art is always to communicate to the uninitiated, to make contact across seemingly insurmountable barriers" (54–55). Indeed, Brooks's family pictures do speak across boundaries, for as James N. Johnson observes, "The excellence of Gwendolyn Brooks is that she is able to tell it like it is while speaking to the basic humanness in us" (48). That she sparks this human connection is evident in her sustained popularity among diverse audiences. Brooks enjoys enthusiastic receptions at colleges and universities, at prisons and public schools, at churches and community festivals, at conferences and conventions, wherever she travels—reading, lecturing, mentoring, teaching, and always promoting poetry.

During her distinguished career, Brooks has written prose pieces, including a novel, *Maud Martha* (1953), and a two-volume autobiogra-

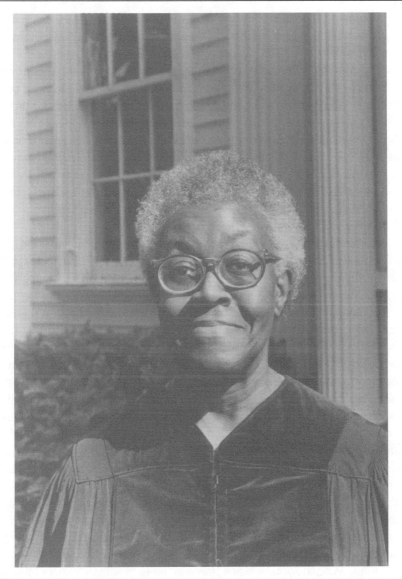

Figure 2. Gwendolyn Brooks

phy—*Report from Part One* (1972) and *Report from Part Two* (1996). But her literary reputation rests principally upon some twenty volumes of poetry, beginning with her debut collection, *A Street in Bronzeville* (1945), and including other volumes such as her 1950 Pulitzer Prize winner, *Annie Allen* (1949). Much of Brooks's poetry is collected in *The World of Gwendolyn Brooks* (1971), *To Disembark* (1981), and *Blacks* (1987).

In her early years, Brooks was primarily an art-for-art's sake poet, who appealed to her largely white audience for equal treatment of Blacks by depicting their lives with dignity and pathos. Like most Black people of that era, Brooks shared the hope that racial equality and equal opportunity could be achieved, but as the civil rights struggles grew more confrontational, her poetry began to reflect the racial tensions of the times. Noting the overly political nature of Brooks's work, a reviewer of *The Bean Eaters* (1960) posed this rhetorical question: "In times as troubled as ours, what sensitive writer can avoid a certain obsession with contemporary ills that may be temporary? . . . Of course she writes of Emmett Till, of Little Rock, of Dorie Miller, of a white [woman] disgusted to see her child embrace the Negro maid. . . . Increasingly, in each of her books, [social poems] have appeared" (Webster 19).

Brooks might have continued writing about social problems had she not attended a writers' conference at Fisk University in Nashville in 1967, where she met a group of Black poets, including Imiri Baraka (then LeRoi Jones). This encounter transformed Brooks's perception of her art and her audience. She was amazed by this group of young, self-affirming writers who were declaring in their poetry what James Brown was commanding in his music: "Say it loud: 'I'm Black and I'm proud.'" This talented group—nurtured in the turbulent decade of civil rights struggle and anti-war sentiment; of marches, demonstrations, and assassinations; of political upheaval, social protest and national trauma—had clarified themselves as BLACK and were shouting it from the ghettoes of the inner-city and from the halls of academia. Feeling as if she were "in some inscrutable and uncomfortable wonderland," Brooks experienced an incipient sea change: "I didn't know what to make of what surrounded me, of what hot sureness began almost immediately to invade me. I had never been, before, in the general presence of such insouciance, such live firmness, such confident vigor, such determination to mold or carve something DEFI-NITE [capitalization hers]" (*Report from Part One* 85). These young, mostly college-educated Blacks, who combined a Black Power 'Black-is-beautiful' aesthetic with a Black Panther self-help activism, were looking at themselves through their own eyes and celebrating the view. They had rejected totally the integrationist stance of their parents. Presented with this different perspective, Brooks, then in her early fifties, began to re-evaluate her own views:

What I saw and heard . . . was of a new nature to me . . . I had been asleep. If I had been asleep. If I had been reading even the newspaper intelligently, I too

would have seen that [the integration effort] simply was not working, that there
was too much against it, that blacks kept exposing themselves to it only to get
their faces smacked. The thing to stress was black solidarity and pride in one's
brothers and sisters. People didn't instruct me [in this idea] . . . I just picked it up
by osmosis, listening to [the young poets] and watching what they did. I went
around with them sometimes and heard them giving readings. Listening to them
was wonderful (*Report from Part One* 176).

While "apprenticing" with these young artists, Brooks also became
involved in her community at the grassroots level, conducting writing
workshops for a youth gang (the Blackstone Rangers) and participating in
neighborhood and cultural events. These experiences eventually trans-
formed her conception of her artistic role and of her audience. In 1972,
she wrote, "Today I am conscious of the fact that—my people are Black
people; it is to them that I appeal for understanding" (*Report from Part
One* 177). She announced that her intention would be

to write poems that would somehow successfully "call". . . all black people: black
people in taverns, black people in gutters, schools, offices, factories, prisons, the
consulate; I wish to reach black people in pulpits, black people in mines, on
farms, on thrones; *not* [italics hers] always to "teach" - I shall wish to entertain, to
illumine. My newish voice, which I so admire, but an extending adaptation of
today's [Gwendolyn Brooks] voice (*Report from Part One* 183).

The contemporary voice of Gwendolyn Brooks is populist, realistic,
and celebratory, often hortatory, but always grounded in and attuned to
the conditions and sensibilities in Black people. Blackness is what I know
very well," she explains. "I want to talk about it, with definitive illustra-
tion, in this time, in this time when hostility between races intensifies and
swirls." "I go on believing," Brooks observes, "that [Blacks who have little
allegiance to Blackness] will, finally, perceive the impressiveness of our
numbers, perceive the quality and legitimacy of our essence, and take
sufficient, indicated steps toward definition, clarification, connection" (*Re-
port from Part Two* 143). Thus, Brooks's post-1967 poetry became a
vehicle for declaring and disseminating a new Gospel—the affirmation of
Blackness, group solidarity, self-respect, and a sense of cultural heritage
among an "entire range of categories: South Africa, South State Street,
the little babe just born in the South Bronx" (Melham, *Heroism* 26).

But in spite of its new impulse, intent, and message, Brooks's poetry
remained rooted in the tradition of well-wrought, polished verse. It con-
tinued to manifest what Jaffe calls a "dedication to craft, to the business
of making" (50). Having studied Black poets like Paul Laurence Dunbar,

Langston Hughes, and Countee Cullen at an early age, Brooks had developed an appreciation for craftsmanship. Furthermore, after completing high school, she had received training in the techniques of modern poets—T.S. Eliot, Ezra Pound, and Robert Frost—during classes at the Chicago Southside Community Art Center conducted by Inez Stark Boulton, a wealthy Chicagoan and reader for *Poetry Magazine* (Melhem 7–9). With excellent training and natural talent, Brooks developed and cultivated a masterful technique that fuses exquisite diction with allusion, ironic contrasts, juxtaposition, repetition, alliteration, and other devices to create poems in which language, form, and idea happily coalesce. Poems selected from Brooks's collected works will enable readers to experience the artistry of a remarkable poet to apprehend the values informing her art, and to revisit issues of race and gender through her eyes.

As a female poet, a wife, and a mother, Brooks has been sensitive to issues affecting women and families throughout her career. As a matter of fact, her first published volume, *A Street in Bronzeville*, included "The Mother," a monologue exploring the psychological effects of abortion. And although Brooks has not aligned herself with feminist movements to challenge white male patriarchy, she nonetheless shares the aim of achieving social equality and economic parity for women while displaying and celebrating the full range of their capabilities and achievements. As Brooks has stated, "Black women, like all women, certainly want and are entitled to equal pay and 'privileges,'" but, in her view, the issue of female equality is complicated by a "twoness" that Black women feel, relating to race and gender. Therefore, she continues, "Today's black men, increasingly assertive and proud, need their black women beside them, not organizing against them" (*Report From Part One* 199). Womanist [1] critic Chikweye Okonjo Ogunyemi elaborates upon this view: "The black woman instinctively recoils from mere equality because . . . she has to aim much higher than that to knit the world's black family together to achieve black, not just female transcendence" (69). Or as scholar Barbara Omolade explains, "Black women have united with black men to struggle for national liberation from white male rule" (253). However, espousing racial unity to achieve liberation does not mean accepting Black male rule, for as Alice Walker avers in this context, "Silent, uncritical loyalty is something you don't usually inflict on your child" (353). Brooks herself speaks plainly on the matter of male domination:

> Black women must remember, through all the prattle about walking three or twelve steps behind or ahead of "her" male, that her personhood precedes her femalehood . . . She is a person *in* [emphasis hers] the world with wrongs to right,

stupidities to outwit, *with* [emphasis hers] her man when possible, on her own when not. And she is also here to enjoy. She will be here, like any other, once only (*Report from Part One* 213).

One can understand, then, Brooks's subtle critique of male domination and female submission in the poem "Gang Girls" from *In the Mecca* (1968). In her poetry workshops, Brooks had interacted with the Blackstone Rangers, a male gang, and although her portraits of the group are mostly sympathetic, she does not romanticize the lifestyle and its effects upon young women. In the poem, the narrator describes gang girls as "sweet exotics," suggesting that they are alien to their tough, male-circumscribed neighborhood. Although Mary Ann, a typical gang girl, "sometimes sighs for Cities of blue and jewel / beyond [the] Ranger rim of Cottage Grove," her longings will not be fulfilled because male rivalries curb her mobility. Excursions beyond the neighborhood are dangerous, the poem states; therefore, Mary Ann, a sensitive, imaginative girl, is restricted by male-imposed boundaries to a stifling, unstimulating environment. The narrator aptly describes her as "a rose in a whiskey glass." This image strikingly reveals the disadvantaged position of gang girls in their relationships with gang members. To escape the deadening effects and frustrations of her confinement, Mary Ann turns to the few diversions her neighborhood offers: "bugle-love," "the bleat of not-obese devotion," and "Somebody Terribly Dying, / under the philanthropy of robins."

In a male-controlled Cottage Grove, gang girls acquiesce to their boyfriends' sexual demands. The narrator describes a passionless encounter in which Mary Ann simply responds as if following a script:

> . . . swallow, straight, the spirals of his flask
> and assist him at your zipper, pet his lips
> and help him clutch you.
> Mary, the Shakedancer's child
> from the rooming-flat, pants carefully, peers at
> her laboring lover . . . (*In The Mecca* 48).

The phrases "pants carefully" and "peers at her laboring lover" illustrate Mary Ann's lack of interest and involvement during this intimate encounter. Much like Langston Hughes's Harlem dancer, the real Mary Ann is not in that place. The shift in the mood from declarative to imperative lends a coercive quality to the "love-making," thereby implying that Mary Ann is not a consenting partner but a sexually exploited servant. Traditional notions of male authority along with peer influence, negative self-images, and non-affirming family dynamics can condition young women

to act against their interests. The narrator warns that the result of female submission will most likely be a blighted future:

> Settle for sandwiches! Settle for stocking caps!
> For sudden blood, aborted carnival
> the props and niceties of non-loneliness—
> the rhymes of Leaning.

This poem suggests that thwarted female potential, arising in this instance from a system of male domination and female submission (complicated by race and social class) is antithetical to Brooks's goal of racial unity and solidarity. Mutual respect and trust, the cornerstones of unity, cannot flourish within a climate of oppression. In this climate, females are unlikely to reach "Cities of blue and jewel," and, ultimately, the creative potential of the human family is diminished.

Gang girls like Mary Ann are not likely to blossom into self-respecting women, but in her gallery, Brooks provides models of self-empowered females worthy of emulation. *Blacks* includes the poem "To Those of My Sisters Who Kept Their Naturals," which praises Black women like Brooks herself, who did not abandon the natural hairstyle once it had become unfashionable. The "natural," or Afro, as it was called in the 1960s, symbolized racial solidarity and Black pride, but because it was worn by outspoken activists like Angela Davis and Rap Brown, it represented to the mainstream a threatening militancy, an unsettling statement of willfulness, self-affirmation, and political radicalism, which many were unprepared to accept. Within this context, Brooks salutes those Afro-wearing women who faced social ostracism and economic disadvantage within and beyond their communities. The speaker begins dramatically, announcing,

> Sisters!
> I love you.
> Because you love you.
> Because you are erect.
> Because you are also bent.
> In season, stern, kind.
> Crisp, soft—in season (*Blacks* 459).

The opening words trumpet forth like a musical flourish, with the exclamation point in the first line signaling a stentorian call and indicating excited anticipation. To imitate this effusiveness, Brooks lengthens each line so that the first boasts a single word; the second, three; the third, four. The speaker appears to love her "sisters" because, even in their

literal difference or their varying postures, they accept and appreciate themselves. Brooks reinforces their heterogeneity by employing metrical diversity—iambs, spondees, and anapests—and she emphasizes their shared qualities through repetition (Because you; in season) and antithesis (stern, kind; Crisp, soft).

The speaker commends the actions of these self-respecting women:

> And you withhold.
> And you extend.
> And you Step out.
> And you go back.
> And you extend again.
> . . .
> You reach, in season.
> You subside, in season.
> And All
> below the richrough righttime of your hair (459).

The lilting regularity of the "And you" lines—mostly iambic diameter except for the final line in iambic trimeter—highlights the common quality of radical pride these women exhibit. Furthermore, the rhythm of the lines suggests the literal and metaphorical acts described in the poem, namely, withholding and extending, stepping out and going back. In addition, the luxuriant alliterative compounds "richrough" and "righttime" mirror the dense texture of the women's natural hair.

Brooks employs a series of negative statements, featuring repetition and rhythm, to convey the speaker's admiration and delight at the "'sisters'" acceptance of Blackness:

> You have not bought Blondine.
> You have not hailed the hot-comb recently.
> You have never worshiped Marilyn Monroe.
> You say: Farrah's hair is hers.
> You have not wanted to be white (460).

Recognizing that Caucasian looks are ethnically incorrect for most Black women (although many women classified as Black because of the "one drop" rule look European), the speaker is pleased that her "sisters" accept what is natural for them. Women's studies scholar Rita Dandridge explains that for Brooks, "having a natural . . . is emblematic of being true to one's nature" (294). Therefore, she disdains efforts to "wriggle out of the race" (Melham, *Heroism* 26). It disturbs her that "hordes of Black men and women straighten their hair and bleach their complexions and

narrow their noses and spell their eyes light grey or green or cerulean—thereby announcing: What nature afforded is poor, is substandard, is inferior to Caucasian glory" (*Report from Part One* 127). To the contrary, Brooks asserts in her poem that Black hair is "the rough dark Other music!" is "the Real/ the Right. / The natural Respect of Self and Seal!" She assures her "sisters" that their natural hair is a "Celebration in the world!" (460).

The self-affirmation lauded in Brooks's poem originates in the sassy, self-assertive attitude many Black girls begin to display in adolescence. Alice Walker characterizes their "audacious, courageous, and willful behavior" as "womanist" (xi). Scholar Tuzylane Jita Allan observes that this attitude "is a rich, self-affirming psychological resource that facilitates survival advantage in the social pecking order." Indeed, this "womanist audacity," she continues, "becomes in the wider social context an unbidden demolisher of arrogant authority" (10–11). In the seventies and eighties, as Blacks entered the marketplace to assume positions opened as a result the civil rights struggles, the natural hairstyles mentioned earlier were unacceptable in some quarters. Many Black women resisted the dress codes banning natural hairstyles. Until their resistance (coupled with court challenges) changed the workplace culture, many Black women risked reprimand, censure, or even termination because of their womanist determination to be themselves. These Black women, psychologically empowered and sustained by their courage and boldness, demolished the status quo and at the same time, exemplified the authentic Black womanhood that Brooks praises in her poem.

Other poems among Brooks's family pictures depict Black manhood as Brooks has observed it among her family, friends, and national figures. Like other Black female writers, Brooks honors exemplary Black manhood as a corrective to and a shield against the steady assaults the Black male often faces in the wider society. Ogunyemi observes that "the intelligent black woman writer, conscious of black impotence in the context of white patriarchal culture, empowers the black man. She believes in him" (68). Brooks strongly supports the figures she includes in her gallery, beginning with her late brother-in-law, Edgar William Blakely, whom she tenderly praised in his elegy "In Memoriam: Edgar William Blakely," the dedicatory poem in *To Disembark*. The two-line opening stanza affirms, "A friend is one / to whom you *can* [italics mine] say too much." The formal elegiac mood, indicated by "to whom," is sustained in the second stanza by the sermonic opening line: "That was the title and the text of Edgar Blakely" (v).

Shifting to colloquial language, Brooks describes Blakely as "our / rich-humored, raw and ready, / righteous and radiant running-buddy." These alliterative phrases, which appeal to the ear, eye, and intellect, are neatly juxtaposed to the more formal line, "responsible to / community and heart," which conveys both the earthiness and virtue of the late Blakely. Colorful folk and slang expressions like "raw and ready" and "running-buddy" combine with the sedate adjectival-phrase construction "responsible to / community and heart" (linked by the alliterated *r*) to show a vigorous, fun-loving man who had substance, wit, and community spirit. Jaffe says that Brooks "can stir the grits or stroke the rococo" (*To Disembark* 56). Actually, she is at her best when she blends both—the colloquial and the formal—as she does in this poem. Brooks's choice of the word "heart" where one might expect "family" or "friends" conveys not only the compassion of the deceased but also the warmth of the in-laws' relationship. The elegy closes with a summing up of Blakely's virtues:

> The document of his living is
> out and plain,
> level and direct. "Be sane. Be
> neighbor to all the people in the world" (v).

The word "document" recalls "text and title" in the second stanza just as "neighbor" relates to "friend" in the opening lines. Brooks's effective use of diction and juxtaposition combine with the theme to create a unified impression of an admired and dearly loved brother-in-law and friend.

Another family picture introduces Walter Bradford, whom Brooks scholar D.H. Melhem describes as "a man of solid merits, pragmatic, dedicated, a worker in the social field of the young, specifically the Blackstone Rangers" (*Poetry and the Heroic Voice* 204). Having worked closely with Bradford on several community projects, Brooks grew to admire and respect him because of his talent, his dedication, and his effectiveness with young people. Speaking in supportive voice of the experienced elder, Brooks advises, encourages, and commends Bradford:

> Just As You Think You're "Better Now"
> Something Comes To The Door.
> It's a Wilderness, Walter.
> It's a Whirlpool or Whipper.
>
> THEN you have to revise the messages
> and, pushing through roars
> of the Last Trombones of seduction,

the deft orchestration,
settle the sick ears to hear and to heed and to hold:
the sick ears a-plenty.

It's Walter-work, Walter.
 Not overmuch for
brick-fitter, brick-MAKER, and wave-
outwitter;
whip-stopper.
Not overmuch for a
Tree-planting Man.

Stay (33).

First, Brooks speaks of the never-ending challenges facing Bradford
and, by extension, others who try to steer young people in constructive
directions. Reflecting the activism and energy of Bradford himself, Brooks
chooses motion-charged images. Wilderness, Whirlpool, and Whipper—
evoking predators, Charybdis, and slavery, respectively—symbolize the
new problems that occur "Just As You Think You Are Better Now."
Bradford as "brick-fitter, brick-MAKER, wave- / outwitter" and "whip-
stopper"—shrewd master craftsman, maker of men and women— is equal
to the task, Brooks asserts. He can handle the delicate and difficult prob-
lems of "[settling] sick ears to hear and to heed and to hold." Brooks
reinforces this fact through typography. The capital letters of the first
stanza indicate the looming threats to progress and stability, while the
lower-case letters of the third stanza indicate Brooks's confidence that
Bradford, like the biblical David, can slay any Goliaths. Further, by identi-
fying Bradford as a "Tree-planting Man," Brooks calls forth literal and
metaphorical associations of Johnny Appleseed, the nineteenth-century
American tree planter, along with the unknown composer of these lyrics:
"Just like a tree planted by the water, I shall not be moved." Brooks
appeals to Bradford, the cultivator of young men and women, not to be
moved but to stand steadfast, to "Stay." Scholar William Hansell states
that Black heroes have always figured prominently in Brooks's poetry
(79). Whether these heroes are friends like Walter Bradford, relatives like
Edgar Blakely, or national figures like Martin Luther King, Medgar Evers,
and Malcolm X, Brooks honors those who demonstrate integrity and an
unwavering commitment to Black people around the globe. In the section
"To the Diaspora" from To Disembark, she includes "Music for Mar-
tyrs," a tribute to Steve Biko, the slain South African anti-apartheid activ-
ist. Its epigraph declares that Biko was slain "for loving his people." The

poem itself contrasts the person's sincere personal grief with orchestrated public memorials. Deeply affected by Biko's martyrdom, the poet mourns:

> I feel a regret, Steve Biko.
> I am sorry, Steve Biko.
> 　　　Biko the Emerger
> laid low (42).

Brooks employs repetition, rhyme and sound devices to establish a funereal tone; Biko's name repeated, the assonantal *o* rhymed, and the *I* alliterated combine to create a lugubrious chant. The anguished "I feel a regret" and "I am sorry" convey turmoil, indicating perhaps the poet's guilt feelings about not having been active enough against apartheid. Alluding to Biko's unfulfilled potential, the title "Biko the Emerger" invests the slain leader with dignity and stature; the mournful euphemism "laid low" implies that the word "murdered" is too inelegant to refer to one so noble.

A catalogue of meaningless tributes contrasts with the poet's heartfelt sorrow:

> Now for the shapely American memorials.
> The polished tears.
> The timed tempest.
> The one-penny poems.
> The hollow guitars.
> The joke oh jaunty.
> The vigorous veal-stuffed voices.
> The singings, the white lean lasses with streaming
> 　　　yellow hair.
> Now for the organized nothings,
> Now for the weep-words.
>
> Now for the rigid recountings
> Of your tracts, your triumphs, your tribulations (42).

Brooks very effectively conveys the hollowness of the tributes through damning images—"polished tears," "timed tempests," "vigorous veal-stuffed voices," and "organized nothings"—all of which the poet views as sacrilegious. The bitter tone in this section of the poem extends to the conclusion, which identifies Biko's legacy—his "tracts," his "triumphs," and his "tribulations"—and suggests that the "shapely" memorials dishonor the young hero's memory.

Along with the men and women who comprise Brooks's gallery are children, whose varying situations exhort families and communities to commit themselves to the young and vulnerable. Like William Blake's "Infant Joy," the first poem. "A Welcome Song for Laini Nzinga" from *To Disembark*, celebrates the arrival of new life. Laini, the child of Brooks's spiritual son, poet Haki Madhubuti, and his wife, enters "through the rim of the world" to parents and friends eagerly awaiting her arrival: "We are here!" they exclaim, "To meet you and to mold and to maintain you." The word "we" appears five times in this eight-line lyric to signify the unity of this extended family and the necessity for its crucial supportive role. "With excited eyes we see you," the personae say. This baby, bringing "the sound of new language," ushers in renewal and hope. The poem ends, "We love and we receive you as our own."

Brooks insists that her picture of a stable, joyous, and united Black family can be multiplied by the thousands, yet the media choose to present images of fragmented Black families in crisis. Brooks thinks that the scores of "firm families" among Blacks . . . must be announced, featured and credited" (*Report from Part Two* 134). The successful Black family of the newborn Laini serves as a prototype of the nurturing circle of family and friends that produces "durable, effective, and forward youngsters" (*Report from Part Two* 134). That some children are not born into warm and welcoming families or communities is demonstrated in "The Life of Lincoln West," which Brooks describes as "a poem presenting a small Black boy coming to terms with outdoor and indoor opinions of his identity" (*Report from Part Two* 129).

The child pictured in this popular poem is unattractive by societal standards of handsomeness. The narrator pronounces this general consensus in the opening lines: "Ugliest little boy / that everyone ever saw. / That is what everyone said." The pronoun "everyone" in the second line rather than "someone" makes the baby's ugliness an indisputable fact, which the details support:

Even to his mother it was apparent -
when the blue aproned nurse came into the
northeast end of the maternity ward
bearing his squeals and plump bottom
looped up in a scant receiving blanket,
bending, to pass the bundle carefully
into the waiting mother-hands - that this
was no cute little ugliness, no sly baby waywardness
that was going to inch away
as would baby fat, baby curl, and

baby spot-rash. The pendulous lip, the
branching ears, the eyes so wide and wild,
the vague unvibrant brown of the skin, and
most disturbing, the great head.
These components of That Look bespoke
the sun fibre. The deep grain (22).

The details of Lincoln's appearance unfold slowly: A "blue-aproned nurse came . . . bearing . . . bending." She bore "squeals and a plump bottom," "a bundle." Synecdoche and metonymy, in this description, heighten the reader's expectation. Likewise, negation intensifies the reader's curiosity about the unfortunate baby's appearance. There is "no cute little ugliness, no sly baby waywardness/ that was going to inch away." Finally, with the actual description of the baby's appearance, the narrator refers to him clinically, as if he is a specimen rather than a human being: "The pendulous lip, the / branching ears, the eyes so wide and wild." This detachment establishes a distance between the reader and the narrative which is erased as the narrator reveals the cold and unfeeling treatment the child eventually faces at home and in the community. Although Lincoln tries desperately to win his parents' affection, "His father could not bear the sight of him," and

his mother high-piled her pretty dyed hair and
put him among her hairpins and sweethearts,
dance slippers, torn paper roses.
He was not less than these,
he was not more (23).

Rejected by his father, Lincoln receives neither love nor attention from his mother, a flighty, vapidly sentimental, self-absorbed woman with little capacity for maternal affection. To her, Lincoln is another acquisition—hardly a treasured one. But the narrator suggests that even if he had been attractive, he would have been only an object for display, not a child to be loved and nurtured. As the mother of two children whom she reared with unconditional love and support, Brooks, through the narrator, is understandably critical of this mother. For as she has shown in poem after poem—most notably in the sonnet sequence "Children of the Poor," from *A Street in Bronzeville*—mothering entails loving, protecting, and training a child. Viewed in this context, Lincoln's mother is not among those Black women who "create and train their flowers." Lincoln, who is a weed in his parents' sight, experiences continual rejection. The narrator says that "even Christmases and Easters were spoiled" because of him:

He would be sitting at the
family feasting table, really
delighting in the displays of mashed potatoes
and the rich golden
fat-crust of the ham or the festive
fowl, when he would look up and find
somebody feeling indignant about him (24).

This snapshot of the sumptuous feast, the animated child, and the disapproving parents starkly reveals a central point of the poem: that senses can be stirred but not hearts.

As if parental rejection were not enough, the narrator reports that Lincoln's kindergarten teacher showed "a concern for him composed of one / part sympathy and two parts repulsion." Playmates "turned their handsome backs on him" when better-looking children appeared. Consequently, Lincoln "spent much time looking at himself / in mirrors. What could be done? / But there was no / shrinking his head. There was no / binding his ears." An answer arrives unexpectedly while Lincoln and his mother are at the movies. He overhears a comment about himself from a nearby moviegoer, who is whispering to his companion,

"THERE! That's the kind I've been wanting
to show you! One of the best examples of the specie. Not like
those diluted Negroes you see so much of on
the streets these days, but the
real thing.

Black, ugly, and odd. You
can see the savagery. The blunt
blankness. That is the real
thing" (27–28).

Although the mother is outraged, Lincoln, misinterpreting the insult, discovers a new self-image, and whenever he is hurt by others or lonely, the narrator says, he takes comfort in knowing that he is "the real thing."

Brooks's artful narration and vivid language point out the pain that rejected children experience and the necessity for ego-building experiences. Whereas Lincoln, a lovable, good natured child, finds a positive outlet for his pain, other children have resorted to acts of violence against others and themselves. Pioneering Black studies scholar Arthur P. Davis considers this poem a parable (in Wright 103). If so, Lincoln may represent the Black community, whose family members have subverted the negative definition of Blackness imposed by society—"Black, ugly, and odd"—and transformed it into "quality and legitimacy."

The final poem, "The Boy Died in My Alley" from *Beckonings* (1975), comments on public and personal indifference to violence among and against children. In the poem, the persona, representing an apathetic community, moves beyond deliberate isolation and indifference to communal responsibility. The opening lines are chilling: "Without my having known. / Policeman said, next morning, / Apparently died alone." The word *Apparently* emphasizes the tragedy of the anonymous boy's death. The end punctuation after the opening phrase highlights the isolation of the persona from the violence surrounding her. To dramatize the point that individuals, however, are not islands unto themselves, Brooks connects the title of the poem and the opening line to form a single statement: "The Boy Died in My Alley Without my having known." This pairing links proximity and emotional distance, calling attention to the fact that the death occurs near the persona, but she is detached emotionally from it. When a police officer asks if she heard the shot, the persona responds:

> Shots I hear and Shots I hear.
> I never see the dead,
> The Shot that killed him yes I heard
> As I heard the Thousand shots before;
> careening tinnily down the nights
> across my years and arteries (49–50).

The words "hear," "heard," and "Shot" in conjunction with the onomatopoeic phrase "careening tinnily" emphasize the persona's past indifference to routine violence. The persona recounts, "Policeman pounded on my door [and said] A Boy was dying in your alley. / A Boy is dead, and in your alley. / And have you known this Boy before?" The conspicuous shift in tense— from the past (progressive aspect) "was dying" to the present "is," and to the present (perfect aspect) "have known" —dramatizes the actual death of the boy and suggests, as well, the pervasiveness of the violence. Acknowledging some acquaintance with "this Boy . . . who / ornaments my alley," the persona confesses that "I never saw his face at all." The verb "ornaments" alludes to the red blood and the persona's uncaring attitude toward children who "deal with death." The persona admits, " I have closed my heart-ears late and early." At the end of the poem, however, she recognizes her silent complicity in the boy's death: "I joined the wild and killed him / with knowledgeable unknowing." Remorsefully, the narrator confesses, "I saw where he was going. / I saw him Crossed. And seeing / I did not take him down." The word "Crossed" combined with the statement "I did not take him down" evokes the

Crucifixion. Further, "Crossed" means both "placed on a cross" and "betrayed." This complex allusion manifests the persona's guilt and anguish. In street vernacular, "to take someone down" means to kill or to seriously incapacitate that person by violent means. Aware of the fact that children were being "taken down" but ignoring them, the persona feels responsible for their deaths. Brooks employs paradox ("knowledgeable unknowing"), allusion, and ambiguity to reveal the persona's feelings. Finally accepting responsibility and recognizing kinship with these children, the persona states, "The red floor of my alley / is a special speech to me." Likewise, this blood is a special speech to readers who have been pulled into the narrative and forced to look at the pain and destruction around them. Such truth-telling, with Brooks's "quiet and merciless accuracy" (Johnson 47), leaves readers no hiding place.

The boy in the alley, Lincoln, West, little Laini, Steve Biko, Walter Bradford, Edgar Blakely, the sisters, and the gang girl are creations of a master artist. Although Brooks paints family pictures, the impulse from which they spring embraces all humanity. As Brooks herself has said, "I cite, star, and esteem all that which is of woman—human and hardly human. And I want the people of the world to anticipate ultimate unity, *active* [italics hers] interest in empathy." (*Report from Part Two* 131). The unity to which Brooks subscribes is

> a unity of distinct proud pieces. Not a stew. . . . Because each entity is lovely–amazing–*exhilarating* [italics hers] in ubiquity and boldness of clear distinction, good design. I hope that in the world, always, there will be Black, brown, yellow, white, red. (And if time has some surprises let us welcome those too.) (*Report from Part Two* 131).

The poetry of Gwendolyn Brooks depicts and celebrates the variegated life of one community within the human family. This Black community, with its prismatic family pictures, has inspired, nourished, and sustained her art. Although directed to this community, her canvases of family pictures, like portraits by the Old Masters, hang in full view of the human family for their enrichment, for their illumination, and for their delight.

Note

1. For a discussion of "womanist" and "womanism," *see* Walker (*In Search of Our Mothers' Gardens,* 1983) and Ogunyemi ("Womanism: The Dynamics of the Contemporary Black Female Novel in English," *Signs: Journal of Women and Culture* 11.1(Autumn 1985): 63-80). In her essay, Ogunyemi says a womanist "will recognize that, along with her consciousness of sexual issues, she must incorporate racial, cultural, national, economic, and political considerations into her philosophy" (64).

Works Cited

Allan, Tuzylane Jita. *Womanist and Feminist Aesthetics: A Comparative Review*. Athens, OH: Ohio University Press, 1995.

Brooks, Gwendolyn. *Beckonings*. Detroit: Broadside Press, 1981.

————. *Blacks*. Chicago: Third World Press, 1987.

————. *In The Mecca*. New York: Harper and Row, 1968.

————. *To Disembark*. Detroit: Broadside Press, 1981.

————. *Report from Part One*. Detroit: Broadside Press, 1972.

————. *Report from Part Two*. Chicago: Third World Press, 1996.

————. *The World of Gwendolyn Brooks*. New York: Harper and Row, 1971.

Dandridge, Rita, ed. *Black Women's Blues: A Literary Anthology, 1934–1988*. New York: G.K. Hall, 1992.

Davis, Arthur P. "Gwendolyn Brooks." *Dark Tower: Afro-American Writers 1899–1960*. Washington, D.C.: Howard University Press, (1974). Rpt. in *On Gwendolyn Brooks: Reliant Contemplation*. Ed. Stephen Wright, Ann Arbor: University of Michigan Press, 1996: 97–105.

Hansell, William H. "The Poet-Militant and Foreshadowings of a Black Mystique: Poems in the Second Period of Gwendolyn Brooks." *Concerning Poetry* 10 (Fall 1977): 37–45. Rpt. in Mootry and Smith 71–80.

Jaffe, Dan. "Gwendolyn Brooks: An Appreciation from the White Suburbs." *The Black American Writer: Volume 2 Poetry/Drama*. Ed. C.W.E. Bigsby. Deland, FL: Everett/Edwards, 1969: 89–98. Rpt. in Wright 50–59.

Johnson, James N. "Blacklisting Poets." *Ramparts* 7 (1968): 53–56. Rpt. in Wright 45–49.

Melhem, D.H. *Gwendolyn Brooks: Poetry and the Heroic Voice*. Lexington: University of Kentucky Press, 1987.

————. *Heroism in the New Black Poetry: Introductions and Interviews*. Lexington: University of Kentucky Press, 1990.

Mootry, Maria, and Gary Smith. *A Life Distilled*. Urbana, IL: University of Illinois Press, 1987.

Ogunyemi, Chikwenye Okonjo. "Womanism: The Dynamics of the Contemporary Black Female Novel in English." *Signs: Journal of Women and Culture* 11.1 (Autumn 1985): 63–80.

Omolade, Barbara. "Black Women and Feminism." *The Future of Difference*. Ed. Hester Eisenstein and Alice Jardine. Boston: G.K. Hall, 1980: 248–257.

Walker, Alice. *In Search of Our Mothers' Gardens*. New York: Harcourt, Brace, Jovanovich, 1983.

Webster, Harvey Curtis. "Pity the Giants." Review of *The Bean Eaters, Annie Allen,* and *A Street in Bronzeville*, by Gwendolyn Brooks. *The Nation* (1 September 1962). Rpt. in Wright 19–22.

Wright, Stephen, ed. *On Gwendolyn Brooks: Reliant Contemplation*. Ann Arbor, MI: University of Michigan Press, 1996.

Chapter 3

Sounding the Abyss of Otherness: Pauline Oliveros' Deep Listening and the *Sonic Meditations* (1971)

William Osborne

Pauline Oliveros (b. 1932) (fig.3) in Houston, Texas, is a composer, performer, humanitarian, and an important pioneer in American music. Acclaimed internationally, for four decades she has explored sound, forging new ground for herself and others. Through improvisation, electronic music, ritual, teaching, and meditation she has created a body of work with such breadth of vision that it profoundly affects those who experience it and eludes many who try to write about it.

Oliveros has been honored with awards, grants, and concerts internationally, including the SEAMUS (Society for Electro-Acoustic Music in the US) Award for Lifetime Achievement, 1999; ASCAP Standard Award, 1982–98; and NEA fellowships in 1990, 1988, and 1984. She has performed in the world's most prestigious venues, ranging from the John F. Kennedy Center in Washington D.C. to the studios of the West German Radio. Through her Deep Listening Pieces and earlier Sonic Meditations (1971), Oliveros helped introduce the concept of incorporating all environmental sounds into musical performance. This requires focused concentration, skilled musicianship. and strong improvisational skills, which are the hallmarks of Oliveros' form.

She has also provided leadership within the music community from her early years as the first director of the Center for Contemporary Music at Mills College in 1966, to becoming director of the

Center for Music Experiment during her fourteen-year tenure as professor of music at the University of California at San Diego, 1967-81. She has served as composer-in-residence at many colleges including Mills College, Oberlin College, and Northwestern University. She has also acted in an advisory capacity for organizations such as the National Endowment for the Arts, the New York State Council for the Arts, and many private foundations.

Fathom: to measure deepness by sounding.
—Webster's Dictionary

Deep calleth unto deep at the noise of thy waterspouts.
All thy waves and thy billows are gone over me.
—Psalm 42

The 1960s and early 1970s were shaped by the sociocultural movement sometimes referred to as the "new sensibility." Among other things, the term reflected the revolutionary spirit of the time as embodied in the civil rights, antiwar, and women's liberation movements. In the popular imagination, it represented hippies, flower children, and free love. In the arts, it was given voice by people such as Allen Ginsberg, John Cage, Susan Sontag, and Andy Warhol. It was also quite notable for explorations of expanded consciousness through newfound uses of meditation, eastern religions, and psychedelics. The new sensibility was one of the most important social revolutions in American history and left an indelible impression on its cultural landscape.

In 1974, during the final stages of the new sensibility, Pauline Oliveros published one of the most important works of her career, the seminal *Sonic Meditations*. The work broke radically from the traditions of western music. Instead of using standard music notation, the composition consisted of twenty-five Roman-numeraled prose instructions, ranging from one sentence to a few paragraphs, which presented strategies for listening. The example below, *Sonic Meditation X*, illustrates their general character:

Sit in a circle with your eyes closed. Begin by observing your own breathing. Gradually form a mental image of one person who is sitting in the circle. Sing a long tone to that person. Then sing the pitch that person is singing. Change your mental image to another person and repeat until you have contacted every person in the circle one or more times (score).

Figure 3. Pauline Oliveros

Oliveros wrote the *Meditations* while involved in teaching and re-
search at the University of California, San Diego. To a certain extent, her
involvement with meditation synthesized academic research with the revo-
lutionary, consciousness-expanding characteristics of the *new sensibility*.

A hallmark of her work in San Diego was a fascination with long con-
tinuous sounds, such as the drones of motors, fluorescent lights, and
freeway noise. Oliveros discovered that through processes of relaxation,
she could listen more closely to drones, and that relaxation also helped
her to gain insights into the phenomenology of listening itself. In the spirit

of the new sensibility, she became interested in forms of meditation that increase awareness, such as those used in Buddhism and T'ai Chi Chuan (Oliveros, *Software* 148). She learned she could apply these forms of meditation to music making and listening with profound effect.

By 1970, several other women had joined her (many of whom were not professional musicians) to form the ♀ ("fem") *Ensemble*—an all-woman improvisation group devoted to studying long sustained sounds, both vocal and instrumental. Oliveros' phenomenological analysis of listening led her to a special interest in the involuntary changes that occurred while the Ensemble sustained tones. Based on her involvement with various forms of meditation, she began to lead improvisations that encouraged spontaneous, subconscious transformation through de-emphasizing mental constructs such as "opinions, desires and speculations" (Oliveros, *Software* 149).

In 1973, Oliveros founded the Meditation Project with funding from UCSD made possible by a Rockefeller grant, and spent nine weeks examining the role of meditation in music with the help of psychologists, kinesiologists, and specialists in the martial arts and T'ai Chi Chuan. The *Sonic Meditations*, which Oliveros wrote for the ♀ Ensemble, were studied as part of the project.

The actual sound making in the *Sonic Meditations* is primarily vocal, but sometimes includes hand clapping or other body sounds. Occasionally, sound-producing objects and instruments are used. Since many members of the ♀ Ensemble were non-professionals, the approach is radically egalitarian. Special skills are not required, anyone can participate. The principal focus is on the cognition of sound. In the second "Introduction" to the work, Oliveros writes that each Meditation is a special procedure for the following:

1. Actually making sounds
2. Actively imagining sounds
3. Listening to present sounds
4. Remembering sounds

Through her research, Oliveros concluded that the *Sonic Meditations* could produce healing, heightened states of awareness and expanded consciousness, changes in physiology and psychology, and new forms of communal relationships (*Sonic Meditations*, "Introduction II"). "In the process a kind of music occurs naturally," she wrote. "Its beauty is not through intention, but is intrinsically the effectiveness of its healing power."

Oliveros continued this work, and by the 1980s, it led to an aesthetic philosophy she refers to as Deep Listening, which redefines listening as being an art in itself. She speaks of hearing as the "primary sense organ," and has summarized Deep Listening as follows:

> "Deep Listening is listening in every possible way to everything possible to hear no matter what you are doing. Such intense listening includes the sounds of daily life, of nature, or one's own thoughts as well as musical sounds. Deep Listening represents a heightened state of awareness and connects to all that there is. As a composer I make my music through Deep Listening" (Oliveros, *Website*).

Oliveros' aesthetic of Deep Listening thus encompasses a very wide, somewhat undefined area of musical thought and consciousness developed over four decades of composition and research. In their practical applications, the forms of Deep Listening embodied in the *Sonic Meditations* hint at new types of music making, new concepts of social order, and new forms of spirituality. As the *New York Times* music critic, John Rockwell has noted, "on some level, music, sound, consciousness and religion are all one, and she would seem to be very close to that level" (quoted in Oliveros, *Website*).

Some Central Concepts of Deep Listening as Embodied by the *Sonic Meditations*

The *Sonic Meditations* can be quite fun to perform. They are often more intimate than normal chamber music and create unusually intense feelings of rapport among the participants. They also create a sense of safety and creative freedom since there is no "right" or "wrong" way of performing them—the bane of both professional and non-professional musicians.

The *Sonic Meditations* embody the concepts of Deep Listening, which include nonjudgmental perception, the development of empathy through listening, the creation of nonhierarchical social relationships in music making, the expanded use of intuitive forms of internal and external awareness, and new understandings of sensuality and the body. These practices are fundamental to Oliveros' work, and shape both her music making and teaching. She identifies creativity as fundamental to human dignity, and feels that helping others to be creative is an essential part of the artist's work. To analyze the *Sonic Meditations* we will look at their relationship to some of the central components of Deep Listening.

Nonjudgmental Perception
Deep Listening cultivates forms of perception unhindered by preconceptions. One of the Deep Listener's goals is to listen to each and every

sound exactly for what it is, nothing more, nothing less. The *Sonic Meditations* thus focus our attention on how listening is an act of cognition that can "filter" or shape auditory perception. This is illustrated in "Sonic Meditation XXII," which asks the practitioners to think of a familiar sound, listen to it mentally, and notice how it affects them differently in various imagined contexts.

By practicing these forms of consciously mitigated listening, one learns to remove cognitive filters in order to experience deeper forms of audition. This form of "nonjudgmental perception" was first introduced to western art music in the 1950s by John Cage, who appropriated it from Zen Buddhism. Oliveros' first contact with Zen came in the 1960s, and she remains a practicing Tibetan Buddhist.

The purpose of nonjudgmental perception in Zen is to break down the boundaries between perceiver and the perceived. When the perceiver and the perceived are two, the ego persists in its function of differentiating and prevents the emergence of a full and creative awareness; nondifferentiation (or nonjudgmental perception) seeks to break down the boundaries between perceiver as subject and perceived as object. The interpenetration of the two gives rise to a mind of harmony and the attainment of creativity (Suzuki, Chang, Herrigel, Cage).

As the Deep Listener's discernment moves toward this form of nonjudgmental perception, he or she gains a particular form of dispassionate objectivity. This, in turn, renders a unique kind of freedom and detachment which gives works of art their most profound meaning.

Global and Focal Listening

Global and focal listening are forms of attention Oliveros employs in Deep Listening to increase awareness of the external and internal worlds, and of the cognitive processes that shape their relationship. These forms of listening are among the most important components of the *Sonic Meditations*. In "Meditation XIII," for example, the practitioner is asked to form all the sounds of her environment into a drone, and then to include internal sounds such as blood pressure and heartbeat. In effect, we listen to listening. We learn how listening is a form of conditioned discernment with profound cultural and existential implications.

Global listening helps us learn that all other forms of sensation are essentially directional, even smell, but that listening is innately spherical. We thus associate listening with the all-encompassing, the universal, even the transcendent. Through such reflection, we discover that it is only through cognitive processes of listening that we give hearing a "sense" of direction.

Global and focal listening meditations also make us conscious of our extraordinary ability to filter sounds, as when we are in a room full of noise and focus in on one person's voice. The ability to create "silence" selectively by focusing our listening is one of the greatest miracles of listening.

We also see that focal listening is a form of global listening, since there is an infinitude of detail in every sound. One of the greatest mysteries of nature and human perception is that the infinitude of the microcosmic comes full circle and weds itself as a mirror of the macrocosmic. Why do the structures of the atomic world bear a resemblance to the galactic world? Why do ice crystals bear literal structural relationships to the erosion of coast lines? Why do the swirls in the little creek outside have the same form as this galaxy? How does an infinitesimal helix of DNA contain the entirety of human evolution? One thinks of the words of Lewis F. Richardson:

Big whorls have little whorls
Which feed on their velocity,
And little whorls have lesser whorls
And so on to viscosity (Gleick 119).

Through meditation on global and focal listening, we sense a unity in multiplicity that raises human folly above our finite and conditioned existence. Mind and Nature reach for each other. It is the infinite in the infinitesimal and the global in the focal that allows our finite religious beliefs and art works to touch the unfathomable. Listen to the infinite details of one sound while listening to the infinite world of sound surrounding you. A mysterious form of unity begins to exist. It can be called beauty.

Indeterminacy and the Witness/Universe Relationship

The *Sonic Meditations* illustrate that Oliveros' focus is wider than musical; it attempts to embrace life as a whole. Deep Listening thus includes our entire sonic environment as part of artistic experience. Oliveros refers to this as the *"witness/universe relationship."* Since the environment is by nature unpredictable, Oliveros' music is indeterminate—that is, it is affected by elements of chance.

In the 1950s, the American composer John Cage developed an elaborate aesthetic based on indeterminacy. His work led musicians to focus more closely on the physiological and psychological processes of musical reception, and how they are changed by the infinite permutations of our human existence. Musicians began to regard the audience as actively engaged in the process of *creative listening*, as opposed to the passive act

of hearing. This is revealed in Oliveros' "Sonic Meditation VI" which asks the listener to observe the random variations of sound in white noise. Oliveros' work is centered on this newfound meaning of listening as a creative act in an unpredictable world.

Because Deep Listening focuses on our auditory environment and the processes of cognition that shape our perception of it, every new performance of the *Sonic Meditations* must be discerned anew, based on a multitude of factors in a state of constant transition and change. This same principle also defines the way we listen to life as a whole. Oliveros moves us away from thinking of music in terms of an idealized aesthetic object in the form of a composition, to an understanding of music as a process of creative cognition in an ever-changing, unfathomable world. We leave behind concepts of artistic experience as a given set of aesthetic principles, concepts, rules, perceptions, or critical evaluations, and move toward artistic experience as something intangible, something constantly transforming in time, something that can be listened to but never fully defined.

The Egalitarian Leveling of Status in Musical Relationships

Since Deep Listening focuses on listening itself as a creative act, it diminishes the hierarchies between the composer, performer, and audience. Each person who does the *Sonic Meditations* simultaneously fills the roles of creator, performer, and audience. This differs from the patriarchal traditions of western music, which emphasize the aesthetic ideology of the composer as a "lone, transcendentally inspired genius" who is regarded as the musical creator, while performers are considered his instruments and the public a relatively passive receptor (Osborne 71–73).

This removal of hierarchical relationships encourages the development of community based on the interaction of every individual empathically listening deeply to the collective—as illustrated by "Sonic Meditation X" (quoted in full at the beginning of this chapter). It also leads to an emphasis on music making through improvisation and meditation, forms that characterize the *Sonic Meditations*. Deep Listeners feel these egalitarian concepts represent a new form of human dignity and community.

Listening as the Cultivation of Empathy and Compassion

Deep Listening seeks to develop empathy and compassion through listening, and this is a central focus of the *Sonic Meditations*. Once again, this reflects the discipline's Buddhist influences, and is related to the philosophy of *brahmavihara*. *Brahmavihara* represents the "four noble practices" through which humans can obtain subsequent "rebirth" in the Brah-

man heaven. The four practices (*apramanas*) represent the perfection of:

1. Sympathy, which gives happiness to all living beings
2. Compassion, which removes pain from living beings
3. Joy, the enjoyment of the sight of others who have attained happiness
4. Equanimity, being free from attachment to everything

Since Oliveros views creativity as fundamental to human dignity, she expands the role of the artist, assigning to her the specific function of helping others to be creative—a goal central to the *Sonic Meditations*. The Deep Listener's renunciation of the artist's solitary, "transcendental" expression (and its special status) in favor of aiding the creativity of others, is specifically related to the second element of *brahmavihara*, which is compassion. The ultimate expression of compassion in Buddhist thought is embodied by the "bodhisattva," who postpones his or her entry into "Nirvana" to work for the "salvation" of others.

Similarly, even if the goals of most Deep Listeners are considerably less grandiose than a quest for "enlightenment," they nevertheless create works or processes which allow both the artist and audience to reach for creative (or possibly transcendental) experience together as a *community*. Sympathy, compassion, and joy at the sight of happiness in others formulate works of art which help the performer/audience achieve creative expression.

Compassion is also reflected in the empathic forms of communication that are a central focus of Deep Listening. This is illustrated by "Sonic Meditation XV," entitled Zina's Circle, which cultivates deep forms of empathic awareness between the participants through ritualistic forms of hand contact and chant. Music, for the Deep Listener, is a form of empathy that creates authentic community. This empathy is based as much on the creative power of the listener/audience as on the composer or performer.

The Development of New Modes of Awareness
Deep Listening attempts to create, expand, and deepen new or overlooked modes of awareness. This ideal is illustrated in "Sonic Meditation III" which experiments with forms of "telepathic transmission."

Deep Listeners also expand their awareness by developing their sense of kinesthesia through training in Tai Chi and yoga. Kinesthesia is a sense mediated by nerves that lie in the muscles, tendons, and joints. Our

kinesthetic sense is stimulated by bodily movements and tensions, and gives us awareness of our body's presence. Since kinesthesia allows us to refine movement deeply, its mastery is important to most forms of artistic expression, such as musical performance, dance, sculpting and painting.

One Deep Listener, the cellist and composer Anne Bourne, plumbs the depths of what might be referred to as "meta-kinesthesia." She describes this as a form of "discernment" which allows her to "find distinction within the dense sonic chaos" of existence, a spherical awareness without spatial limitation "open to the cosmos and beyond," a form of sensation without a "literal affirmation in meaning" (e-mail to author, 15 April 1999). This same sense of metakinesthesia might be reflected in "Sonic Meditation V," which suggests walking at night so silently "that the bottoms of your feet become ears" (score).

Another form of expanded awareness explored by Deep Listening might be referred to as *empathic resonance*—a type of non-verbal communication through sound or music that allows people to form strong bonds of communal identification—such as illustrated by "Meditation X" quoted at the beginning of this article. The processes of empathic resonance through music are readily observable, though they remain undefined.

Kissing might be an example of empathic resonance that shares mechanisms of discernment used in some forms of music-making. Why do we experience such intimate and ecstatic forces of togetherness through a kiss? Even to put our lips near another person's brings sensations beyond mere touch and the quickening of the body and emotions. What is this sensual discernment that seems to shine for a moment a diffuse beam of light into our desolate separateness? Even pursing the lips can create a billion textures of ecstatic sensuality, and their gentle opening reveals the intense longings created by the unfathomable abyss of our otherness.

This might explain why the breath and lips are so central to many forms of music making. Through what appear to be forms of synesthetic kinesthesia, the discerning sensuality of the lips and the "breath of life" are transferred to our hands and ears through music-making with a wind instrument. We have all seen how artists can make music with the same ecstatic power of empathy, passion and compassion as a kiss. Can we listen so deeply that we sense the other's sounds as ecstatically as if our lips and breath of life were touching? Can we listen so deeply we sound the depths of otherness, and light the abyss of our separation?

These new modes of awareness are some of the speculative doors of perception opened by Deep Listening.

The Desire of the Unfathomable

Oliveros feels that the forms of meditation and improvisation used in Deep Listening allow one to create music with a complexity difficult for notated music to achieve. It is the undefinable in music, the desire to touch the unfathomable, that distinguishes the *Sonic Meditations.*

Oliveros' trio, the Deep Listening Band, which includes the trombonist, Stuart Dempster, and the electronics specialist, David Gamper, is devoted to the exploration of these undefinable regions of music. Since their music is made "by ear," it freely creates nuances of rhythm, timbre, pitch, and inflection which cannot be captured by any known system of notation. Even though we can discern the profundity of this music, its exquisite discernment remains unfathomable by its nature. The music maintains an extraordinary clarity, logic, precision and originality to the discerning ear, even though it is for the most part beyond analysis or definition (Deep Listening Band, *Suspended Music*). These same qualities can be achieved through the *Sonic Meditations.*

Our capacity to discern the unfathomable brings into being many aspects of human consciousness that would otherwise not exist, such as artistic and religious experience, as well as the capacity to experience the irrational aspects of our human psyche, such as dreams and emotions. Jungian forms of dream analysis, conducted by Oliveros' collaborator, the psychotherapist Carole Ione, are thus an important part of the training in Deep Listening retreats (Ione). These techniques of Deep Listening have allowed the composer Norman Lowrey to make dream-consciousness a central part of his work. Using his dreams as a reference, he meticulously recreates global sonic environments as part of rituals using highly poetic texts and astonishingly beautiful masks to make profound commentaries on society's relationship to its natural environment (Lowrey website). His works help us gain a deeper respect for the many levels of human consciousness and the insights they can provide. Through discernment, the witness/artist is able to feel and channel the unfathomability of life, and this is a central focus in Deep Listening.

The Understanding of Folly as Central to Artistic Experience

One of the most unusual aspects of Deep Listening is the element of folly that is part of its practices, a form of radical playfulness that Oliveros feels is essential to fostering creative expression. This explains why some of the *Sonic Meditations* involve the participants in seemingly ridiculous

acts, such as engaging in mental telepathy with aliens (number IV), or why orchestra musicians are dispersed in rowboats on a lake (number VIII).

By definition, folly is an act or instance of foolishness, an undertaking having an absurd or ruinous outcome. Folly can also be a perilously or criminally foolish action, associated with evil, wickedness, lewdness, or lasciviousness. There is also a performance genre referred to as follies, an elaborate theatrical revue consisting of music, dance, and skits.

Art in its best sense is related to folly, an undertaking that is seemingly absurd and foolish, something that allows us momentarily to break out of the controlling and stultifying paradigms of our social and cultural conditioning. (That is also why it is sometimes called criminal, evil, and lascivious.) One of the values of Deep Listening is folly, the way it leads us to listen with abandon, to transcend the deafness of cultural conditioning. It moves us beyond such constructs as "logical" discourse, rationality, and traditional music. In a sense, Oliveros takes us on a date to the biggest show on earth, The Follies of Life, the three-ring circus of sound.

The forms of folly and playfulness inherent in Deep Listening are not new to cultural history. We see that what begins as fatuous, gradually becomes the new paradigm we live by, the powdered wigs, the fox trots, or the Cadillacs with big sputnik fins. Then by the same path of rivers within rivers, cultural paradigms (follies) return to their fatuous status, this time as outdated. What, for example, is more "folliful" than Gothic cathedrals? We look at the infinitude of gargoyles, saints, Popes, and angels and acknowledge not so much God as the folly of the human spirit. Righteousness is temporal, but folly is eternal. History is a kind of chronicle of human delusions.

Such folly has always shaped the history of music as well. Sixteenth century Italians, for example, decided to rub horse tail hairs over cat intestines stretched taut over poorly varnished pine boxes to make music using a tonality created by a harmony of spheres revolving around the earth like a big, godly clockwork. One of the most ironic paradoxes of being is that our lives are given deep meaning by the sheer folly of our existence. Folly is part of the preciousness of life, and this leads to the humanism of Deep Listening: it celebrates the folly of life and being.

A Critical Assessment: Discerning the Ironic Separation of Interpretation

In spite of the dangers of essentialism, one could suggest that Oliveros' work is an interesting example of "cultural feminism." The concept of

cultural feminism was discussed by Alice Echols in 1983 in an article entitled "The New Feminism of Yin and Yang." Cultural feminism asserts that certain traits are innate to women, and that those traits must be revalued and reintegrated into society as a whole in order to bring a balanced gender identity to western culture. Deep Listening's nonjudgmental perception, empathy, egalitarianism, intuitive awareness, and new understandings of sensuality and the body, are all forms of consciousness we might associate with the feminine, and in many respects they embody Oliveros' notions of cultural feminism. They are qualities of being that allow us a fuller, more balanced realization of gender and human identity.

This kind of feminism, however, is often objected to as essentialist. *Essentialism* is a form of biological reductionism that defines certain kinds of behavior as "natural" to specific genders, races, or cultures. Racists, for example, might have an essentialist belief that a certain group is biologically disposed toward criminality. Sexists might code certain behavior, such as intuition, as innately feminine, while coding logic as masculine and superior. Cultural feminism, which also codes behavior according to gender, could thus be ironically turned around by patriarchy to reaffirm and consolidate its oppression of women (Przybylowicz 259). This does not change the fact, however, that Oliveros' work makes many important responses to the monolithic cultural paradigm of patriarchy. The ironic essentialization of her work comes more from limited interpretive theories than from her beliefs and compositions themselves.

One such irony derives from western culture's tendency to essentialize gender by categorizing "doing" as masculine and "being" as feminine. Traditionally, we esteem men for what they accomplish in life, and women only by the nature of their being, such as their grace, charm and beauty. If Deep Listening were to be theorized as feminine, it, too, would follow a similar essentializing pattern, since it focuses on profound concepts of being, and de-emphasizes music as a "virtuosic" form of doing. This essentializing irony, however, stems from a reductive interpretive theory rather than from the practice itself. Deep Listening reveals that being and doing are fundamental parts of all human behavior, and that the well-integrated personality balances both "feminine" and "masculine" characteristics simultaneously.

This illustrates why Oliveros is not always comfortable with reductive categorizations of her work as "feminine," although its feminism seems very important. In 1970, she published an article in the *New York Times* which strongly rejected the label of "lady composer," a demeaning slang term still common at the time. The article was not an attack on the

masculine, but rather an attempt to end terminology that leads to biased, unbalanced views. Discussions of the identity of women who compose, and the confusing terms used to describe them, are still an important part of her classes at Mills College thirty years later. She has also consistently stood for the rights of lesbians, even from the early 1960s when such stances were still quite uncommon.

Even though Oliveros is strongly aware of the feminist elements in her work, she notes that her goal has not been so much social opposition, as the manifestation of her inner identity:

> I didn't mean to oppose the mainstream so much as to express the inner values that I have and that I feel have to come from the inside, rather than taking the imposition of structures from the outside which tend to support what's going on inside. And I'm looking not necessarily to oppose or overthrow but to balance out, and come to a different understanding of what can be done (Taylor 392).

Again, the ironies of an overly reductive interpretation would be apparent. Her life and work take a more feminist stance than that of any other major composer, yet her goal was not to "oppose," but to "balance out." Her desire was "to come to a different understanding of what can be done," and she did this by remaining true to what "comes from inside." By holding to her own personal vision, she has made a profound contribution to the identity and autonomy of women in culture and society.

In an article entitled "Breaking the Silence" written for a music festival in Cologne, Germany in 1998, she referred to this rebalancing as a healing of society:

> "Music created by women could have a special function . . . for healing separations that cloud the spirit of humanity. . . . Music can not go on as a lopsided affair belonging only to men. As music changes so will the world as we know it. We need a balanced society with equal representation for both women and men and support for all composers and musicians" (Website).

In the same article, she includes recommendations for creating a balance that would "break the silence and change the paradigm of [male] exclusiveness in music" (23). These would include:

- Encouraging the performance of music by women
- Using teaching materials written by women
- Researching the lives of women and writing their history
- Encouraging journalists to write about the music of women
- Keeping a list of women who create music in your community or city

- Listening to music by women and commissioning them
- Joining organizations that support women who are musicians

She also stresses that composers should emphasize community building over career building, and question their relationship to the forms of music they are writing. "Are you listening," she asks, "to your own inner voice and answering its call? Are you expressing what you need to express, or what you have been taught to express by the canon of men's musical establishment?" (22).

Such statements illustrate that to theorize her stance solely in terms of opposition would be too simple. As she has noted, her ultimate goal is not merely opposition and activism, but also the realization of balance and inner-identity. These ironic tensions between intention and effect, or between reductive interpretive theories and actual practice, make it difficult to analyze the aesthetic concepts of Deep Listening and the *Sonic Meditations*. On the one hand, Oliveros advocates radical egalitarianism, but some of Deep Listening's proponents almost place her on a pedestal. This results in a mild personality cult surrounding her with something of a spiritual aura. She is quite down-to-earth in her human relationships, advocating a form of music making that requires no special abilities, and yet she occupies, and perhaps even cultivates, a position in society similar to the "artist-prophets" of western patriarchal traditions. Due to changing historical contexts and the essentializing characteristics of cultural feminism—which theorizes only certain behavior as ideologically true—ironies abound. The lives and work of women who are artists can seldom be explained by theory alone.

Similar theoretical ironies also affect the concept of compassion in music making. In society as a whole, notions of compassion are often dispensed from the privileged position of the "enlightened" and imply a system of power and authority that is anything but egalitarian or compassionate. Far from being a "feminist" leveling of hierarchies, the *political* concept of compassion might represent overtones of patriarchal "forgiveness" in which the "penitent" pays a heavy price in loss of status. In the actual practices of Deep Listening, which are almost impossible to capture with theory, these ironies are resolved.

Ironies between intention and effect also influence the notion of nonjudgmental perception—the first component of Deep Listening discussed in this article. Perception and judgment are so deeply interconnected in the human mind that we have no proof they can be separated. The forms of perception that presumably move us beyond judgment cannot be revealed through language, since, as first postulated by the French

postmodernists, language itself is a morass of implicit values. "Enlighten-
ment," for lack of a better word, is beyond words, methodologies, and
rationality. It is beyond the status quo, and it is beyond rejecting the status
quo, since both are implicit judgments. There is thus an ironic danger for
those striving toward the "suspension of judgment," because the percep-
tion of a presumed absolute reality might just be another form of absolute
idealism.

This irony affected John Cage's ideal of nonjudgmental perception,
which did not emancipate auditory perception to the extent its propo-
nents claimed. Instead, it channeled listening toward a rarified modernist
aesthetic. Cage's formulation of nonjudgmentalism in the 1950s divided
the new music world into two opposing factions, which came to be la-
beled according to their geographic centers in Manhattan: the "Uptown"
(which was against Cage), and "Downtown" (which was for him).

Such aesthetic encampments are the stomping grounds of orthodoxy,
and ironically, nonjudgmentalism thus became a stylistic ideology whose
foil was the equally stubborn and closed Uptown. If the Downtowners
had really suspended judgment, they would not have been inclined to wall
themselves into highly specialized, dualistic modernist ideologies, and the
closed co-dependent professional networks it took to support them. The
aesthetic of nonjudgmentalism became a cognitive filter in itself—an ideal
that often made its proponents quite opinionated about which new music
was "best." Such forms of ideologically deafened elitism were a hallmark
of modernism. Once again, in the discerning practices of Deep Listening,
these ironies are resolved.

In some respects, the postmodernists have been more successful in
freeing listening—at least in regard to style. By employing methods of
analysis developed during the 1970s by psychologists such as Jacques
Lacan, and literary critics such as Jacques Derrida and Michel Foucault,
the postmodernists challenged the authority of knowledge, and thus the
ideologies that place evaluations on stylistic differences in music. Through
increasing our awareness of the modalities of cultural conditioning and
how it arbitrarily shapes our concepts of "truth" (and thus aesthetic be-
lief), postmodern thought has helped us develop a wider appreciation for
musical styles crossing cultural, gender, and high-brow/low-brow dichoto-
mies (Jencks 11–12).

In order to keep pace with these changes, Oliveros and other propo-
nents of Deep Listening will need to strengthen and clarify its theoretical
foundations. This will help Deep Listening's value in musical practice and
education become apparent to a wider spectrum of musicians. It will

expand Deep Listening's influence, and enable it more successfully to fulfill its mission of nurturing creativity by taking the preconceptions out of listening.

As Deep Listening continues to evolve in these ways, it might eventually provide useful additions to postmodern thought. It offers, for example, a form of authenticity lacking in postmodernism's almost nihilistic landscape of non-commitment. A central part of postmodern aesthetics is based on a distanced assemblage of cultural artifacts, an "irrealistic constructionism," an ironic "carnivalisation" of experience (Hassan 196–198). Some typical examples in music range from John Zorn's collaging of spaghetti western sound tracks to Michael Dougherty's symphonic works alluding to comic book heroes. The artifacts used by postmodernists often have an exaggerated quality, a tone of bombast, artificiality or distortion that leads us to look at the nature of culture, often with a subtle tone of ridicule. Postmodernism is often characterized by this ironic distancing, this element of intentional inauthenticity and noncommitment.

This stands in contrast to the forms of quietude and authenticity represented by the *Sonic Meditations* and Deep Listening. Their humanistic ideals seem to be part of an earlier time. In 1975, one year after the *Sonic Meditations* were published, the historian Gordon Wright declared, "Our search for truth ought to be quite consciously suffused by a commitment to some deeply held humane values" (in Himmelfarb 141). Such views no longer seem fashionable. As Wright's colleague, Gertrude Himmelfarb, recently commented, "In 1975 . . . it was still possible to speak respectfully of the search for truth—and, indeed, to speak of truth without the ironic use of quotations marks" (Himmelfarb 141). And so one might ask, what are the *Sonic Meditations* in the light of postmodernism? What are these studies of authentic "being" in a landscape of noncommitment? What is Deep Listening in a world where truth is equated with coded cultural bias?

In its gentle, self-reflective way, Deep Listening might offer some responses. Through its examination of cognitive processes, Deep Listening illustrates that artistic experience is not only the evaluation of objects, but also complex self-reflective evaluations of ourselves as the perceiver. The forms of discernment characteristic of Deep Listening thus bring self-awareness and phenomenological analysis into the creative process similar to postmodernism's concepts of "deconstruction."

When trying to make something out that is at first difficult to perceive, discernment continually reevaluates and reshapes its *own* processes of perception until it is convinced of the validity of its observations.

Discernment is thus innately self-reflective; it constantly reevaluates the modalities of the cognitive process as a whole. This self-reflective evaluation formulates the witness/universe relationships of Deep Listening, and thus, the identities of Deep Listeners as artists. Deep Listening dissolves subject/object dichotomies into a process of transformation and growth which allows Mind and Nature to reach for each other. Deep Listening's self-reflective discernment thus seems to show how we might move toward an authenticity and truth that are something more than culturally conditioned biases.

Seen from a larger speculative overview, Deep Listening's movement toward the unification of subject/object dichotomies is part of a newly evolving cultural paradigm with profound implications for a transformation of western society. The subject/object dichotomy of idealistic, patriarchal transcendentalism, with its concept of the cultural-hero-as-redeemer, is being replaced with a holistic and participatory view of Mind and Nature (Bateson, Skolimowski, Tarnus) which balances the feminine and masculine in a sort of sacred marriage. This seems closely related to Oliveros' statement that the goal of her work is to *"balance out, and come to a different understanding of what can be done."* This balancing is created by the self-reflective discernment and empathic resonance of Deep Listening. They are new unifying or connective modalities of perception that rebalance our obsessively dualistic, patriarchal culture.

Due to its historical implications, the importance of this new paradigm is clear. After the horrors of the twentieth century—such as the Holocaust and the post-nuclear Cold War—western culture has become aware that its dualistic values contain elements that are inherently genocidal. On the most archetypal and metaphorical level, it seems to have something to do with the cultural-hero-as-redeemer wanting to annihilate all other patriarchs so that only "His" genes remain: the alpha-male as mass murderer. This dark view lends a certain absurdity and ignominy to human life and cultural expression, when we sense, for example, that the mass graves of the Holocaust and the music of Beethoven are both "fathered" by patriarchy, and are so intermingled in a common ground of cultural manifestations, that no matter how hard we try, they cannot be sifted apart.

Deep Listening responds to this darkness by breaking down the paradigm of subject/object dichotomies and providing new ways of sounding the abyss of otherness. The openness of its nonjudgmental perception, its development of empathy, its creation of nonhierarchical social relationships, its expanded use of intuitive forms of awareness, and its new understanding of sensuality and the body, are all forms of consciousness

bringing a new balance and vibrancy to western culture—something like, if you will, a prophetic foreshadowing of the return of the Goddess. Deep Listening thus represents a sacred marriage of Mind and Nature in which the feminine and masculine elements of human identity are united. Perhaps this "Sacred Marriage" and its implicit emancipation of "womanity" is a promise that is our hope.

Works Cited

Bateson, Gregory. *Mind and Nature: A Necessary Unity*. New York: E. P. Dutton, 1979.

Cage, John. *Silence*. Middletown, CT: The Wesleyan University Press, 1961.

Chang, Chung-yuan. *Creativity and Taoism: A Study of Chinese Philosophy, Art, and Poetry*. New York: Julian Press, 1963.

Deep Listening Band. *Suspended Music*. Periplum, 1997.

Derrida, Jacques. *Of Grammatology*, G. Spivak, trans. Baltimore: Johns Hopkins University Press, 1976.

Echols, Alice. *"The New Feminism of Yin and Yang." Powers of Desire: the Politics of Sexuality*. Ed. Ann Snitow, Christine Stansell, and Sharon Thompson. New York: Monthly Review Press, 1983. 439–459.

Foucault, Jacques. *Power and Knowledge: Selected Interviews and Other Writings*. G. Gordon, ed., New York, 1977.

Gleick, James. *Chaos: Making A New Science*. Viking Penguin, 1987.

Hassan, Ihab. "Pluralism in Postmodern Perspective." *The Postmodern Reader*. Ed. Charles Jencks. London: Academy Editions, 1992. 196–207.

Herrigel, Eugen. *Zen in the Art of Archery*. Trans. R.F.C. Hull. New York: Vintage Books, 1971.

Himmelfarb, Gertrude. *On Looking into the Abyss: Untimely Thoughts on Culture and Society*. New York: Vintage Books, 1995.

Ione, Carole. *Is This a Dream?: A Handbook for Deep Dreamers*. Kingston, NY: M.O.M. Press, 1999.

Jencks, Charles, "The Postmodern Agenda." In *The Postmodern Reader*. Ed. Charles Jencks, London: Academy Editions, 1992.

Lacan, Jacques. *Speech and Language in Psychoanalysis*. A. Wilden, trans. Baltimore: Johns Hopkins University Press, 1968.

Lowrey, Norman. *Singing Masks: Spirit of Dream Time*. Aug. 11, 1999. <http://www.users.drew.edu/~nlowrey>

Oliveros, Pauline. "And Don't Call Them 'Lady' Composers." *New York Times* 13 Sept. 1970. II: 29.

———. *Deep Listening Pieces.* Kingston, NY: Deep Listening Publications, 1990.

———. *Pauline Oliveros Web Page.* 30 July 1999. <http://www.artswire.org/pof/peop_po.html>

———. *Software for People.* Baltimore: Smith Publications, 1984.

———. *Sonic Meditations.* Baltimore: Smith Publications, 1974.

Osborne, William. "Symphony Orchestras and Artist-Prophets: Cultural Isomorphism and the Allocation of Power in Music." *Leonardo Music Journal* 9 (1999): 69–76.

Przybylowicz, Donna. "Toward a Feminist Cultural Criticism: Hegemony and Modes of Social Division." *Cultural Critique 14* (1989-90): 259–301.

Skolimowski, Henryk. *The Participatory Mind: A New Theory of Knowledge and of the Universe.* London: Penguin, 1994.

Suzuki, D.T.. *Zen Buddhism.* Garden City, NY: Doubleday Anchor Books, 1956.

Tarnus, Richard. *The Passion of the Western Mind.* New York: Ballantine Books, 1991.

Taylor, Timothy. "The Gendered Construction of the Musical Self: The Music of Pauline Oliveros." *The Musical Quarterly.* 177:3 (Fall 1993): 385–396.

Chapter 4

The Secularization of the Sacred: Judy Chicago's *Dinner Party* and Feminist Spirituality (1975–79)

Deborah Johnson

Judy Chicago was born Judy Cohen in Chicago, Illinois, on July 20, 1939. She elected the name Chicago in 1970 as a statement of divestiture of patriarchal naming traditions in the West. Prior to this point, Chicago had studied at the University of California at Los Angeles, receiving her B.A. in 1962 and her M.F.A. in 1964. Trained as a sculptor, Chicago found her reception among artists within sculpture circles particularly cold, even hostile: machismo myths were especially prevalent in this arena where raw physical strength is often an asset, and her gender was held against her. She initially attempted to assimilate by "masculinizing" her own persona; this, however, proved both unsuccessful and unsatisfying.

In line with feminist theory emerging late in the 1960s, she abandoned this tack and turned to emphasizing and celebrating female difference. Her faculty appointments at California State University at Fresno from 1969–71, and then at the California Institute of the Arts in Valencia from 1971–73, were remarkable for introducing female pedagogy into the academy: at CalState, she founded the first Feminist Art Program, transplanting it to the California Institute of the Arts, where she co-directed it with Miriam Schapiro.

Based in the sociopsychology of feminist consciousness-raising, the Feminist Art Program did nothing less than redirect the development of modern art and feminist theory. Womanhouse,

a month-long installation in a dilapidated Los Angeles mansion, produced by Chicago, Schapiro, and their students in 1972 may be considered the birthplace of feminist performance art and the first monument to essentialism. Essentialism rejects the notion of male/female sameness, and instead, celebrates the markers of quintessential femaleness, such as uniquely female biological characteristics. This is stated most forcefully and articulately in Chicago's own ground-breaking installation, The Dinner Party *of 1975–79, often regarded as the first, most important—and surely, most controversial—feminist art work.*

*Throughout the 1970s and beyond, Chicago has continued her political and artistic engagement with feminism, and has received mainstream recognition for this activity: in 1976 and 1977, she was the recipient of two National Endowment for the Arts grants, and in 1992, she was given an honorary doctorate from Russell Sage College in Troy, New York. Her most recent, ambitious, multimedia work, however, has not taken feminism as its primary subject, but the Holocaust (*The Holocaust Project, *1993), and this has proven to be almost as controversial as* The Dinner Party. *Chicago currently lives in New Mexico.*

The Dinner Party, Judy Chicago's major installation piece of 1975–79, has long been thought of as the feminist art manifesto, par excellence (fig. 4). Its reception by public and critics, for good or for bad, has rested almost exclusively on this identification. In a positive way, it has earned it: *The Dinner Party* is one of the earliest and most ambitious discourses on the role of women—and women artists—in history and in art.[1] Establishing the fact of women's historical exclusion, it literally brings to light the forgotten names of significant women, and through the use of metaphor, their forgotten achievements. It is also a key reflection of the celebration of positive images of woman that characterizes feminist posture in the 1970s, and that turned, after that point, to explicit critique of the objectifying male gaze. Thus, it is a marker not only for the history of art, but for the history of feminist consciousness in the second half of the twentieth century.

Nonetheless, the characterization of *The Dinner Party* as single-mindedly feminist in implication has obscured multiple referential layers that usually make up the most significant works of art.[2] This includes

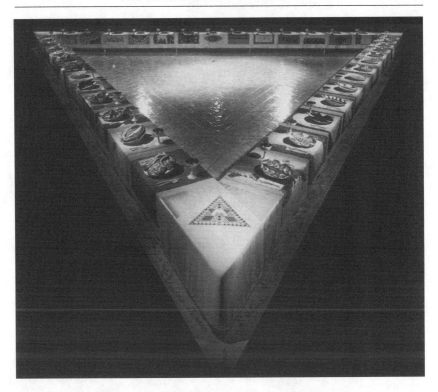

Figure 4. Judy Chicago, *The Dinner Party*, overview, mixed media, 1979

references to other artworks, and especially, concepts which aspire to spiritual significance. An interface of Christian and Jewish religious ideas comprise several of *The Dinner Party*'s sources, and the Jewish concept of *tikkun olam*—healing of the world—ultimately emerges as the point and purpose of the work. This broadens the scope of its feminist intent, and marks *The Dinner Party* as among the few works in modern times to redress and redefine "religiosity" in art.

 The Dinner Party is comprised of a triangular-shaped table raised onto a porcelain platform, covered with lavishly embroidered cloths, and set with clay goblets, utensils, and plates whose distinguishing feature is a distinctly gynecological imagery (fig. 5). For a variety of reasons, the plates have long been the center of controversy surrounding *The Dinner Party*, and are the only components of the piece completely handwrought by Chicago herself. Every other component of the piece, as well as its installation as a whole, was designed by Chicago and produced by members of

Figure 5. Judy Chicago, Susan B. Anthony plate from *The Dinner Party*, china paint on porcelain, 1979

her studio working under her direction. A slightly larger-than-life scale (48′ × 48′ × 48′ for the triangular platform) was adopted by the artist ultimately to remove the piece from reality and underscore its identity as art.

There are thirty-nine place settings, each of which is prepared for a specific, identified, female "guest" from the beginning of time through the twentieth century. Although largely western in bias—and controversial, as a result—the guests constitute an earnest attempt at an otherwise even-handed range of women. These include mythological figures such as Ishtar and Kali, religious figures such as Judith and St. Bridget, women of color such as Sacajawea and Sojourner Truth, political figures such as Empress

Theodora and Susan B. Anthony, intellectuals such as Hypatia and Isabella d'Este, and visual artists and writers such as Artemisia Gentileschi and Virginia Woolf. Research on these individuals was conducted by Chicago and a collaborative team of historians. Even twenty years later, it provides an impressive record, and in some cases, is ground-breaking and/or definitive.

As in her manipulation of scale, Chicago hoped to minimize the particularity (and implied hierarchy) of the piece: all the guests "have been transformed in *The Dinner Party* into symbolic images . . . that stand for the whole range of women's achievements . . . I have fashioned them from my sense of the woman, the artistic style of the time . . . and my own imagery" (*The Dinner Party* 52). Isabella d'Este, for example (fig. 6), "represents the achievement of female scholars during the Renaissance, the importance of female patronage of the arts, and the political position of Italian women of her century" (Lippard, "Dinner Party"123). Isabella's plate utilizes Renaissance ideas and aesthetic she, herself, helped to promote, and is fabricated in the clay and textile techniques of her period: Urbino majolica, Assisi work, and Cavandoli macramé.

The issue of cultural and historical inheritance is made explicit in the platform on which the table sits, called the Heritage Floor. Comprised of triangular porcelain tiles, it is inscribed with the names of 999 additional women. Since these names are arranged according to chronology around each special guest at the table above, they form the literal foundation for her: they establish her "heritage," and in turn, stand for the many anonymous women whose contributions have been wholly lost to history. On one level, this strategy was a practical response to the vast quantity of historical information unearthed by Chicago and her team, and 999 held additional appeal as "a nice Biblical number" (*The Dinner Party* 18). On a deeper level, the artist specifically hoped to minimize the implication that women's achievements could be reduced to—or essentialized in—a canon of thirty-nine individuals.

The Heritage Floor creates one of the more beautiful and subtle visual allusions in *The Dinner Party*. Painted in gold china paint and covered with a transparent luster overglaze, the names appear and disappear as the viewer walks around the table, symbolizing the fragility of female historical survival. The metaphor grows as individual names come together as units. In concert with the sexual allusions of the plates, the inscriptions can be seen to pulse in rhythms that are almost orgasmic; at least, they flow like tributaries from a waterfall—interconnected, interdependent, and building upon one other from a single source—invoking suggestions of the sea as distinctly female.

Figure 6. Judy Chicago, Isabella d'Este plate and runner from *The Dinner Party*, china paint on porcelain and embroidery on fabric, 1979

Discussing her unusual choice of subject matter, Chicago wrote in the catalog to a later installation piece, *The Holocaust Project*, "I have frequently been attracted to iconographic voids, and addressing them has been one of the hallmarks of my work" (*The Holocaust Project* 4). At its most obvious, the "void" addressed by *The Dinner Party* is the names and achievements of significant women throughout history. The work was originally conceived as "25 Women Who Were Eaten Alive," suggesting that the civilized ritual of *The Dinner Party* masked a subtext of literal consumption of women's lives by meaningless social activity. While the double entendre remains, the "void" also refers more broadly to the day-to-day lives of Everywoman: "Women had been embedded in houses for centuries and had quilted, sewed, baked, cooked, decorated, and nested their creative energies away" (*Through the Flower* 104).

Chicago chose to reflect and honor these "creative energies" in two distinct ways: to acknowledge the creation of a dinner party as a potential act of art making through larger-than-life scale and the context of exhibition; and to obfuscate the distinction between the maligned "craft" techniques of historically home-bound women (pottery, sewing, and general "making pretty") with traditional definitions of art. By employing only the former in what is clearly an ambitious and serious art project, Chicago forces us to conclude that traditional female craft is high art making, as well. Thus, the significance of women's activities throughout history—individually and collectively—is expressed not only through content, but through technique. Form and aesthetic come to exist for the ways in which they metaphorically express subject.

Chicago wrote that her subject matter "between 1968 and 1982, had focused primarily on issues of female identity" and specifically, on issues related to the female body (*The Holocaust Project* 4). This interest was most ambitiously declared first in her "Menstruation Bathroom" for the *Womanhouse* Project of 1972. Chicago, her students at the California Institute of the Arts, and her CalArts colleague, Miriam Schapiro, constructed a series of installations and performance pieces in a decaying Los Angeles mansion. Once again using a domestic context to isolate and identify women's issues, Chicago completely covered the "Bathroom" and all its accoutrements with red paint, and new and used sanitary products. The piece drew attention not only to the fact of the female menstrual cycle, but our culturally predetermined responses to it. Just prior to this, she had explored the concept in a much misunderstood lithograph of a bloody tampax as it was pulled from between a woman's legs.

The Dinner Party, sometimes treated as if sprung out of nowhere and without context, is a culmination of forms and issues with which Chicago had been struggling for nearly a decade. Most critical was her search for symbols by which to characterize women, individually and archetypally. The triangular format of the table, for example, is not based in aesthetic decision making as much as it is intended immediately to establish the principle of gender: the triangle is one of the earliest symbols of the female—the *mons veneris*—and suggests the configuration of the female groin. Similarly, although plates are typically round, the circularity of the dinner service also brought particular meaning to the piece. In earlier paintings, such as the *Pasadena Lifesavers* series (1969), Chicago had focused upon circular imagery as a veiled, abstract reference to the idea of female core. At its most straightforward, "female core" stands for the external and internal reproductive anatomy of the female as traditional source of female power or, conversely, entrapment.

In Chicago's pictorial shorthand, general referencing to circularity in the *Pasadena Lifesavers* ultimately became more specific, and in particular, vaginal, in *The Dinner Party.* In evolving this shorthand, Chicago enriched its implications with other levels of signification. She first linked the circle with the flower, probably inspired by the paintings of one of her heroes, Georgia O'Keeffe. She said that she found in the work of many women artists "a frequent use of the central image, often a flower or abstracted flower form." Moreover, she saw this as more than formal motif. It was ". . . each woman's need to explore her own identity" from a cloud of societally-imposed concealment (*Through the Flower* 143). It was also one of Chicago's first acts of "reappropriation": infusing with new meaning a type, genre, or form that had been traditionally characterized as female and thus dismissed.

As Chicago herself moved through the flower to the vagina as visual language, particularly in *The Great Ladies* series of 1972, she assimilated its stereotypical meaning. She specifically saw the flower as a "symbol of femininity" in which ". . . the petals [reveal] . . . space beyond the confines of our own femininity" (141). In the central core imagery she identified with the works of women artists, Chicago also found "central images . . . sometimes surrounded by folds or undulations, as in the structure of the vagina" (143). The blooming flower *qua* vagina, not merely an image of female sexuality and its messages, became the symbol of hidden meaning in her own early work, in the work of many women artists, and a metaphor of female invisibility in general.

It is fitting that Chicago entitled her first autobiography *Through the Flower,* published in 1975 before she had received significant national

attention with *The Dinner Party*. It is also not surprising, then, that the book is relatively uninvolved with the typical autobiographic program which charts the rise of a single, gifted individual to public recognition. *Through the Flower* concerns the tug of war between a culture and a representative of that culture critical of its values. While a journey of self-analysis, it offers the example of Chicago's experiences as a guide to self-discovery for all women. It is, in other words, about the potential for communal passage from abnegation to identity, silence to voice: "Moving through the flower is a process . . . that can lead us to a place where we can express our humanity and values as women through our work" (206).

At least one other major formal and symbolic archetype mediated alongside the flower as transitional form from circle to vagina: that of the butterfly. Chicago had been attracted to the butterfly motif as a student in the 1960s, even painting it on the hood of her car. In 1973, the butterfly-as-vagina image emerged clearly in *Transformation Painting: The Great Ladies Transformed into Butterflies*. In several of *The Dinner Party* plates, such as that for Elizabeth Blackwell, it is the butterfly motif, rather than the flower or vagina, that is the operative metaphor (fig. 7). Most often, the butterfly is so well integrated within the primordial vaginal form that it is virtually indistinguishable from it. However, Chicago has cited the butterfly as the "consistent motif in the plates" (*Embroidering Our Heritage* 15). It was meant "to symbolize liberation and the yearning to be free . . . Sometimes [the butterfly] is pinned down; sometimes she is trying to move from a larva to an adult state; sometimes she is nearly unrecognizable as a butterfly; and sometimes she is almost transformed into an unconstrained being" (*The Dinner Party* 52).

The shifting identities of the butterfly become apparent in comparing similar designs, as, for example, the runners and plates for Christine de Pisan and Artemisia Gentileschi. De Pisan was a prolific writer against the misogyny of fifteenth century France. As allegory, her "butterfly" seems to rear up from the threatening points of the Early Renaissance-type Bargello needlework runner all around it (fig. 8). The plate of Gentileschi, the seventeenth century artist well known for her paintings as well as a gruesomely public rape trial, bears a "butterfly" that is twisted and tormented. It is nearly overwhelmed by the black hole of the runner and stifling drapery surrounds (fig. 9).

The Dinner Party plates chronicle a remarkable visual passage of form. Almost all emanate from and share the emphasis on central core imagery.[3] That this was a conscious choice on the artist's part and a statement of solidarity with other women artists is clear from those plate designs that are fundamentally geometric rather than biologic; that is, they are

Figure 7. Judy Chicago, Elizabeth Blackwell plate from *The Dinner Party*, china paint on porcelain, 1979

adapted to the notion of central core with difficulty (fig. 6). Specific configurations, as in the case of the butterflies discussed above, contain within them references to individual biographies. As the circles become increasingly organic—whether flower, butterfly, or vagina—they can be seen as general metaphors for the revelation of self. Several play very directly with the concepts of opened and closed, potent or impotent, often through the nominal form of biology in process. For example, the Primordial Goddess, symbol of early matriarchal societies and the power of female procreation, is metaphorized by a strong, dilated vaginal form in the crowning phase of childbirth (fig. 10). In contrast, the plate for Sophia, an

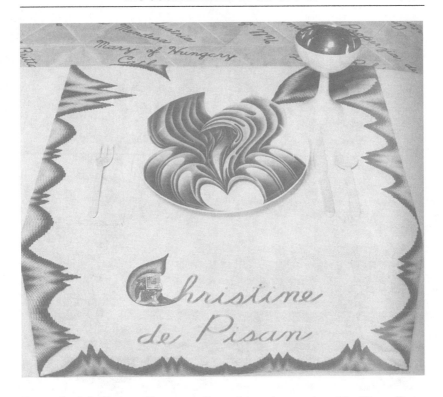

Figure 8. Judy Chicago, Christine de Pisan plate and runner from *The Dinner Party*, china paint on porcelain and embroidery on fabric, 1979

anthropomorphic persona originally representing female wisdom but later reduced in popular consciousness to amorphous spirit, is seen as a flower just past its prime; even its runner is muted by a veil of white chiffon symbolizing "the waning of female power" (fig. 11; *Embroidering Our Heritage* 50).

Chicago did not produce the plates chronologically. There were multiple mishaps in fabrication which ultimately precluded strict chronological sequencing. Thus, any urge on Chicago's part to approach the work academically was replaced by a dynamic process of learning by doing. This seems to be a characteristic work trait of the artist, and reflects her willingness to take risks in the evolution of technique. Nonetheless, there is a straightforward progression from table wing to table wing. The first wing of thirteen place settings, identified with figures "From Prehistory to Rome," shifts to thirteen places on wing two "From the Beginning of

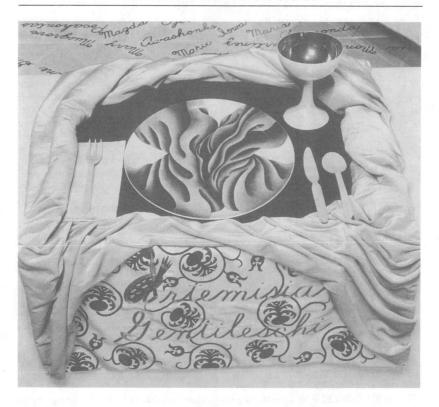

Figure 9. Judy Chicago, Artemisia Gentileschi plate and runner from *The Dinner Party*, china paint on porcelain and embroidery on fabric, 1979

Christianity to the Reformation," and then to the last wing of thirteen, "From the American Revolution to the Women's Revolution." As the artist moved from wing one to wing two, the flat painting of the plates began to give way to carving, first seen in the Hatshepsut plate. The runner designs also grew increasingly three-dimensional. By the third wing, Chicago set out to break any remnant rigidity or rectilinearity of the earlier wings as if to parallel the revolutionary theme of the period and metaphorize women's struggle for autonomy. As in the Susan B. Anthony plate at the middle of the third wing (fig. 5), it is here that the butterfly forms begin to lift aggressively off the plates, and where the most realistic vaginal forms are found. These forms correspond to individuals noted for feminist anger and activism, thereby linking them directly to symbolic concepts of the open flower—that is, of revelation, liberation, and voice.

Figure 10. Judy Chicago, Primordial Goddess plate from *The Dinner Party*, china paint on porcelain, 1979

The public history of *The Dinner Party* spans the period of its first exhibition at the San Francisco Museum of Art in the spring of 1979, to 1990, when Chicago aborted an attempt to make a gift of the piece to the University of the District of Columbia (UDC). During that time, controversy around the vaginal implications of the forms dominated critical response. In her journal, Chicago described herself as "confused" and even "devastated" by the intense hostility of the critics, especially those in New York (*The Birth Project* 24 and 30). Hilton Kramer, influential art critic for *The New York Times*, charged the work with "an outrageous libel on female imagination" (c1,18), and Kay Larson, writing in the *Village Voice*, denounced it as "gay art" (113). Despite this (or perhaps because of it), public attendance during its initial showing in San Francisco was record-

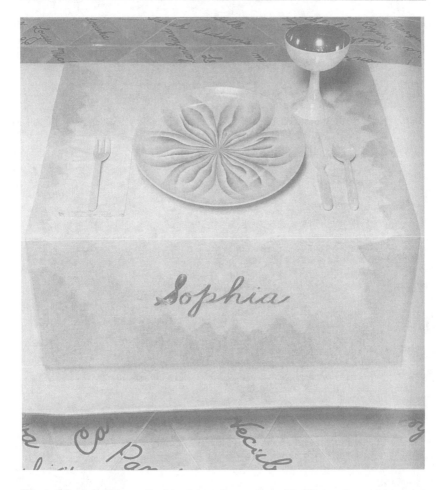

Figure 11. Judy Chicago, Sophia plate and runner from *The Dinner Party*, china paint on porcelain and embroidery on fabric, 1979

breaking, and continued to run high through a nine-year tour of six countries and fourteen sites. Nonetheless, several institutions, most notably, the Seattle Art Museum and the Rochester Memorial Art Gallery—both of which had committed early to the project—cancelled their exhibitions following the first wave of critical reaction. Seattle attributed its cancellation to "inadequate space," and Rochester cited a "communications breakdown" with the artist (Lippard, "Dinner Party" 124–5).

Just as this initial reaction reflected the fear and fascination of female power that polarized the American public in the 1970s, the 1990 incident

at the University of the District of Columbia was completely enmeshed within the politics of backlash. For Chicago, her gift of *The Dinner Party* to the new multicultural center at UDC was a wish come true. She had developed a morbid fear that the piece would sink into oblivion (like the work of so many women celebrated in *The Dinner Party*), and longed to see it permanently installed in a public institution in California or Washington. With $1.6 million already promised for library and gallery renovations, UDC was prepared to make a commitment to Chicago, and a careful contract detailing the sharing of revenues from admissions and souvenir sales was drawn up.

The United States Congress, responsible for the administration of funds to UDC, became suspicious of the agreement, and reincited hostility around the plate imagery. The timing could not have been worse. At this moment, Congress was also debating the validity of government support of controversial art works by Robert Mapplethorpe and Andreas Serrano. Representatives such as Dana Rohrabacher (R-California) denounced *The Dinner Party* as "weird sexual art" and Stan Parris (R-Virginia) labelled it "clearly pornographic" (Lippard, "Uninvited Guests" 41). While prepared to weather the governmental attack, Chicago severed the agreement with UDC when students protested the "inappropriateness" of the gift of a work by a white artist to the predominantly African-American institution.

At the point of its first exhibitions, the timing was also not right for *The Dinner Party* to be wholly embraced by the feminist community. Modern feminist theory is seen to have evolved largely over three periods: an initial period of profound intellectual and political reawakening, initiated by the work of Simone de Beauvoir (1949; 1974); a redefinition and celebration of all things quintessentially female, beginning in the middle 1960s and leading to a pronounced activism; and a gradual abandonment of essentialist theories, ca. 1975, in favor of the investigation of the relativity, implications, and meanings of gender categories.

Many feminists praised the apotheosis of woman and her achievements on which *The Dinner Party* was based. Others rejected as sexist and misogynistic the denotation of woman by her body parts: this was sexual objectification differing only in the gender of its author from a long history of such objectification in art. Still other feminists, those of the third generation, questioned the validity of essentialist theories and the concept of woman as delineated by a fixed sign; any attempt at such delineation must inevitably be shallow and counterproductive. Even Georgia O'Keeffe, the climactic figure in *The Dinner Party*, would have rejected her inclusion as an act of ghettoization. She had aggressively opposed

perceptions of gynecological imagery in her work, and had struggled against them since the 1920s (Lynes in Broude and Garrard 436–449). Years of marginalization on the basis of her sex and the inferred sexuality and/or femininity of her work had led O'Keeffe to an intuitive rejection of essentialism.

Finally, several feminists criticized the apparent acceptance of status quo patriarchal, social, and historical preconceptions represented by *The Dinner Party*. These were feminists in the vanguard of deconstructionist theory for whom the real goal was not filling in the blanks of a pre-established historical record with the names of women, but a total reassessment of the subjectivity of history. Tamar Garb, for example, objected to Chicago's adoption of the historical construct of the "Great White Western Man," *qua* woman, which left intact the traditional structure from and by which women had been excluded (Garb, 131–33). Similarly, Carrie Rickey argued that the fundamental authoritarianism of the table overwhelmed any impulse to counterbalance it, as in, for example, the Heritage Floor: "This is history using the Great Women theory. What happened to the anonymous women?" (Rickey 72).

Chicago herself had written that "the imagery on the plates incorporates both vulval and . . . [active vaginal] motifs . . . The incorporation of vulval iconography was certainly intended to challenge the pervasive definitions of women and female sexuality as passive" (*The Dinner Party* 5–6). The potential for a radical rethinking of sexual identity and response promoted in these words might have been expected to appeal to third-generation feminists. In terms that suggest the deconstructionist theories of Jacques Lacan, Chicago presumes to privilege the female as organizing principle of the symbolic order: the vagina and vulva are now something to see, not Freud's presentation of female sex organs as non-penile and thus based in "lack," but as Lacanian phallus—that is, central to experience and understanding, and signifier of power. In fact, however, the image of female gynecology that Chicago presents remains patriarchally defined. It is not the vulva that is foregrounded here, but the vagina, with the vulva presented only as labial folds that serve to conceal or reveal it to scopophilic or tactile exploration. The clitoris, capable of sexual response independent of the penis—and thus subject as an image to autonomous phallic signification—is virtually unrepresented.

This is not entirely inappropriate. While unaffected by newly emergent feminist/deconstructionist ideas, *The Dinner Party* is archetypically circumscribed by feminist/essentialist notions specific to the period in which it was produced. Despite the important visual and iconographic relation-

ship to the flower and the butterfly, it appears as unabashed celebration of vaginal form, and is a powerful symbol in and of itself. Its presence as the central motif of *The Dinner Party* demands attention: the viewer is virtually forced to look hard at an image otherwise concealed, and thereby, to reconsider complex layers of personal and social conditioning. More-over, as opposed to the deconstuctionist implications of genuine vulval imagery, the viewer inevitably confronts the negativity ascribed in patriar-chy to women's bodies, sexuality, and for Chicago, at least, general being.

Chicago's interest in the notion of female core, as well as fixed signs of the female as represented by the vagina, are not only informed by the essentialist ethos of the 1970s. It can also trace its pedigree to Simone de Beauvoir's ground-breaking post-war publication, *The Second Sex*. De Beauvoir discussed the implications of female core not merely as quintes-sential sexual and/or anatomical sign, but as determining the relationship of the female to the outside world: as females are structured around the central core, so have we carried the burdens of inwardness and introspec-tion, and have organized our lives around the central, inward core of home and its concomitant attention to details. Men, in contrast, have oriented their relationship to the world on the model of male anatomy, that is to say, outward.

The characterization of *The Dinner Party* as essentialist has been controversial from its inception, with every conceivable position taken for or against essentialism, and for or against *The Dinner Party* as essential-ist. Chicago has established here a community of women who by virtue of their sex—their vaginas—has met with erasure, and who through imagistic solidarity around the table has found voice. The collectivity of female invisibility and visibility as Chicago presents it is clear. While this may, indeed, reflect utopian universalist conceptions that are essentialist at base, notions of collectivity had been promulgated in American avant-garde art circles since the 1930s. Specifically, the writings of psychoanalyst Carl Jung on the collective unconscious—the common psychobiological re-sponses shared by all human beings across gender, race, class, age, and time—were actively or implicitly invoked by artists throughout the 1940s and 1950s. Jungian theory came to serve as frame for a feeling-based, nondeterminate style of language, particularly manifest in Abstract Ex-pressionism. The probability of a "quintessential" human being—or at least, a set of human feelings—was mainstream by the 1970s; in fact, among the major contributions of deconstruction is its insistence on di-verse subjectivities. Feminist essentialist theory, itself, may be a part of this ethos of collectivity, and this problematizes its presumed scaffolding

of *The Dinner Party*. Nonetheless, that *The Dinner Party* absorbs and reflects so much theory of Chicago's generation, feminist and otherwise, contributes immeasurably to its status as quintessential art manifesto.

As art object, *The Dinner Party* is also deeply embedded in art world interests of the 1960s and 1970s. The work cannot be understood without reference to Pop Art and Minimalism, for example, despite Chicago's dislike and ultimate rejection of these movements. The very notion of recasting an object or event from everyday life into the new and startling context of work of art is the essence of Pop principle. While it can be traced at least to Marcel Duchamp and World War I, recontextualization became a Pop signature. Similarly, the overall simplicity of form of *The Dinner Party* is unquestionably related to Minimalism and Chicago's earlier sculptural work within this mode. Compared to a rigorously Minimalist piece by a mainstream sculptor such as Don Judd, a place setting like that for Gentileschi (fig. 9) might be considered lavish and Baroque; nonetheless, it and other place settings owe their attention to high polish and pristine surface in large part to Minimalist aesthetic.

The most immediate precedent for *The Dinner Party* is Chicago's own series of paintings of 1972, the *Great Ladies*. The nominal subjects of this series are significant female historical figures, and although the imagery was based in central core, it is wholly abstract. More specific references to subject were made in notes Chicago wrote directly on the canvasses and the walls on which they were hung. These included messages regarding personal processes of discovery and creation, and Chicago has suggested that they thus broke the literary art taboo against artist self-explanation. To the contrary, however, this had been a growing trend in art of the 1960s, particularly among Pop artists like Claes Oldenburg, Robert Rauschenberg, and Jasper Johns, and became a virtual fetish in the work of southern California artists, such as John Baldessari and Ed Ruscha.

As the 1970s began, Chicago was a well-integrated part of the southern California art scene. A unique and dynamic subculture, it had been initiated and nourished by a variety of developments of special relevance to Chicago: the 1950s Happenings of Alan Kaprow, which laid the foundation for Performance and Conceptual art; the presence of Oldenburg, whose experiments in the 1960s with new, recontextualized, and intramedia were among the most interesting of the period; and the founding of the California Institute of the Arts, arguably the most creative institution of its type in the 1960s and 1970s, under whose auspices Chicago produced *Womanhouse*. Although committed to formalism at the start

of her career, Chicago came to artistic maturity aware of the power of idea, open to experimentation, and familiar with a range of radical techniques. Prior to *The Dinner Party*, she had worked with concept in several aggressive performance pieces, and had fabricated work in smoke flares, industrial plastics, and automotive painting. As with its imagery, in this context, *The Dinner Party* was not an art historical leap so much as it was a culmination.

The Dinner Party bears an interesting relationship to another work which takes as its primary subject the implications of female sexuality: Pablo Picasso's *Demoiselles d'Avignon* (fig. 12). Aspects of Chicago's vaginally inspired forms seem to constitute the missing ingredient in Picasso's painting, literally and metaphorically. Personal shame, Edwardian decorum, and Cubist non-particularity precluded any specific imaging of female genitalia in Picasso's Avignon prostitutes. They are clearly implied, however, in several key instances, most notably, in the splay-legged figure at the right. In early versions of the picture, this figure sat closer to the viewer, back to us, opening herself to a sailor at middle-ground. The absence of genitalia in the final version is thus explained by her original posture, back to the viewer. Nonetheless, this is ambiguous, and made more so by the fact that the African mask used for her head faces toward us. The posture itself draws attention to her genitalia (and its hidden presence), and establishes one of the major Freudian themes of the work: woman as sexual carnivore, bearer of the cavernous maw, waiting to devour any man who can be trapped between her legs. Not only does Chicago bring Picasso's implied vagina into full view, she makes explicit the Freudian link of sex and consumption. However, she reverses its evil metaphor: in *The Dinner Party*, it is woman who has been swallowed up, not through her sexuality, but as a symbol of it.

While the best-known of the early feminist artists, Chicago was not the first. In the arena of feminist, and specifically activist, iconography, a fruitful comparison can be made with the New York artist, Faith Ringgold. At the end of the 1960s, Ringgold was known for canvasses utilizing Pop culture images (such as the American flag) stripped of all humor, and infused with African-American protest themes. To her chagrin, she was even better known for her successfully organized strikes against the white art establishment. Soon, she "felt the need to shed some light on who I am as a . . . woman . . . outside the stereotypes that people place on me" (Freeman). Although feminist subjects were not rendered as aggressively as her African-American subjects, this had to do with a shift in the artist's worldview, rather than a lesser commitment to women's issues. Ringgold

Figure 12. Pablo Picasso, *Demoiselles d'Avignon*, oil on canvas, 1907

turned increasingly to themes of personal and cultural self-discovery early in the 1970s, in many ways paralleling the evolution of both the feminist and African-American movements. As Chicago would a few years later, Ringgold conspicuously chose traditional, female craft media in order to integrate her own past and to bring reconsideration to the creative activities of women throughout history. One of these works, *Bernice Mask* (fig. 13), incorporates a variety of textile techniques with found objects in an installation piece that tells a story of individual, cultural, and aesthetic "rape," and finally, resolution.

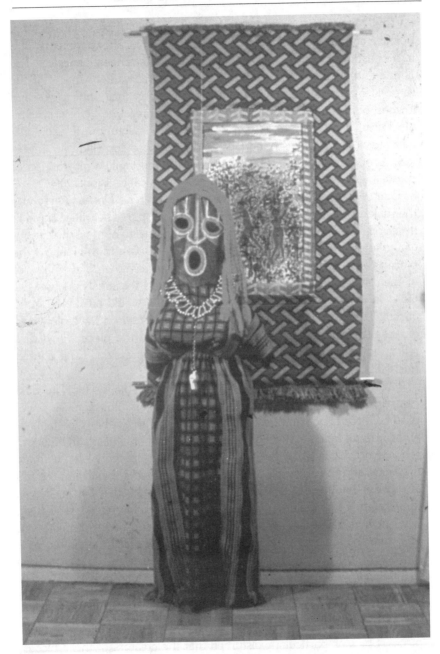

Figure 13. Faith Ringgold, *Bernice Mask*, mixed media, 1974

The Dinner Party reflects a unique combination of personal ambition, political commitment, aesthetic vision, and technical experiment. Of a more particular nature, Lippard wrote that the strongest aspect of *The Dinner Party* is that it "weaves and interweaves varied aspects of the same ideas through different materials and techniques until words and images, objects and perceptions, become the same fabric" (Lippard, "Dinner Party" 116). The same can be said of its integration of traditional religious sources. Jewish and Christian references constitute an important secondary theme of *The Dinner Party*, and imply a redefinition of spiritual authority that parallels Chicago's historical revisionism.

One of the earliest sources of inspiration for *The Dinner Party* was the subject of Leonardo da Vinci's *The Last Supper*. Their titles stand in ironic relationship to one another, and a witty duality of meaning continued to inform Chicago's thinking about this: "I began to think about the piece as a reinterpretation of *The Last Supper* from the point of view of women, who, throughout history, had prepared the meals and set the table. In my Last Supper, however, the women would be the honored guests. Their representation in the form of plates set on the table would express the way women had been confined, and the piece would thus reflect both women's achievements and their oppression" (*The Dinner Party* 11).

This framework further suggested thirteen at table, as for *The Last Supper*, but was "feminized" in several distinct ways. Thirteen was multiplied by three to accommodate more figures and to establish the table as an equilateral triangle, the sign of the female and of equality. In addition, there is no Judas or Christ figure, reducing the potential for ultimate hierarchy and the suggestion of saviors or betrayers. Finally, Chicago's awareness that thirteen women also constituted a witches' coven allowed for a statement on the usurpation of female power. In prefeudal societies, witches were respected for their medical skills and spiritual mediation, and were the last remnants of goddess-worshiping cultures. Later, as a function of misogyny, they were persecuted for the talents and autonomy that had earlier served them well.

The wealth of sewn cloths throughout *The Dinner Party* was also motivated by Christian models. Chicago's immediate inspiration was a visit to a church exhibition of newly embroidered chasubles and altar-pieces. She was particularly disturbed that the creators of these pieces, while present, were otherwise anonymous: "It was as if I were seeing our whole condition as women embodied in that room. Instead of devoting their energies and skill to honor each other and their own heritage, women were submerging their time and efforts in support of male institutions

and male-dominated belief systems . . . After we left the exhibition, I began thinking about extending the religious metaphor of *The Dinner Party* by incorporating into it more of the objects traditionally associated with Christian worship" (*Embroidering Our Heritage* 263).

While Chicago was inspired by the idea of giving voice to centuries of anonymous artisans and craftswomen, the influence of the church pieces was direct and specific. Each corner of *The Dinner Party* table was covered by an "altarcloth." The second cloth, marking the transition from wing one to wing two (that is, classical times to Christian times), was executed in traditional ecclesiastical embroidery techniques. These were significant iconographic moves, and shifted the overall implications of the work. The table was now transformed into a kind of altar, an impression corroborated by the presence of the platform which raises the table off the floor—like an altar—to create a sacralizing distance.

Susan Hill, one of Chicago's assistants, further suggested the fabrication of individual runners modelled on the "fair linen" that covers the altar during the Eucharist. Eucharist, the Christian sacrament of Communion, commemorates the martyrdom of Christ through the mystical transformation of Christ's body into the Communion wafer, and Christ's blood into wine. Notions of martyrdom and Communion unquestionably appealed to Chicago as deeply relevant to a work similarly based on sacrifice and consumption—of women's lives. Simple porcelain cups were included in the piece on the model of the chalice used for the sacramental wine, and even the plates may be seen as patens, the surface that holds the Communion wafer. Chicago hoped for a sacred experience of communal celebration in the presence of *The Dinner Party*: "Communion is performed as the audience moves around the table, viewing this assembled community of women—apostles, if you will—all of whom have served women through their lives and work" (267).

Just as Chicago's vaginal forms were met with a certain amount of hostility and misunderstanding, many critics found her Christian references inappropriate. Restating the radical feminist position, some saw it as the validation of an institutional framework (specifically, Christian) based in oppression, patriarchy, and exploitation. Others regarded as hubris the infusion of sacramental character into a plainly secular work of art. The rendering of the secular into the sacred, however—one of the most important aspects of *The Dinner Party*—may have been determined as much by Chicago's Jewish background as by her feminist program and Christian references.

Chicago has written that the "sacramental nature of *The Dinner Party* is a deliberate part of its imagery" and that the "Eucharist . . . traditionally

conducted at the church altar" is also ". . . enacted at the dinner table" (*Embroidering Our Heritage* 262, 264). With this, she metaphorically related the martyrdom of Christ with that of countless women who have been sacrificed to home and family. Elsewhere, she specifically linked the altar with the Christian dinner table: "During early Christian times, the household table was transformed into an altar simply by covering it with a clean white cloth" (264). Nonetheless, as Chicago herself has asserted: "It may seem strange for me—Jewish and basically irreligious—to create a work of art that aspires, as *The Dinner Party* does, to spiritual significance" (262).

As Chicago would have experienced in her Jewish family, nowhere is the table more frequently and seamlessly transformed into an altar than during Jewish ritual celebrations. While most of these rituals contain a component of outside communal worship, virtually all are observed in the context of the home, an inheritance from ancient Israel, where one traveled to the Temple only three days a year, and of diaspora. The beautifully set table is the center of Jewish home life, and is described in the liturgy as both *mizbei-ach* (altar) and *mekdash me-at* (miniature sanctuary or holy place). It is unlikely that Chicago could have approached either the idea or the fabrication of *The Dinner Party* without the concept of *mizbei-ach* in mind.

At the time she was working on *The Dinner Party*, Chicago's attitude toward her Jewishness was frankly ambivalent. She had grown up in the 1940s, and in her autobiography, she described her family's ritual practices as lax. It was a period of self-conscious assimilationism on the part of many Jews, and Chicago remembered that in her community, references to the Holocaust—the key Jewish issue of the day—were silenced and mysterious. As an adult, her ambivalence resurfaced as anger:

> It was Yom Kippur, the highest holiday of the year, and the traditional *yiskar* or memorial services were being held. I wanted to commemorate the death of my father . . . During the service, envelopes were passed around with printed requests for donations so that 'our loved ones could rest in peace'. . . I was horrified . . . I never again attended religious services (*Embroidering Our Heritage* 262).

Throughout the 1960s and early 1970s, Chicago continued to struggle with a variety of assimilationist impulses, even adopting a "macho" persona in her attitude toward her art, her materials, and her invariably male colleagues. Nonetheless, she recognized that aspects of *The Dinner Party* were shaped by her Jewishness. For example, her attention to the beauty

used to go to services alone from time to time . . . [and admired] . . . the Torah [Bible scroll] cover—which was, like other Temple furnishings, embellished with embroidery" (*Embroidering Our Heritage* 262). In addition to the Torah cover and *bimeh* (altar) cloths, embroidered liturgical pieces at home included the sabbath tablecloth and the *challah* (bread) cover.

One could trace many of the premises of *The Dinner Party* to Chicago's recollections of her Jewish childhood. Although her memories of religious holidays "were of boring, empty rituals," she acknowledged an exception "for the good food and the sense of family" (*The Holocaust Project* 22) and cited the Jewish dinner table as altar (*Embroidering Our Heritage* 269). More specifically, she characterized the interweaving of domestic and religious traditions as "particularly clear in the Passover Seder," when the everyday becomes the holy, and "which was, of course, the scene of the Last Supper" (*Embroidering Our Heritage* 269). Chicago herself characterized the Jewish contribution to *The Dinner Party* as fundamental:

> "When I began to work on the problem of creating an art language which could express my faith in the potential power of women . . . those early memories began to come into play. They helped shape my sense of ritual, my connection with history, and my belief that the force of the human spirit could best be expressed through art" (*Embroidering Our Heritage* 263).

Chicago reassessed her background and expanded its relationship to *The Dinner Party* in her latest installation piece, *The Holocaust Project* (1985–1993). Her decision to work on this subject—one which is implicit to modern Jewish identity and Chicago's own childhood—attests to a committed level of ethnic, if not religious, consciousness. Nonetheless, as Chicago evolved through the project, she saw the Holocaust not as an exclusively Jewish tragedy, but controversially, as part of a greater circle of hate and persecution. To the artist, this was reflected in the Nazi extermination of Gypsies, homosexuals, and dissidents; in a variety of ethnogenocidal episodes through time, such as that in Armenia and Africa; and in the long history of impulse to social hierarchy on the basis of gender, race, and class. Rescue or redemption is presented as achievable only by active and deep commitment to small-and large-scale humanitarian effort. Chicago recognized this position as the Jewish ideal of tikkun olam, literally, the repair or healing of the world.

In discussing the motivation for *The Dinner Party* in 1979, Chicago wrote that ". . . part of what comprises my attitude about the meaning of

life was probably passed on to me through 23 generations of rabbis . . .
By example, [they] taught me to respect the dignity of all human beings
and the historical importance of their struggles for independence" (262).
This is the foundation of tikkun olam, and fifteen years later, in the cata-
log for *The Holocaust Project*, she described it as such. She wrote that
the Jewishness of *The Dinner Party* lay in the "concept of tikkun . . . and
the historical struggle for change that is part of . . . Jewish democratic
traditions" (3–4). She further cited her own "lifelong commitment to the
ethical values of justice [as] values . . . shaped by my Jewish heritage"
(11), and a resultant "interest in the victim experience" (9). Human dig-
nity and historical struggle, justice and victimization informed her identity
as a feminist, and most or all of her subject matter from *The Dinner
Party* at one end of her career to *The Holocaust Project* at the other. It
also grounds as fundamentally Jewish the universalization of the Holo-
caust experience in her latest project, an attitude that is largely unpopular
within the Jewish community, itself.

In an interview of 1980, Chicago asserted the notion—critical to
deconstructionist theory—of the interchangability of myth and history.
She stated her belief in the power of art to affect consciousness by shap-
ing its myths. Everyday life can be transformed by "the use of art as
purveyor of myth" and that "myth, at its base, has to be challenged be-
fore economics or sociology or philosophy will change" (Lippard, "Din-
ner Party" 115). This is a sophistication of Chicago's goal in *The Dinner
Party*, restated in 1993, "to teach through art" (*Holocaust Project* 3).
The notion of teaching through art has little basis in Jewish conscious-
ness, due, in part, to the proscription against graven images established
in the biblical story of Moses as well as to the exigencies of a diasporic
population lacking a power base from which to commission art. Nonethe-
less, the function of learning and teaching in the repair of the world—a
form of consciousness-raising— is basic to tikkun olam.

Fundamentally, the purpose of *The Dinner Party* is to complete and,
therefore, "fix" history, and to that end, Chicago embarked on a major,
intensive course of study. Learning was structured around her own re-
search and that of her research team. It was then internalized in Chicago's
insistence on historical accuracy in aesthetic presentation; for example, to
sew the runner for the Fertile Goddess, a bone needle was fabricated
from the femur of a cow, as it might have been by the earliest peoples.
Finally, learning became teaching through the object itself, and through
writing about it. Chicago has accompanied every major project to date
with catalogs that combine excerpts from her journals, prose writing, and

with catalogs that combine excerpts from her journals, prose writing, and historical and aesthetic discourse. *The Dinner Party* included two such volumes, one devoted primarily to the plates, the other to the textiles. She further anticipated (but never realized) the publication of an illuminated manuscript of women's mythology and history, including a rewriting of the *Book of Genesis*. This recalls rabbinic biblical commentary, and especially, the tradition of alternative writings on biblical themes known as *midrashim*. Finally, within the piece, itself, a narrative runs along the cloth on the inside of the table to assure the viewer's grasp of the basic tenets of Chicago's historical revisionism.

Tikkun was equally apparent in Chicago's development of her studio community. It is estimated that over 400 people had a hand in the production of *The Dinner Party* sporadically from 1976 to 1979, and six individuals were continuously involved. Feminists have been critical of Chicago's workshop practices, charging that models of patriarchy and hierarchy based in Chicago's domineering nature made true cooperation impossible. While Chicago was adamant against relinquishing aesthetic or managerial direction, she was careful to preserve and publicize the names of all participating artisans. She was also committed to feminist consciousness-raising. One of the stated goals of the project was the education of women to "take command," and in the summer of 1977, she provided a two-month workshop for the training of "facilitators [of] feminist education processes" (Lippard, "Dinner Party" 122). She hoped for both short-and long-term results: that with "effectiveness training," her assistants might be in stronger positions to assert control over the project, and that ultimately, this would transfer to greater control over their own lives. While the patriarchy in this pronouncement is apparent, one cannot disregard Chicago's impulse to achieve positive social change—tikkun olam—through humanitarian effort.

The two major iconographic references in *The Dinner Party*—religious and feminist—do not typically exist easily within the same space. In the conception, fabrication, and intention of *The Dinner Party*, however, religious ideas facilitated feminist ideals. The linking concept is that of tikkun olam, premised in the impulse to right the world according to just and egalitarian values, and demanding a certain level of activism to do so. The bond thus forged between otherwise separate programs can stand as a symbol of the seamless interweaving of a variety of potentially divergent ideas in this work.

Despite the controversy surrounding *The Dinner Party*, its status as feminist art manifesto is secure. Less recognized are its religious underpinnings in an age characterized by a dominant secularity. While it is

impossible to describe a kind of art that would definitively express spirituality at the end of the twentieth century, *The Dinner Party* seems uniquely modern and articulate. It establishes a broad-based spiritual foundation for a work that, while incomplete, is both inclusionary and humanitarian. At the heart is not God or dogma, but humanity itself. In this, the secularization of the sacred is, in fact, achieved. Significantly, it is achieved without loss of ritual sense or of its specific sources. While offensive to some, religious practice through the twentieth century has grown increasingly intimate, demystified, and democratic. Just as it has come to express a specific epoch within feminist history, *The Dinner Party* may come closer than any modern work to describing a universal spirituality for the modern age.

Notes

1. *The Dinner Party* is certainly not the first work of the twentieth century to address women's issues in a politically challenging way. This distinction probably belongs to Louise Bourgeois, whose *Femmes-Maisons* were produced in the 1940s. To the extent that the personal is not the political, Frida Kahlo's work of the 1930s is referenced in the personal in a way that creates an enormously important body of female iconography, but not a politically significant one.

2. For an excellent discussion of the context around *The Dinner Party*, both within Chicago's own work as well as that produced by other young artists with similar concerns, see Amelia Jones, ed., *Sexual Politics: Judy Chicago's Dinner Party in Feminist Art History*, University of California Press, 1996.

3. A curious exception to this is the plate for Black abolitionist/feminist, Sojourner Truth, presented as an unfolding of three heads. This image has been criticized as desexualizing—and thus, in this context, marginalizing—Black women from the terms of community established by Chicago.

Works Cited

de Beauvoir, Simone. *The Second Sex*. Ed. and Trans. H. M. Parshley. New York: Vintage Press, 1974.

Chicago, Judy. *The Birth Project*. Garden City, NY: Doubleday, 1985.

————.*The Dinner Party*. Garden City, NY: Anchor Press, 1979.

————. *Embroidering Our Heritage*. Garden City, NY: Anchor Books, 1980.

————. *The Holocaust Project*. New York: Penguin, 1993.

————. *Through the Flower*. Garden City, NY: Doubleday, 1975.

Freeman, Linda, producer. *Faith Ringgold: The Last Story Quilt*. Video. New York: Public Media, 1991.

Garb, Tamar. "Engaging Embroidery: The Subversive Stitch," *Art History* ix (1986): 131–134.

Jones, Amelia, ed. *Sexual Politics, Judy Chicago's Dinner Party in Feminist Art History*. Los Angeles: University of California, 1996.

Kramer, Hilton. Review of *The Dinner Party*. *New York Times* October 17 1980, c1,18.

Larson, Kay. Review of *The Dinner Party*. *Village Voice* 17 December, 1979, 113.

Lippard, Lucy. "Uninvited Guests: How Washington Lost *The Dinner Party*," *Art in America* 79 (1991): 39+.

————. "Judy Chicago's Dinner Party," *Art in America* 68 (1980): 114–126.

Lynes, Barbara Buhler. "Georgia O'Keeffe and Feminism: A Problem of Position." *The Expanding Discourse*. Eds. Nora Broude and Mary Garrard. New York: HarperCollins, 1992, 436–449.

Rickey, Carrie. "*The Dinner Party*: Brooklyn Museum, NY," *Artforum* 19 (1981): 72–73.

Chapter 5

Cindy Sherman's *Untitled Film Stills*: Reproductive or Transgressive Mimicry? (1977–81)

Maura Reilly

Cindy Sherman (b.1954) was born in Glen Ridge, New Jersey. Even as a child in the 1960s, she found herself deeply fascinated by television, makeup, and disguises, interests that would become definitive in her art. She began academic training in painting at the State University of New York at Buffalo, but by junior year turned to photography, in part because of then-current notions that painting was no longer modern or viable.

In 1976, she earned her B.A. and the following year, moved to New York City. Her earliest photographic images had, by then, documented her obsession with personae in a series of black and white self-portraits which showed her applying makeup; by 1977, these had evolved into the Untitled Film Stills *series in which she enacted scenarios around these invented personae, drawing upon her obsession with soap opera, grade B movies, and detective magazines. Although she had some success as an exhibiting photographer even in her undergraduate years, in 1980, Sherman received her first New York one-person shows, at the Kitchen and Metro Pictures.*

Typically willing to move in new directions, Sherman switched to color photography in 1980-81, and in 1983 became one of

I would like to thank Robert Lubar, Deborah Johnson, Linda Nochlin, Debra Wacks, Laura Morowitz, Ariella Budick, and Jessica Falvo for their critical comments and assistance.

*the youngest artists in the history of the Guggenheim Foundation
to win a coveted fellowship. Her works continued to change, largely
in response to criticism that they, especially the black and white*
Untitled Film Stills, *were ambiguous in their attitudes toward gender
stereotyping: although an avowed feminist, Sherman was accused
of promoting, rather than critiquing, these stereotypes. Sherman's
work grew aggressive and startling in limiting the ways in which the
viewer could respond to her imagery. In 1986, she began to incor-
porate detritus as the main theme of her work, and by 1990, this
often resulted in extraordinary apocalyptic images of decay.*

*In 1992, she began to explore systematically the links between
sex and violence, especially in the context of abused women, em-
ploying plastic dolls as sex toys in her work along with plastic medi-
cal models of body parts and internal organs. The large scale and
spectacular palette of these photographs conflate repulsion, desire,
and fear, and charges of ambivalence toward her subject matter
continue to follow her. Nonetheless, her works may be found in
virtually all major museums internationally, including the Metro-
politan Museum in New York, the Tate Gallery in London, and
the Pompidou Center in Paris.*

———————

In recent years, there has been a critical debate surrounding the usage of
deconstruction within a feminist context.[1] The terms themselves–
deconstruction and feminism–have been deemed irreconcilable insofar as
the former is always necessarily "doubly coded" (Hutcheon 168); which is
to say that it is always already complicitous within the system it seeks to
deconstruct. This is particularly problematic in the context of a feminist
endeavor in that any deconstructivist strategy or resistance from within
(parody, masquerade, appropriation, for instance) will inevitably repro-
duce and perpetuate precisely the modes of representation that the strat-
egist had sought to displace. If, as Audre Lord has said, "the master's
tools can never dismantle the master's house" (hooks 36), will we not
always be *within* the system of representation that binds us? Can we ever
break from the straightjacket of phallogocentrism? And if so, how?

Mimesis, in the context of mimicry of male discourse, is one way in
which women may disrupt and exceed patriarchal logic. A political strat-
egy which engages directly with the "powers that be" by repeating its
discourse from the point of view of a woman, mimicry aims to ape that
discourse in order to undermine it by appropriating its "voice." However,

mimicry is not without its problems. For unless the mimic is careful, her efforts may succeed in reinforcing the patriarchal discourse. In other words, if mimicry fails to produce its difference, via excess or a gesture of defiance, for instance, then it runs the risk of reproducing, and thereby affirming, the very tropes it has set out to dismantle. This polemical form of mimicry will be termed reproductive mimicry.

It is in light of this polemic that we may look at the work of photographer Cindy Sherman. From a feminist perspective, her tactical strategy of mimicry is problematic. In her photographic series, the *Untitled Film Stills* (1977–81), Sherman parodies the cultural roles of women by disguising herself in stereotypically "feminine" roles: suburban gardener, sex object, urban shopper, career girl, housewife. The series itself consists of eighty-five black-and-white photographs which comprise a vast repertoire of characters, all of which are Sherman herself in costume. The images, reminiscent of "real" film, stills from 1950s/'60s cinema (namely, film noir,[2] B-Grade movies, horror films), are scrupulously reconstructed. In her representation of a stereotyped "femininity," Sherman borrows various pictorial strategies from her sources—a nostalgic photographic style, dated costume, moody lighting, objectifying camera angles, and a partial narrative approach. It is via this tactical strategy of mimicry, by actively playing out the stereotype of the passive female, that Sherman attempts to expose "femininity" as a fictitious, social construct.

The series itself has been variously received by the critics. For the poststructuralists and theorists of postmodernism, Sherman's deconstructivist endeavor succeeds precisely because it wreaks semiotic havoc within the system—because it "scrambles the codes."[3] Sherman is deemed a "demystifier of myth" in that, via a subtle display between signifier and signified, the viewer is unable to "buy into the myth" of femininity.[4] Such theorists insist that we must "look under the hood"[5] at the signifiers (depth of field, grain, light, etc.), in order to understand how Sherman brings forth the masquerade of femininity. To some, feminists and humanists, Sherman is considered the quintessential postmodern feminist in her ability to "jar" the gender codes, to defetishize conventional femininity.[6] They argue that in her emphasis on femininity as "surface," gender comes to be understood as a facade, as a mask that one can take off, or put on, at will.

For other feminists, however, her project falls short: the critique is not quite right, or just not enough.[7] These critics argue that in her attempt to deconstruct "feminine" stereotypes, she merely reinstates them.[8] They argue that in her critique of the patriarchal system, Sherman uses the very

"tools" employed by that system, and, paradoxically, confirms rather than subverts the social constructions of that dominant order. Emphasizing the importance of disrupting visual pleasure, these critics pose an important question: if Sherman's series fails to disrupt the scopophilic dialogue between the (presumably) male spectator and the female image, and if it fails to thwart the language of desire, could it not be read as a reaffirmation of stereotypical "feminine" codes?[9] It is particularly in light of Sherman's more recent work and its successful deferral of the scopophilic gaze that the *Film Stills* are deemed weak and nonargumentative.[10]

How is it that Sherman's work can elicit such diverse reactions? How is it that, depending on the viewer and how s/he "reads" the work, the *Film Stills* can be seen as creating a sense of both defeat and of insurrection? How is it that she can be simultaneously negating and reaffirming the gender codes that she has set out to dismantle? This essay will reconsider the *Untitled Film Stills* in light of this inherent paradox. The series will be reexamined as a problematic feminist project from which much is to be learned regarding the usages of deconstructivist strategies within a feminist context.

Sherman's interest in masquerade began as a young child when she would dress-up in imitation of the female characters she viewed on television and at the movies. This fascination with "playing dress-up" continued through her teens and into college where she would spend countless hours in front of the mirror, changing makeup, and putting on different dresses and wigs. Often finding herself "all dressed up with no place to go," she would go out—in "drag"—to parties, class, to work (Nairne 132). In 1975, at the suggestion of then boyfriend Robert Longo, she began documenting herself during this laborious cosmetic process. In the resulting *Cutouts* (1975-77), Sherman would write a melodramatic short story, photograph herself, dressed in the role of protagonist, at different points in the narrative. She would then cut her images out "like paper dolls" (Siegel 270) and glue them to pieces of stiff paper. Finally, she would hang them in sequence on a wall to create a storyboard. One of these *Cutouts* was included in "Pictures," a show at Artists Space in 1976. Referring to this show, Sherman has said that the images were presented "in a filmic sort of way; scene went all the way around the room . . . [The Cutouts were] about how to put all these different characters together and tell a story without words" (Siegel 270).

Sherman moved to New York City upon graduation from the State University of New York at Buffalo in 1976. It was there that she began to explore more fully her childhood interest in film. She frequented Bleecker

Street Cinema for Grade-B movies, film noir, and European films from the 1950s and 1960s, especially ones with subtitles.[11] As Sherman says:

> I was more interested in going to the movies than I was in going to galleries and looking at art. Sam Fullers' *The Naked Kiss, Double Indemnity,* those kind of classics. I would go to Bleecker Street Cinema just to look at the Samurai movies. But I'd go to see any kind of movie, really" (Siegel 273).

She was most intrigued by production film stills for horror movies within which "brooding character[s] [were] caught between potential violence and sex" (Siegel 272). Sherman also claims to have been influenced by European stars like Jeanne Moreau and Brigitte Bardot because, to her, they seemed to be "more vulnerable, lower-class types of characters, more identifiable as working-class women" (272).

In 1977, Sherman visited fellow artist David Salle's studio where she encountered some "sleazy detective magazines" from the 1950s. As Sherman describes these soft-core porn images:

> They [the women in the magazines] seemed like they were from '50s movies, but you could tell that they weren't from real movies. Maybe they were done to illustrate some sleazy story in a magazine. They were these women in these situations. What was interesting to me was that you couldn't tell whether each photograph was just its own isolated shot, or whether it was in a series that included other shots that I wasn't seeing. Maybe there were others that continued some kind of story. It was really ambiguous (Marzorati 85).

This encounter proved to be a crucial turning point in her work. Having grown tired of the *Cutouts,*[12] Sherman had been searching for a way to make "a filmic sort of image" in which a character reacted "to something outside the frame so that the viewer would assume another person" (Siegel 271). The 8" by 10" glossies in the soft-core detective magazines proved to be a solution to her problem. It was the women in unspecified situations captured in "one isolated shot," and the ensuing ambiguity of this partial narrative approach, that struck Sherman as a way out of the limited narrative format of the *Cutouts.*

As a result of the collision of "feminine" stereotypes from film and porn magazines, Cindy Sherman created her first "film still" in 1977 in the hallway just outside her loft. *Untitled Film Still #4,* 1977 (fig. 14) exemplifies Sherman's deconstructivist strategies, in which she formally mimics her mass media sources. Her use of lighting and shadow (here, as elsewhere) creates a scenario of psychodrama as the figure, starkly lit, is surrounded by ominous shadows which lurk behind her and down the

Figure 14. Cindy Sherman, *Untitled Film Still #4,* silver print, 1977

hallway. The camera angle, placed at a "safe" distance, leaves the viewer (who acts as a voyeur) on the same plane as the woman. The surface of the photograph is grainy and coarse, creating a dematerialized, nostalgic presence. Furthermore, Sherman's partial narrative approach is visible here; she is waiting—for whom or for what, however, is uncertain.

In the *Film Stills,* Sherman manipulates each image in an attempt to *re-present* mass media representations of woman as sex object. The mimetic strategies (props, camera angles, cropping, close-ups) are employed to emphasize the theatricality of the scenarios, the fictitiousness of the charade. To achieve her task, she scrupulously reconstructs the scenarios, and alters her appearance in accordance with the chosen narrative. Her costuming and makeup, selected and applied by Sherman herself, are in perfect imitation of her mass media sources. The "women" are made-up and garbed in clothing stereotypically associated with the 1950s and 1960s: hip-huggers, polyester dresses, lip gloss. The cosmetics and attire aim to highlight the traditional signifiers of "femininity": cheekbones, eyes, breasts, and buttocks. As Laura Mulvey has written, in opting for the "nostalgia genre," Sherman "draws attention to the historical importance of this

period for establishing a particular culture of appearance—specifically, the feminine appearance" ("A Phantasmagoria"141). As Sherman has explained, having "come out of the '70s, which were concerned with the 'natural look,' I was intrigued with the habits and *restraints* women of the '50s put up with" (Siegel 279).

Most of the settings which Sherman (re)constructs in the *Untitled Film Stills* are eerie and foreboding, as if something "bad" is about to occur. Many of the *Stills* depict the "women" in gendered spaces or sites representative of the "woman's place"—in a kitchen, in front of a mirror, or on a bed. But always a feeling of impending doom resides. Oftentimes, the characters are waiting—alone—at a train station, on a ledge, or on a deserted road. It is this aloneness and the omnipresent aura of vulnerability that suggest a negative or even violent fate for these women—as if trapped in the confines of a horror film.[13] For example, in *Untitled Film Still #27* (1979), (fig. 15), the woman seems to have just experienced or seen something horrific as mascara-colored tears run down her cheeks. She appears to be in complete shock and one can almost feel the cigarette—her oral consolation, or phallic trope—shaking nervously in her right hand. To achieve this horror-film effect, Sherman manipulates natural and artificial light to heighten the drama and to invoke feelings of fear. This is a consistent strategy. In *Untitled Film Still #30* (1979), for example, Sherman gives us just enough light to see the bruises, swollen lips, and perspiration on the woman's face as a dramatic light cuts in from the left. The severe contrast of light and dark, and the way in which the light sculpts her face visually contribute to the woman's obvious anxiety and "hysteria."

Yet this self-conscious appropriation of the stereotype of the weak, distraught female can unfortunately produce split effects. Because of the inherent paradox of utilizing deconstructivist strategies, in that the "master's tools" are being used to dismantle the "master's house," such imagery could be "read" as either an uncritical celebration of a weak femininity or as a debunking of the myth of the hysterical female. Perhaps Sherman's mimicry *without a difference* is most visible when comparing one of the *Untitled Film Stills* to a "real" film still, that is, that of Kim Novak in *Vertigo* (1958) or Tippie Hendren in *Marnie* (1964), (fig. 16). The similarity between these images and *Untitled Film Still #13*, (fig. 17), for example, is uncanny: a seemingly distraught woman, alone, looking outside the frame toward some unidentified person or thing. There is nothing *visible* within Sherman's image that jumps out at the viewer exclaiming, "this is a construction." Her images are so scrupulously reconstructed,

Figure 15. Cindy Sherman, *Untitled Film Still #27,* silver print, 1979

and therefore so closely aligned with the representational strategies of film that they merely repeat the codes. Without the "knowing wink" or gesture of defiance to the noncognizant viewer, these images could function to reaffirm the negative stereotype of the distraught female.

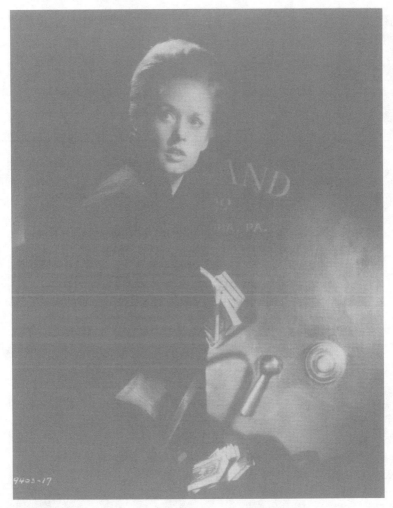

Figure 16. Tippi Hedren in *Marnie*, 1964 (Alfred Hitchcock, director)

The empty facial expressions and lack of eye contact in this series are conscious artistic choices which mimic the traditional mode of representation. The women in these photos never look directly at the viewer. They are always looking just outside of the frame at some unidentified person or thing. Most often, the women wear fundamentally unreadable facial expressions—entirely ambiguous, blank, and empty—as if they, the silent women, have already been spoken for;[14] or as if they, the silent women, are "voiceless."[15] Lost in thought, vacated or abandoned, the women seem apathetic to the camera's incarcerating gaze: "the camera

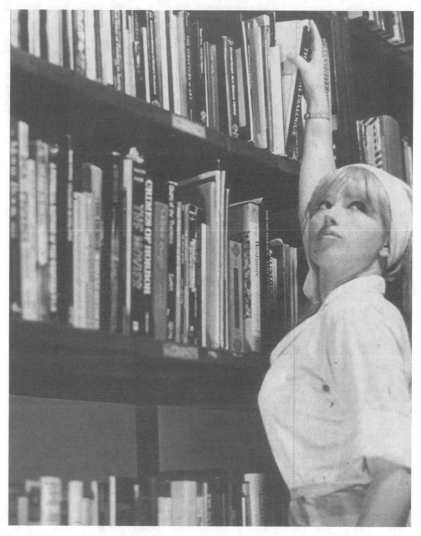

Figure 17. Cindy Sherman, *Untitled Film Still #13*, silver print, 1978

never draws or contains her full attention" (MacDonald 39). In this conventional relationship to the camera in which the viewer can/cannot possess the female figure, Sherman oscillates between negation and reaffirmations of such seductive tropes. Her blank expression, without the "knowing wink . . . of empowerment" (McClary 6), merely reproduces the conventional codes.

In her mimesis of mass media representations of women, Sherman employs strategic camera angles, cropping techniques, and close-ups. In

Untitled Film Still #13 (1978), (fig. 17), the woman is cropped at the hip as she reaches—breasts protruding, buttocks out—for a book. Her partial body, confined into a shallow space, is tightly framed by the edge of the photograph and the oversized bookshelves. The woman, now a fragment of a body compressed into a claustrophobic area, is restricted by the frame of the photograph—a metaphor for women's restricted terrain in society or her lack of mobility—which "cuts her off, reduces her and sets limits on her body in order to contain her" (Goldberg 29). As film theorist Laura Mulvey has explained about such formal techniques in cinema:

> Conventional close-ups of legs (Dietrich for instance) or a face (Garbo) integrate into the narrative a different mode of eroticism. One part of a fragmented body destroys the Renaissance space, the illusion of depth demanded by the narrative; it gives flatness, the quality of a cutout or icon rather than verisimilitude to the screen ("Visual Pleasure" 367).

Mulvey explains how camera angles, cropping techniques, and close-ups fragment the body, and as devices for aestheticizing and fetishizing, aid in the objectification of women in film by allowing only a *portion* of the iconic female to be controlled by the (presumably) male spectator. By uncritically re-producing a fragmented female form without extensively disrupting the codes, Sherman fails to complicate traditional desire—a goal heralded by many feminists.

A similarly strategic use of camera angle is visible in *Untitled Film Still #34* (1979), (fig. 18), where we gaze down at a woman who lies, in seductive position, upon a bed. Reminiscent of a porn shot or a pin-up, the woman possesses a "come-hither" look in her provocativeness: her body, in lingerie, is laid out on a bed of black satin sheets. But while Sherman is playing with and dis-playing the conventional codes of the 1950s–'60s cinema, she fails to alter the rhetoric radically, so that, ultimately, in her role as object of the (presumably) male gaze, Sherman's imaging of herself uncritically regurgitates the iconic female image omnipresent in the mass media.

Sherman's use of a film still creates a moment of ambiguity with no before or after except that which the viewer proposes. After contemplating one of Sherman's images, the viewer can attempt to construct a narrative, but is given only a "hint" of one. For instance, in *Untitled Film Still #35* (1979), the viewer is granted few narrative clues: it seems as if a woman has just hung up a man's overcoat, hat, and umbrella on a coat rack and is not very happy about it, judging from her stance and facial expression of disquiet. Because there is no filmic sequencing, an image such as this becomes extremely provocative and open-ended. Such a

Figure 18. Cindy Sherman, *Untitled Film Still #34*, silver print, 1979

strategy is deemed perfect postmodern posture in that the author of the work is "dead" because each viewer will "rewrite" the text according to his/her own reading.[16] The work is essentially meaningless without the existence and imagination of the viewer.

While the viewer is ultimately responsible for the meaning of the stills, Sherman-the-artist is the "manipulator" of meaning. She functions, therefore, as a "mouthpiece" for the ideas omnipresent within the patriarchal

system. As the sole actress, lighting director, camera technician, makeup artist, and costume designer, Sherman seems to control the narrative of the *Film Stills*. She sets up the scenario, manipulates the *mise-en-scène*, then lets the viewer take over to make of it what s/he will. Because the "manipulator of meaning" is a role typically associated with the male (in patriarchal society), Sherman's active co-option of that role, along with her simultaneous masquerade as subject of the gaze, subsequently posits her as both Absolute and Other.[17] Throughout the series, Sherman's role vacillates between artist and model, between Absolute and Other, between victimizer and victim. She inhabits both positions and thereby refuses closure. But, while her transvestism turns sexual identity into a kind of play, "her oscillation between artist and model," as Margaret Iversen has stated, "only reinforces the positions it was meant to call into question. The riddle of the female artist is answered by assigning her the role of performer. The 'feminine' position as object of the male gaze remains intact"(53). Art critic Peter Schjeldahl's reaction to Sherman's images is paradigmatic of this polemic:

> As a male, I also find these pictures sentimentally, charmingly, and sometimes pretty fiercely erotic: I'm in love again with every look at the insecure blond in the nighttime city. I am responding to Sherman's knack, shared with many movie actresses, of projecting feminine vulnerability thereby triggering (masculine) urges to ravish and/or protect (9).

Similarly, as Ken Johnson has confessed, "Like motorists without gas, these are lonely women waiting desperately for men to rescue them from passionless isolation"(50). Illusionism has been sustained for these two viewers in that the tactical mime has not been perceived as such. Because Sherman has remained too loyal to her source, and has failed to emphasize her difference visually, the imagery continues to function in a problematic manner.

In her subtle dis-play of femininity, Sherman fails to overhaul the myth of the weak, powerless, vulnerable woman. For mimicry to be successful, it must *uncomfortably* inhabit the paternal language itself; which is to say that it must be unruly, defiant, and aggressive.[18] Otherwise, such parodic repetitions will *comfortably* exist within the system—a system which will forever recuperate such endeavors precisely because they do not threaten it. Lynda Benglis's well-known *Artforum* advertisement (November 1974), can function as a counter-example of an unruly image that successfully threatens the system. In this scandalous ad, Benglis mimics a sexy porn centerfold: she slicks up her nude body, places a humongous dildo at her

groin, and with one hand on her hip, turns belligerently to confront the viewer. This mocking and defiant gesture in which Benglis "performs a violently threatening female subjectivity" (Jones 33), is an aggressive statement against conventional femininity and against the traditional role of the silent woman artist.[19] In her utter usurpation of the "phallus" (or signifier of masculine power), and in her outright naked unruliness, Benglis's image can do nothing but *uncomfortably* inhabit the paternal language. Such transgressive mimicry, in its excess, precludes recuperation. [20] Benglis self-consciously images herself as a sex-object, but hers is a mimicry *with a difference* (her "difference" being her gesture of defiance). While Benglis's image is a self-conscious attempt to implode patriarchal logic from within, Sherman's is a playful dis-play of that logic.

Ostensibly a series of self-portraits, the *Untitled Film Stills* reveal an artist who adamantly rejects a search for the interior "self." As such, the very notion of the self-portrait is radically rearranged in this series. As David Rimanelli has stated, "Conforming herself to innumerable stereotypic personae, Sherman is everyone in her art and as such she is no one in her art" (187). Sherman is always masquerading as someone other than her Self. This schizophrenic shifting of identity repeatedly rejects the traditional notion of a fixed identity, or a "centered" self. Such a strategy could be understood as a celebration of multiple identities, or as a heralding of woman's infinite possibilities, thereby disseminating the Enlightenment notion of a single, "centered" self upon which patriarchal ideology is based. Such a strategy is lauded by the postmodernists and poststructuralists who believe subjectivity to be fictitious, and who believe that the deconstruction of fixed identities would foster a crisis in subjectivity which, in turn, would spawn a crisis in patriarchy.[21] A celebration of decentered subjectivities may be tempting from a feminist perspective insofar as the traditionally centered subject is male. In fact, one could read Sherman's multifariousness as relaying the message that femininity is a "take it or leave it" possibility. Her mimicry, therefore, may be understood as relaying the fiction of gender identity by positing that identity as illusory and unoccupiable.

However, some theorists have argued that as a feminist strategy, the decentering of subjectivity is highly problematic. They argue that "since men have [already] had their Enlightenment, they can afford a sense of a decentered self. On the other hand, for women to take on such a position is to weaken what is not yet strong" (Nicholson 6-7). In other words, without a unified concept of "woman," what would be the categorical basis for a feminist politics? As Judith Butler has inquired, "What [then

would] constitute the 'who,' the subject, for whom feminism seeks emancipation? If there is no subject, who is left to emancipate?" (327). Such theorists would perhaps argue against Sherman's multifariousness, or schizophrenic shifting of identity, in that feminism itself depends on a relatively unified notion of the social subject "woman," a notion postmodernism would attack. In short, the *Untitled Film Stills* raises interesting questions about whether or not the de-centering of subjectivity would be a successful maneuver for feminism.

To be politically effective, mimicry must produce its slippage, its difference. In order to have one's mime be identified as tactical, as transgressive, an artist must grant the viewer some "clue" or sign of his/her transgression from the source. One way in which mimicry can produce its difference is via a qualitative excess, or hyperbole. It is when mimicry reaches the hyperbolic that it becomes a kind of *talking back*. Such an image does not merely dis-play the stereotype, but it also transgresses it by mocking its "naturalness" to the point of absurdity. This is a reappropriation and amplification of the "feminine" for the purpose of problematizing intelligibility. For to "enact a defamiliarized version of femininity" (Doane 182) is to inhabit *uncomfortably* the system that binds us, and to displace and exceed the "logic" of gender.

This essay has emphasized Sherman's tendency toward reproductive or recuperative mimicry—her inability to relay visually her tactical mime. However, Sherman *does* emphasize her difference on several occasions vis-à-vis an important tactical device which involves her deliberate exposure of the shutter cord (e.g., *Untitled Film Still #6,* 1977, fig. 19).[22] In several images, she allows the shutter cord, the apparatus by which she actually "shoots" the photograph, to be seen. Upon recognition of the cord, the spectator is forced to become aware of the fabrication of the image. Sherman's conscious inclusion of the shutter cord is an attempt to reveal the theatricality of the scenarios as artistic constructs (and, by extension, the artificiality of such roles in society). The presence of the shutter cord is an example of how Sherman has not remained "loyal" to her sources. She is attempting to jar the viewer into recognizing the masquerade. Such a "reality effect" succeeds in guiding the perception of the image. This process of "aesthetic interruption" destroys illusionism, thereby forcing the viewer to feel a sense of estrangement, or to feel oddly about his/her relationship to the image.[23] The "visual shocks" resulting from the shutter cord preclude the spectator from identifying with the illusory and ideological functions of representation. From a feminist perspective, these are the most successful images in the series because they

Figure 19. Cindy Sherman, *Untitled Film Still #6*, silver print, 1977

instantaneously make the viewer aware of the *tactical mime*. This results in a disruption of the (male) scopophilic viewing position in that the "reality effect" of the shutter cord disrupts any uncomplicated visual pleasure. Thus, the "reality effect" of the shutter cord relays the message that

this image is not a vindication of, but a reconstruction of, the gender codes for the purpose of social commentary.

In her exploration of the cultural codes of female identity, Cindy Sherman masquerades in stereotypically "feminine" roles. As she says of the *Untitled Film Stills* series: "I wanted to imitate something out of culture, and also make fun of the culture as I was doing it" (Nairne 132). Although she says she is doing it for fun, the effect is not so funny. In the actual act of appropriation, her copy's proximity to the original problematizes the critique. Sherman's reproductive mimicry does not always undermine the authority it seeks to negate; it often reasserts it. For instance, Sherman maintains throughout the *Film Stills* a nostalgic connection and ambivalent relationship toward the appropriated material—so much so that ambiguity is *built into* the project. It is this feeling of nostalgia, even fetishization, towards her source that keeps the *Film Stills* from ever being didactic, and which results in a diminution (if not a negation) of any critical edge. Thus, the nature of one's dependency on that which one critiques becomes the centrally valenced question.

As a strategy of resistance *from within*, reproductive mimicry will always be complicitous, and never transgressive. Indeed, all deconstructivist strategies are ambivalent and contradictory precisely for that reason— because they are doubly coded, because the "master's tools" are being utilized to dismantle the "master's house." In order to break from this paradox, the mimic must mime *with a difference*. She must *talk back* by refusing to repeat loyally the source. For mimicry becomes critical precisely at its most reflexive moment, when the apparatus or "constructedness" of the image is visually apparent (as is the case when the shutter cord is visible). It is this "slippage" that problematizes the spectator's relationship to the image, causing him/her to question his/her (gender) assumptions. Thus, it is only via a productive (versus a reproductive) mimicry that future resignifications can be spawned, or that a new "spin" on the familiar dialogues can be generated.

Sherman's *Film Stills* do not create resignifications or new texts but reproduce the old ones.[24] In relation to other women artists and performers such as Lynda Benglis, Carolee Schneeman, Barbara Kruger, and even the pop star Madonna, Sherman's refusal to *talk back* becomes more evident. These other artists, many of whom employ mimesis as strategy, and many of whom fall into the same polemic of negation/ reaffirmation, do so from an aggressively defiant stance.[25] They create new ideologies, liberatory images which destroy the old visual pleasure and man-made entrapments of desire. In their passionate explorations of

gender identity, their works serve as optimistic endeavors: woman has the potential to determine her own ideology. In Sherman's *Untitled Film Stills* series, in her nonargumentative exploration of gender identity, woman is, and always will be, trapped behind the mask of "femininity."[26]

Notes

1. See, for example, Linda Nicholson, ed., *Feminism/Postmodernism* (New York: Routledge, 1990); Craig Owens, "The Discourse of Others: Feminists and Postmodernism," *The Anti-Aesthetic*, ed. Hal Foster (Port Townsend, WA: Bay Press, 1983) 57–82; Janet Wolff, "Postmodern Theory and Feminist Art Practice," *Feminine Sentences: Essays on Women & Culture* (Berkeley: University of California Press, 1990) 85–102; Judith Butler, "Contingent Foundations: Feminism and the Question of Postmodernism," *Praxis International* 11, no. 2 (July 1991) 150–165; Toril Moi, "Feminism and Postmodernism: Recent Feminist Criticism in the United States," *British Feminist Thought: A Reader*, ed. Terry Lovell (Cambridge, MA: Blackwell, 1990) 367–76; Susan Suleiman, "Feminism and Postmodernism: In Lieu of an Ending," *Subversive Intent: Bender, Politics, and the Avant-Garde*, ed. Susan Suleiman (Cambridge, MA: Harvard University Press, 1990) 181–206; Frances Bartowski, "Feminism and Deconstruction: 'A Union Forever Deferred'", *Enclitic* 4 (1980) 70–77; Margaret Ferguson and Jennifer Wicke, eds. *Feminism and Postmodernism* (Durham, NC: Duke University Press, 1994).

2. Film noir is a cinematic term used to describe and categorize a series of films made in America during World War II and the postwar era characterized by dark, fatalistic interpretations of contemporary reality.

3. The poststructuralists have posited Sherman as "code scrambler," in the Barthean sense. See R. Krauss, *Cindy Sherman* (New York: The Noonday Press, 1993) "Myth Today," pp. 109–159. Similarly, for critics such as Douglas Crimp, Craig Owens, and Erik MacDonald, Sherman's "text" is deemed perfect postmodern posture, especially vis-à-vis Roland Barthes's notion of the "death of the author," which will be discussed later on in this essay, in which the reader alone lays claim to meaning and subjectivity. See Douglas Crimp, "Pictures," *October* no. 8 (Spring 1979); Craig Owens, "The Discourse of Others: Feminism and Postmodernism" *The Anti-Aesthetic,* ed. Hal Foster (Port Townsend, WA: Bay Press, 1983); Erik MacDonald, "Dis-seminating Cindy Sherman: The Body and The Photograph," *Art Criticism* 5 (1989) 35–40.

4. Rosalind Krauss (20) heralds Sherman as a "de-mystifier of myth." She argues that Sherman very self-consciously uses many different signifiers (internal frames, graininess, lighting, etc.) as a way of creating a "slide" between the multiplicity of unstable signifiers. In other words, Krauss believes that if one looks "under the hood" at the signifiers, then intelligibility (of, in this instance, gender identity) can be problematized.

5. *Ibid* 20.

6. See, here, for example: Judith Williamson, "'Images of Woman'—The Photographs of Cindy Sherman," *Screen* (Nov –Dec 1983): 102–116 and Abigail

Solomon-Godeau, "Suitable for Framing: The Critical Recasting of Cindy Sherman," *Parkett*, no. 188 (July-Aug 1991): 112–121.

7. See, for example, Laura Mulvey, "A Phantasmagoria of the Female Body: The Work of Cindy Sherman," *Parkett* no. 188 (July-Aug 1991): 136–150; Margaret Iversen, "Fashioning Feminine Identity," *Art International* (Spring 1988): 52–57; Anne Friedberg, "Mutual Indifference: Feminism and Postmodernism," *The Other Perspective in Gender and Culture: Rewriting Women and the Symbolic,* Juliet F. MacCannel, ed. (New York: Columbia University Press, 1990): 39–58; Mira Schor, "From Liberation to Lack," *Heresies*, no. 24 (1989): 15–21; Jan Avgikos, "Cindy Sherman: Burning Down the House," *Artforum* (Jan 1993): 74–79.

8. For example, as Mira Schor states: "her images are successful partly because they do not threaten phallocracy, they reiterate and confirm it" (17).

9. Most of these critics have been highly influenced by Laura Mulvey's seminal article "Visual Pleasure and Narrative Cinema," where the author insists that feminists must resist male visual pleasure by refusing the construction woman-as-object. According to Mulvey, women must refuse to become objects of fetishistic, scopophilic male desire.

10. As Laura Mulvey contends: "The visitor [of a Sherman retrospective exhibition] who reaches the final images and then returns, reversing the order, finds that with the hindsight of what was to come, the early images are transformed" ("A Phantasmagoria" 129). Mulvey argues that while the *Film Stills* emphasize the surface of the body as a facade, as a mask, the later works (namely the *Untitled* series of 1983 and the *Untitled* series of 1984) reveal the "monsters" behind the "cosmetic facade" (146). Sherman's *Untitled* series of 1991–92 is deemed superior to the earlier work as well. In the very grotesqueness of the imagery, and in the mere mutilation of the female form, some critics argue that Sherman has finally succeeded in disrupting the scopophilic gaze and in negating "visual pleasure." See Avgikos, "Cindy Sherman: Burning Down the House" (79).

11. To Sherman, "the subtitles made the individual images on the screen appear more separate, each with its own diegesis." Peter Schjeldahl, *Cindy Sherman.* (New York: Whitney Museum of American Art, Oct. 1987): 194.

12. "When we moved to New York, I had grown tired of doing these cutesy doll things and cutting them out. It was so much work and too much like playing with dolls." Sherman as quoted in Siegel (271).

13. For information regarding the equation of violence with beauty within slasher films, see Carol Clover, "Her Body, Himself: Gender in the Slasher Film," *Misogyny, Misandry and Misanthropy,* R. Howard Block and Frances Ferguson, eds. (Berkeley: University of California Press, 1989): 205.

14. ". . . it is man who speaks, who represents mankind. The woman is only represented; she is (as always) already spoken for" (Owens 61).

15. A term used by Whitney Chadwick in her preface to *Women, Art and Society* (London: Thames & Hudson, Ltd., 1990).

16. A quote by Roland Barthes crystallizes these ideas: "A text is made of multiple writings drawn from many cultures and entering into mutual relations of dialogue, parody, contestation, but there is one place where this multiplicity is focused and that place is the reader, not, as was hitherto said, the author." "Death of the Author" in *Image-Music-Text*, ed. and transl. by Stephen Heath (New York: Hill & Wang, 1977).

17. As Simone de Beauvoir has noted: "Woman is defined and differentiated with reference to man and not he with reference to her; she is the incidental as opposed to the essential. He is the Subject, he is the Absolute—she is the Other." *The Second Sex* (New York: Vintage Books, 1952) xxii.

18. For more information on the "unruly woman" as the feminist *par excellence* via an analytic reading of Miss Piggy and Roseanne Barr, see Kathleen Rowe, *The Unruly Woman: Gender and the Genres of Laughter* (Austin, TX: University of Texas Press, 1995).

19. According to Benglis, her "intention was to mock the idea of having to take sexual sides—to be either a male artist or a female." Leslie C. Jones, "Transgressive Femininity: Art and Gender in the Sixties and Seventies," *Abject Art: Repulsion and Desire in American Art* (New York: Whitney Museum of American Art, 1993): 52. See also Amelia Jones, 'Postfeminism, Feminist Pleasures, and Embodied Theories of Art," *New Feminist Criticism: Art—Identity—Action*, eds. Joanna Frueh, Cassandra Langer and Arlene Raven (New York: HarperCollins, 1994): 16–41.

20. This image was so confrontational that several editors from *Artforum* magazine (such as Rosalind Krauss, Max Kosloff, Lawrence Alloway, and Annette Michelson) insisted in the following issue of the magazine that they had no prior knowledge of the advertisement. An excerpt from that editorial letter reads: "For the first time . . . a group of associate editors feel compelled to dissociate themselves publicly from a portion of the magazine's content, specifically the copyrighted advertisement of Lynda Benglis . . . In the specific context of this journal it exists as an object of extreme vulgarity" *Artforum,* 13, no. 4 (Dec 1974): 9.

21. Why should a "centered" self be rejected? As postmodern theorist Louis Althusser has explained, the *function* of ideology is to create the very category of the "coherent" subject. And since ideology can only exist by/for "coherent" subjects, a crisis in subjectivity (as would be produced via the celebration of "de-centered" subjects) would necessarily entail a crisis in ideology. See L. Althusser, "Ideology and Ideological State Apparatuses," *Lenin and Philosophy* (London: Monthly Review Press, 1971): 127–186; Kaja Silverman, "From Sign to Subject: A Short History," *The Subject of Semiotics* (New York: Oxford University Press, 1983): 3-53; and especially, Carolyn J. Dean, *The Self and Its Pleasures: Batailles, Lacan, and the History of the Decentered Subject* (Ithaca: Cornell University Press, 1992).

22. Of the eighty-five photographs in this series, five reveal the shutter cord.

23. The images in which the shutter cord is revealed are excellent examples of Brechtian *distanciation*, as defined by Griselda Pollock in her essay "Screening the Seventies: Sexuality and Representation in Feminist Practice–A Brechtian Perspective," *Vision and Difference: Femininity, Feminism, and the Histories of Art* (London: Routledge, 1988): 155–199.

24. As Martha Rosler has observed, "If the woman artist, [as] prisoner of phallocentric language, refuses to try to speak, her refusal, coupled with her continuing to seek the validation of critics, curators and buyers, [will confirm] the image of woman as bound and impotent" (73).

25. I have already argued extensively in favor of Benglis's "unruliness." Carolee Schneeman's *Interior Scroll* (staged in 1975)—in which the artist, naked, her body painted decoratively, pulled a long scroll from her vagina, and read the narrative text to the audience—is another example of an aggressively defiant act which negated the fetishizing process by emphasizing the taboo concept of woman-as-lack. Barbara Kruger, whose works include such statements as "Your gaze hits the side of my face," or "Your body is a battleground," offers feminists an enlightening, liberatory ideology. Madonna, an artist whose "feminism" has been highly debated, is a powerful female icon, I believe, in her active, defiant production of her own image. Woman-as-producer, woman-with-phallus, via its oxymoronic implications, is necessarily transgressive according to paternal logic. As Anne Friedberg has commented, "Madonna's reenactment in her 'Material Girl' video of the 'Diamonds Are a Girl's Best Friend' number from *Gentlemen Prefer Blondes* (in which she appropriated the Monroe image) was according to [Madonna], 'knowing, defiant, successful' . . . The text accompanying these photos, producing a written image of Madonna, claims: 'Instinctively she positions herself. Beautiful but strong. A feminist's Marilyn'" (Friedberg 51).

26. Sherman was well aware of the polemic inherent within the *Film Stills*. As she said in a 1988 interview, "After viewing the problems with that work [the *Film Stills*] and the way people interpreted it, I consciously switched to a vertical format featuring strong, angry characters, women who could have beaten up the other woman, or beaten up the men looking at them. . . . That's when I got tired of using makeup and wigs in the same way, and I started messing up the wigs, and using makeup to give circles under my eyes or give five o'clock shadows, or hair on my face – to get uglier" (Siegel 276). A recent show at Metro Pictures (1992) exemplifies this shift in self-perception. Her critical posture in these more recent works is radically different than in the earlier, nonargumentative pieces. In the *Untitled* series, 1991–92, Sherman transformed the innocent, docile women of the *Film Stills* into mutilated plastic dolls. The images portray scenes of rape, mutilation and S/M: used condoms are ubiquitous amidst disseminated body parts. In the very grotesqueness of the works, and in the mere mutilation of the female form, Sherman has succeeded in disrupting the scopophilic gaze. However, ultimately, one is left wondering whether the negation of "feminine" stereotypes and the disruption of the Male Gaze can only be achieved via an "uglification" of the female form.

Works Cited

Butler, Judith. "Gender Trouble, Feminist Theory, and Pyschoanalytic Discourse," *Feminism/Postmodernism*. Ed. Linda Nicholson. New York: Routledge, 1990.

Doane, Mary Ann. *The Desire to Desire: The Woman's Film of the 1940's*. Bloomington: Indiana University Press, 1987.

Goldberg, Vicki. "Portrait of a Photographer as a Young Artist," *New York Times* 23 Oct. 1983: H-29.

hooks, bell. "Feminist Theory: A Radical Agenda," *Talking Back: Thinking Feminist, Thinking Black*. Boston: South End Press, 1989: 35–41.

Hutcheon, Linda. *The Politics of Postmodernism*. London/New York: Routledge, 1989.

Iverson, Margaret. "Fashioning Female Identity," *Art International* (Spring 1988): 52–57.

Johnson, Ken. "Cindy Sherman and the Anti-Self: An Interpretation of Her Imagery." *Arts Magazine* (Nov. 1987): 47–53.

Jones, Amelia. "Postfeminism, Feminist Pleasures, and Embodied Theories of Art," in *New Feminist Criticism: Art–Identity–Action*. Eds. Joanna Frueh, Cassandra Langer and Arlene Raven. New York: HarperCollins, 1994. 16–41.

MacDonald, Erik. "Dis-seminating Cindy Sherman: The Body and The Photograph," *Art Criticism* 5 (1989): 35–40.

Marzorati, Gerald. "Imitation of Life," *Art News* (Sept. 1983): 78–87.

McClary, Susan. "Living to Tell: Madonna's Resurrection of the Fleshly," *Genders* (Spring 1990): 1–21.

Mulvey, Laura. "A Phantasmagoria of the Female Body: The Work of Cindy Sherman,"*Parkett* 188 (July-Aug 1991): 136–150.

———. "Visual Pleasure and Narrative Cinema." Brian Wallis, ed. *Art After Modernism* (New York: New Museum of Contemporary Art, 1984): 361–373.

Nairne, Sandy. *State of the Art: Ideas and Images in the 1980s*. London: Chatto & Windus, Ltd., 1987.

Nicholson, Linda. "Introduction," *Feminism/Postmodernism*, Ed. Linda Nicholson. New York: Routledge, 1990. 1–16.

Rimanelli, David. "Cindy Sherman." *Artforum* (May 1990): 187.

Schjeldahl, Peter. *Cindy Sherman*. New York: Pantheon Books, 1984.

Siegel, Jeanne, ed. *Artwords 2: Discourse on the Early 80s*. Ann Arbor: UMI Research Press, 1988.

Chapter 6

Zaha Hadid: *The Peak Club* Competition and the Politics of Architecture (1982)

Loretta Lorance

Zaha Hadid (b. 1950), was born in Baghdad, Iraq. She studied architecture at the Architectural Association (AA) in London from 1972 to 1977. She was awarded the Diploma Prize in 1977 for her project, Malevich's Tectonic. *After graduation, she began to teach at the AA and became a partner at the Office for Metropolitan Architecture. In 1979, she opened her office with the design for an apartment in Eaton Place which received the Architectural Design Gold Medal in 1982.*

In 1983, Hadid won the first of many international competitions with her project for the Peak Club in Hong Kong. This accomplishment was followed by first place in the competitions for the Kurfürstendamm, Berlin, 1986, and Art and Media Center, Düsseldorf, 1989. The Düsseldorf project was awarded the Erich Schelling prize for architecture in 1994. Hadid's designs also took first place in the competitions for the Cardiff Bay Opera House, Cardiff, Wales, in 1994, and the Contemporary Arts Center, Cincinnati, OH, in 1998.

Her first major built project was a fire station in the Vitra furniture complex at Weil-Am-Rhein, Germany, 1993. This was quickly followed by a residential complex in Block 2 of the IBA development in Berlin. Smaller projects include a Music Video Pavilion, Groningen, The Netherlands, 1990; installation of the 1992 exhibition The Great Utopia *at the Guggenheim Museum in New York; a Pavilion for Blueprint magazine at the 1995 Interbuilding exhibi-*

tion in Birmingham, England; Moonsoon Restaurant *in Sapporo, Japan, 1989–90; and residential projects and furniture.*

Hadid has continued to teach throughout her career. She ran her own studio at the AA until 1989. She has also held the Kenzo Tange Chair at the Graduate School of Design at Harvard University in 1994. In 1997 Hadid was awarded the Sullivan Chair at the University of Chicago School of Architecture. She has also been a visiting professor at the Hochschule für Bildende Künste, Hamburg, Germany and at Columbia University, New York.

Prestigious architecture competitions generate excitement and enthusiasm. They offer architects monetary reward, an opportunity to realize a showcase building, and widespread publicity. They can also set the stage for a battle of styles and egos. Therefore, when an important competition is announced, unknown and established architects examine the guidelines with the intention of transforming the brief into persuasive architectural form.

Frequently, but not always, these competitions are won by stars of the profession: architects with a proven track record and an established style. Yet, the unexpected sometimes happens and the award may go to an unconventional submission by an unknown architect. For example, in 1983, the deconstructivist design of Zaha Hadid, an Iraqi woman with a London practice, took first place in the coveted competition for the Peak Club, a speculative residential and sports complex in Hong Kong. The reaction to such an unusual choice was similar to what happened in 1980 when Maya Lin's design won the competition for the Vietnam Veterans Memorial in Washington, D.C. The praise and excitement generated by the awards were countered by attacks on the women's integrity and competence; the quality and suitability of their designs were challenged. When the Memorial was dedicated in 1982, the selection committee's choice of Lin's design was vindicated. It has become one of the most acclaimed public memorials in the United States. Hadid was not to be so fortunate: changes in the client's finances resulted in the project's cancellation. Hadid would wait a decade before realizing her first building. In the interim, she won more competitions, successfully completed a number of projects, and widely exhibited the paintings and drawings of her designs. Thus, by the time the Vitra Fire Station in Weil-am-Rhein, Germany was finished in 1993, Hadid had herself become a star, a frequent winner of competitions.

As a star woman architect, Zaha Hadid occupies a unique place within the hierarchy of architecture. Her star began to ascend when she was propelled into the international arena with her unexpected triumph in the Peak Club competition. There are other women in that arena, including Denise Scott Brown of Venturi, Scott Brown and Associates (VSBA), Laurinda Spear of Arquitectonica, and Diana Agrest of Agrest and Gandelsonas, but their work is presented under the auspices of a firm or partnership. Hadid is the only woman architect at the end of the twentieth century with her own firm whose standing equals that of her high-ranking male colleagues. In addition, because her work and reputation are so strong, her office attracts some of the best developing talent in the field. As the critic Marcus Field has noted: "She has an office of around 20 people . . . from very diverse, international backgrounds . . . and their pedigrees are of the highest caliber. If you're notching up experience with names[1] like [Rem] Koolhaas or [Peter] Eisenman or [Arata] Isozaki on your CV, the thinking goes, then you must also have Hadid" (Field, 38). Of course, such a reputation is not based upon the value of one project. Hadid has worked hard to maintain and solidify the international acclaim she received upon winning the Peak Club competition.

The brief for the Peak Club competition, sponsored by OLS Property Development Company of Hong Kong, included specific guidelines. The speculative luxury residential and sports complex was called the Peak Club because its intended site was on a mountain, Victoria Peak, in Hong Kong overlooking the harbor. In response to the size of the site, less than 75,000 square feet, and local zoning regulations, the brief limited the height of the building to three stories. In addition, the building's design was required to follow the principles of *feng shui* without specifically recalling the forms of traditional Chinese architecture. *Feng shui*, literally wind and water, is concerned with a structure's relationship to its surroundings, including how the landscape can influence a building's beauty and the happiness of its inhabitants.[2] Facilities included a sports club, 15 studio and 20 one-bedroom apartments, a 150-seat restaurant, a bar and lounge, library, swimming pool with snack bar, squash and tennis courts and a 100-car parking garage. The guidelines indicated the client wanted a contemporary building that could meet the needs of the club's members and the requirements of its location.

An international jury was assembled to judge the 539 entries submitted to the competition. Alfred Siu, the client's representative, Ronald Poon, president of the Hong Kong Institute of Architects, and the architects

John Andrews (Australia) who served as chair, Arata Isozaki (Japan), Richard Meier (U.S.), and Gabriel Formoso (Philippines) were on the jury. They met in March 1983 to determine the winning entry. Given the high profile and the $100,000 purse of the competition, the caliber of the submissions was expected to be quite high. The jury, however, was generally disappointed with the quality of the designs and complained that "most architects slavishly followed the brief without question and as a result, an alarmingly uniform range of solutions was presented"(*The Peak* 55). After an extended debate, the jury voted to award first place to Hadid. The decision was not unanimous: the decisive factor was her interpretive, not mimetic, use of history. The jury explained that "in the present climate of obsessive reference to the ancient past, the architect has chosen as axis of reflection the Suprematist philosophy of the '20s, translating it into a modern language that is both original and creative" (Knobel 2). Although the uniqueness of her design was a point in her favor, Hadid had yet to realize her first building, and this was a deterrent. The jury's debate centered around "the question of a selection based on demonstrable competence or the acknowledgment of a brilliant idea, with full competency obviously possible but yet to be demonstrated" (*The Peak* 55). Ultimately, the jury selected "the brilliant idea" as the winner with the second and third place prizes going to more conventional designs by more established firms.[3]

When OLS announced that Hadid's deconstructivist design won the $100,000 first prize, shockwaves of disbelief and incredulity were felt through some parts of the architectural community. Among the criticism was that she was an inexperienced architect working in a new style. There was worry that her design could not be built. It was unjustly maligned as "unbuildable[4] and simply an attempt by the judges to foist an architectural ego trip on to a hapless developer" (Sudjic 10). Often implied, but unstated, was the issue of her gender. The most valid objection was that her design had initially been rejected for not following the competition brief.

There is as much drama in the way her project was selected as there is in its design since it "was plucked from a pile of rejects by a late-arriving judge" (Giovannini 26). Arata Isozaki, the "late-arriving judge," was intrigued by the quality of Hadid's project even though it did not comply with the guidelines. For example, Hadid's design was for an eight-story building, which was five more stories than the brief allowed. Furthermore, Hadid's presentation paintings are unusual. She often presents her buildings at different angles and in different stages (fig. 20) in a painting instead of the traditional method of giving a single view, such as an eleva-

tion, in each painting. This approach can make Hadid's paintings difficult to read. Yet, it also emphasizes the individuality and dynamism of her work. Isozaki responded to these aspects of her presentation paintings as well as to the originality of her design. He explained:

> Zaha Hadid's entry was so unusual that it had been rejected from the start. I managed to save it from a mountain of other rejected proposals, but convincing others that it deserved to win was most difficult. . .The reason I advocated the selection of Hadid's scheme so strongly was the uniqueness of its expression and the strength of its logic. . . This proposal ignored all the guidelines indicated in the competition conditions (causing its initial rejection), and made a completely fresh start. The plan was divided into horizontal layers instead of the more commonsensical division into vertical zones. . .The laws of deployment of the style itself violated and deconstructed the actual architectural program. . .Thus, though the work of Zaha Hadid employs a pure modernist vocabulary, it can be seen as postmodern[5] in character (Isozaki 7–8).

In Hadid's project, Isozaki saw the potential of a new direction, a new possibility for architectural design that was connected to but not derivative of modern architecture.

Although her design was rooted in the geometry of modernist architecture, Hadid used the dynamic rhomboid as the basis of her project instead of the stable rectangle. She horizontally layered four rhomboid-shaped beams, or lofts, and partially embedded the bottom two in the hillside (fig. 21). This technique enhanced the building's relationship to its site and also emphasized its artificial nature: the beams appear to project away from the hill. The beams are of different lengths and each level is stepped back from the one below it, with the bottom beam the most forward and the top beam the furthest recessed. The third beam is almost flush with the second. The beams are not neatly stacked, but placed at different angles, askew from one another. Again, the position of the third beam is close to that of the second and they make a unit. Anchoring and stabilizing the beams are vertical elements, such as elevators, canted supports and a truss containing some of the building's services. Curving ramps contrast with the rhomboid beams and lead to the centralized sports facilities.

The plan of the Peak Club is hierarchical with the most important spaces placed at the highest levels. The bottom beam consists of fifteen double-height studios; the second beam contains twenty apartments of varying sizes and plans; the third beam houses luxury penthouses; and the private apartment of the promoter is in the top beam. The space between the second and third beams measures 13 meters (about 42 feet)

Figure 20. Zaha Hadid, *Peak Club Competition Painting*, Hong Kong, 1982

high and the sports club was incorporated into this space, or void, as Hadid described it.

By utilizing the void between the second and third beams, the structure was kept low to detract from the fact that it exceeded the three-story zoning limit. The horizontality and layering also helped to make the building appear shorter than it was. In addition, the architect suggested leveling the site to give the building an even base and to prevent the building from dominating the hill. Some of the excavated material was to be polished and used as exterior cladding to make the building appear like a polished granite mountain set into the natural hill, also helping to camouflage the building's height.

The techniques of partially setting the building into the hill and of horizontal layering were in accordance with the requirements of *feng shui*, one of the competition's guidelines. According to Evelyn Lip, proper *feng shui* orientation requires that a site be backed by hills and face water; the perfect site is on the side of a mountain. A building should rise in terraces but not be as high as the summit because it must be protected and shaded by the summit (Lip 6-9). While the client had chosen the hillside location overlooking Hong Kong Harbor, the project's *feng shui* was improved by Hadid's design.

Figure 21. Zaha Hadid, *Peak Club Competition Painting*, Hong Kong, 1982

Hadid called her design "Suprematist geology" because of its dynamic quality and the way it was "like a knife cutting through butter, devastating traditional principles and establishing new ones, defying nature but not destroying it" (Wilson 84). The "traditional principles" she wanted to devastate were those of modern architecture, and by combining modern architecture with the ideas of Russian Suprematism and Constructivism,

she wanted to establish "new ones." She had been exposed to these ideas
during her studies at the Architectural Association (AA) in London from
1972 to 1977. Rem Koolhaas and Elia Zenghelis, her tutors, brought this
work to her attention when they challenged her to develop Kazimir
Malevich's tectonic exercises[6] into a building. According to Hadid: "The
assignment was to rewrite the script of Modernism, and in order to do it,
I felt I needed a new calligraphy [. . .] It led me to use drawing as research,
a way of testing a design from every angle"(Dietsch 118). To formulate
her new "calligraphy," Hadid studied the "unfinished experiments" of
Constructivism and Suprematism which she used as a "point of departure":

> The most exciting thing about the Russians is. . .that their experiment was never
> finished. There was no conclusion. They were the most adventurous of their time,
> not only as painters but as architects as well. They tried to stretch the limits. They
> were my point of departure. . .What interested me most about the Suprematists
> was that they painted things that were implied as architecture, but which were
> never injected into architecture, except perhaps in the work of [Ivan] Leonidov
> . . . His work was very simple but he pushed the limits of all things that the
> Constructivists and Suprematists had invented—how you actually correlate be-
> tween the formed image, the presence on a particular site, its programmatic
> content, its assembly and so on. That was the principal lesson I learned from the
> avant-garde of Russia (Hadid 11).

Hadid's 1982 entry to the Peak Club competition was a demonstration of
that lesson which had presented her with options beyond the confines of
the modernist canon.

The general characteristics of modern architecture are: emphasis on
volume instead of mass; use of regular geometric forms, especially the
rectangle and square; horizontality; no applied ornament; and celebration
of structure (what holds the building up and together). While some of
these are apparent characteristics in the Peak Club design, Hadid rejected
others. The Peak Club is a series of undecorated horizontal volumes. Yet,
these volumes are not regular geometric shapes, but narrow rhomboids
that dynamically push against the site. Although the horizontal beams are
connected by vertical elements, it is not clear how the building works. The
structure has been subordinated to visual effect. As Isozaki commented,
Hadid "deconstructed the actual architectural program" of the competi-
tion. In doing so, like the Constructivists and Suprematists, Hadid was
questioning the limits of architecture.

By the time of the Peak Club competition, other architects were also
questioning modern architecture, and they were also winning important
competitions. These architects tended to deviate from the modernist canon,

as Richard Rogers and Renzo Piano did in the Centre Georges Pompidou in Paris, or broke away from it, as Michael Graves did with his Portland Building in Portland, Oregon. When Piano and Rogers won the 1971 competition for the Pompidou, the decision also sent ripples of disbelief through the architectural community. Like Hadid, they had very little experience and had proposed a building in a radically new style, High Tech. Although they used the rectangular metal and glass box of modernism, they turned the building inside out by placing the services and circulation on the exterior. Graves took a different approach to design in his 1979 entry to the Portland Building competition. He placed the main section of the Portland Building on a stepped back base, varied the facades and fenestration, and applied color and decoration. This was not the open metal and glass container of modernism, but the decorated hybrid of postmodernism. As the first publicly funded large office building in the postmodern style, the Portland Building demonstrated the legitimacy of the style. Furthermore, the Portland Building helped to advance Graves's career: before winning the competition, he was considered a theoretical architect and an artist, not an established architect.[7] Bernard Tschumi was also known as a theoretical architect when he won the competition for Parc de la Villette, Paris, in 1983. His entry was also in the deconstructivist style, but was quite different from Hadid's. Tschumi's proposal for "an urban park for the 21st century," as the project was called, consisted of cubic follies (garden structures intended to highlight a view) randomly varied and arranged according to a grid.[8] The Peak Club and Parc de la Villette winners were announced almost simultaneously. This dual triumph in contemporaneous competitions confirmed the credibility of deconstructivist architecture, signifying that it was as valid as High Tech, postmodernism and modernism.

Confirmation of this validation was received in 1988 when Philip Johnson and Mark Wigley curated "Deconstructivist Architecture" at the Museum of Modern Art (MoMA) in New York.[9] The show was heralded as presenting "a radical architecture, exemplified by the recent work of seven architects" (Johnson and Wigley back cover). Actually, eight architects were represented: Frank O. Gehry, Daniel Libeskind, Rem Koolhaas, Peter Eisenman, Zaha M. Hadid, Bernard Tschumi, and Wolf D. Prix and Helmut Swiczinsky as Coop Himmelblau, their firm. In addition, most of this "radical architecture," including Hadid's Peak Club design, would never be realized; it exists only on paper. This aspect of the exhibition was not new; there is a long tradition of paper architecture. Paper architecture provides an opportunity to explore formal solutions to architectural

problems and is often very influential. Most of the Constructivist and Suprematist designs that inspired Hadid exist only on paper. Hadid was the only woman included in the exhibition. In addition, her paper architecture is legendary and the Peak Club drawings have become icons for many students of architecture (Blume 20). Hadid's inclusion in "Deconstructivist Architecture" placed her in an elite group at the forefront of a "radical architecture" and celebrated the innovative nature of her work.

Hadid was fortunate to receive recognition for this aspect of her work. Leslie Kanes Weisman, a feminist architect, would describe Hadid as "the exceptional one":

> Historically, high-spirited women who dared trespass upon the inviolable male domain of architecture, followed one of two career paths; they stayed single and developed independent practices of extraordinarily high professional standards or they married architects and formed professional partnerships in which their work was largely attributed to their husbands" (Weisman 313).

Hadid, Julia Morgan, and Chloethiel Woodard Smith (although she was married to a diplomat) are in the first category. Denise Scott Brown and Marion Mahoney Griffin are in the second. There are, of course, many other women in both categories.[10] Unfortunately, no matter in which category they belong, their work is usually misattributed, as Weisman noted, or overlooked and remains obscure. Such treatment is often justified by claims that the work of women architects is derivative or not of the same merit as that of important male colleagues. Hadid's architecture defies such classification and dismissal.

Hadid's architecture is based on form and the interactions between solids and voids, not theory. She is not concerned with theory, which she calls "the verbalization of architecture" and "overwhelming" (*Transition* 21). There are woman architects concerned with theory, but their contributions also tend to be overshadowed by the work of their male colleagues. For example, when twenty-five leading international architects were invited to a conference at the University of Virginia in 1982, no women were included. Peter Eisenman, one of the conference organizers, explained: "We took the best people we could find and there were no women in that class . . . of . . . building architects who had a theoretical position" (Flanagan 13). This may have come as a surprise to Diana Agrest, Denise Scott Brown, and Alison Smithson.[11] Their exclusion was more likely prompted by the star system of architecture and their status as wives of architects, not their status as architects and as theoreticians.

Scott Brown knows this treatment intimately: she is married to Robert Venturi, one of architecture's brightest stars. In her essay "Room at the Top? Sexism and the Star System in Architecture," Scott Brown described her frustration at being classified as the wife who just also happens to be an architect:

> The social trivia (what Africans call *petty apartheid*) [such as] wives' dinners ('We'll just let the architects meet together, my dear'); job interviews where the presence of 'the architect's wife' distressed the board; dinners I must not attend because an influential member of the client group wants 'the architect' as her date; Italian journalists who ignore Bob's request that they address me because I understand more Italian than he does; the tunnel vision of students toward Bob; the 'so you're the architect!' to Bob, and the well-meant 'so you're an architect too?' to me (Scott Brown 238).

To his credit, Venturi has tried to counter the way Scott Brown has been marginalized by acknowledging her work and by asking others to do the same. But this is one of Venturi's projects that has basically been ignored. Scott Brown blames her treatment on the star system of architecture:

> I married a colleague and we joined our professional lives just as fame. . .hit him. I watched as he was manufactured into an architectural guru before my eyes and, to some extent, on the basis of our joint work and the work of our firm. . .The first indication of my new status came when an architect whose work I had reviewed said, 'We at the office think it was Bob writing, using your name'. . .What would Peter Eisenman do if his latest article were attributed to his co-editor, Kenneth Frampton. . .with perhaps a parenthesis to the effect that this was not intended to slight the contribution of others? So I complain to the editor who refers to 'Venturi's ducks,' informing him that I invented the 'duck.' (He prints my letter under the title 'Less Is a Bore,' a quotation from my husband.) (Scott Brown 237–39).

Scott Brown has received recognition for her work on sexism and the star system, but found that this has led to a different type of marginalization:

> For a few years, writers on architecture were interested in sexism and the feminist movement and wanted to discuss them with me. In a joint interview, they would ask Bob about work and question me about my 'woman's problem.' 'Write about my work!' I would plead, but they seldom did (Scott Brown 245).

Yet, they were writing about one facet of Scott Brown's work. And Scott Brown has earned her own star for this work, although she prefers to be recognized for her design and theoretical work.

When the firm of Venturi, Rauch and Scott Brown received the American Institute of Architects[12] Firm Award in 1985, Scott Brown's design

and theoretical work were recognized at the highest level and in proper context. She was the second woman to be so honored: in 1977, the firm of Frances Halsband and Robert Kliment received the award. The Royal Institute of British Architects (RIBA)[13] has also honored women in the same way by awarding its gold medal to the Office of Charles and Ray Eames in 1979 and jointly to Michael and Patricia Hopkins in 1994. No woman has individually been awarded a RIBA or AIA gold medal or the distinguished Pritzker Architecture Prize.[14] One rationale for this could be found in the low percentage of women architects. When Hadid won the Peak Club competition, women made up only seven percent of the AIA and RIBA memberships. In 1999, they constituted twelve percent and ten percent respectively.[15] A second reason might be found in the tendency to dismiss architecture by women as less valuable than that by men with the exception of women "competent enough" to work with men. While it is curious that no woman has been independently granted any of these awards, when receiving awards, no architect should be removed from the professional context under which that architect's work was produced.

Male architects are frequently honored outside their professional contexts and this reinforces the gendered hierarchy of architecture. For example, in 1991, the Pritzker was awarded to Robert Venturi even though he has been part of a firm since 1958. Two important projects from the 1960s, his mother's house and the book *Complexity and Contradiction in Architecture,* brought Venturi, not his firm, critical acclaim. But in the 1960s, he was not yet an "architectural guru." Had his contributions to architecture been limited to these early projects, he would never have been considered for a Pritzker. Some of Venturi's most important work has been produced in collaboration with his partners at Venturi, Rauch and Scott Brown and its successor, VSBA. Whereas the AIA chose to honor the firm as a whole, the Pritzker committee chose to honor only the "architectural guru" of the firm and thus perpetuate gender imbalances within the discipline.

Neither the Pritzker committee nor the AIA transformed Venturi, the architect, into Venturi, the star. Scott Brown credits this to the "critic/ historian" and the men's club mentality of the architecture profession. Peter Eisenman has confirmed the presence of a men's club mentality in architecture although he claims there is no intention to ostracize women: "There's definitely an old boys' network and there's also such a thing as a locker-room mentality. But we don't sit around thinking about how we can exclude women" (Flanagan 11). As Weisman has pointed out, there is no need to devise ways to sabotage women because

in architecture practice, the mechanisms that marginalize women are the same as in other professions: an emphasis on a full-time professional life at the expense of a personal and family life; the reliance on an exclusive 'old-boys' network' as a means of achieving status and advancement and a professional mystique in which male competence and 'character' are the 'norm'" (Weisman 313).

In such a biased environment, there is no need to exclude women because they do not carry the same cachet as the men.

Scott Brown believes the motivation for promoting men over women is not exclusion, but the desire to protect the reputation of the critic:

> Criticism is big business; you manufacture reputations and build movements, and in so doing you build yourself. . .The critic/historian wants to be a king maker, and he can't crown a woman king. It wouldn't help him with his gang, which he wants to impress. He would be the laughing stock among his crowd if he said a woman was the best architect in New York" (Dean 48–9).

Like Scott Brown, Jane Thompson, an architect, believes that architectural kings are preferred over queens but finds this attitude inherent in the perception of architecture as a man's field. Thompson states: "I think it's a fair assumption that they're looking for kings rather than queens. I think critics are looking for the latest gimmick and as long as architecture is seen as creating monuments or as building the most for the bucks, it will be viewed as a male field" (Dean 49).

But what happens when a woman architect demonstrates her worthiness to be crowned queen? What if she has her own practice and her work cannot be credited to another person in the firm? What if she is working in an innovative new style? What if she is propelled into the international spotlight by winning an important competition before she has built anything? And, what if she is able to maintain that momentum primarily through paper architecture for ten years until her first building is constructed? This is the case of Zaha Hadid, who occupies a singular position within her profession.

Ironically, despite receiving international acclaim for her innovative architecture, Hadid is rarely discussed by feminist architectural historians and critics. Although she was included in the important 1997 exhibition, "Drawing on Diversity: Women, Architecture and Practice" at the RIBA Heinz Gallery in London, she is conspicuously absent from most books about women architects, including *Architecture: A Place for Women* (1989), *Women in Architecture: A Contemporary Perspective* (1990), *The Architect: Reconstructing Her Practice* (1996).[16] It is difficult to explain this except to speculate that Hadid's lack of interest in gender issues has not brought her to their particular attention. In addition, Hadid's

disinterest in both gender and theory may explain why she is not included as author or subject in books exploring these issues, such as *Sphinx in the City* (1992), *Desiring Practices* (1996), and *The Sex of Architecture* (1996).[17] Unlike Woodard Smith, who argued that sexism had not affected her career in her essay "Architects without Labels,"[18] and unlike Scott Brown, who has been outspoken about the sexism she has experienced, Hadid has made little comment about the gender politics of architecture.

The few observations Hadid has made about any sexism directed toward her have been insightful. In 1985, when Hadid was invited to design a residential block for the Internationale Bauausstellung (IBA) in Berlin, she accepted despite her reservations about being included in the women's section of Block 2, the only area allotted to women architects. She described it "like being told you have leprosy" (Dietsch 122). She did not mind being one of three women commissioned for the project, but objected to being segregated on the basis of gender. Her gender may also help to explain the prolonged controversy over her winning the Cardiff Bay Opera House competition in 1994. Hadid took first place in this important open international competition that received 267 submissions. But there were strong objections to her design by both the general public and Opera House Trust officials whom Hadid believed could not read the drawings (Blume 20). Four of the original finalists (Hadid, Norman Foster, Manfredo Nicoletti, and Itsuko Hasegawa) were asked to rework their designs and resubmit them. Hadid won the competition a second time, although this version may never be realized. It has been suggested that the strongest objections are not to the design but to Hadid, because of her gender. When questioned on this issue, she replied, "It is not overt but [I] can feel it. . .But I ignore it" (Ouroussoff 82). Stating that she "has to get on with [her] work," she has little to say about being a woman because she doesn't "know what it is like to be anything else" (Blume 20).

Despite numerous frustrations, canceled projects, and distracting controversies over the viability of her designs, Hadid's creativity has not been diminished and her productivity is impressive. The early promise of her Peak Club project has been kept, although her ability to do so was doubted. The cancellation of the Peak seemed to set a pattern, and for quite a long time, she seemed destined to become "the mistress of the unbuilt school of architecture" (Blume 20). Yet she was not destined to be a paper architect. Both the Vitra Fire Station and the IBA residential block were completed in 1993. Other successful projects followed. In the process, Hadid has become a star architect, a status she might not have attained if her entry to the Peak Club competition had been left in the reject pile.

Notes

1. The title of Field's article, "Zaha Builds Again," exemplifies the annoying tendency of architectural critics to refer to women architects by first name in print, which is unacceptable when referring to a male architect. Joan Ockman also remarked upon this discrepancy in her review of Peter Adams's *Eileen Gray, Architect/Designer*: "[Adams] refers to his subject throughout as "Eileen"—a first-name basis inconceivable in the biography of a male architect" (Ockman, "Two Women in Architecture," *Journal of Architectural Education*, September 1992 (Vol. 46, No. 1): 51–55; 55.) For example, one would not refer to either Frank Lloyd Wright or Frank Gehry as Frank.

2. *Feng shui* is a complex system requiring that the orientation of a building be determined according to the direction of the sun and wind. This will expose it to the sun in winter and shelter it from the wind in both winter and summer. A north-south axis is ideal. On the southern side of the site, there should be a distant view, perhaps looking across a valley to a range of hills or a great plain.

3. Second place was awarded to PDCM Pty. Ltd., Architects, Melbourne, Australia, who received $60,000. The third place prize of $40,000 was equally divided between Edmund Burke & Partners, Architects, Dublin, Ireland, and Hagmann/Mitchell, Architects, New York City. See "The Peak Architectural Competition" (1983) for reproductions of these entries.

4. Sudjic is quoting an article from the British weekly magazine *Architects' Journal*. Sudjic gives Hadid's response as: "My engineer really laughed at that story in the *Architects' Journal*. I don't mind the criticism, but that was just offensive. Architecture should be about more than just turning out yet more mediocre buildings."

5. Isozaki is making a word play here. He is not describing Hadid's project as postmodern in style but in terms of chronology: it comes after (post) modern architecture.

6. For a discussion of tectonics (tektonika) see Christina Lodder, *Russian Constructivism*, New Haven: Yale University Press, 1987, specifically pp. 94–98.

7. For brief, but excellent, discussions of these two buildings, see Volume 2 of *The International Dictionary of Architects and Architecture*, Ed. Randall J. Van Vynckt, Detroit, MI: St. James Press, 1993. The Centre Pompidou is discussed on pages 224–225; the Portland Building on pages 1003–1005.

8. For a discussion of Parc de la Villette, see *GA Document 26*, Tokyo: ADA Edit. (May 1990): 38–47. Bernard Tschumi is given a biographical entry in Volume 1 of *The International Dictionary of Architects and Architecture,* but the Parc is not discussed as a separate entry. In addition, neither Hadid nor any of her projects are included. I estimate that there are fewer than 10 women architects included in the two volumes which constitute approximately 2,000 pages of text.

9. Philip Johnson's involvement with "Deconstructivist Architecture" was unexpected, especially since he and Henry-Russell Hitchcock curated the influential 1932 exhibition "The International Style: Architecture Since 1922" at MoMA. He was widely criticized for jumping on the Deconstructivist bandwagon and abandoning the floundering ship of Modernism which he had helped to launch.

10. To discover some of these women see Doris Cole *From Tipi to Skyscraper: A History of Women in Architecture,* New York: George Braziller, 1973; Susana Torre, ed., *Women in American Architecture: A Historic and Contemporary Perspective,* New York: Whitney Library of Design, 1977; Dolores Hayden, *The Grand Domestic Revolution: A History of Feminist Designs for American Homes, Neighborhoods and Cities,* Cambridge, MA: MIT Press, 1981; Ellen Perry Berkely, ed., *Architecture: A Place for Women,* Washington, D.C.: Smithsonian Institution Press, 1989; Clare Lorenz, *Women in Architecture: A Contemporary Perspective,* New York: Rizzoli, 1990; Francesca Hughes, *The Architect: Reconstructing Her Practice,* Cambridge, MA: MIT Press, 1996.

11. Similar to the tendency to overlook the contributions women have made to architectural design, their contributions to architectural theory are also obscured. Agrest, Scott Brown, and Smithson are among the few women recognized for their theoretical work. For example, two important anthologies of architectural theory were published in the 1990s. *Architecture Culture 1943–1968: A Documentary Anthology* (New York: Rizzoli, 1993) was edited by Joan Ockman. It reprints seventy-three essays. Two are credited to single women authors, Helena Syrkus and Jane Jacobs. Two list women, Denise Scott Brown and Alison Smithson, as co-authors. There are fifty-one essays in the second, *Theorizing a New Agenda for Architecture: An Anthology of Architectural Theory 1965–1995,* which was edited by Kate Nesbitt. In this book, articles by Diane Ghirardo, Karsten Harries, and Diana Agrest are reprinted. Denise Scott Brown is again listed as a co-author. A fifth woman, Eva Meyer, is represented by her interview of a male philosopher.

12. Founded in 1857, the AIA is the largest and most influential professional association for architects, interns, and those directly involved with the practice of architecture in the United States.

13. RIBA is the first and most famous architectural institute in Great Britain. Founded in 1834, its aim is to advance architecture for the common good.

14. The Pritzker Architecture Prize was established in 1979 and annually honors a living architect whose built work demonstrates a combination of talent, vision, and commitment, having made consistent and significant contributions to humanity and the environment through the art of architecture.

15. Although the AIA and RIBA memberships do not include all the licensed architects practicing in the United States and Great Britain, their ratios of female to male members demonstrate that gender parity has not been achieved in architecture. In the twenty-six years from 1973, when the organizations began to chart gender demographics, to 1999, when this essay was written, there has been a

small increase in the number of women members in both organizations as the following chart illustrates:

Percentages of AIA and RIBA Female Membership: 1973–1999

	1973	1983	1993	1999
AIA	4.3	7	10	12
RIBA	6	7	9	10

Sources are Stephen Cook at RIBA; Pradeep Dalal at AIA; Nora Richter Greer, "Women in Architecture: A Progress (?) Report and a Statistical Profile," *AIA Journal,* 71.1 (January 1982): 42–51; and Nadine Beddington, "The RIBA and Women," *Architectural Design,* 45.8 (August 1975): 75–76.

16. See note 10 for complete citations.

17. Elizabeth Wilson, *The Sphinx in the City: Urban Life, the Control of Disorder, and Women,* Berkely: University of California Press, 1992; Duncan McCorquodale, Katerina Rüedi, Sarah Wigglesworth, eds., *Desiring Practices: Architecture, Gender and the Interdisciplinary,* London: Black Dog 1996; Diana Agrest, Patricia Conway, Leslie Kanes Weisman, eds., *The Sex of Architecture,* New York: Harry N. Abrams, Inc., 1996.

18. Chloethiel Woodard Smith, "Architects without Labels: The Case Against all Special Categories." In Ellen Perry Berkeley, ed. *Architecture: A Place for Women.* Washington, D.C.: Smithsonian Institution Press: 221–227.

Works Cited

Anonymous. "The Peak Architectural Competition." *Architectural Record* 171.11 (September 1983): 54–59.

"Zaha Hadid." *Transition.* May 1987 (Number 20): 17–21.

Blume, Mary. "Zaha Hadid and Her Bold Architecture of Ideas." *International Herald Tribune.* March 25–26, 1995: 20.

Dean, Andrea O. "Women in Architecture: Individual Profiles and a Discussion of Issues." *AIA Journal.* January 1982 (Volume 71, Number 1): 42-51

Dietsch, Deborah K. "Beyond the Peak: Three Projects by Zaha Hadid, Architect." *Architectural Record.* June 1987 (Volume 175, Number 7): 118–129.

Field, Marcus. "Zaha Builds Again." *Blueprint.* October 1998 (Number 154): 38–41.

Flanagan, Barbara. "Women Making A Slow Break Into Architecture." *Newsday.* October 10, 1985: 11, +13.

Giovannini, Joseph. "Architecture's New Diva Makes an International Scene." *Architectural Digest.* January 1996 (Volume 53, Number 1): 26, +28–29, 32, 35.

Hadid, Zaha. "Alvin Boyarsky Interviews Zaha Hadid." *Planetary Architecture Two*, London Architectural Association, 1983: 4–11.

Isozaki, Arata. "A Style Acting of Itself: The Architecture of Zaha Hadid." *GA Architect 5: Zaha M. Hadid.* Tokyo: ADA Edit., 1986: 7–8.

Johnson, Philip and Mark Wigley. *Deconstructivist Architecture.* New York: The Museum of Modern Art, 1988.

Knobel, Lance. "At the Peak of Optimism." *Domus.* September 1983 (Number 642): 2–9.

Lip, Evelyn. *Feng Shui: Environments of Power: A Study of Chinese Architecture.* London: Academy Editions, 1995.

Ouroussoff, Nicolai. "Urban Flights: Zaha Hadid's Modern Cities." *Artforum.* February 1995 (Volume 33, Number 6): 78–83.

Scott Brown, Denise. "Room at the Top? Sexism and the Star System in Architecture." *Architecture: A Place for Women.* Ed. Ellen Perry Berkely. Washington, D.C.: Smithsonian Institution Press, 1989: 237–246.

Sudjic, Deyan. "Enemies in High Places: Zaha Hadid's Triumph." *The Sunday Times* (London, England). November 20, 1983: 10.

Weisman, Leslie Kanes. "Designing Differences: Women and Architecture" *The Knowledge Explosion: Generations of Feminist Scholarship.* Eds.Cheris Kramarae and Dale Spender. New York and London: Teachers College Press, 1992: 310–321.

Wilson, Peter. "The Park and the Peak—Two International Competitions." *AA Files* 4 (July 1983): 76–87.

Chapter 7

This Is Not a Story My People Tell: Musical Time and Space According to Laurie Anderson* (1984)

Susan McClary

Laurie Anderson (b. 1947) was born in Chicago, Illinois. She attended Mills College in Oakland, California, before transferring to Barnard College, where in 1969, she graduated magna cum laude, Phi Beta Kappa. Anderson went on to graduate school at Columbia University and in 1972 received her MFA in sculpture. Shortly thereafter, she began performing original works both in the United States and in Europe under the influence of performance artists like Phil Glass and Vito Acconci. In 1976, Anderson and Bob Bielecki configured the Tape Bow Violin and with this electronic instrument, Anderson submerged herself in the avant garde music scene of Europe in the late 1970s.

After ten years of creating, composing, and performing small original works in alternative and shared venues, Anderson, in 1980, performed United States Part II *at the Orpheum Theatre in New York. With this show, Anderson garnered a great deal of media attention. From this point, she went on to release various songs from her performances, signed on with Warner Brothers records in 1981, and in 1983, had her first multimedia retrospective exhibition at the Philadelphia Institute of Contemporary Art. In 1984, she won a Grammy nomination for* Gravity's Angel.

*This article was originally published in Susan McClary's *Feminine Endings: Music, Gender, and Sexuality*. Minneapolis: University of Minnesota Press, 1991. Reprinted by permission of the publisher.

Throughout the 1980s, Anderson continued to perform, make appearances at fund raisers (especially those for AIDS), and either host or appear on various television programs. In 1990, she received an honorary doctorate of fine arts from the Art Institute of Chicago. In 1991, she premiered Voices from the Beyond, part of a series at the Museum of Modern Art, and in 1992, debuted Stories from the Nerve Bible at the '92 Expo in Seville. Anderson's autobiographical retrospective was also published in 1992. In 1995, Anderson toured with her then newly-released album, Bright Red. This was her first album in nearly five years, and it was another four years before her theatrical performance, Songs and Stories from Moby Dick, *toured in 1999.*

In her composition "Langue d'amour"—just after she retold the Adam and Eve story and just before she moves into the ecstatic stasis that ends the piece—Laurie Anderson says:

> This is not a story my people tell. It's something I know myself. And when I do my job I am thinking about these things. Because when I do my job, that's what I think about.[1]

She thus casually evokes a typical ethnographic situation, in which a native informant delivers authentic folklore to an anthropologist.[2]

The ethnographic reference here is deliberate. In the book version of *United States*, the text of "Langue d'amour" is given in French, interspersed with English translations. The obvious referent here is Claude Levi-Strauss, the French structural anthropologist, the great collector and interpreter of myths who has been a prominent intellectual figure since the late 1960s. Moreover, the text is accompanied by close-up stills of a non-Caucasian male—an Other of unidentified origin—who appears to be telling a story (fig. 22). In the last three frames, the camera slides away from the ostensible "subject," revealing that he is situated among some tropical trees. The final frame includes only a tree (fig. 23).

Several familiar conditions for the production of meaning are here put self-consciously into play: we are apparently being offered the testimony of the "primitive" as recorded by a Western ethnographer, who delivers to us a raw, seemingly incoherent myth before it is cooked—made palatable and rational—through the imposition of objective structural analysis. This homage to elite French theory invites one to assume that Levi-Strauss's elegant binarisms can easily reduce this (like all other cultural artifacts, regardless of content) to stable universal oppositions, can thus make sense of items such as the elusive details of the snake's stories.

But there are problems here: Who are the individuals referred to as "my people"? Who is this speaking, and why are her stories different? First, within the photographs themselves, the jungle that had seemed to be mere background—the detail that seems to guarantee the on-site veracity of the ethnographic event being recorded—suddenly looms up to share the frame with the foregrounded human and then supplants him altogether. Nor is our narrator a trustworthy informant: by her own admission, she is refusing to deliver what is always understood to be the desired anthropological commodity—authentic, transparent access to "the stories my people tell." Even the language of native storytelling is corrupted by the slang phrases of popular culture, such as "happy as a clam" or "hothead": clichés that are plenty meaningful but that disrupt our ability to hear the story as the pure voice of the "folk."

And tropical vegetation and anthrospeak notwithstanding, this is not a primitive myth at all, but rather a pointed retelling of *our own* Western narrative of origin. Moreover, despite the ethnographic photographs of the male subject, the story is being told by a woman and from a woman's point of view. With the lightest of touches, Anderson sets up what seems at first glance the standard binary oppositions underpinning Western knowledge: anthropologist/primitive, human/nature, truth/fiction, authenticity/corruption, Western/non-Western, male/female. Then she tilts them slightly, so that they begin to slip. Their bedrock certainty just evaporates.

1

Laurie Anderson's work always involves several discourses all operating simultaneously, all interconnected in unpredictable, sometimes contradictory ways. It is virtually impossible to separate out any one aspect of her pieces for examination without violating her own insistent violation of the genre boundaries that organize the traditional art world. Most critics of drama, film, performance art, and postmodern culture accept, and even celebrate this in their analyses of her work. But while such multimedia approaches are indispensable when one deals with Anderson, one prominent aspect of her work—the music—almost always gets slighted in such accounts for the simple reason that nonmusicians have difficulty verbalizing about music and its effects.

Unfortunately, the academic musicians who know how to talk about music have shown little interest in Anderson's work. Most of the analytical techniques that have been developed in academic music theory slide right off her pieces. Because much of her music is triadic, the harmonic theory designed for the analysis of the standard eighteenth- and nineteenth-century repertories might seem relevant. But all harmonic theory

Figure 22. Laurie Anderson, "La Langue d'Amour" (or "Hothead") from *This Is Not a Story My People Tell,* 1984

Hothead (la langue d'amour)

Voyons . . . euh . . . c'était sur une île. Il y avait un
serpent et ce serpent avait des jambes. Et il pouvait
marcher tout autour de l'île.

Let's see . . . uh . . . it was on an island. There was a
snake and this snake had legs. And he could walk all
around the island.

Oui, c'est vrai. Un serpent avec des jambes.

Yes, that's true. A snake with legs.

Et l'homme et la femme étaient aussi sur l'île. Et
ils n'étaient pas très malins, mais ils étaient
heureux comme des poissons dans l'eau. Oui.

And the man and the woman were on the island too.
And they were not very smart, but they were happy as
clams. Yes.

Voyons . . . euh . . . alors un soir le serpent faisait
un tour dans le jardin en parlant tout seul et il vit
la femme et ils se mirent à parler. Et ils devinrent
amis. De *très* bons amis.

Let's see . . . uh . . . this one evening the snake was
walking about in the garden and he was talking to
himself and he saw the woman and they started to talk.
And they became friends. *Very* good friends.

Et la femme aimait beaucoup le serpent parce que
quand il parlait il émettait de petits bruits avec sa
langue et sa longue langue lui lechait légèrement
les levres.

And the woman liked the snake very much because
when he talked he made little noises with his tongue
and his long tongue was lightly licking about his lips.

Comme s'il y avait un petit feu à l'intérieur de sa
bouche et que la flamme sortit en dansant de sa
bouche. Et la femme aimait beaucoup cela.

Like there was a little fire inside his mouth
and the flame would come dancing out of his
mouth. And the woman liked this very much.

Et après cela elle se mit à trouver l'homme
ennuyeux parce que quoiqu'il advint, il était
toujours aussi heureux qu'un poisson dans l'eau.

And after that she was bored with the man
because no matter what happened, he was
always as happy as a clam.

Que dit le serpent? Oui, que disait le serpent?

What did the snake say? Yes, what was he saying?

O.K. Je vais vous le dire.

O.K. I will tell you.

Le serpent lui raconta des choses sur le monde.

The snake told her things about the world.

Il lui parla du temps ou il y eut un grand tiphon
sur l'île et ou tous les requins sortirent de l'eau.

He told her about the time when there
was a big typhoon on the island and
all the sharks came out of the water.

Oui, ils sortirent de l'eau et ils vinrent droit dans
votre maison avec leurs grandes dents blanches.
Et la femme entendit ces choses et elle tomba
amoureuse.

Yes, they came out of the water and they
walked right into your house with their big
white teeth. And the woman heard these
things and she was in love.

Et l'homme vint et lui dit: "Il faut qu'on s'en
aille maintenant," et la femme ne voulait pas
s'en aller par ce qu'elle était une brûleé.
Parce qu'elle était une femme amoureuse.

And the man came out and said: "We have
to go now," and the woman did not want to
go because she was a hothead. Because
she was a woman in love.

Toujours est-il qu'ils monterent dans leur
bateau et quitterent l'île.

Anyway, they got into their boat and left the island.

Mais ils ne restaient jamais très longtemps
nulle part. Parce que la femme ne pouvait
trouver le repos.

But they never stayed anywhere very long.
Because the woman was restless.

C'était une tête brûlée. C'était une femme
amoureuse.

She was a hothead. She was a woman in love.

Ce n'est pas une histoire que raconte mon peuple.
C'est une langue que je sais par moi-même.

This is not a story my people tell. It is
something I know myself.

Et quand je fais mon travail je pense à tout cela.

And when I do my job I am thinking about these things.

Parce que quand je fais mon travail, c'est-ce à quoi
je pense.

Because when I do my job, that is what I think about.

Figure 23. Laurie Anderson, "La Langue d'Amour" (or "Hothead") from *This Is Not a Story My People Tell,* 1984

Oooo la la la la.

Voici. Voilà.

Oooo la la la la.

Voici le langage de
l'amour.

Oooo la la la la.

Voici. Voilà la la.

Voici le langage de
l'amour.

Ah! Comme çi, comme ça.

Voilà. Voilà.

Voici le langage de
l'amour.

Voici le langage de
l'amour.

Attends! Attends! Attends!

Attends! Attends! Attends!

Écoute. Écoute. Écoute.

Oooo la la la la.

Oooo la la la la.

Voici le langage de
l'amour.

Voici le langage dans
mon coeur.

Oooo la la la la.

Voici le langage dans
mon coeur.

Voici le langage de
l'amour.

Voici le langage dans
mon coeur.

Voici le langage dans
mon coeur.

Yeah, La La La La

Here and there.

Oh yes.

This is the language
of love.

Oooo. Oh yeah.

Here it is. There it is. La la.

This is the language
of love.

Ah! Neither here nor there.

There. There.

This is the language
of love.

This is the language
of love.

Wait! Wait! Wait!

Wait! Wait! Wait!

Listen. Listen. Listen.

Oooo. Oh yeah.

Oh yeah. Yeah.

This is the language
of love.

This is the language of
my heart.

Oooo. Oh yeah.

This is the language of
my heart.

This is the language
of love.

This is the language of
my heart.

This is the language of
my heart.

can do is label the pairs of alternating chords that often serve as the material for her pieces. Musicians often dismiss Anderson's music as being nothing more than this, as though it were intended for beginners in ear-training classes: "O Superman" gives the boneheads eight minutes to hear the difference between two chords. Next week, a three-chord structure. After a year, maybe a Mozart sonata. Finally, Schoenberg or Carter. For these are, of course, the stories—the authorized stories—"my people" tell, in both concert halls and classrooms.

In this essay, I want to focus on the musical dimension of Anderson's work. If her music resists analysis as we practice it in the academy, it is not necessarily because her pieces are faulty according to universal, objective criteria, but rather because her premises are different. As it turns out, Anderson's musical experiments—the stories she tells herself when she does her job—can tell us quite a bit both about the discursive conventions of the standard repertories and also, by extension, about music theory as it is practiced in the academy. Because they resist many of the categories of traditional music theory, her pieces demand that we develop a new set of analytical questions. Accordingly, this essay concentrates on some very basic issues: the organization of space and time in Anderson's music and musical performances.

2

American musicology and music theory have rarely been interested in examining the temporal and spatial dimensions of music per se. The scarcity of literature in this area is emphasized by Robert Morgan's pioneering article, "Musical Time/Musical Space," which develops some useful ways of considering various kinds of spatial relationships within music (Morgan 627–28). However, except for a brief aside in which he mentions pieces that deliberately exploit spatial arrangements within performance sites, Morgan's comments address only the metaphorical space within compositions: qualities of high and low, of relative distance, of surface and background. Many aspects of Anderson's pieces can fruitfully be discussed in these terms, and I will return to them later. But there are other spatial issues at stake in music—issues that are not only neglected but actively repressed by most professional musicians and theorists. And Anderson forces us to become aware of these submerged, though critical, issues.

The most significant of these concerns the physical source of sound. In many cultures, music and movement are inseparable activities, and the physical engagement of the musician in performance is desired and ex-

pected. By contrast, Western culture—with its puritanical, idealist suspicion of the body—has tried throughout much of its history to mask the fact that actual people usually produce the sounds that constitute music. As far back as Plato, music's mysterious ability to inspire bodily motion has aroused consternation, and a very strong tradition of Western musical thought has been devoted to defining music as the sound itself, to erasing the physicality involved in both the making and the reception of music.[3] Renaissance nobles sometimes hid their musicians behind screens to create the impression that one was listening to the Harmony of the Spheres (Leppert 26); Schopenhauer defined music as the trace of the metaphysical Will itself (theorist Heinrich Schenker later revealed precisely how the Will said what it said); and orchestral musicians dress in black so as to minimize the embarrassing presence of their physical beings. The advent of recording has been a Platonic dream come true, for with a disk, one can have the pleasure of the sound without the troubling reminder of the bodies producing it. And electronic composition makes it possible to eliminate the last trace of the nonidealist element.[4]

The genre known as performance art arose in the 1960s and was in part a reaction against this erasure of people from art.[5] One of the principal features of performance art is the insistence on the artist as a performing body. Gone is the division of labor in which a composer constructs an object and passes it on to a performer who executes faithfully the demands of the master. In performance art, artist and performer are usually one, and the piece is that which is inscribed on and through the body. The radical separation of mind and body that underwrites most so-called serious music and music theory is here thrown into confusion.

Anderson's treatment of the body in performance is far more complex than the in-your-face transgression that characterizes some performance art. First, her compositions rely upon precisely those tools of electronic mediation that most performance artists seek to displace. In order to put this aspect of her work into perspective, it is important to recall that most modes of mechanical and electronic reproduction strive to render themselves invisible and inaudible, to invite the spectator to believe that what is seen or heard is real.[6] By contrast, in Laurie Anderson's performances, one actually gets to watch her produce the sounds we hear. But her presence is always already multiply mediated: we hear her voice only as it is filtered through Vocoders, as it passes through reiterative loops, as it is layered upon itself by means of sequencers. For some pieces, she attaches contact mikes to drum machines and produces sounds by striking various parts of her body; for others, she speaks through a pillow speaker located inside her mouth.[7] The closer we get to the source, the more distant

becomes the imagined ideal of unmediated presence and authenticity. Mary Ann Doane has written about the anxiety provoked in film when a voice is not securely grounded in a particular body to ensure unity (Doane 34). Anderson deliberately plays with those anxieties. She insists on and problematizes her mediation.

The problem this extreme mediation calls up is sometimes referred to as "Man versus Machine," and in fact many reviewers of Anderson's work have assumed that she, too, is merely critiquing the alienating influence of the media on human authenticity.[8] But to interpret her work in terms of that standard dichotomy is to ignore her obvious fascination with gadgetry. As she has remarked:

> It's true that there is a lot of alienation in songs like 'Big Science' and 'O Super-man.' All of my work that deals with machines, and how they talk and think, is inherently critical. That's certainly the bias. But I think many people have missed an important fact: those songs themselves are made up of digital bits. My work is expressed through technology—a lot of it depends on 15 million watts of power[9] (Block 44).

If her work refuses the options offered by the traditional Man-versus-Machine dichotomy, it is in part because she is not a Man. The fact that hers is a female body changes the dynamics of several of the oppositions she invokes in performance. For women's bodies in Western culture have almost always been viewed as objects of display. Women have rarely been permitted agency in art, but instead have restricted to enacting—upon and through their bodies—the theatrical, musical, cinematic, and dance scenarios concocted by male artists.[10] Centuries of this traditional sexual division of cultural labor bear down on Anderson (or any other woman performer) when she performs, always threatening to convert her once again into yet another body set in motion for the pleasure of the masculine gaze. It may be possible for men in the music profession to forget these issues, but no woman who has ever been on stage, or even in front of a classroom, can escape them. This raises the stakes enormously and makes much more significant Anderson's insistence on her self-representation within the performance space.

When Anderson involves herself with electronics, she confuses still other habits of thought grounded in gender difference. For it is supposed to be *Man* who gives birth to and who tames the Machine. Women in this culture are discouraged from even learning about technology, in part so that they can continue to represent authentic, unmediated Nature. To the extent that women and machines both occupy positions opposite that of Man in standard dichotomies, women and machines are incompatible terms. But as Anderson wrestles with technology, she displaces the male

subject who usually enacts the heroic feat. And by setting up an implied alliance and identification with the machine, she raises the conventional anxiety of the self-directed robot—the living doll who is self-created, who flaunts her electronic constructedness.[11] As she says in her piece "Closed Circuits," "You're the snake charmer, baby. And you're also the snake."

For all these reasons, musical space in Laurie Anderson's music is multiply charged. No longer merely a metaphorical concept, the space within which her music occurs is the arena for many kinds of cultural struggles. It is electronically saturated at the same time as it insists on the body—and not simply the neuter body that has been erased from consideration in music theory, but the problematic female body that traditionally has been the site of the spectacular.

In order to balance out these various tensions, Anderson assumed an androgynous persona while working on *United States*.[12] Her androgyny downplays her sexuality, which, given the terms of tradition, always threatens to become the whole show. By contrast, pop singer Madonna takes control of her erotic self-representation, insisting on her right to construct rather than deny her sexuality (McClary 149).[13] But Anderson, too, has commented—in imagery strikingly like Madonna's—on the possibility of deriving power from being a knowing "object" of the male gaze: "Women have rarely been composers. But we do have one advantage. We're used to performing. I mean like we used to tap dance for the boys—'Do you like it this way, boys? No? Is this better?'" (Block 42).

But whether a woman performer denies or emphasizes her physical presence, it is always read back onto her. Anderson is sometimes criticized, for instance, for presenting gestures "from which spontaneity and joy [read: sexuality] have been banished," or for preventing the audience from identifying with her—for withholding the kind of nurturing presence we expect women performers to deliver (Bergman and Horn 93, 97).[14] She walks a very thin line—foregrounding her body while trying not to make it the entire point. As she puts it: "I wear audio masks in my work—meaning, electronically, I can be this shoe salesman, or this demented cop, or some other character. And I do that to avoid the expectations of what it means to be a women on stage" (Block 42).[15]

3

I would like to move now into the music itself, provided that we not forget the problematized theatrical space within which these sounds are produced. For many of the same dilemmas Anderson faces as a women on stage confront her again when she decides to compose. How does a woman

composer negotiate with established musical discourses? What options are available, and what do her choices signify?

Music is generally regarded as a neutral—neuter—enterprise, again because of the desire not to acknowledge its mediation through actual people with gendered bodies. Some women composers accept this position and write music that is indistinguishable from that of their male colleagues.[16] Many of them chafe at the suggestion that their sexual identity might have something to do with their music, and understandably so: for centuries it has been thought that if women did write music, it would sound frail and passive—that is, would sound the way dominant culture assumed women were and should be. In the last few decades, many women have risen in the area of composition to command the respect of both male and female peers. Respect not as women composers, but as composers. Period. I want to stress here once again that I very much admire the accomplishments of these women.

However, Laurie Anderson is a performance artist whose priorities lead her not only to acknowledge but to insist upon her gender identity in her work, in the music as well as the more theatrical components. But it is not at all obvious how to make gendered differences audible in music, nor is there a single theoretical position on this matter. Some feminist artists endeavor to create images of feminine eroticism in order to celebrate their own experiences and to seize control of the representation of the female body, which has been so thoroughly colonized by pornography throughout Western art history.[17] This option often produces exuberant, liberatory work, but it threatens to reinscribe the old patriarchal notion that women are simply and essentially bodies, are reducible to their sexualities. Poststructuralist feminists tend to resist what they see as the simplistic celebration of the body and concentrate instead on demonstrating how certain binary oppositions in Western thought—oppositions such as Male/female, mind/body, culture/nature—organize social reality. They argue that essentialist identifications of women with sexuality, the body, and nature only play back in to the hands of the oppressive mainstream.[18] However, the other side often sees poststructuralist feminists as repudiating the potential strengths of gender difference and occupying the same disembodied, joyless, neuter position as the most sterile of mainstream enterprises.

Recently, theorists such as Teresa de Lauretis and Denise Riley have argued that women need to derive strategies from both of these apparently mutual exclusive positions: to practice deconstructive analyses of the tradition when necessary, but also to try to imagine new social realities—worlds in which the celebration of the erotic need not reduce women

back to sex objects, in which the intellect and the body can be mutually supportive and collaborative. As de Lauretis puts it:

> Now, the movement in and out of gender as ideological representation, which I propose characterizes the subject of feminism, is a movement back and forth between the representation of gender (in its male-centered frame of reference) and what that representation leaves out or, more pointedly, makes unrepresentable. . . . Thus, to inhabit both kinds of spaces at once is to live the contradiction which, I have suggested, is the condition of feminism here and now: the tension of a twofold pull in contrary directions—the critical negativity of its theory, and the affirmative positivity of its politics—is both the historical condition of existence of feminism and its theoretical condition of possibility (de Lauretis 26).[19]

While much of Anderson's music predates such theoretical formulations, I want to argue that her work has enacted such a solution by continually shifting back and forth across boundaries, sometimes focusing on social critique and sometimes on developing new models of pleasure.

4

"O Superman," the 1981 hit single from the extended work *United States*, is a good example of Anderson's deconstructive mode.[20] It is dedicated to Massenet and refers obliquely to his *Le Jongleur de Notre Dame,* a fairly obscure opera from 1902. Anderson's piece invokes Massenet's opera in two ways. First, the opera contains an aria that begins "O souverain, o juge, o père," which is transformed into Anderson's opening line, "O Superman. O Judge. O Mom and Dad." Second, the climax of the opera occurs when the juggler, pursued by an angry mob, backs up against a painting of the madonna and is saved when her arms draw him into the picture. The relevance of this imagery to Anderson's piece is quite obvious ("So hold me Mom, in your long arms . . . your military arms . . . your petrochemical arms"), though typically difficult to unravel. Her engagement with this text offers yet another level of critique, though one available only to those with esoteric musicological knowledge. Ironically, it is precisely those people who are most invested in "high culture" who are likely to catch this reference, only to have yet another beloved object deconstructed.

The musical constant in "O Superman" is a pedal on middle C on a single syllable: "ha, ha, ha." In performance, one watches as Anderson generates this sound and establishes its technological reiteration through a delay mechanism. It gives the impression of being expressively authentic, as though it exists outside of or prior to language, and it evokes powerful though contradictory affective responses; alternately it may be heard as

sardonic laughter or as anxious, childish whimpering. It runs for the duration of the composition, changing only when it is thrown temporarily out of kilter through phrasing. Its apparent shifts in meaning are due solely to context, for the sound itself is frozen into place electronically.

Two alternating chords inflect the pedal harmonically: an A-flat major triad in first inversion and a root-position C-minor triad. It is her dependence on such minimal musical material that makes some musicians dismiss Anderson as unworthy of serious analytical discussion. But like many other aspects of Anderson's work, the music often is carefully organized in terms of austere binary oppositions, the kinds of oppositions that structuralists such as Saussure and Levi-Strauss revealed as lying at the foundations of Western thought and that poststructuralists have been concerned with deconstructing.[21] The binary opposition that she has chosen is not innocent, and as the piece unfolds we learn a good deal not only about "O Superman," but also about the premises of Western musical discourse and our own postmodern condition.

The triadicity of "O Superman" invites listeners to read its material in terms of the traditional codes of tonal procedure. Indeed, some critics hear Anderson's music as a simplistic return to the familiar, reassuring comforts of tonality in reaction against the intellectual rigors of serialism. Yet as easy as it may be to label the individual moments in the piece, we run into trouble as soon as we try to fix the two chords in terms of tonal hierarchy. The pedal is first harmonized by A-flat major, which serves as the reference point for much of the piece. The C-minor harmonization appears initially as a brief inflection that is quickly altered back to A-flat.

There are a few details, however, that make the relationship between the alternatives a bit uneasy. First, the only difference between the two chords is the choice between the pitches A-flat and G. The dramatic action of the piece hangs on that flickering half step. Second, the A-flat chord is in first inversion and is thus somewhat flimsy, while the presumably decorative C-minor chord is very solid. Third, the semiotics of tonal music associate major with affirmative affective states (hope, joy) and minor with negative states (sadness, depression). And as the piece swings between these two stark triads, one is encouraged to hear the alteration as a happy/sad dichotomy. But the fact that the major alternative is always unstable (because it is in inversion) and the minor always stable suggests that security ultimately lies with the negative opinion. Thus although the major triad was established first (and therefore has some claim to the status of "tonic"), it is increasingly heard as an inflection poised to resolve to C-minor.

In other words, even though we are given only two closely related triads, it is difficult to ascertain which is structural and which ornamental. Consequently, the affective implications of the opposition become confused. Usually in tonal narrative, we are led to desire affirmative, major-key states while dreading the minor. And we are likewise accustomed to defining structural stability in terms of the initial tonic and to expecting that dissonances will be resolved out for purposes of narrative closure. But what about a piece that mixes up these two mechanisms of desire and dread, when clinging to hope spells unstable illusion and certainty comes only with accepting dread?

To be sure, this crossing of affective and narrative wires occurs occasionally in the standard repertory, though only in pieces that themselves are calling into question the premises of tonality and its conventional forms. Haydn's String Quartet, op. 33, no. 3, for instance, risks presenting the opening tonic in first inversion, and at the moment of recapitulation it is the mediant minor that seems to have prevailed—though this turns out, of course, to be simply a musical pun. The definition of tonic is never seriously in question, and the narrative schema of sonata procedure easily remedies whatever anxiety might have been generated by the confusion. The principal key is quickly reinstated, and all is well. There are also two pieces in which an intolerable minor tonic is fled to the affirmative if unstable and untenable major key on the sixth degree. Beethoven's *Ninth Symphony*, several of his late quartets, and Schubert's *Unfinished Symphony* come to mind here. In these pieces, stable dread and unstable hope form the contradictory poles structuring the narratives, although inasmuch as the pieces are tonal, we know in advance that they must conform finally to the tonic.[22]

Anderson's piece is in some ways like a performed-out analytical reduction of the axes upon which many such tonal pieces turn. Nothing extraneous is present—she gives us only the binaries that underlie and inform the more complex narratives of the tonal repertory. But the fact that the hierarchical relationship between her two chords is undecidable means that there is not even the potential security of the tragic ending. We may not like Schubert's rejection of the pretty theme and the affirmation of brutal reality at the end of the *Unfinished Symphony*'s first movement, but that ending at least confirms the necessity of dissonance resolving to consonance, or the inevitability of second themes yielding to the first. The formidable metaphysics of tonality and sonata form win out over romantic illusion, and there is considerable security in knowing that something—even if that something is harsh and tyrannical—guarantees meaning.[23]

Anderson's monologue causes us to map the alternations with certainty at first: Man/Machine, Home/Alienation, and so on. But then things become confused, as Mom becomes Machine, and the clichés of American patriotism become codes of totalitarian control. Finally, we are left with the ambiguity of the initial sound and the undecidability of the binarisms. Duration and accent turn out to count enormously in this piece, for it is only through relative temporal and textual emphasis that one or the other of the chords achieves prominence, thus offering us a point of reference, at least for the moment. The most awful part of the piece begins with the words "So hold me, Mom," when both chords finally appear in root position, both equally oppressive. Near the end, after the singing has concluded, predictable periodic phrasing occurs for the first time. An inexorable bass ostinato enters, and over it the two chords switch on and off mechanically. These fade until finally we hear only the original track: laughing or whimpering, human or electronic—all or none of the above.

It is in thus questioning the metaphysics of traditional tonal music that Anderson performs some of her most incisive work. For having invoked the kind of dualistic axis upon which conventional tonal narratives rely, she deftly unhinges it. At stake in the verbal text of "O Superman" are issues such as self versus Other, home versus the public sphere, autonomy versus external control. As her performance splits her off into multiple identities, as the security of Mom becomes indistinguishable from technological, many of the constants upon which we habitually depend are thrown into turmoil. In her music, as the structural is confused with the ornamental, as the musical semiotics of desire and dread, of hope and disillusion, of illusion and reality get mapped and remapped, inscribed upon and erased from the same two chords, the tidy structures of formal analysis—those assurances of unitary control—become hopelessly tangled.

<div align="center">

5

</div>

Robert Morgan has suggested that one of the great attributes of tonal music is its ability to create the impression of "depth" beneath the musical surface (Morgan 530–34).[24] Because we are familiar with tonal procedures, we are able to take pleasure in the note-by-note events in a piece of music and still follow the long-term structural mechanisms underlying it. Anderson tempts us to hear the kinds of depth in this piece: to interpret one or the other of these chords as simply ornamental. But while this illusion is continually being raised in "O Superman," it is just as continually voided. Thus what we finally have is neither narrative nor depth, but only our craving for both in the face of what is perhaps only the digital

technology that guarantees postmodern electronic life. [25] Anderson delib-
erately activates beloved narratives and demonstrates to us that we are
still highly invested in them, even though they may be bankrupt. Or worse.

One of the charges often leveled against postmodern theory and art is
that it is nihilistic—that it flaunts its cynical refusal to believe in anything.
Jean Baudrillard has decried this as the age of the simulacrum, in which
codes and signs that used to signify are set loose to play in flashy if
meaningless media assemblages (Baudrillard 166–84). Fredric Jameson
has characterized postmodern artworks as "blank pastiche" (Jameson
114). And Anderson's deconstructive enterprises certainly can be read as
celebrating the crisis in Western meaning currently being experienced.

However, not all plays of signifiers are nihilistic and not all pastiches
are blank. Discovering that social reality has been humanly organized
through binary oppositions can call forth widely different reactions: for
those who have benefitted from the illusion that culture and knowledge
were grounded in truth (rather than social ideology and privilege),
postmodern deconstruction is a calamity.[26] But for those who have been
kept in their places by those reigning oppositions, deconstruction can be
cause for celebration. The cultural theory of black philosopher Cornel
West emphasizes this point repeatedly.[27] And feminist theory likewise
delights in taking apart the strictures that have held women in positions of
passivity, that have prevented them from participating as full agents in
social, economic, or cultural spheres. As Anderson has said: "I also think
that women are excellent social critics, basically because we have nothing
to lose, anyway. It's like we're not in a position of power, so we don't risk
a lot by being critical of it (Rockwell 131).

Depending on your point of view, then, Anderson's strategies of simul-
taneously evoking and denying classic structural dichotomies are nihilis-
tic, transgressive, or exuberant. It depends on whose meaning is being
displaced. Her music may sound simple up against the sophisticated de-
vices of music theory, but the self-contained rigors of music theory can
seem almost endearingly naive up against Anderson's music, the
multivoiced popular culture with which it has fused, and the social reality
that is being negotiated through such new voices and forms.[28]

6

But deconstruction is only one of Anderson's interests. "Langue d'amour"
appeared in both *United States* and later, in a more elaborate version, on
the 1984 album *Mister Heartbreak*. Its musical materials, too, are el-
emental. Four pitches (D, E, G, and A) cycle through the bass in a synthe-

sized sound that evokes drumming. The pitches occur in any sequence—order and hierarchy don't matter here. Likewise, although there are strong pulses, there is no regular metric organization. The piece encourages physical motion, but it refuses to regiment that motion. Surface events in the piece are unpredictable, yet because they take place within an enclosed musical space that is securely bounded by these few pitches, nothing unexpected happens. Narrative is thus sacrificed for the sake of sustained pleasure.

Layered on top of the mix are sounds of what are identified as electronic conches—teasing glissandos that slide upward, smearing that certainty of diatonic articulation. Even Anderson's voice is split off into several registers at once by means of the Vocoder—unitary identity is exchanged for blurred, diffused eroticism. Eventually the decisiveness of verbal speech is abandoned for a prolonged moment of musical *jouissance*, in which the murmured text—"Voici, voilà la langage de l'amour" and La, la, la, la"—puns continually on "tongue": the tongue of love, the tongue that flickers in and out of the snake's mouth, the tongue inciting feminine ecstasy.

This is most emphatically *not* a story my people tell, if by "my people" is meant official Western musical culture. For feminine pleasure has either been silenced in Western music or else has been simulated by male composers as the monstrous stuff requiring containment in *Carmen* or *Salome*.[29] Indeed, Anderson's text invokes the primal story of feminine containment—the biblical account of Man's seduction by Woman, the hurling of Mankind into history and narrative. The original story has informed our culture ever since. Retelling it from Eve's point of view quietly eliminates the pathos, the lethal mixture of desire, dread, and violence that compels narrative structure. When I play this piece in my classes, male students often complain that it makes no sense, that nothing happens in it, that it is creepy and vague. In short, it lacks narrative. But the women tend to beam at each other in recognition of something that they have never heard formulated in music and yet feel they have always known. For when they do their jobs, this is what they are thinking about.

There are a few pieces in the standard repertory that attempt to build nonteleological models of time, for instance, Debussy's *Prelude à l'après-midi d'un faune* or the third movement of Beethoven's *Ninth Symphony*. Given the programmatic dimension of the Debussy and the overall context of this movement of the Beethoven, both of these pieces seem to be concerned with presenting antinarratives. Yet *L'après-midi d'un faune* manages to shape itself only by moving as though toward climax, even though the climax is ultimately refused. And the final movement in

the *Ninth* hurls us more violently back into narrative than any other piece I know. The peaceful third movement seems almost to have been a transgression, an obstacle to the transcendental quest that fuels this symphony.[30] As the "man" says in *Langue d'amour*, "We have to go now." In Anderson's piece, by contrast, there is no transgression, no remorse, no impulse to return to narrative. There is only pleasure.

By suggesting that Anderson produces images of feminine pleasure in this piece, I do not mean that there is something essential about the female body and its experiences or that her artistic processes are irrational. On the contrary: what Anderson is doing is very complex, both musically and intellectually. It relies heavily on her deconstructions of the presumably neuter terms of Western music, and it requires that she manipulate the materials of music so as to produce alternative metaphors. For if many people have experienced the "structure of feeling" conveyed by Anderson, she has had to work very hard to organize pitches and rhythms such that listeners recognize it as music.[31] But having isolated and analyzed the elements that have underwritten patriarchal narratives of control throughout history, she now has space within which to assemble those elements in accordance with a different organization of time.[32]

While women have been marginalized with respect to Western culture for most of its history, our perspectives from the margins have offered some advantages. For example, we have been privy both to the public displays and explications of official masculine culture—including the ways male artists construe women—as well as to experiences not accounted for within that official culture, but which Anderson and a few other women are beginning to map.

So as far as we know, only one man—Tiresias, the seer in Greek mythology—has had the opportunity to experience both feminine and masculine realms: he was permitted to live in the body of a women for several years, and then was changed back into a man. When asked who had the greater erotic pleasure, he answered that women's *jouissance* was seven times that of a man. For divulging this information he was struck blind. I do not want to repeat his mistake by insisting on the superiority of Anderson's erotic imagery in "Langue d'amour." So I will conclude with this:

> Think of it.
>> Think of it as.
>>> Think of it as a new way.
>>>> Think of it as a new way of structuring time.

Notes

1. The two recordings are quite different: the first is performed in keeping with the austere performance-art style of the rest of the *United States*, while the second is part of a collection designed specifically for distribution through recording. Like the other numbers on *Mister Heartbreak*, it is musically more complex. Peter Gabriel sings backup vocals, and electronic conches (played by Anderson) are added to the mix. The text is available in Laurie Anderson, *United States* (New York: Harper & Row, 1984).

2. See also Anderson's piece "Hey Ah," also in *United States*, in which a Native American is asked to sing for a documentary and finds he no longer knows any of the traditional songs. In performance, Anderson accompanies this piece with a video animation of a powerful buffalo trying to run, always to be looped back. For a collection of poststructuralist critiques of anthropology that resonate with some of Anderson's strategies, see James Clifford and George E. Marcus, eds., *Writing Culture: The Poetics and Politics of Ethnography* (Berkeley: University of California Press, 1986).

3. For more recent diatribes against the body in musical performance, see Theodore W. Adorno, "Perennial Fashion-Jazz," *Prisms*, trans. Samuel Weber and Sherry Weber. (Cambridge, MA: Massachusetts Institute of Technology Press, 1981) 119–32 (quoted in Chapter 3 of *Feminine Endings*). Robert Walser has written on Adorno's erasure of the body and the consequences in Adorno's criticism of both classical and popular music in "Retooling with Adorno: Bach's Ontology and the Critique of Jazz" unpublished paper, Minneapolis, 1988. See also Edward T. Cone, *Musical Form and Musical Performance* (New York: W.W. Norton) 1968: "Leo Stein has suggested that music requiring bodily motion on the part of the listener for its complete enjoyment, like much popular dance music, is by that token artistically imperfect; perhaps that same principle can be applied to performance" (17).

 This denial of the body in music is not, however, a constant, even in Western culture. For instance, C.P.E. Bach advocates physical motion on the part of performers. See his *Essay on the Time Art of Playing Keyboard Instruments*, trans. and ed. William J. Mitchell (New York: W.W. Norton, 1949) 152–53. Caricatures of the great nineteenth-century virtuosi (Berlioz, Liszt, etc.) suggest both how scandalized and yet titillated audiences were by their outrageous histrionics.

4. See Milton Babbitt, "Who Cares If You Listen?" *High Fidelity Magazine* 8, no 2 (February 1958) "I dare suggest that the composer would do himself and his music an immediate and eventual service by total, resolute, and voluntary withdrawal from this public world to one of private performance and electronic media, with its very real possibility of complete elimination of the public and social aspects of musical composition. By so doing, the separation between the domains would be defined beyond any possibility of confusion of categories, and the composer would be free to pursue a private life of professional achievement, as opposed

to a public life of unprofessional compromise and exhibitionism"(126). For an analysis of this attitude and its effects on academic music as well as music in the academy, see my "Terminal Prestige: The Case of Avant-Garde Music Composition," *Cultural Critique 12* (Spring 1989) 57–81.

5. For background reading in performance art, see Moira Roth, ed, *The Amazing Decade: Women and Performance Art in America, 1970–1980* (Los Angeles: Astro Artz, 1983); RoseLee Goldberg, *Performance Art: From Futurism to the Present.* (rev. ed. New York: Harry N. Abrams, 1988); and Greil Marcus, *Lipstick Traces: A Secret History of the Twentieth Century* (Cambridge, MA: Harvard University Press, 1989).

6. Walter Benjamin addressed this priority very early on in the history of the media. See his "The Work of Art of Mechanical Reproduction,"in *Illuminations*, trans. Harry Zohn (New York: *Schocken*, 1977) 217–51. Film theorists often demonstrate how the apparatuses of cinema manage to manipulate us while erasing themselves. Concerning the coordination of sound and visual image, see especially Mary Ann Doane, *The Desire to Desire: The Women's Film of the 1940s.* (Bloomington: Indiana University Press, 1987); and Kaja Silverman, *The Acoustic Mirror: The Female Voice in Psychoanalysis and Cinema* (Bloomington: Indiana University Press, 1988). And digitally processed music gives the impression of pure, unmediated, hyperreal sound by breaking sounds down into binary bits and then carefully reassembling them after the "noise" of actual reality has been removed. See also John Mowitt, "The Sound of Music in the Era of Its Electronic Reproducibility," in *Music and Society: The Politics of Composition, Performance and Reception*, ed. Richard Leppert and Susan McClary (Cambridge: Cambridge University Press, 1987) 173–97.

7. The piece using a pillow speaker is "Small Voice," from *United States*. There is a diagram explaining how the mechanism works, as well as a photograph of Anderson with the speaker in her mouth, in the book *United States*.

8. For some balanced and perceptive discussions of Anderson and her technology, see Greil Marcus, "Speaker to Speaker," *Artforum* (25 February 1987) 9–10; and Billy Bergman and Richard Horn, *Recombinant Do-Re-Mi: Frontiers of the Rock Era* (New York: Quill, 1985) 93–97.

9. She says this in response to Block's observation: "You seem very ambivalent about technology—fascinated, yet convinced that it may prove malignant and lethal."

10. See John Berger, *Ways of Seeing.* (London: BBC and Penguin Books, 1972) 45–64; Laura Mulvey, "Visual Pleasure and Narrative Cinema," *Screen 16,* no.3 (Autumn 197) 6–18; Teresa de Lauretis, *Alice Doesn't: Feminism, Semiotics, Cinema* (Bloomington: Indiana University Press, 1984). Susan Rubin Suleiman, ed., *The Female Body in Western Culture.* (Cambridge, Mass.:Harvard University Press, 1986) See also Chapter 3 of *Feminine Endings*.

11. The "living doll" image in conjunction with Anderson is John Mowitt's. See his "Performance Theory as the Work of Laurie Anderson," *Discourse 12,* no. 2 (1990). I wish to thank John for permitting me to read the prepared typescript.

See also Donna Haraway, "A Manifesto for Cyborgs: Science, Technology, and Socialist Feminism in the 1980's," *Socialist Review 80* (1985): 65–107.

12. Owens, "Amplifications: Laurie Anderson," *Art in America* (March 1981) "*United States II* marked Anderson's recent transformation from a radiant Midwestern Madonna into a expressionless, neuter 'punk'—a transformation that corresponds to a shift in musical styles" (122).

13. See Chapter 7 in *Feminine Endings.*

14. See also Patrick Goldstein, "An overexposure of Home," *Los Angeles Times,* June 20, 1986, Section 6: "Anderson is so busy showing off her electronic wizardry that we never feel any sense of intimacy or identification with her performances" (1).

15. She appropriates yet another masculine prerogative when she constructs her own Other: a male counterpart produced when she speaks through the Vocoder. Later, in her voice work for the PBS series "Live from Off Center," she created a body for this voice—a compressed image of herself dressed as a man, who is known as her "Clone." The "Clone" serves as a kind of oppressed wife/assistant/slave doing all the work while Anderson typically lounges in the background.

16. See the discussions of "serious" women composers in Chapters 1 and 5 of *Feminine Endings.* For a wide range of attitudes of women composers toward gender issues, see the questionnaire by Elaine Barkin in *Perspectives of New Music* 19 (1980–81): 460–62, and the responses in *Perspectives 20* (1981–82): 288–330.

17. Helene Cixous, "The Laugh of the Medusa," trans. Keith Cohen and Paula Cohen, *New French Feminism,* ed. Elaine Marks and Isabelle de Courtivron (New York: Schocken, 1981) 245–64; and Luce Irigaray, "This Sex Which Is Not One," trans. Claudia Reeder, *New French Feminism,* 99-106. See also the following anthologies: Elaine Hedges and Ingrid Wendt, eds. *In Her Own Image: Women Working in the Arts* (Old Westbury, NY: Feminist Press, 1980) and Rozsika Parker and Griselda Pollack, eds. *Framing Feminism: Art and the Women's Movement 1970–1985.* (London: Pandora, 1987). The best-known works from this perspective are Judy Chicago, *Dinner Party: A Symbol of Our Heritage.* (New York: Anchor 1979) and *The Birth Project* (Garden City, NY: Doubleday, 1985).

18. For an excellent discussion of this debate, see Toril Moi, *Sexual/Textual Politics: Feminist Literary Theory* (London: Routledge, 1985).

19. See also Denise Riley, "Am I That Name?" *Feminism and the Category of "Women" in History.* (Minneapolis: University of Minnesota Press, 1988); and discussion of Janika Vandervelde's *Genesis II* in Chapter 5 of *Feminine Endings.*

20. "O Superman" is available on *United States* and on *Big Science* (Warner Bros. Records, WB M5 3674, 1982). The two performances are quite different, especially with respect to pacing. The former is a recording of a live performance that incorporates visuals. The latter was recorded in a studio specifically for audio

release, and it is much tighter musically since sound is its only available parameter. The piece lasts three minutes longer in the live recording.

21. See for instance, Claude Levi-Strauss, *The Raw and The Cooked*, trans. John Weightman and Doreen Weightman (New York: Harper & Row, 1975); and Ferdinand de Saussure, *Course in General Linguistics*, ed. Charles Bally and Albert Sechehaye, trans. Wade Baskin (New York: McGraw-Hill, 1966). For deconstruction, see Jacques Derrida, *Of Grammatology*, trans. Gayatri Chakravorty Spivak (Baltimore: Johns Hopkins University Press, 1976). A useful guide to this complex terrain is Christopher Norris, *Deconstruction: Theory and Practice* (London: Methuen, 1982).

22. See my "Pitches, Expression, Ideology: An Exercise in Mediation," *Enclitic* 7, no. 1 (Spring 1983) 76–86. For more on theories of narrative in tonality and sonata, see Chapters 1, 3, and 5 of *Feminine Endings*.

23. This sense of narrative security is not universally desirable, however. In both his theories and music Arnold Schoenberg resisted precisely these "givens" of tonality, though his solutions were very different from Anderson's. See the discussions in Chapters 1 and 4 of *Feminine Endings*.

24. See also Jean-François Lyotard, "Several Silences," trans. Joseph Maier, in *Driftworks*, ed. Roger McKean (New York: Semiotext(e), 1984) 95–98, for a discussion of the depth-producing premises of tonal music and the implications of both serialism and Cage's experimentation.

25. This is what has been called "the postmodern condition." See Jean-François Lyotard, *The Postmodern Condition: A Report on Knowledge,* trans. Geoff Bennington and Brian Massumi (Minneapolis: University of Minnesota Press, 1984) for a discussion of the breakdown in the great narratives of Western culture. For some extremely perceptive discussions of Anderson as a postmodern artist par excellence, see Craig Owens, "Discourse of Others: Feminists and Postmodernism," *The Anti-Aesthetic: Essays on Postmodern Culture*, ed. Hal Foster (Port Townsend, Wash.: Bay Press, 1983) 57–82; Owens, "The Allegorical Impulse: Toward a Theory of Postmodernism"; *Art after Modernism: Rethinking Representation,* ed. Brian Wallis (Boston: David R. Godine, 1984); and Fred Pfeil, "Postmodernism as a 'Structure of Feeling,'" *Marxism and Interpretation of Culture,* ed. Cary Nelson and Lawrence Grossberg (Urbana: University of Illinois Press, 1988) 381–403.

26. See, for instance, the reaction of Allan Bloom, *The Closing of the American Mind* (New York: Simon & Schuster, 1987).

27. See Anders Stephanson, "Interview with Cornel West," in *Universal Abandon? The Politics of Postmodernism*, ed. Andrew Ross (Minneapolis: University of Minnesota Press, 1988) 269–86. See also Edward W. Said, "Opponents, Audiences, Constituencies and Community," *Anti-Aesthetic*, 135–59.

28. For a discussion of the emergence of twentieth-century formalist music theory, see Chapter 4 of *Feminine Endings*.

29. For discussions of how narrative closure operates in music, see Catherine Clement, *Opera, or the Undoing of Women*, trans. Betsy Wing (Minneapolis: University of Minnesota Press, 1988) and also Chapters 1, 3, 4, and 5 of *Feminine Endings*. *Carmen* is dealt with extensively in Chapter 3, *Salome* in Chapter 4. For a discussion of how narrative in general works with respect to gender, see de Lauretis, "The Violence of Rhetoric," in *Technologies of Gender*, 42–48.

 Quite a bit of feminist work has been done on the Adam and Eve story as presented in Genesis. Donna Haraway, in "Manifesto for Cyborgs: Science, Technology, and Socialist Feminism in the 1980s," (see *Socialist Review* [1985] 80: 65-108), rereads this story of origin as a struggle for language. See also Elaine Pagals, *Adam, Eve, and the Serpent* (New York: Random House, 1988) and Kim Chernin, *Reinventing Eve* (New York: Harper & Row, 1987).

30. See the discussion of Beethoven's *Ninth Symphony* in Chapter 5 of *Feminine Endings*.

31. For a new epistemology that argues persuasively that all human knowledge is grounded metaphorically in bodily experience, see Mark Johnson, *The Body in the Mind: The Bodily Basis of Meaning, Imagination, and Reason* (Chicago: University of Chicago Press, 1987). Johnson's formulation is extremely useful for avoiding disembodied rationalism on the one hand and unmediated essentialism on the other. See the discussion of Johnson in Chapter 1 of *Feminine Endings*.

32. See Julia Kristeva, "Women's Time," in *Critical Theory Since 1965*, ed. Hazard Adams and Leroy Searle (Tallahassee: Florida State University Press, 1986) 471–84.

Works Cited

Anderson, Laurie. "Closed Circuits." in *United States.* Burbank, CA; New York: Warner Bros. 1984.

———. "Langue d'amour," in *United States.* Burbank, CA: Warner Bros. 1984a and *Mister Heartbreak.* Burbank, CA: Warner Bros.1984b.

Baudrillard, Jean. *Selected Writings,* ed. Mark Poster. Palo Alto, CA: Stanford University Press, 1988.

Bergman, Billy and Richard Horn. *Recombinant Do-Re-Mi: Frontiers of the Rock Era.* New York: Quill, 1985.

Block, Adam. "Laurie Anderson in Her Own Voice," *Mother Jones* 10 (August/September 1985): 42, 44.

De Lauretis, Teresa. "The Technology of Gender." *Technologies of Gender: Essays on Theory, Film and Fiction.* Bloomington: Indiana University Press, 1987.

Doane, Mary Ann. "The Voice in the Cinema: The Articulation of Body and Space." *Yale French Studies* 60 (1980): 33–50.

Jameson, Fredric. "Postmodernism and Consumer Society," Ed. Hal Foster, *Anti-Aesthetic,* Port Townsend, WA: Bay Press, 111–25.

Leppert, Richard. "Music, Representation, and Social Order in Early Modern Europe," *Cultural Critique* 12 (spring 1989): 26.

McClary, Susan. *Feminine Endings, Music, Gender, and Sexuality.* Minneapolis: University of Minnesota Press, 1991.

Morgan, Robert. "Musical Time/Musical Space." *Critical Inquiry* 7 (1980): 530–34, 627–28.

Rockwell, John. "Laurie Anderson: Women Composers, Performance Art and the Perils of Fashion," *All American Music.* New York: Alfred A. Knopf, 1983.

Chapter 8

Erecting a Statue of an Unknown Goddess in Amy Tan's *The Kitchen God's Wife** (1991)

Phillipa Kafka

Amy Tan (b. 1952) (fig. 24), the only daughter of recent Chinese immigrants, was born in Oakland, California and appropriately named "An-mei," blessing from America.

The character of Jimmy Louie in Tan's The Kitchen God's Wife *(1991) is based on the author's father, John Yueh-han, a Beijing-educated engineer who worked for the United States Information Services during World War II and ultimately became a Baptist minister. Several characters in various works are based on the author's mother, Daisy Ching, most notably the character of Winnie Louie in* The Kitchen God's Wife. *Although she has recently been diagnosed with Alzheimer's disease, her invaluable memories of her experience of what it was like to be a female in China from 1923 to the end of World War II in 1945 will endure forever in her daughter's monumental work.*

In 1966, after her older brother and father both died of brain tumors, Tan's mother took Amy and her younger brother to Europe. At this time, the author discovered that her mother had been married previously in China and had left three daughters there when she emigrated to the United States with her second husband. This tragic situation appears in The Joy Luck Club *and again in* The

* This essay contains passages from an original chapter on Amy Tan in my book *(Un)Doing the Missionary Position: Gender Asymmetry in Contemporary Asian American Women's Writings*, Greenwood Press, 1997; an imprint of Greenwood Publishing Group, Inc., Westport, CT.

Figure 24. Amy Tan

Kitchen God's Wife, *which also contains the 1987 trip to China that the author made with her mother to reunite with her Chinese children.*

Tan attended high school in Switzerland and eight different colleges. At one of them, Linfield College, a small Baptist college in Oregon, she met Lou DeMattei, a tax attorney, whom she married in 1974. She earned a bachelor's degree in English and linguistics (1973) and a master's degree in linguistics from San Jose State University (1974). Tan tried a wide variety of jobs as bartender,

switchboard operator, A&W carhop, pizza maker, teacher of devel-
opmentally disabled children, horoscope writer, and finally a
freelance business writer for IBM, ATT, and Apple before writing
The Joy Luck Club.

Celebrated primarily as the author of the phenomenally success-
ful The Joy Luck Club, *which won the Los Angeles Book Award and*
the National Book Award, Tan also wrote the screenplay for the
book of short stories when it became one of the few Asian Ameri-
can works to be mainstreamed into a Hollywood movie. In addition
to The Kitchen God's Wife *(1991), Tan has published* The Hundred
Secret Senses *(1996) and two children's books. The author lives in*
San Francisco and New York.

Of the younger generation of Asian American women authors, Tan most
closely follows Maxine Hong Kingston's feminist lead in *The Woman
Warrior* (1977) in reversing traditional Chinese gender perspectives.
Winnie, the major character in *The Kitchen God's Wife*, can be defined
as feminist by the end of her life. This is the case because she opposes the
constraints of her cultural indoctrination and critiques, as illustrated in her
erection of a statue to a goddess, Lady Sorrowfree, in place of a male
god, the Kitchen God.

Scholars who have studied the Sung dynasty (1126–1278 A. D.) de-
scribe the Chinese belief that in the beginning there was "one abstract
principle" and that this principle was "the first cause of all existence.
When it first moved, its breath produced the great male principle (yang)
and when it rested it produced the female principle (yin)" (Bloomfield 9).
One of the key tenets of this Chinese worldview is that there is a yin/
yang relationship between male and female and that this is the fundamen-
tal basis for all relationships. Tan, through Winnie's act, substitutes the
mother-daughter relationship as the fundamental basis for all relationships.

In Louis Chu's novel *Eat a Bowl of Tea* (1961), the husband of a
woman who commits adultery accepts fatherhood of the child. The critic
Ruth Y. Hsiao argues that this is the first time such a heresy is permitted
in Chinese/Chinese American literature, that "overtly or subversively, the
literature has repeatedly attacked the Confucian fathers" (154). But Winnie's
construction and naming of a statue to an unknown female goddess in
place of a male god is more than an attack on the Confucian fathers. The
new mother goddess is a daring heretical ideological displacement of tra-
ditional Chinese iconography. Removing the Kitchen God, a capricious

and sexist male deity, from his time-honored niche and replacing him, instead, with an anonymous female statue, Winnie paints her gold, names her, and decrees that she should be worshiped as Lady Sorrowfree.

In traditional Chinese literature, females and female issues and relationships are of little consequence, always peripheral to the manifold masculine activities and heroics of villains and heroes alike. Through Winnie's act, Tan applies the Confucian model of yin/yang in relation to men and women, not to male-female, but to mother/daughter relations instead, by substituting the never-ending, circular flow of continuity as from mother to daughter.

Unless the older generation's stories are transmitted to the next generation of women, all their struggles will go for naught. Only when this is done, as when Winnie tells her story to her daughter, can a productive syncretism become possible. Communication is necessary between the Asian immigrant mother generation—Mother Courage ("Winnie, "a winner")—and the Asian American daughter ("Pearl," the post-colonial pearl of great price). Each generation will judge older women and find them wanting, as is so painfully the case throughout *The Joy Luck Club* and *The Kitchen God's Wife*. There will then exist the gap between each woman in an endless discontinuity of generations that the system of patriarchy creates and perpetuates, instead of the flow.

In order to make her case against the Kitchen God patriarchy as strong as possible, Tan has constructed Winnie's first husband, Wen Fu, as its extreme by-product. The excruciating details of Winnie's long struggles over years of marriage to Wen Fu (metaphorically, the Kitchen God) are set within the context of the patriarchal Chinese culture from around 1930 to 1945.

Unlike the rest of his group of pilot comrades, who all die, Wen Fu survives the Japanese war against China. He survives everything, as Tan's commentary on the incredible staying power of the patriarchal extremes of the Kitchen God system he embodies. Tan's pun on the cause of Wen Fu's death near the end of the novel—"heart failure"—is an especially powerful choice of illnesses, because she has depicted him time and again throughout the text as the most heartless of men. Ironically, both Winnie's husbands die from heart disease. The first had too little "heart" but dies a slow, dignified death surrounded to the end by loving friends and family. The second, Jimmy Louie, had too much "heart." A genuinely good man, a Baptist minister, he dies young and suddenly from a heart attack.

Wen Fu first charms and plays with women and then seduces and/or rapes them, even murders one, and is responsible for two of their suicides. While Winnie is away in the hospital bearing their child, he even

sleeps with a mistress in his wife's bed and repeatedly rapes a fourteen-year-old servant girl who becomes pregnant and later dies while trying to abort the fetus.[1] After Wen Fu chases his mistress away, he returns to Winnie's bed, while continuing to sleep with many other women. He can do this, Winnie concludes, because women were all alike to him, "like a piece of furniture to sit on, or a pair of chopsticks for everyday use" (282).

After Winnie becomes disenchanted with him, he performs sadistic, perverse, and painful sex acts on her. His brutality even extends to violently beating their baby and allowing it to die. When Winnie brings the dying child for a second and last time to Wen Fu, to the group in which he is seated playing mah jong, Wen Fu calls her a "stupid woman" for not telling him that the child was so ill. To add insult to injury, to say the least, he next makes a loud public cry of outrage at her lack of maternal feeling: "What kind of mother are you!" he demands (266). Later, she is even jailed because the authorities believe his charge that she is an unfit mother. Just as humiliating, during her trial, she is judged from Wen Fu's point of view in sensationalized front page newspaper items replete with photographs of Winnie and her lover, Jimmy Louie.

Interestingly, Winnie felt no anger in these early stages of her life because she had not been trained that there was such a response possible for a Chinese woman, ever. "This was China. A woman had no right to be angry" (170). The anger Winnie conveys during her narration is anachronistic. It erupts into her consciousness only after years of abuse and oppression by her husband, her gatekeepers, and her sexist culture.

Wen Fu shamelessly uses his uniform and war record to bluster about his sacrifices wherever he goes. Actually, his grotesque appearance, injuries, and disabilities were the results of an adulterous junket. With Winnie's dowry money Wen Fu buys a car for himself, which he promptly destroys in a joy ride. Later, he gets into an accident with a jeep he had commandeered without permission. While speeding, he almost runs into a truck. A girl he had taken with him is killed, "crushed underneath" the vehicle (248).

Because Winnie meets another man at an officers' dance and dances with him, Wen Fu pulls her by the hair and throws her to the floor once they return home. Pointing a gun at her head, he makes her fill out divorce papers (which she eagerly does). He then informs her that as a divorced woman she is now worthless because she has "no husband . . . no home . . . no son" (308). He then demands she kneel down on the floor at his feet and beg him not to divorce her, to tear up the papers. With the gun still at her head, he proceeds to rape her, "telling me I had lost the privileges of a wife and now had only the duties of a whore." He

forces her to "do one terrible thing after another. He made me murmur thanks to him. He made me beg for more of his punishment. I did all these things until I was senseless, laughing and crying, all feeling in my body gone" (309). The following morning she leaves Wen Fu, but he finds her with the help of a neighbor, Helen, who informs him of Winnie's hiding place when he demands the information of her.

After the war ends, Wen Fu, Winnie, and their son return to Shanghai to her father's house. Here Wen Fu literally and metaphorically proceeds to undermine and destroy Winnie's patrimony. Armed with his army record as a hero against the Japanese, he takes over his father-in-law's decaying mansion because the old man had collaborated with the enemy and enters into an orgy of "selling and spending" for his own benefit. For example, he sells a "magistrate's table" that had been in the family "for many generations, at least two hundred years" (329). When it can't get through the door and the purchaser wishes his money back, Wen Fu takes a chair and cracks the carved table legs in half. If anyone attempts to say one word against him, he blackmails them with being thrown in jail "along with this traitor [Winnie's father]" (330). Throughout the time of this stay, Wen Fu treats Winnie as if she "were a folding chair" (330), rolling her over, unbending her arms and legs with no words exchanged. When he would return to his room, she would immediately wash herself where he touched her and throw the water out the window.

Winnie's mother-in-law, her cousin Peanut's mother-in-law, as well as all the mothers-in-law in this novel are described as obedient to their culture's prescription for mothering men. According to Tan, they created monsters when they backed their sons totally, even in the sons' tantrums and egomania. They swallowed the culture's promise to them as mothers and mothers-in-law that great economic and social benefits, such as complete power over their daughters-in-law, would accrue to them once they achieved seniority. Motivated by the conviction that they act as good and proper wives and mothers when they abide by the rules of their culture, they perceive themselves as entitled to regard the property of their daughters-in-law and the daughters-in-law themselves as theirs by right of motherhood to their sons, who own their wives and their wives' property. They cannot or do not realize that they thereby perpetuate between women exploitative and abusive relationships devised by men. These female gatekeepers disrupt and destroy what would otherwise be the natural chain of continuity between generations of women.

Tan creates a scale of female characters in terms of their responses to this harsh system. Lowest on the scale are those women like Winnie's

mother-in-law who adhere with servile fidelity to their culture's prescriptions for females. Whether self-serving or unthinking, they act as "consenting subordinates" (MacLeod 553) by perpetuating injustices against their own kind. As Michel Foucault puts it, they impose whatever their culture's "regime of truth" (131) dictates for those females who are within their sphere of influence as junior and subordinate to themselves in the hierarchy. They suppress themselves and other females and thereby collude in their culture's oppression of women.

Like Hong Kingston before her, Tan represents these gatekeepers as using "brainwashing" on their charges, primarily in the form of adages. One of Tan's favorite techniques for conveying her antagonism to the patriarchy is to have the adage-givers expose the evils of the system by means of the very adages they cite to reinforce it. As Maxine of *The Woman Warrior* was raised by her mother, so Winnie of *The Kitchen God's Wife* is raised by Old Aunt with dire threats and frightening stories. This is the Chinese way of ensuring obedience, according to Winnie:

> Giving threats to children was the custom in old families like ours. Old Aunt's mother probably did this to her when she was a child, handing out warnings about another kind of life, too terrible to imagine—also giving examples of obedient children too good to be true. This is how you made children behave. This was how you drove selfish thoughts out of their foolish heads. This was how you showed you were concerned for their future, teaching them how they too could keep order in the family" (132–34).

Old Aunt, who represents the traditional Chinese matron, relentlessly stuffs cultural prescriptions into her younger female charges. "The girls' eyes should never be used for reading, only for sewing. The girls' ears should never be used for listening to ideas, only to orders. The girls' lips should be small, rarely used, except to express appreciation or ask for approval" (102). She seizes upon Winnie's first menstruation as an opportunity to indoctrinate the child further: "The bleeding is a sign. When a girl starts having unclean thoughts, her body must purge itself. That is why so much blood is coming out. Later . . . if she becomes a good wife and loves her husband, this will stop" (183).

Sad endings were reserved for girls who married only for love "with scary morals given at the end: Lose control, lose your life!. . . Fall in love, fall into disgrace! . . . Throw away family values, throw your face [honor, reputation] away!" (340). These endings used to make Winnie cry the most because they reminded her of her mother's disgrace. Old Aunt blamed Christian missionaries for this tragedy: "The foreign teachers want to

overturn all order in the world. Confucius is bad, Jesus is good! Girls can be teachers, girls do not have to marry . . . Upside-down thinking!—that's what got her into trouble" (103).[2]

After Winnie marries, she undergoes the torture of traditional Chinese marriage customs, a kind of graduate school of obedience training under her gatekeeper mother-in-law's tutelage. Some of this woman's choice sayings were:

> To protect my husband so he would protect me. To fear him and think this was respect. To make him a proper hot soup, which was ready to serve only when I had scalded my little finger testing it. . . . "Doesn't hurt!" my mother- in-law would exclaim if I shouted in pain. "That kind of sacrifice for a husband never hurts (168).

In a remarkable exhibition of acuity, Winnie blames her mother-in-law, not Wen Fu, for tending "to all his desires as if she were his servant, for always feeding husband and son first, for allowing me to eat only after I had picked off bits of food stuck to my father-in-law's beard, for letting the meanness in her son grow like a strange appetite, so that he would always feel hungry to feed his own power." This passage is followed by another, even more remarkable one. Winnie realizes that in blaming her gatekeeper mother-in-law, she is blaming "another woman for my own miseries." She attributes it to the way she was raised in her culture: "never to criticize men or the society they ruled, or Confucius, that awful man who made that society. I could blame only other women who were more afraid than I"(257).

It takes a rare combination of intelligence and compassion to see beyond one's oppressor(s) to the system that sets the hierarchies of oppression in place. Winnie reasons that fear is trained into women by the culture and that women's obedient passivity rather than active opportunism reinforces the system. Still, she blames women gatekeepers, especially women as mothers, despite her conviction that fear kept them in place. She even distances her present self from her youthful self. Whenever her baby girl would begin to cry in response to Wen Fu's noisy shouting, the infant "would not stop until I told her more lies" such as, "if she were good, her life will be good too." Winnie has spent many years observing her culture, her own and other women's indoctrination, and meditating about her own and other women's oppression in Chinese culture by the time she demands of Pearl: "How could I know that this is how a mother teaches her daughter to be afraid?" (258)

At the other end of the scale from gatekeepers are women who pay a steep price for open rebellion against the system. They are made to expe-

rience loss, abandonment, suicide, death, or death in life: social ostracism. Nevertheless, these heroic women continue to attempt to improve intolerable conditions and are forced to flee in order to fight again elsewhere. For example, Winnie's cousin Peanut, married to a homosexual husband, hides out in a battered women's shelter from her intolerable situation before escaping Shanghai with a Communist lover; Winnie's mother escapes into the hills to join Mao, also with a Communist lover, and Winnie finally escapes to the United States with the aid of a Chinese American lover, her future second husband.

Winnie's eternal sense of mother-loss goes forever unrequited. As a grown woman, she views her mother as a young girl sold into a miserable polygamous marriage. Passionately devoted to a revolutionary ideal that would change China forever, she chose exile/death/freedom over her own personal love for her child. More likely, however, Winnie's mother felt that leaving Winnie to live with her wealthy father, other wives, and numerous siblings would lessen the little girl's suffering and sense of loss. At the very least, Winnie could continue her comfortable existence. Or perhaps she chose to sacrifice her private pleasures, small as they were, for what she and millions of other men and women considered a far higher cause than personal feelings. Either way, Winnie's mother did not factor in her child's sense of irrevocable loss and abandonment or her husband's loss of face to the point where he could not bear to look at Winnie. As a result, he exiled her to his brother's home, where she was treated as an orphaned outsider. Tan thereby subverts the original context of the traditional Chinese cautionary tale of the runaway wife by representing Winnie's mother's flight as from an intolerable political situation in which women's domestic situation serves as but one example of feudal oppression and the denial of their human rights. Winnie, in keeping with the tradition begun by her mother, also flees her marital prison on these grounds.

One of the most effective ways of stopping women from escape is through social ostracism, to deny that the rebel even exists. Winnie's runaway mother is turned into an object of pity and victimization by the family's public face-saving claim that she has committed suicide. No matter what story is made up about the rebel, she is still excised from the rolls of the family, the community, the body politic, the culture, as Hong Kingston had described to her readers as the fate of her No-Name Aunt in *The Woman Warrior*.

Miserable under the Confucian Chinese system of polygamy, as well as with class inequities, Winnie's mother cuts her hair and runs away to become a Communist revolutionary. An old friend of her father's "bought"

Winnie's mother as a "second second" wife to substitute for his first second wife who had just committed suicide. But before her enforced marriage to Old Jiang, she had chosen for her male companion a brilliant young Marxist student from the country, from a family of fishermen. And although she had been trained in a Christian missionary school, her choice of a peasant Communist male reveals that she had rejected both the Confucian philosophy and the Christian religion by turning to Communism.

Now past seventy, Winnie still remains inconsolable:

> In my heart, there is a little room. And in that room is a little girl, still six years old. She is always waiting, an achy hoping, hoping beyond reason. She is sure the door will fly open, any minute now. And sure enough, it does, and her mother runs in. And the pain in the little girl's heart is instantly gone, forgotten. Because now her mother is lifting her up, high up in the air, laughing and crying, crying and laughing, 'Syin ke, syin ke! There you are! (109).

Later on, when Winnie creates Lady Sorrowfree and describes for Pearl the benefits the goddess will bring future generations of women, she uses identical language. Historically, many such stories about "runaway wives" (as the Chinese folktales define these rebels) are similar in every culture and generation. Such cautionary tales prevent continuity, forcing each new generation of rebellious women to reinvent the movement of opposition anew. Winnie's gradual and arduous transition—from obedient acceptance, to questioning, to disbelief, to revision and subversion of her culture's dictates—is rare.

Midway in Tan's scale between the collaborators and the rebels, she places the saboteurs, the covert revisionists who attempt by a variety of means to manipulate the cultural order in order to improve their situations. Sadly, *ad hoc* problem solving provides temporary, personal relief only for themselves and their friends and relatives.

When Winnie first meets her, Helen, her neighbor, is a crude, earthy country girl just Winnie's age who is married to Wen Fu's fellow officer. At first, Winnie confides in Helen that her husband is forcing her to have sex with him even while she is pregnant, but Helen upbraids her instead of giving her much-needed sympathy and support. She demands of Winnie why she shouldn't do this for her husband, because when he loses interest in her he will go elsewhere. Then Winnie will truly find out what unhappiness with a husband is all about. She ends her harangue with a folk saying, a habit also characteristic of her: "Eh, if you think a dish won't be cooked right, then of course, when you taste it, it won't be right" (188). Winnie, from the mandarin class, finds Helen coarse and vulgar, especially about her body functions. As a result, she feels superior to her. She

is convinced that she has nothing in common with her but accidental propinquity, an elitist attitude she retains to some degree all her life, although she always sympathizes with the lower classes philosophically.

By 1990, it appears to Winnie's daughter Pearl that her mother has an elderly sister-in-law, one with whom she battles and for whom she frequently expresses contempt, while they remain in a close and enduring relationship with one another. Here again readers can observe Tan's transformation of the pattern of yin/yang:

> No one would believe me now if I said Helen is not my sister-in-law. She is not related by blood, not even by marriage. She is not someone I chose as my friend. Sometimes I do not even enjoy her company. I do not agree with her opinions. I do not admire her character. And yet we are closer perhaps than sisters, related by fate, joined by debts. I have kept her secrets. She has kept mine. And we have a kind of loyalty that has no word in this country (72–73).

Winnie and Helen begin their relationship only because they are neighbors. As such, it is impossible for Helen not to know what Wen Fu was like. Yet she and her great-aunt Du, who lives with her, appear not to notice. Because Helen is childless, Winnie assumes that Helen's lack of sympathy is due to jealousy. However, at the end of the book, Winnie suddenly discovers that Helen (as well as Auntie Du) did know and did care all along. Helen had handled the situation in her own way—shrewdly, indirectly, covertly. She is not the collaborationist she appears to be, but a saboteur. She fights guerrilla warfare, with maximum safety for herself and her allies.

Helen's primary concern all along was that Winnie's husband should never realize that she did know about all his evil doings. If so, she brilliantly reasoned, he would have deprived Winnie of her proximity, of whatever small comfort she could be to her. This revelation is amazing in its profundity—that a woman who seems so insensitive and so self-absorbed as Helen should all the time have known and cared and have had her friend's best interests at heart! Scholar Nilda Rimonte points out the relevant difference between Pacific Asians' and white women's acculturation: Pacific Asian women "traditionally conceal and deny problems [such as domestic violence] that threaten group pride and may bring on shame" (328). Rimonte attributes this to heavily inscribed training in these women to avoid disgracing or dishonoring one's family at almost any cost, including one's own well-being. As Winnie tells Pearl:

> In China back then, you were always responsible to somebody else. It's not like here in the United States—freedom, independence, individual thinking, do what you want, disobey your mother. No such thing. Nobody ever said to me, Be good,

little girl, and I will give you a piece of candy. You did not get a reward for being good, that was expected. But if you were bad—your family could do anything to you, no reason needed (132).

Rimonte believes that if the oppression of Asian American men were "removed from the environment," they would stop abusing their women (328). She claims that because the man's culture accords him "privileges and esteemed place," he feels that his woman should adhere to traditional culture, which benefits only himself. If she rejects her culture, she is therefore rejecting her man (329). This is Wen Fu's point of view as well. In actuality, the problem is not due to changes that threaten the man. Patriarchy itself leads to abusive tendencies. Without checks and balances, all situations where one individual or one group dominates over others lead to abuse of the dominated by the dominant.

In musing about why Helen and she are still friends, Winnie concludes not so much that they are alike in any way, but that neither woman had anyone else "to turn to" and that this isolated situation still persists for them (194). Whatever else is true, Winnie and Helen "dare to be themselves—to listen to their own pains, to report the ravages, and finally, to persist in finding strengths from sources that have caused inestimable anguish" (Cheung, *Reading the Literature* 184).

Now in 1990, Winnie and Helen are living out their long lives as squabbling partners in a jointly owned florist shop. Nevertheless, an undying sense of connectedness due to shared past sufferings underlies their essential class differences. Helen has come from such great poverty that at one time she had to dole out beans by number to her sister. Winnie loves Auntie Du, as well, for many reasons, primarily for her courage, honesty, and loyalty. Even though both Auntie Du and Helen were trained to internalize gender asymmetry and therefore served Wen Fu's side too long, eventually both women apologized to Winnie for doing so and proceeded to forge the closest of lifelong ties with her. More than that, both women assisted Winnie in her quest for freedom from Wen Fu and in whatever else she needed. At the end of the book, Helen is even returning to China with Winnie.

Winnie does not entirely blame the female gatekeepers, the collaborationists like her maternal grandmother, or her Old and New Aunts. She does not even entirely blame her mother-in-law and her father's other wives, who had made her mother and herself so miserable with their endless intrigues against one another to secure Old Jiang's favor. Such women are unthinking participants in their own oppression for a long time before they take a stand, if they ever do, as Helen and her aunt

finally did. In having these former collaborators rise up against the system, Tan reveals yet another way for women to relate to it. They repudiate the system and befriend Winnie, although extremely late in the game. It is only on page 411 of a 415-page book that Helen finally admits "something": not that she lied, but that she "said many wrong things" (411).

Wen Fu is not only an awful husband as an individual, but every one of his problematic features of personality, conduct, and attitude is meant by Tan to signify the Chinese codes for male gender behavior carried to extreme limits. It is therefore highly significant when Helen admits that "I always told you Wen Fu was not a bad man, not as bad as you said. But all along I knew. He was bad. He was awful!" She waved her hand under her nose, chasing away a big stink. . . . "I tried to make you think he was a nice man" (411). Helen's sudden reversal is shocking, since for years she had justified Wen Fu's evil behavior on the flimsy grounds of his disfiguring accident. Further, in the process of making such an admission, Helen now reveals to Winnie that she lied to protect Pearl, to prevent Winnie from blaming Pearl because she was his daughter: "He was mean, a very bad man" (412), she concludes, as does the novel.

Yet another form of subversion on a lower scale is revealed by Winnie's Old and New Aunts (her paternal uncle's first and second wives). Publicly, New Aunt loudly objects to her daughter's leaving her husband and joining the Communists. She says terrible things about Winnie's cousin Peanut when Winnie expresses her wish to see her. Suddenly, in the midst of her vituperation, New Aunt throws "a piece of paper on the bed" and leaves. A few minutes later, Old Aunt enters Winnie's room and puts "a small wrapped package" (339) in the same place, claiming as she does so that she had borrowed something from a friend and wanted it delivered. The addresses on both the package and the piece of paper are identical. By this means, Tan conveys that these collaborators do not practice what they preach. Their concern for Peanut causes them to send her assistance while publicly vilifying and disowning the female rebel.

Despite the fact that in China the community formed by fathers' and uncles' wives was an enforced one occasioned by polygamy, nevertheless, women forged a community of friendship and assistance in order to "gather strength through a female network" (Cheung, *Reading the Literature* 172). Tan would add that they did this not so much to ease the force of the blows against them from a harsh and hostile world, but to subvert, transform, and even rebel against it.

Instead of hating her husband's mistress as she is trained to do, Winnie identifies strongly with Min. She feels compassion for her "pretty skin,

foolish heart, strong will, scared bones." It seems a great tragedy to her that the war had made many, such as Min, so "full of fear, [so] desperate to live" that they could stomach men like Wen Fu as lovers. Consequently, she perceives their sisterhood in oppression, that she "was no better than [Min] was" (272), despite their differences in class and therefore in treatment.

Min would tell Winnie risqué stories (which seemed glamorous to the sheltered, upper class young woman) about "old boyfriends, dance parties . . . Shanghai nightclubs" where she had worked as a singer and dancer. She had also worked in an act that emphasized sadism against women in "an amusement arcade in the French concession catering to foreign customers, a very wicked and dangerous place for women" (273). She had also sung to "entertain crowds in the open restaurants" (275) at Sincere, the department store on Nanking Road, until the store was bombed.

For these reasons, not despite them, Winnie found Min to be "good company," as well as a "sincere" woman who appreciated Winnie's cooking, admired her jewelry and clothes, and "never complained, never ordered the servants around . . . thanking them for the smallest favor." She would also help Winnie by taking her baby and holding him when he cried (273). Winnie also admires the girl's resiliency, despite the ever-downward trajectory of her life. Before Wen Fu casts Min out, the many good times the young women have together provide the only rays of sunshine in their otherwise drab lives. They take endless pleasure in one another's company, especially while dancing together. Some years later when Winnie learns that Min ended her life in suicide, she genuinely grieves for her.[3]

In the person of her own hostile spouse, Tan represents the result of Winnie's having to confront a powerful enemy every day of her life. Her nightmarish life with him has inadvertently shaped her into a far stronger woman than she would otherwise have been had she obediently followed her training without question. Nevertheless, the reformative act for which Winnie will live in literary history becomes real only when Winnie bridges the gap with Pearl by sharing her past with her daughter. Tan has shaped and organized the novel to prepare readers for the message at the end of the text through Winnie's present of the Kitchen God to her daughter. At first, Pearl is flippant about the strange gift her mother forces on her. Winnie explains that the Kitchen God is occasionally "in a bad mood." If he is, and if he doesn't like a family, he will "give them bad luck." If he does this, then the family is "in trouble" and there is absolutely nothing they "can do about it." This being the case, Winnie demands, "Why should

I want that kind of person to judge me, a man who cheated on his wife? His wife was the good one, not him" (55).

In brief, this is the story of the Kitchen God as Winnie tells it, according to Pearl. A rich farmer blessed with a hardworking wife "had everything he could ask for—from the water, the earth, and the heavens above" (54). But "he wanted to play with a pretty, carefree woman named Lady Li." He brought her home and "made his wife cook for her." He then allowed Lady Li to chase "his wife out of the house." The two lovers despoiled his land and emptied his pockets. Once everything was all gone, Lady Li ran off with another man. Zhang became a beggar and began to starve. One day he fainted and awoke to find himself being cared for in his wife's house. He "jumped into the kitchen fire just as his wife walked in the room"—and ended up "burning with shame and, of course, because of the hot roaring fire below" (54–55). When the Jade Emperor in heaven heard everything, he made Zhang a Kitchen God "for having the courage to admit you were wrong. . . . Every year, you let me know who deserves good luck, who deserves bad" (55).

Winnie also separates herself from and critiques Christianity. "When Jesus was born, he was already the son of God. I was the daughter of someone who ran away, a big disgrace. And when Jesus suffered, everyone worshiped him. Nobody worshiped me for living with Wen Fu. I was like that wife of Kitchen God. Nobody worshiped her either. He got all the excuses. He got all the credit. She was forgotten" (255).

Winnie despises the Kitchen God, much as she did Wen Fu, who shares all of the god's qualities when the latter lived as a man on earth. "He is not Santa Claus. More like a spy—FBI agent, CIA, Mafia, worse than IRS, that kind of person! And he does not give you gifts, you give *him* things [emphasis in the original]. All year long you have to show him respect—give him tea and oranges" (55). During Chinese New Year, the gifts have to be even better, because "you are hoping all the time his tongue will be sweet, his head a little drunk, so when he has his meeting with the big boss, maybe he reports good things about you" (55).

If Wen Fu epitomizes the Kitchen God, Winnie is the Kitchen God's wife. As far as Winnie is concerned, this long-suffering female nonentity has for too long served as a background foil to the Kitchen God. Let him be her foil for a change, Winnie decrees, and proceeds to make her fateful decision: "I'm thinking about it this way," she finally announced, her mouth set in an expression of thoughtfulness. "You take this altar. I can find you another kind of lucky god to put inside, not this one" (56). The examples of Winnie's experiences over a lifetime as summarized on previous pages

are encapsulated in Winnie's story of the man who was made into the Kitchen God despite his selfish nature and cruel treatment of his wife. She would disqualify him from that honor, even though he expressed that he was ashamed of himself as he died. Tan has Winnie gradually become alienated from the Kitchen God, alias Wen Fu and men like him, and distances her from the culture that oppresses women and treats men like gods on earth.

Accordingly, she removes the picture of the Kitchen God and sets out to replace the unpleasant Kitchen God with a more inspiring goddess, at least to women. First she buys a statue of "a goddess that nobody knows" that might "not yet exist" (413). She paints it gold and puts her name on the bottom, while Helen joins in her project by purchasing good incense. The goddess is going to live "in her new house, the red temple altar with two candlesticks lighting up her face from both sides. She would live there, but no one would call her Mrs. Kitchen God. Why would she want to be called that, now that she and her husband are divorced?" (414). After reading this passage, readers are now aware that Winnie and her mother are both united in the one female deity, Lady Sorrowfree.

Winnie takes Pearl up to her bedroom to advise her on the proper medicine for Pearl's multiple sclerosis and there relates to her the magical, mystical properties of the statue. Both her link to the goddess and her sardonic humor are once again in delightful evidence: "See how nicely she sits in her chair, so comfortable-looking in her manner. Look at her hair, how black it is, no worries. Although maybe she used to worry. I heard she once had many hardships in her life. So maybe her hair is dyed" (414).

She tells Pearl that the goddess wants her to speak to her, that she understands English, and that she bought the goddess for her. Finally melting at these scarcely veiled allusions to herself and her mother, Pearl cries. Winnie believes that Pearl is upset because she has paid "too much" for the goddess, an erroneous assumption though ironically correct on a deeper level. The psychic price Winnie has paid to come to this point is indeed inordinately high. Pearl is crying over what she now finally realizes is the beauty, the tragedy, the greatness of her mother, alias the Kitchen God's wife, now Lady Sorrowfree.

Winnie proceeds to explain to Pearl what the "goddess will do" for her; that is, the nature of the goddess's properties and attributes. When she is afraid, Pearl can talk to her and "she will listen. She will wash away every-thing sad with her tears. She will use her stick to chase away everything bad." Most importantly, Winnie has deified and named the anonymous

wife of a minor god "Lady Sorrowfree, happiness winning over bitterness, no regrets in this world" (414–15).

Winnie tells the story from the perspective of the Kitchen God's abused wife. She speaks to women everywhere who are abused by their menfolk. What she is attempting to do is not to change this traditional Chinese myth, but to shift its focus onto the Kitchen God's wife and attach its moral to her character. She thereby rebukes the culture that worships him while it forgets her. She has subverted the Kitchen God and retold his narrative, but in private, because at the present time there is no public forum worldwide to support and validate Winnie's revisionism.[4]

By confronting the existing order and shaping it to her needs, Winnie goes even further than any of the other women characters represented by Tan as challenging patriarchy. This includes Winnie's mother, who rebels against her culture, but within the confines of Communism, which, when all is said and done, is an all-male-run system seeking to rival an already existing all-male-run system.

Winnie creates a goddess, Lady Sorrowfree, out of her own needs, her own vision, her own interests. By so doing, Winnie is making a statement. If men can allocate to themselves the right to create their own deities and their own myths, then women can also. Winnie questions why women must go along with men's projections. From her point of view, a masculinist perspective places the focus on the Kitchen God. His wife (Everywoman) is peripheral. She fades off and is forgotten by the tale's end, except as an instrument in his death and transfiguration into the Kitchen God. Her nameless name is put in lower case—"the Kitchen God's wife"—whereas the god's name is in upper case. Yet even in the masculinist version, she alone is the one who has shown mercy. Thus from Winnie's perspective, it is the Kitchen God's wife who has been wronged. In this way, Tan suggests through the character of Winnie that women must take the initiative to point out the masculinist discourse of the existing patriarchal models and to reshape existing gods, myths, and customs in order to project and reflect themselves instead.

Winnie, in her final epiphany and transfiguration into Lady Sorrowfree, becomes her own mother in her enduring fantasy of her mother's return, when she will be lifted up and held once again in her arms. Lady Sorrowfree also reflects her feelings as a mother in relation to Pearl, especially in regard to Pearl's illness. The healing solutions Winnie calls for are women's laughter: what Hélène Cixous defines as "jouissance." Winnie promises Pearl that "when we laugh [Lady Sorrowfree will lift] our hopes, higher and higher" (415). She thereby also calls for the creation of a female

discourse, a self-autonomous female community and goddesses within the existing structures and systems.

In Winnie's seating of the new goddess on the old altar, Tan performs a linguistic and semiotic subversion that reverses the situation by creating in Lady Sorrowfree a revision of the Kitchen God's myth: "a talk story [that] allows a shift into pure fantasy . . . to project an alternative world untrammeled by the oppressive rules of society." She does this as a way of redeploying, like Hong Kingston, "fable, dream, and fantasy to evoke a world independent of time-worn rules, monocultural imperatives, and binary oppositions" (Cheung, *Articulate Silences* 123, 125). Unfortunately, the problem with Winnie's solution is that "subversive or resistant perspectives" in Tan's text "cannot undo the power of what is socially dominant" (McCormick 662).

Patriarchal "binaries" will not go away "simply through the discursive deconstruction of opposition." This can only happen "when the socioeconomic conditions producing the contradictions in society are eradicated through the construction of nonexploitative social relations" (Ebert 45).

By replacing the Kitchen God's wife with Lady Sorrowfree, Winnie imposes changes of community structure on her daughter only, but she is in a way imposing them on the white western man of science and technology to whom her daughter is married. He is Pearl's Kitchen God in the home where Winnie wants her daughter to set up an altar presided over by a goddess named Lady Sorrowfree. Under such a husband's caustic scrutiny, readers cannot imagine Pearl actually lighting incense and praying to Lady Sorrowfree for her health.

Still, the mere presence of such a goddess in a home dedicated to valorizing abstract reason, science, and technology over emotion and superstition would be subversive. Through Winnie's gift to her daughter of the statue of Lady Sorrowfree seated on her altar, Pearl will no longer totally repudiate that which is Chinese in her life (the "silly" superstitions of her mother). On the other hand, neither will she follow the Western perspective entirely. At this point, Tan reveals her resolution to Pearl's dilemma. First, she uses negative imagery associated with "Dr. Phil." Pearl's husband is a pathologist—a doctor of and to the dead. He is also totally absorbed in "playing" with his new computer. Secondly, she represents him as a master of snide and witty put-downs at his mother-in-law's expense, as well as Pearl's. Reflecting colonial attitudes toward Other, in this case, Chinese Others as "backward" and inferior, his aim is to convince Pearl to feel that insofar as she adheres to her ancestral

"Chineseness," she is exposing an irrational, emotional weakness for an inferior culture. He makes her feel ashamed to display affinity for her mother's Chinese ways of knowing or any desire to perpetuate them. And he has succeeded up to the moment in time when Pearl hesitantly accepts her mother's gift. By intruding Lady Sorrowfree into the domestic space she shares with her husband and two small daughters, Tan insinuates that Pearl might combine both ways and in so doing might just carve out her own unique way.

Notes

1. This is a connubial detail not uncommon in ethnic American women's literature. See Sandra Cisneros, "Woman Hollering Creek" in *Woman Hollering Creek and Other Stories* (New York: Vintage, 1992) p. 50, for example.

2. This is also an oblique reference to the Boxer Rebellion at the turn of the century. Boxers opposed, among other violations of Chinese sovereignty, the unwarranted intrusion into their country of "foreign teachers"–European and American racist and religious zealots. These were Christian missionaries who built Christian churches and schools on Chinese land for the express purpose of imposing a "superior" religion on the "heathen" Chinese.

3. This is much like the source of Celie's attraction for Shug in Alice Walker's *The Color Purple* (New York: Harcourt, 1982). There is an attraction of opposites, who are opposites only in experience and not actually in perspective. Interestingly, both Celie and Winnie become extremely attached to their husband's mistresses rather than becoming distanced and inimical, as their respective cultures would decree. Also possibly intimated is an attraction that Winnie feels for Min. It is she who suggests that Min call herself "Miss Golden Throat," which Min does in her future career.

4. I am unaware of any goddess created by women for women from a female perspective within a culturally sanctioned and approved public female-centered mythology. I am only aware that some feminists have claimed that originally there were female goddesses, such as fertility goddesses. The claim has even been made that some depictions of these goddesses holding infants were painted over after Christianity and made to represent Mary and the infant Christ. But in all existing cultures that still worship fertility goddesses, such as Nigerian culture, they are worshiped only from well within a patriarchal perspective. They have been created as a mechanism to control and run that system by ruling males in order to perpetuate their system as well as their gender. Men are still respected and valued in and of themselves, unless they are homosexuals. In most cases homosexual men become subject to the same cultural contempt, disapproval, and ostracism as the culture affords unmarried and childless women. Fertility would hardly be the major reason for their creation of a female goddess. Lady Sorrowfree, for example, was created by and for a woman to ward off whatever brings sorrow to women, both physical and mental, and to heal illness. Since Pearl has borne only daughters, Winnie's failure to include in her list of Lady Sorrowfree's attributes the granting of fertility in general to her supplicants, or fertility specifically in producing sons, would appear to prove my point.

Works Cited

Bloomfield, Frena. *The Book of Chinese Beliefs: A Journey into the Chinese Inner World.* New York: Ballantine Books, 1989.

Cheung, King-Kok. *Articulate Silences: Hisaye Yamamoto, Maxine Hong Kingston, Joy Kogawa.* Ithaca, New York, and London: Cornell University Press, 1993.

————. "'Don't Tell': Imposed Silences in *The Color Purple* and *The Woman Warrior.*" *Reading the Literature of Asian America.* Ed. Shirley Geok-lin Lim and Amy Ling. Philadelphia: Temple University Press, 1992. 163–189.

Cisneros, Sandra. *Woman Hollering Creek and Other Stories.* New York: Vintage, 1992.

Ebert, Theresa L. "Ludic Feminism, the Body, Performance, and Labor: Bringing Materialism Back into Feminist Cultural Studies." *Cultural Critique* 23 (1993): 5–50.

Foucault, Michel. "Truth and Power." *Power and Knowledge.* Ed. and Trans. Colin Gordon, et al. New York: Pantheon Books, 1980. 109–133.

Hsaio, Ruth Y. "Facing the Incurable: Patriarchy in *Eat a Bowl of Tea.*" *Reading the Literature of Asian America.* Ed. Shirley Geok-lin Lim and Amy Ling. Philadelphia: Temple University Press, 1992. 151–162.

Kingston, Maxine Hong. *The Woman Warrior: Memoir of a Girlhood Among Ghosts.* New York: Vintage, 1977.

MacLeod, Arlene Elowe. "The New Veiling in Cairo: Hegemonic Relations and Gender Resistance as Accommodating Protests." *Signs* 17.3 (1992): 533–557.

McCormick, Richard W. "From Caligari to Dietrich: Sexual, Social, and Cinematic Discourses in Weimar Films." *Signs* 18.3 (1993): 640–668.

Rimonte, Nilda. "Domestic Violence Among Pacific Asians." *Making Waves: An Anthology of Writings By and About Asian American Women.* Ed. Asian Women United of California. Boston: Beacon Press, 1989. 327–337.

Tan, Amy. *The Kitchen God's Wife.* New York: Putnam, 1991.

Walker, Alice. *The Color Purple.* New York: Harcourt, Brace, Jovanovich, 1982.

Chapter 9

Jane Campion's *The Piano*:
A Feminist Tale of Resistance (1993)

Denise Bauer

Jane Campion (b. 1954) (fig. 25) was born in Wellington, New Zealand, where she graduated from Victoria University with a degree in anthropology in 1975. However, she is commonly regarded as an Australian director since she started her filmmaking career there. She graduated from the Sydney College of the Arts with a painting major in 1979, and in the early 1980s attended the Australian School of Film and Television where she first began making movies.

On a modest budget, Campion wrote, directed, and edited her first short film, Peel, An Exercise in Discipline *(1982), which received an award at the Cannes Film Festival, making her the first women filmmaker to receive such an honor. After this stunning debut, she went on to make three more shorts:* Passionless Moments *(1983),* After Hours *(1984), and* A Girl's Own Story *(1984).*

Campion's first feature film, Sweetie *(1989), which she co-wrote and directed, was less uniformly applauded, although it did receive the LA Film Critics' New Generation Award in 1990 as well as additional international recognition. Her next feature,* An Angel at My Table *(1990), also won many awards, including the Silver Lion award at the Venice Film Festival. Both films circulated primarily at art film venues.*

The Piano *(1993) has been Campion's most significant critical and commercial success to date. Among numerous awards, it was nominated for several Academy Awards and won Best Original Screenplay in 1993.*

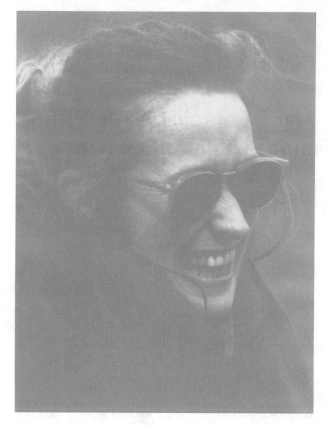

Figure 25. Jane Campion

While The Piano *is often linked with* Wuthering Heights *and Afri-can Queen as among its literary inspirations, Campion's next film,* Portrait of a Lady *(1996), is a deliberate adaptation of the novel by Henry James. In 1997, she released* Filmmaker's Journey: The Mak-ing of Jane Campion's The Portrait of a Lady.

Campion is currently writing and directing a forthcoming film, Holy Smoke.

The Piano is a nineteenth-century love story that is at once deeply dis-turbing and deeply moving. Feminist critics have argued vociferously about whether or not it is a feminist film. One view asserts that the story of a mute, mail-order bride shipped to New Zealand to a husband who brutally

chops off her finger and boards her up in his house cannot possibly be a feminist film. Other feminists have celebrated the female protagonist, Ada, as remarkably and profoundly feminist for her sexual agency and strong will in the face of overwhelming oppressions. It seems to me that Jane Campion has not made a uniformly feminist film, but neither has she made a strictly misogynist one. It is the tension between these two tendencies, however, that makes *The Piano* so compelling and unforgettable.

Jane Campion was born and raised in New Zealand in an artistic and, by her own account, unusual family (Cantwell 40), an inspiration, perhaps, for her notably odd film characters. After graduating from film school in Australia, Campion joined the Women's Film Unit, a government-sponsored program aimed specifically at promoting the work of female film directors. While she clearly benefited from it, she also distinguished herself from what she described as the more "radical feminist group" who were responsible for establishing the program in the first place. About this Campion has said, "I think it's quite clear in my work that my orientation isn't political or doesn't come out of modern politics" (Cantwell 42).

While Campion incorporates many feminist ideas in *The Piano*, her point of view is not defined by feminist polemics. In fact, as a young woman, her ambitions were to "just learn enough so that I could in some way be supportive of somebody who really was gifted" (Cantwell 44). Once she decided to commit herself to being an artist, however, she also decided to "try and make my artwork directly about the things that I'd rush home to ruminate about. Things like confusions about sex and intimacy, for instance" (44). Thus was born the hallmark of Campion's films: telling a story from a woman's perspective.

In *The Piano,* however, this woman is a mute victim of nineteenth-century systems of female commodification and horrendous male violence. Feminist cultural critic bell hooks has criticized the way Campion uses these misogynist themes, asserting "Violence against land, natives and women in this film . . . is portrayed uncritically, as though it is "natural," the inevitable climax of conflicting passions" (4). She specifically takes issue with Campion's portrayal of Ada as having to choose between her piano and "true love," when in the end, Ada throws the piano overboard as she and Baines leave together for Scotland: "Since this is not a documentary film that needs to remain faithful to the ethos of its historical setting, why is it that Campion does not resolve Ada's conflicts by providing an imaginary landscape where a woman can express passionate artistic commitment and find fulfillment in a passionate relationship?" (5).

hooks derides *The Piano* for its portrayal of a female protagonist whose development as a woman and an artist is controlled not by her own process of self-actualization, but by the oppressive forces of the dominant order.

Other feminist film critics, however, like Kathi Maio writing in *Ms.* magazine, celebrate Ada's return to Scotland with Baines as a feminist victory, writing "By choosing whom to love, Ada brings down the wrath of the patriarchy" (83). Acknowledging the disagreement among feminists about labeling *The Piano* "feminist," Maio concludes that because Ada's will wins in the end, *The Piano* is a feminist film. Certainly, the ambiguity of the ending leaves the film's larger feminist meaning(s) open to interpretation.

This tension between the misogynist and feminist elements in *The Piano* has been criticized as confused or ambivalent. Feminist film critic Barbara Quart sees it differently, applauding Campion's "openness to irrational forces resistant to neat understanding and verbalization" (4). Indeed, Campion has described not wanting to dictate to her viewers what to feel, purposefully admitting ambiguity into her films (Cantwell 44).

In a larger way, Campion simultaneously participates in and destabilizes the dichotomies of object/subject, masculine/feminine, victimizer/ victim, and colonizer/colonized, and this is where the feminist impact of *The Piano* is most apparent. Although not strategically feminist, Campion's point of view challenges existing hierarchies with an impressive tale of feminist resistance. Told with visual grandeur, an epic scope, and strong emotional appeal, the story of Ada's resistance to the dominant order is powerful and memorable.

At the same time that Campion's point of view is not strictly feminist, she frequently employs filmic techniques which are aesthetically and theoretically feminist. For example, in all of her films she ignores the male gaze by shooting from the perspective of her female protagonists. Her first feature, *Sweetie* (1989), is the story of two middle-class sisters and their dysfunctional family, and *An Angel at My Table* (1990) was based on the autobiography of the New Zealand writer Janet Frame. Campion keeps the camera on the female protagonists in both of these films. It is their feelings, points of view, and experiences that direct the look and feel of each film. In *The Piano*, feminist tropes are provided by the use of women's clothing like the white hooped petticoat on the beach, the bridal dress, and the matching outfits of mother and daughter. Combined with melodious, even hypnotic, piano music throughout the film, Campion

creates a feminine texture which makes it feel familiar to many women viewers. Similarly, in *An Angel at My Table,* the conflicts between two very different sisters are narrated with great humor, sensitivity, and understanding of the complexities of sisters' interdependencies. And in complete contrast to the typical Hollywood film, the male characters in Campion's films play largely supportive roles. This is most notable in *An Angel at My Table,* where the father is the most mild, accommodating, and tolerant character in the family.

Campion's films are markedly *by* a woman and *about* women, and this makes them a wonderful anomaly. There are only a fraction of visible, producing female directors and even fewer films in which women are cast not as objects, but as whole human beings with independent feeling and thinking lives of their own. As Quart has written about *The Piano:* "To build this grand drama on what a woman needs (and, unlike the Forties weepies, what a strong, non-self-sacrificing woman needs, without compromises) is in itself an event. It needs hardly be said that only a woman director would be likely to do it" (54).

The Piano was Campion's third feature film which she both wrote and directed, and her first big budget film (Cantwell 53). Unlike her first two more modestly successful art house films, *The Piano* was a huge critical and commercial success when it was first released in 1993. It won her the highly esteemed Palme d'Or award in Cannes in 1993, making her the first female director so honored. Campion also won an Oscar and an Academy Award for best original screenplay. Performances by Holly Hunter as Ada, Harvey Keitel as Baines, Sam Neill as Stewart, and Anna Paquin as Flora were widely applauded by critics.

The Piano garnered a great deal of critical attention. Film critic Vincent Canby of the *New York Times* called it a "post-Freudian period romance" ("Early *Cannes* Favorite" 81) and "one of the funniest, most strangely erotic love stories in the recent history of film" ("The Piano" 169). Others, like Stuart Klawans of *The Nation,* were more introspective about *The Piano's* wide acclaim, calling the film "astonishing, even ravishing" but were themselves unable or unwilling to identify with the female protagonist, Ada (704, 706). Many of these male critics, lacking a vocabulary or complete understanding of feminism, missed the full importance of *The Piano's* alternative vision. This is not surprising when one considers how unusual it is to see a woman's point of view so fully and consistently privileged in a major commercial film.

In the film's opening sequence set in Scotland, we learn that Ada, a mute woman who has had a child without being married, is being sent by

her father to New Zealand to marry a colonist named Stewart. Ada tells us in a voice-over that she stopped speaking at the age of six, "No one knows why, not even me. My father says it is a dark talent and the day I take it into my head to stop breathing will be my last" (Campion 9). Her piano, however, is her voice, the expression of her self. When she is caught playing passionately by a curious servant, she abruptly stops in embarrassment. In this opening sequence, two things are established: while Ada's fate has been decided as an object to be exchanged between two men (her father and future husband), she is also a subject, a woman of deep feelings and a rich inner life that she expresses, however furtively, through her piano. By juxtaposing these dichotomies in Ada's character and her fate, Campion simultaneously interrogates and subverts her feminine victim status. And by telling the story from Ada's point of view, Campion inverts the male gaze that typically structures Hollywood films.

The power of the film resides most immediately in its spectacular cinematography. Drawing on her visual art background, Campion creates painterly, stunning images and moods in this film. Set in the lush New Zealand bush, many of the scenes are cast in a magical blue/green glow. The camera alternates between high-angle views of the rolling thunderous sea, deserted beaches and the tangled thick brush, and low-angle views of booted feet trudging in deep mud through filtered sunlight. The native people of New Zealand, the tattooed, long-haired Maoris, populate many of the scenes, furthering the native, "uncivilized" look of this film. Aside from Ada's piano playing, the natural sounds of the bush-birds chirping, rain falling, branches snapping, Maoris shouting in their native tongue comprise most of the film's sound. Set in the mid-nineteenth century as the island was still being colonized by Europeans, the visual contrast between colonizer and colonized constitutes a major motif and tension in the film. The western European society, exemplified by the piano and the Victorian clothing and customs worn by the colonizers, or *pakeha* (white people), is strikingly distinguished from the colonized indigenous Maori people, their culture, and the unspoiled landscape.

For example, the spectacular natural and exotic setting is first visually contrasted by the heavily costumed figures of the Victorian woman, Ada, and her child, Flora, as they arrive by sea from Scotland. They are identically bonneted and cloaked in matching black and white. In a scene that speaks directly to the incongruity of the old and new worlds, Victorian mother and child are awkwardly carried to land on the shoulders of a group of shouting, vulgar seamen. In one long shot, the white foaming sea pounds the beach as the figures, small and insignificant, walk up to

land. When one asks if they will need shelter for the night, Ada, who is disgusted by the indecency of the seamen, who think nothing of relieving themselves right in front of them, speaks through Flora: "She says she would rather be boiled alive by natives than get back in your tub" (Campion 16). Despite their restrained appearance in elaborate Victorian dress, which necessitates their being carried across the water, and despite Ada's inability to speak, the film establishes right away that Ada is perfectly able and unafraid of asserting her own opinions. In this way, she transgresses the codes of nineteenth-century respectable feminine behavior, and they end up camping out on this faraway beach alone for the night. Again, Campion juxtaposes Ada's apparently helpless status with a strong sense of agency.

While *The Piano* is a fictional period piece that is based on actual historical events and circumstances, Campion freely and quite effectively adds a large dose of fantasy and some anachronistic social behavior and attitudes. Most notably, despite sharing the same social station in life as the cursing seamen who bring Ada and Flora to shore, Baines, the character who becomes Ada's love interest, is a gentle, understanding man, a "courtly lover...[with]...the sexual openness of a twentieth century male subject" (Hendershot 102). For reasons like these, critics have commonly described *The Piano* as a kind of fairy tale; with its spectacular cinematography, unforgettable characters, and extraordinary natural setting, the film's look, and at times its plot, are often otherworldly.

For example, in one of Campion's most striking and magical images in the film, Ada and Flora create a small tent in which to pass the night out of Ada's white hooped petticoat. Lit from within, the odd bell shape, circled with stones and shells, glows alone beside the piano and the scattered boxes on the deserted beach. Inside, in a beautiful moment of intimacy between mother and daughter, Ada and Flora sign to each other, wondering about the husband and father they are about to meet. In the morning, they are abruptly awoken by Stewart and his party of Maori workers and translator, Baines.

Among Campion's greatest skills is her development of fully human characters; she never resorts to cliché. In fact, her characters are usually highly unique. This is apparent especially in her portrayal of women, but also is true of her male characters. Our first glimpse of Stewart, the landowning colonist who has mail-ordered a wife, is of an uncertain man stopping to comb his hair and look at himself in a mirror while clutching a small photo of his purchased bride. In addition, although Stewart is the European colonizer and therefore, the most politically, socially, and

economically dominant of the characters in the film, his authority is mocked by the Maoris, who follow along with him laughing, mimicking, disobeying his orders and calling him "old dry balls." So while he fully represents the dominant order on several levels, his character is more complex, and the film's treatment of his authority is less reverent, at times, than this dominance might suggest. In another feminist move, Campion decenters male authority.

The most transgressive male character, Baines, is the interlocutor between the Maoris and Stewart. Baines is also European but illiterate and of a lower class than Stewart. However, he speaks the Maoris' language and has even tattooed his face in their style. But his tattoo is only partial, as the screenplay explains, as perhaps an indication that his relationship to the native people cannot be complete. Baines occupies the in-between position of colonizer/colonized, and as the plot progresses (and as I will discuss), also subverts the category of the masculine when he falls in love with Ada.

As Stewart speaks loudly to awaken Ada and Flora, they slowly emerge from their billowy white tent, and an awkward first meeting occurs between husband and wife. The Maoris look curiously at the two Victorian creatures, fingering their stiff black clothes and remarking on the small size of Ada's feet. Stewart begins to question the content of the many boxes scattered around them. When Ada insists that the piano be carried along with the other boxes, Stewart refuses, exclaiming in disbelief "Do you mean you don't want your kitchen ware or your clothing?" (Campion 23). Transgressing the feminine, Ada is less a wife concerned with domestic details and more an artist concerned with her piano and its/her expression. Right away, however, this point is lost on the less sensitive and more conventional Stewart.

Stewart orders the Maoris to carry all but the piano. As is the pattern throughout the film, the camera remains most often with Ada. We see her anguished face and as the party slowly departs, there is a long point-of-view shot from a cliff, as Ada looks longingly at the piano left abandoned on the beach. The film's visual and emotional focus on the piano and Ada's deep attachment to it serves, among other things, as a leitmotif in the film of the power and allure of artistic expression. By being forced to leave the piano behind, Ada is stripped of a vital part of her being. Because the camera remains with Ada, we are invited to identify with her pain and to see the commanding Stewart as cruel and unfeeling.

When they arrive at Stewart's hut, set deep in the bush in an unsightly clearing of burnt, smoking stumps, we meet two simple-minded white

women, Aunt Morag and Nessie, who take care of Stewart's household. Their antics are comical and silly, in a display of Campion's trademark wit. Aunt Morag and Nessie fussily prepare for the requisite wedding photo. The wedding dress, however, is nothing more than a one-sided prop, a facade for what this arranged marriage really is: an economic exchange between men. After the photo is taken in the pouring rain, Ada angrily tears the one-sided dress off and runs to the window, concerned for her piano left alone on the beach in bad weather (Campion 32). Aunt Morag gasps in disapproval at Ada's angry disinterest in the dress. A wedding and in particular, the wedding gown, are traditionally seen as the apex of a young woman's life; Ada shows no regard for such conventions and longs instead for her piano, a more genuine extension of her self. While the characters of Aunt Morag and Nessie most fully occupy the category of the feminine by keeping house, arranging the wedding, and emotionally supporting Stewart, Ada is an artist and does not conform to these roles and is therefore deemed "odd" by the others.

The next morning after Stewart leaves, Ada and Flora go to Baines's hut to ask for his help in retrieving the piano from the beach. He reluctantly agrees. The camera then cuts to a transformed Ada, passionately playing her piano on the beach while Flora dances and twirls, waving seaweed in the air and shouting out happily. Suddenly, they are as wild and free as their beautiful exotic environment, no longer expressionless and contained. Baines stands by, watching their joyful abandon with great curiosity. We then cut to a darkening sky as the day begins to fade and in an overhead shot, Ada and Flora leave the piano with Baines following slowly behind. A beautifully arranged pattern of shells and stones decorate the beach that was the day's stage. Again, Campion has captured a wondrous moment between mother and daughter as they share music, dance, and play the piano together. Their displacement to this foreign land makes their closeness all the more touching. This privileging of the mother-daughter relationship is one of the many ways Campion brings a feminine sensibility to the film. It is also noteworthy that Baines's quiet, attentive observation of them also respects this relationship and foreshadows his love interest in Ada.

Stewart remains oblivious to the importance of the piano in Ada's life, and wonders aloud to Aunt Morag if Ada is "brain affected" when he finds her pretending to play the piano on the kitchen table. The next scene is one of the few in which there are only men: as Stewart deftly chops wood, a forewarning of his violent chopping of Ada's finger, Baines asks Stewart to exchange some of his land for the piano. In yet another

arrangement between men about her fate, Stewart agrees and they decide that Ada will give Baines piano lessons. Ada, however, is furious when she is told that the piano has been given to Baines. In a full expression of her will, she stomps on the floor, furiously writes notes to Stewart, and throws dishes and plates across the room in anger. At first, Stewart hesitates, but then finally asserts his full male authority and demands her acquiescence. Again the camera rests on Ada's reaction: her large sorrowful eyes are haunting. She is like a caged animal, stripped of her piano and for the moment, her will.

After a series of visits, we learn that Baines's intention is not to learn the piano, but to gain sexual favors from Ada. They strike a deal: for her to "earn back" her piano, a sexual favor will be granted for every black key. From a feminist perspective, this turn in the plot is infuriating and disturbing. Her already victimized status as a mute, mail-order bride who has been stripped of her piano is made worse by yet another economic exchange between men. Now she must suffer the cruel humiliation of using her body to gain what is rightfully hers and what she desperately needs—her piano.

However, something unexpected happens. After a series of scenes in which Baines escalates his demands on Ada, first to pull up her dress, to look at her arms and eventually lie beside him naked in the bed, Baines falls in love with Ada. He touches her with great tenderness and looks at her longingly as she plays the piano. In one scene, he buries his face in her jacket as she plays the piano. As he asks her to undress, he, too, undresses, maintaining "an equal state of undress" (Hendershot 102).

In one of the more famous scenes, Baines takes off his clothes entirely and stands nude before Ada in a remarkable reversal of the male gaze. His body is strong but vulnerable; sensual but not idealized. The female nude has served as one of the great genres in western art and culture, and Hollywood films are replete with images of nude or partially nude women posed for the male viewer's pleasure. But the display of a male body for a female's pleasure is a rarity. Campion joins other feminist artists like painters Sylvia Sleigh and Alice Neel who have transgressed this tradition by painting and eroticizing the male nude. In another significant feminist revision of filmic conventions, Campion creates a male object of the female gaze.

Finally, during one visit, Baines sits in the corner of his hut, love sick and withdrawn, and tells Ada: "I am giving the piano back to you. The arrangement is making you a whore and me wretched. I want you to care for me but you can't" (Campion 76). Baines also gives up the land that

was to be swapped to Stewart. These actions are tantamount to a renunciation of his male privilege and a revocation of his economic power—another significant subversion of the masculine. When Ada returns his love, a love affair blooms.

Some feminist critics like bell hooks have asserted that by turning Ada and Baines's "arrangement" into a love affair, the film "betrays feminist visions of female self-actualization [and] celebrates and eroticizes male domination" (5). Indeed, it remains questionable how Ada comes to love a man who blackmailed her for sexual favors. While the progress of Baines's feelings are well developed in the film, the progression of Ada's feelings toward him are less obvious.

However, while hooks describes Baines as "seducing" Ada, I believe that there was a more mutual attraction that was conveyed through the many parallels Campion draws both visually and emotionally between Baines and Ada. For example, they are both outsiders of sorts—Ada is a newly arrived European bride who is really an artist, and Baines is a European man who lives among the native Maori. When Stewart is dismissive of Ada's need for her piano, Baines expresses curiosity and ultimately arranges for her to have it. Baines forsakes his male privilege by returning the piano. His vulnerability is expressed through his love for Ada and visually as the object of the female gaze. Ada is granted power through the return of her piano and the expression of her own sexual agency outside the confines of her arranged marriage. The effect of these examples and many others is to draw Ada and Baines together in a way that subverts the categories of masculine/feminine and into what appears to be, arguably, an egalitarian relationship. This result is all the more remarkable given the originating conditions of their relationship.

After the piano has been returned to Stewart's home, Ada goes to Baines and they make love freely and fully for the first time. This time is different because Ada willingly seeks him out, acting on her own volition and exhibiting her own sexual agency. There are no longer any economic obligations between them; they disrobe together and as the screenplay indicates, they are "profoundly equal" (Hendershot 102). Stewart, whose suspicions have been aroused, follows Ada, then watches through cracks in the walls of Baines's hut as his wife, with whom he himself has not slept, makes love to another man.

The centerpiece of this romantic film is the love triangle that develops between Ada, Baines, and Stewart, and specifically, the highly charged erotic scenes between Ada and Baines upon which so many critics have seized. For example, Vincent Canby wrote about their lovemaking:

> Their love is a simultaneous liberation. The director's style is spare. No swooping
> camera movements over naked, writhing bodies. The camera observes the lovers
> from a distance . . . as if the camera respected the lovers' privacy but felt com-
> pelled to show us what the others see ("The Piano" 169).

What Canby is describing is an erotic scene that is not exclusively represented
through the male gaze as it is in conventional Hollywood films. This is striking
because although Stewart becomes a voyeur (as does Flora at one point),
there are only a few shots from his point of view. For the most part, the scene
is shot from the side and the camera does not move. Ada's and Baines's
naked bodies are sensuous and beautiful as they embrace in the bright, fil-
tered sunlight inside Baines's hut. Campion represents sexuality as equally
pleasurable and gratifying for both partners. In addition, the historical context
of the film permits a more innocent view of sex than our own twentieth-
century sensibility affords. As Campion has explained, her fictional nineteenth-
century characters are sexually pure:

> They have nothing to prepare themselves for its strength and power. We grew up
> with all those magazines that described courtship, giving us lots of little rules and
> ways of handling it. We grow up with so many expectations around it, that it's
> almost like the pure sexual erotic impulse is lost to us. But for them . . . the
> husband Stewart had probably never had sex at all. So for him to experience sex
> or feelings of sexual jealousy would have been personality-transforming. The im-
> pact of sex is not softened, it's cleaner and extremer for that. (138)

However, as Quart points out, the "sexual wholeness" that Campion brings
to the scene is "disturbingly frame[d]...through the threatened violence of
the jealous Stewart's male gaze" (55). In a following scene when he finds
Ada again on the path to Baines's hut, this threat is realized when Stewart's
jealousy and rage explode. A struggle ensues and Stewart attempts to
rape Ada. He drags her through the thick brush, visually arranged as a
kind of trap, as she clings desperately to some branches, horizontally
extended across the screen. The pace of editing quickens as Ada struggles
furiously; Stewart is possessed with anger and sexual frustration. Finally,
he stops when Flora's voice is heard nearby. However, in a following
scene, Stewart is boarding up the house with Ada and Flora inside, in a
crude attempt to contain his wife's passion for another man.

Just when Ada's victimization seems to have crushed her, she takes
matters into her own hands. For the first time, she approaches Stewart
sexually, coming to him at night and lightly caressing his body. When he
reaches for her and calls her name she abruptly withdraws; she remains in
control while he shudders and moans with desire. Like Baines's full fron-

tal nudity before the dressed Ada, Stewart's emotional and physical vulnerability in response to Ada's sexual advances are an inversion of the usual objectification of the female body by the male. In both cases, it is Ada who exhibits sexual agency and power and the men who are sexually objectified.

Stewart is seduced into trusting Ada after two evenings of such intimacy and takes down the boards, releases her from the house and goes away for a few days. Ada takes the opportunity to send a message to Baines, a key from her piano carved with the inscription "Dear George, You have my heart, Ada McGrath." She asks Flora to bring it to him, but instead Flora brings it to Stewart.

The next scene is the most violent, disturbing, and stunning in the film. In a furious rage, Stewart physically assaults Ada, puts an ax through her piano, then drags her outside in the pouring rain and chops off one of her fingers on his chopping block. Flora stands as a witness, screaming in horror as blood splatters on her face and dress. In a close-up, Ada's face is terrified and stupefied after the finger has been cut off; she attempts to stand and in a kind of lilting walk moves away, then collapses to the ground, her dress ballooning around her. Flora screams for her mother; Stewart commands her to bring the severed finger to Baines and Flora obeys.

This very disturbing scene expresses the misogynist violence of a man toward a woman, a woman already victimized in so many ways. But it is also disturbing for its portrayal of a daughter betraying her mother. This is particularly troubling since the film so repeatedly and clearly expresses a special kinship between Ada and Flora, visually through similar dress, emotionally in their near-constant shared intimacy, and practically in their unique ability to communicate through signing. Why does Flora finally obey the male authority instead of her own mother? This betrayal seems remarkably at odds with Campion's earlier depiction of their togetherness. This turn in the plot might be seen as one of the misogynist tendencies in the film, particularly since the rupture in Ada and Flora's relationship leads to the film's most climactic and violent scene.

As Ada lies in bed, nearly unconscious from the trauma of the event, Stewart feebly tries to explain himself, saying "I clipped your wing, that is all" (Campion 112). Ada remains motionless with her eyes shut. To add insult to injury, Stewart begins to fondle her. When he begins to unbuckle his belt and move over her, he realizes that she is fully awake and looking directly at him. In a later scene, we learn that it was at this moment that he "heard" Ada in his head, telling him to let her return home with Baines.

He describes Ada "telling" him, "I am frightened of my will, of what it might do, it is so strange and strong" (115).

The following scenes follow the preparations for Ada, Flora, and Baines's departure. In one shot, Ada is framed by the door of Stewart's home, her arm in a sling, her face ashen and shattered. While Baines kisses her passionately when they meet before their trip back to the sea, Ada's mood is desultory. She seems completely defeated by Stewart's violence and expresses no happiness about her union with Baines, leaving open to question the meaning and purpose of their departure together. Is the joy of leaving with the man she loves less significant than the violent trauma she has experienced at the hands of her husband?

They return to the beach where Ada and Flora first arrived. They board the boat together and after some expressed concern about the weight of the piano, Ada demands that the piano be thrown overboard. Baines and Flora are shocked but Ada insists and so they agree. Then Ada slips her foot into the unwinding rope and goes overboard with the piano. In this near drowning, there is yet another surprising twist in the plot; Ada releases her foot from the rope and swims back to the surface. In a voice-over, she says "What a death! What a chance! What a surprise! My will has chosen life!" (Campion 121).

We then cut to a contented Baines, Ada, and Flora back in Scotland. Ada is fitted with a metal-tipped finger, playing the piano and practicing how to speak out loud. Baines remains doting and loving towards her. Flora plays happily.

But the final scene suggests something more than this apparent happy ending. In an eerie image, we return to the submerged piano with Ada floating above it, "her hair and arms stretched out in a gesture of surrender" as the screenplay describes it (122). In a voice-over, we hear Ada speaking: "At night I think of my piano in its cold ocean grave, and sometimes of myself floating above it. Down there everything is so still and silent, that it lulls me to sleep. It is a weird lullaby and so it is; it is mine" (Campion 122).

There is a theme which appears frequently among women artists and their female characters in which a female protagonist who acts with agency is repeatedly punished and driven to suicide as the plot's only possible resolution to her transgressions. Campion continues this theme in *The Piano* but with a different twist. Like works by writers Sylvia Plath, Virginia Woolf, and, most directly, Kate Chopin in her short story "The Awakening," where the female protagonist, Edna Pontlier, finally drowns herself, Campion depicts a woman whose suffering at the hands of a

deeply misogynist society finally becomes unbearable; suicide seems the only solution. This theme among women artists is striking for its desperate expression of the ways women's lives are crippled by social and political norms, and it is deeply disturbing that it persists in contemporary art and culture.

However, like the two female protagonists in *Thelma and Louise*, another contemporary film written by a woman (Carrie Khouri), Ada's suicide attempt is deliberately made ambiguous. In *Thelma and Louise*, the high-speed chase at the end of the film culminates in the two women driving their car off a cliff in an apparent attempt to escape police arrest for killing an attempted rapist. However, their car does not tumble down a ravine as might be expected. The final scene is of the car suspended in midair, suggesting not a defeat but a transcendence. Like Ada, Thelma and Louise take extreme measures—blowing up a lewd truck driver's truck, running from the law—to resist the social norms that condone male violence against women. These female characters resist the dominant order, and in so doing, transform the filmic conventions that typically maintain women as objects.

Similarly, Ada's decision to choose life after nearly drowning is a more hopeful resolution for such transgressive women than this tradition among women artists usually follows. As Kathi Maio has written: "Ada refuses to become the madwoman in the attic or the tragic loser washed out to sea. She literally snatches life back from the depths (of female despair) and applies her will to finding a new voice" (83).

In the end, while a part of Ada was defeated by the assertion and violence of the masculine, another part remains intact, attempting to heal and move on, learning to speak without her piano. So in some regards, Campion resolves Ada's victimized status by returning her to Scotland with the man she loves rather than having her remain in a foreign land with the man who was chosen for her. But still the trauma lingers in the air as the camera focuses on Ada's metal finger clicking on the piano keys. It is her will to live after such violence—as well as the destruction it leaves in its wake—that finally becomes the feminist message of resistance in this unforgettable film.

Works Cited

Campion, Jane. *The Piano*. New York: Hyperion, 1993.

Canby, Vincent. "Early *Cannes* Favorite: A Post-Freudian Romance." *New York Times* 18 May 1993: 81–82.

———. "The Piano." *The New York Times* 16 Oct. 1993: 169–170.

Cantwell, Mary. "Jane Campion's Lunatic Women." *New York Times Magazine* 19 September 1993: 40 +.

Hendershot, Cyndy. "(Re)visioning the Gothic: Jane Campion's *The Piano*." *Literature-Film Quarterly* 26 (1998): 97–108.

hooks, bell. "Sexism and Misogyny: Who Takes the Rap?" *Z Magazine* (Feb. 1994) in "Misogyny, gangsta rap and *The Piano*" http://eserver.org/race/misogyny.txt.

Klawans, Stuart. "Films: *The Piano*." *Nation* (Dec. 1993): 704–706.

Maio, Kathy, "The Key to the *Piano*." *Ms.* (March 1994): 84.

Quart, Barbara. "*The Piano*." *Cineast* 20 (1994): 54–56.

Chapter 10

Yielding to Multiplicity: The Kaleidoscopic Subject of Paula Vogel's *How I Learned to Drive* (1997)

Sarah Lansdale Stevenson

Paula Vogel (b.1951) (fig. 26) was born in Washington D.C., and grew up in suburban Maryland. After studying briefly at Bryn Mawr, she earned a B.A. in theatre from Catholic University in 1974. She entered the doctoral program at Cornell University, although she ultimately chose not to write a dissertation. Instead, she became a lecturer at Cornell in 1977, and received her first playwriting fellowship from the National Endowment for the Arts in 1979. Now a theatre professor at Brown University, she became chair of the Graduate Theatre Program in 1984.

Her early plays include Desdemona: a Play *about a Handkerchief (1977), a feminist reconsideration of Shakespeare's heroine;* The Oldest Profession *(1981), a comic glimpse at the economics of prostitution; and And* Baby Makes Seven *(1984), a dark comedy about a makeshift nuclear family made up of a lesbian couple, a gay man, three imaginary children, and a single real one on the way.*

Vogel achieved her artistic and commercial breakthrough with The Baltimore Waltz, *a dizzying romp through a Europe of the imagination, dedicated to her brother, Carl, who died of AIDS in 1988. Produced in 1990 by the Perseverance Theatre of Douglas, Alaska, and subsequently by the Circle Repertory Company in 1992,* The Baltimore Waltz *received the OBIE Award for best play. Vogel's next play,* Hot 'N' Throbbing, *was a grim but powerful tale of pornography and sexual abuse. The American Repertory Theatre produced the premiere in 1994.*

Figure 26. Paula Vogel

Vogel wrote The Mineola Twins *and* How I Learned to Drive *during a residency at the Perseverance Theatre from 1995 to 1998. The Mineola Twins, a comedy, opened at Perseverance in 1996, followed by a Broadway production at the Roundabout Theatre in*

1998. How I Learned to Drive opened in 1997 at The Vineyard Theatre in New York City, where it won an array of awards including the OBIE Award for best play, the Drama Desk Award, and the New York Drama Critics Circle Award, and culminating in the 1998 Pulitzer Prize for drama. In the 1998–1999 season, How I Learned to Drive was the most-produced play in American regional theatre with a staggering twenty-six productions nationwide.

Vogel is currently in the first year of a three-year residency at Arena Stage, in Washington, D.C. As playwright-in-residence, she will teach playwriting workshops and write two new works. Her plays are currently available in two collections: The Mammary Plays *(Theatre Communications Group, 1998) and* The Baltimore Waltz and Other Plays *(TCG, 1996).*

The two current collections of the plays of Paula Vogel feature two artists' interpretations of the female body in Vogel's work on their covers, offering an intriguing perspective from which to view the plays. A collage by Gustavo de Leon graces the cover of *The Baltimore Waltz and Other Plays*. At its center is a painting of a woman that is cubist in inspiration. Her face is depicted simultaneously in frontal and profile perspectives, and she is at once clothed and nude, as the paper on which her shirt is painted is partially torn away, revealing one naked breast and shoulder on a layer underneath. This painting is surrounded by a series of framing possibilities, as if various samples from a frame shop are being tried out at once. How best to frame this body? An ornate Florentine frame, a simple wooden frame, and several others jostle, as if the question is left unanswered, or that the framing itself proves impossible. The artwork featured on *The Mammary Plays* (the collection that includes the 1998 Pulitzer Prize-winning play *How I Learned to Drive* and *The Mineola Twins*) is by Chip Kidd. Like that of the former collection, this cover features a female body, viewed from the torso up. In this case, however, the body is a silhouette, a negative space in a sea of light. Highlighted on the body are two tape measures that encircle the chest and waist. The act of measuring is an ironic counterpoint to the invisibility of the body in question, and the tape-measures' attempted measuring provides a parallel to the impossibility of framing presented by the previous cover. Lined up beneath the simultaneous erasure and measuring of the female body in the primary image, however, is a string of six photographs of women in fifties-style bras—shown only from waist to chin—the bodily absence in the

primary image challenged by this kaleidoscopic proliferation of chests. The combination of fragmentation, erasure, framing, measuring, and multiplication of the female body, as displayed in these two artists' interpretations of Vogel's work, emphasizes the complex and dynamic relationship between Vogel's female characters and their bodies that is at the core of this study.

Fragmentation

In *How I Learned to Drive*, the primary force of the relationship between character and body is of conflict and division. Rather than an essential whole, the body is portrayed in *How I Learned to Drive* as a collection of parts, pieced together rather than unified. Discussions of the body in the play tend to revolve around the subject of the breasts, which are a frequent topic of conversation in Li'l Bit's household. Titling the collection *The Mammary Plays*, Vogel highlights the crucial importance of the body, and in particular the breasts, to Li'l Bit's telling of her story, a story that revolves around the incest she suffered from age eleven to seventeen at the hands of her uncle, a forty-year-old man named Peck. The resultant relationship to her body is one of alienation and fragmentation. But the term "Mammary Plays" hints at more than merely the body itself. It derives from a line delivered by Li'l Bit as she introduces a group of scenes from high school: "1966. The Anthropology of the Female Body in the Ninth Grade—Or a Walk Down Mammary Lane" (Vogel 52). This comic-seeming pun of mammary with memory highlights the fact that the fragmentation of the body is paralleled by a fragmentation of memory. It is the emergence of these fragmented memories that forms the structure of the play. Focusing on the fragmentation of body and memory, and the ultimate fragmentation of subject that they represent, we will see how Vogel uses the dramatic structure to both depict and overcome that fragmentation.

Many of the discussions of the body in the play are comic on the surface, but this comedy only slightly masks the true alienation of Li'l Bit from her body. The series of scenes that make up the "Mammary Lane" section showcase Li'l Bit's attempt to navigate a high school world with what seem to her (and to her classmates) to be abnormally large breasts. A series of attempts to determine the status of her breasts range from a male student's feigned allergy attack ["*Li'l Bit*: Golly. What are you allergic to? "*Male Greek Chorus* [as Jerome] (*With a sudden grab of her breast*): Foam rubber" (53)] to the ultimate test: the gym class shower

scene. As Li'l Bit bravely drops her towel to enter, one shower-mate gloats: "Told you! It's not foam rubber! I win!" (54). But the mere fact that her breasts are biological in origin does not, for Li'l Bit, make them part of a unified body. Instead, as she explains to her perplexed school-mate, it feels as if "these alien life forces, these two mounds of flesh have grafted themselves onto my chest, and they're using me until they can propagate and take over the world," killing her off in the process (57). Thus even though the breasts are determined to be "real" rather than "fake," it is made clear that she does not consider them a true part of her. Not only are they a false part, they are parasitic rather than benign. If one part's mission is to eliminate the rest, there can be no possibility of a unified whole. Throughout the play, a tension is constantly established between Li'l Bit's breasts as viewed from the outside (by the other) and as experienced from the inside (by the self). Peck refers to them as "celestial orbs" (12), her grandfather makes the pronouncement that "five minutes before Li'l Bit turns the corner, her tits turn first," and asks "what does she need a college degree for? She's got all the credentials she'll need on her chest" (16–17). Her family, Peck, and her high school classmates all attempt to define her by her breasts, and Li'l Bit, not able to accept these breasts as they define them, disconnects from them, and sees them as alien.

The central division that takes place within the body of Li'l Bit can be viewed in terms of a clash between the two primary perspectives on the body. Stanton Garner explores the fact that the body is in a continual oscillation between "subject and object" (4). Using phenomenologist terminology, Garner distinguishes between the *lieb,* which he defines as "the body as it is experienced," or "lived-body," and the *korper,* the "body as it is given to external observation" or "thing-body" (28). The oscillation between lieb and korper is continual. Following phenomenologist Herbert Plugge, Garner argues that in illness, "the 'thing body' intrudes on the experience of lived bodilyness as a quasi-alien facticity—a husk, burden or weight that no longer belongs to the experiencing subject," thus leading to a "fundamental self-estrangement" (32). As illustrated by the cover images of Vogel's works, the bodies of her protagonists yield a similar estrangement, one whose fundamental basis is a division between the subject's inner-experience of her body, a being in the body, and the body as defined from the outside: body-as-object. Li'l Bit's description of her relationship to her breasts as "alien life forces" echoes Garner/Plugge's "alien facticity." In *How I Learned to Drive,* the struggle between the thing-body and the lived-body stems from the central violation of her body that the play uncovers, the trauma of incest, initially experienced at

the age of eleven. Psychological theory holds that a radical separation from the body is characteristic of the incest-survivor's relationship to her body. In *Secret Survivors: Uncovering Incest and Its Aftereffects in Women*, Sue Blume describes one of the primary aftereffects of incest as an "alienation from the body" (Blume, xviii). Describing the survivor of child sexual abuse, Blume writes:

> In reaction, she generally feels disconnected from her body. During the initial abuse, and during later life when these attitudes prevail, seeing her body as the site and source of her violation, she may separate from her own physical self to separate from her pain, discomfort and embarrassment. To endure her negative attitude toward her body, she may feel that the self and body are not the same (194).

Li'l Bit's breasts, the site of her violation by her uncle, are rejected by her. They are objects for men to ogle. At a high-school dance, she complains of a boy who asks her to dance: "I think he asks me on the fast dances so he can watch me—you know—jiggle." Her female classmate's response: "You should take it as a compliment that guys want to watch you jiggle. They're guys, that's what they're supposed to do" (56–57). Their purpose firmly established as objects for the use of others, Li'l Bit's breasts are no longer part of herself.

Just as Li'l Bit's body is fragmented and alienated, so, too, are her memories. Just as the body is not a unified whole, neither can her memories be seen as a linear whole. It is this fragmentation of memory that forms the structure of the play. As an incest survivor, her past is not available to her in a unified, linear progression, but rather, as a series of nonchronological memories that must be recovered by digging back into the past and that do not initially accept the deeper trauma of her relationship with her uncle. There are thus two primary manifestations of Li'l Bit's alienation from memory in *How I Learned to Drive*: the complex chronological structure of the emergence of memory, and the initial representation of the nature of her relationship with her uncle as one of mutual complicity.

Li'l Bit presents her story from the vantage point of her self as a thirty-five-year-old woman. Shifting back and forth in time over two decades, encompassing the years from 1962 to the present, she alternates between narration and the re-creation of pivotal scenes of the incest that took place during her adolescent years (from ages eleven to seventeen) with her uncle. Vogel punctuates the time shifts with the metaphor of a car shifting gears. The most common is the one that labels each shift

backward in time: "You and the Reverse Gear" (21, 46, 51, 59, 69, 86). The regression in time can be divided into three major stages. The first revolves around Li'l Bit at ages sixteen-seventeen, the second reaches back to age thirteen, and the final one breaks the memory barrier to uncover the initial abuse at age eleven. This regression is neither smooth nor continuous, but occasionally shifts forward, punctuated with titles such as "Downshift while going forward" (40), "Shifting Forward from Second to Third Gear" (72),"Shifting Forward from Third to Fourth Gear" (74), in order to reach further back. A forward movement marks the shift between each of these progressions.

The first sequence revolves around Li'l Bit's final years of high school and first year of college [time sequence of scenes: 1969, 1969, 1968, 1969]. These scenes depict what seems to be a mutual relationship (7-40). Exploring the intricacies of a relationship in which Li'l Bit seems to maintain the power to determine what she will and will not accept, Vogel creates, on the surface, a complicit and tangled relationship, rather than one of predator to prey. Reviewers have alternately praised and criticized Vogel for this refusal to portray Peck as a predator and Li'l Bit as a passive victim. Li'l Bit herself continually insists that it is a relationship, and one that she controls. Li'l Bit appears to be in control of her body, and what she will or will not allow Peck to do:

> Peck: Are you ever going to let me show you how good I am?
> Li'l Bit: Don't go over the line now.
> Peck: I won't. I'm not going to do anything you don't want me to do.
> Li'l Bit: That's right (10).

Likewise, when Peck takes her to an inn to celebrate her new driver's license, and convinces her to have a martini (that turns into three or four martinis), she initially seems to be the one who wants to go up to a room: "You're not taking me . . . upstairs? There's no room at the inn? (Li'l Bit giggles)" (31). When she changes her angle and states "This isn't right, Uncle Peck," he responds with a series of questions: "What isn't right? . . . What are we doing? . . . Have I ever forced you to do anything?" When she acknowledges that he hasn't, he continues: "We are just enjoying each other's company. I've told you, nothing is going to happen between us until you want it to. Do you know that?" (32). In this first memory-progression, Li'l Bit paints a picture that is of a consenting and mutual relationship. It is perhaps not fully "right," but it does not seem to be a true victimization. That the initial recollection, challenged by later events in the play, is quite benign is perhaps not entirely surprising. According to

Blume, the first memories of incest are often not seen by the survivor as a true victimization:

> The child victim of incest often sees herself as a participant rather than a victim. The term "incestuous relationship," used casually today by even the relatively well-informed, illustrates how pervasive this attitude is. Actually, in incest, one person is active and one passive, one dominates and one acquiesces. The incest survivor herself often fails to make this distinction (Blume, 111).

Blume explains this trick of perception and memory by the fact that to face the alternative, for the incest survivor, is to admit that she was in a position of complete powerlessness. Thus, she needs to hold on to the fiction that she is in control and that the relationship is, in fact, a mutually desired and complicit one. In addition, Peck's continual insistence that he will do nothing without Li'l Bit's permission clearly insists on her complicity, as well, thus making sure she shares in the responsibility for the incest and exonerating him of self-blame.

Between this sequence and the next, Vogel brings the play forward to 1979 to a brief scene depicting Li'l Bit's own seduction of a teenage boy, a clear indication that a cycle has been established. After narrating this scene, Li'l Bit states "I lay on my back in the dark and I thought about you, Uncle Peck. Oh. Oh—this is the allure. Being older. Being the first. Being the translator, the teacher, the epicure, the already jaded. This is how the giver gets taken" (41). This forward shift is the first direct address to Peck from the adult Li'l Bit, and the first implication that she now views the relationship as more manipulative than she knew as a teenager. It is after this revelation that she begins the second progression of scenes which begin counting backwards in time, year by year: 1967, 1966, 1965, 1964 (41–72). It is in this series of scenes that Peck's manipulation of Li'l Bit begins to emerge more clearly. Peck's continued statement is that she has the power to draw the line, and yet the continual need for this reiteration challenges its veracity. As the play progresses, moments become evident where he clearly succeeded in having her "re-draw" that line. In a scene in which Li'l Bit agrees to pose for an erotic photography session for Peck, he asks:

> Peck: Look, are you sure you want to do this?
> Li'l Bit: I said I'd do it. But—-
> Peck: —I know, you've drawn the line.
> Li'l Bit (reassured): That's right. No frontal nudity (60).

And yet at the end of the scene, even after she has become upset by his allusion to the possibility of one day sending the pictures to *Playboy,* he

can get her to re-draw the very line she has established, simply by stating
that he loves her:

> Peck: I love you . . . Do you know that? (*Li'l Bit nods her head yes*) I have
> loved you every day since the day you were born.
> Li'l Bit: Yes. (*Li'l Bit and Peck just look at each other. Beat. Beneath the
> shot of herself on the screen, Li'l Bit, still looking at her uncle,
> begins to unbutton her blouse.*) (66).

This sequence, in which Peck's manipulative power is seen clearly, culmi-
nates in 1964, the Christmas in which Li'l Bit offers to make a "deal" with
Peck: to meet weekly without others knowing to help cure his demons
and end his fight with alcoholism:

> Li'l Bit: I could make a deal with you, Uncle Peck.
> Peck: I'm listening.
> Li'l Bit: We could meet and talk—once a week. You could just store up whatever's
> bothering you during the week—then we could talk.
> Peck: Would you like that?
> Li'l Bit: As long as you don't drink (71).

She states that she would prefer that the meetings remain secret, and that
"You've got to let me—draw the line. And once it's drawn, you mustn't
cross it" (71). Thus, it seems at this point in the text that the "relation-
ship" has in fact been initiated by Li'l Bit, and that she is in control, giving
what she will in order to help Peck. This regression sequence thus culmi-
nates in what seems to be the origin of the relationship, an origin that
makes clear Li'l Bit's desire to remain, in her memory, the one in control.

Before the memory regression can continue any further, the structure
jumps forward again, back to the end of 1969 (73–86). Leaving home for
college in 1969, she finally sees the need to end her "relationship" with
Peck after a series of letters he sends that are, in essence, counting down
to her eighteenth birthday, which, she realizes, is the date at which statu-
tory rape is no longer in effect. She breaks away from him in the only way
that she knows how, and the only way that she knows will be effective:
she offers him a drink of the champagne that he has brought her as a gift,
thus turning his own seduction on him with the words "It's not polite to
let a lady drink alone" (77). She is using his own rhetoric, recalling such
lines of Peck's as "The lady would like a drink, I believe" (25). He used the
reference to "lady" to justify their relationship by elevating her to adult
status in his eyes. In rejecting him and turning him back to alcohol, Li'l
Bit seals his doom, as she acknowledges in a monologue that follows the
scene: "It took my uncle seven years to drink himself to death" (84).

It is only after this scene, after the abuser has been destroyed, that Li'l Bit can dig fully back into the past to the final sequence of scenes (86-90). It is only after reliving his self-destruction that she shows the audience the true origin of the relationship, in a car driving home from the beach: Li'l Bit was a child of eleven, when he first pulled her onto his lap to "drive" and molested her. It is 1962 when the abuse truly begins, and there is nothing consensual or mutual about it. It is, instead, clearly depicted as a traumatic scene of sexual abuse. That this revelation comes quite late in the play, and only after Li'l Bit has confronted (and eliminated) her abuser, testifies to the deep alienation of Li'l Bit from that initial trauma. In *Surviving Child Sexual Abuse: A Handbook for Helping Women Challenge Their Past*, Liz Hall and Siobhan Lloyd write that the first incidence of abuse is often recalled late in a disclosure. At this point, "it is not unusual for a woman to remember that the abuse began at a much earlier age than she had previously recalled" (166). In the memory that forms the structure of the play until the confrontation with and destruction of the abuser, Li'l Bit could initially only remember/disclose the later, more benign-seeming "relationship" and not the earlier, much more traumatic onset of the abuse which led to the alienation and fragmentation of body and memory.

The divisions played out within the body and memory of Li'l Bit also function as a metonymic representation of an even more important division. The fragmentation of the body and memory can be viewed in parallel with the fragmentation of the inner self, manifested in Vogel's play as a division between inner and outer self. A useful theoretical tool for analyzing the root of the division that Vogel creates within the character of Li'l Bit is psychoanalyst Jacques Lacan's splitting of the subject at the mirror stage. In the mirror-stage, the child, although not yet able to unify and control its own body, recognizes its image in the mirror. The ideal unified image that is reflected is initially alienating, but the child quickly "identifies" with it, which Lacan defines as "the transformation that takes place in the subject when he assumes an image" (2). The child's early "fragmented" vision of the world is replaced by an image of itself that is at once a recognition and a misrecognition. The self that is reflected in the mirror is identical to, and yet separate from, the self that looks (2-3). The mirror-stage thus splits the child into a perceiving self and a reflected, idealized body image that he or she mistakes (and substitutes) for the self. This separation of the inner, perceiving self from the self as it is represented (to itself) in the context of an external, unifying viewpoint is cemented during the acquisition of language, as the child takes up the gram-

matical position of the "I." Like the image in the mirror, the "I" that the child takes up in speech is a fiction (both self and not-self), because it is a false unity that substitutes for the inner subject. Thus Lacan posits a separation in the speaking subject between the "I" that speaks, the *sujet de l'énonciation* (subject of the utterance), and the "I" that is spoken of when the speaker says "I," the *sujet de l'énoncé* (subject of discourse).

The split that occurs is thus in two stages. At the mirror stage, the division is between the self which experiences, and the self as it is seen (by the self). This division is comparable to the division of the body outlined by Garner as lieb and korper. At the entry into language, the split is between the inner self and its incomplete representation (to others) that results from that self's translation into the unified "I" of language. Both the visual representation and the grammatical representation stand in as incomplete substitutes for the inner, phenomenal "I" that cannot be represented. They unify the child's fragmented experience of itself into a perceived whole, and even if that whole is fictitious, it is necessary for the subject's self-perception and then for its interaction with the world through self-representation.

The trauma of the abuse experienced by Li'l Bit served to fragment the inner self from the outer representations, thus reversing the unification achieved at the mirror-stage. This splitting from self is a common description of a child's reaction to abuse. Unable to integrate the experience into her perception of herself, the child's method of survival is to separate bodily from herself. The self refragments into a watcher and a watched, thus viewing the self as other and forcing a separation between the outer body/image, to whom the abuse is happening, and the inner self, which cannot be touched:

> Unable to remove herself physically from the abuse, the creative child victim finds other ways to leave. Frequently, this leaving takes the form of 'separation from the self,' or depersonalization. Many incest survivors refer to this separation as 'splitting.' . . . I have often heard depersonalization described as an out-of-body experience: 'I left my body and floated up to the ceiling,' or, more simply, 'I could just feel myself slipping out of my body; therefore, it wasn't happening to me any more' (Blume, 83).

In splitting, the child preserves her inner self by divorcing it from the abuse.[1] In doing so, she loses a sense of her self as a unified whole, thus negating the effect of the mirror-stage.

The resultant radical division between the inner self and the outer self/self-as-image is given concrete form in *How I Learned to Drive* during

the photo-shoot. As Li'l Bit attempts to accustom herself to the camera, her discomfort evident, Peck takes photographs whose images appear on a screen above them, a montage that alternates shots of models [*"à la Playboy, Calvin Klein and Victoriana/Alice Liddell"*] with photographs of Li'l Bit [*"Li'l Bit looks up, blushes. Peck shoots the camera. The audience should see this shot on the screen"* (62)]. As the scene unfolds, the contrast of the sexualized image of Li'l Bit on the slide projector with the bodied Li'l Bit on the stage creates a division between Li'l Bit's inner self and image: the inner Li'l Bit (who is clearly uncomfortable although acquiescing) and her translation into the sexual image captured for Peck on the screen.

That this sexualized image, divided from Li'l Bit's inner self, replaces the ideally unifying mirror-stage image is hinted at in the very terminology that Peck uses to get her to pose naturally: "Pretend you're in your room all alone on a Friday night with your mirror" (62). This scene makes clear Peck's co-optation of the mirror ideal, of Li'l Bit's outer image. Blume points out that incest survivors "may avoid or be indifferent to mirrors. Often they feel no wholeness with their physical selves, no continuity between the experiences of their physical feelings and their bodies" (Blume, 200). The child, denied the unifying potential of the mirror-stage, can thus not achieve the next step, the translation of her fragmented subject position into language as a unified grammatical "I."

Multiplicity

The project of *How I Learned to Drive* is to find a way for Li'l Bit to represent herself. Li'l Bit opens the play stating, "Sometimes to tell a secret, you first have to teach a lesson" (7), thus emphasizing that finding the form with which to tell her story is integral. She must find a way to represent herself so that she can find a way to integrate the fragmented aspects into a sense of wholeness. The basic dilemma arises: if the assumption of the mirror-image and the grammatical "I" are supposedly necessary to representation, and those two unifying methods are alienated from Li'l Bit, whose self and body are co-opted by Peck, how does she satisfactorily represent herself? As the Women's Research Centre (WRC) writes in *Recollecting Our Lives: Women's Experience of Childhood Sexual Abuse*, "Survivors told us of trying to bridge the gap between how they present themselves to the world and what they feel inside" (216). The effect of the fragmentation of Li'l Bit from her own image (seen in the alienation of the mirror-stage unity in the photography scene)

is seen in her attempt to represent herself to the world, through the consequent inability to assume the fictitious unified subject-in-language.

The division of the subject-in-language is foregrounded throughout the play in the relationship between the speaking Li'l Bit (as narrator) and her representations of herself in scenes (as character). Catherine Belsey's analysis of the mirror-stage in *Critical Practice* stresses the fact that to represent oneself in discourse requires identifying with a unified subject position, and that this fiction of a unified self can prove impossible to sustain. Even as the self as it is represented in discourse conforms, the unconscious, which has been formed in the gap between the phenomenal self and the discursive self, continually carries the potential for disruption. The awareness of the disruptive potential imbedded in the twice-split "I" leads to a realization that the subject can never be the unified subject that classic realism (or ideology) represents. For the incest survivor, alienated from her fragmented body and memory, the inability to hold up the fiction of a unified self is even more pronounced. What form is available to her?

In Belsey's analysis, the "classic realist text" suppresses any potential for disruption by subsuming its multiple voices within a single coherent subject position with which the spectator can identify. Within the classic realist text, the diverse characters (analogous to sujets de l'énoncé) are constantly circumscribed by a unified and unifying authorial voice (analogous to the sujet de l'énonciation). Belsey proposes, as an alternative, the "interrogative text," which refuses this overarching authorial voice, thus refusing to contain the sujet de l'énoncé within a sujet de l'énonciation. With no one voice in possession of the truth, "no invisible discourse situates the others by means of readily identifiable irony. As a result, the only position of intelligibility offered to the spectator by the play in its entirety is an actively critical one" (Belsey 96–97).

The alienation-effect in acting popularized by the work of Bertolt Brecht is one example of this form of resistance. Due to the foregrounding of the actor's performance of the character, the audience is unable to develop an overemotional attachment to the character: "The audience [is] hindered from simply identifying itself with the characters in the play. Acceptance or rejection of their actions and utterances [is] meant to take place on a conscious plane, instead of, as hitherto, in the audience's subconscious" (Brecht 91). Elaine Aston and George Savona analyze the alienation effect in acting as a means of representing the Lacanian split subject in the theatrical sign-system. In this equation, the speaking subject, the actor, is visibly differentiated from the subject of the discourse, the character: "In a

gestic or 'demonstrating' style of acting, the "I" of the performer is not submerged in the "I" of the character" (Aston and Savona 69). In *How I Learned to Drive*, Vogel uses various Brechtian techniques, including having actors who represent the "Greek Chorus" play multiple roles. The actor playing the Male Greek Chorus, for instance, plays Grandfather, Waiter, and a variety of high school boys, and the distance between the actor and character is continually foregrounded.

For the character of Li'l Bit, however, Vogel offers a more radical approach to the relationship between the speaking subject and its representation that combines the two forms described above, layering them within Li'l Bit herself, and thus challenging the neat separation between sujet de l'énoncé and sujet de l'énonciation. It echoes Belsey's interrogative text in the split between Li'l Bit as narrator and Li'l Bit as a character in her own discourse. It echoes Brechtian alienation in the split between Li'l Bit as actor (her adult self playing her younger selves) and Li'l Bit as character (her younger selves). Through the use of the contradictory, divided representations of a single self (as narrator, actor, and character), Vogel achieves the disruption of the unified subject, and finds a way to represent the fragment body and memory of Li'l Bit. The location of the split changes, which offers a more radical approach to the relationship between the speaking subject and its representation. Neither between narrator and characters (Belsey's interrogative text), nor over the theatrical boundary from actor to character (Brechtian alienation), the split takes place within the bounds of the character herself. Rather than narrating her story from a fixed and stable position, Li'l Bit relives her story bodily, creating an alienation between the body from which she speaks and the body in which she acts.

In *How I Learned to Drive*, Li'l Bit's past and present selves exist simultaneously, overlapping, and contradicting (without negating) each other. The opening scene establishes the fact that a clear separation of the sujet de l'énonciation (Li'l Bit/narrator) and the sujet de l'énoncé (Li'l Bit/character) is impossible. The *dramatis personae* characterizes Li'l Bit as "A woman who ages forty-something to eleven years old" (4). When we first encounter the character, she is described as follows: "'well endowed,' she is a softer-looking woman in the present time than she was at seventeen" (7). This physical description immediately precedes Li'l Bit's first monologue, which she concludes with the announcement that "*it's 1969. And I am very old, very cynical of the world, and I know it all. In short, I am seventeen years old*" (7-8). The result is a discrepancy in

the age the character claims ("I am seventeen") and the age the stage
direction disclaims (no longer as she was at seventeen). As a single body,
she simultaneously embodies the "am" and the "was," the past "I" and
the present "I."

If this were a classic realist film, she could perhaps be played by a
teenage actress who would be listed in the credits as "Li'l Bit at Seven-
teen," and the older Li'l Bit would be present as a Voice-Over, narrating
and reflecting on her past. Thus, the two selves would be satisfactorily
separated, the past viewed from the stable, all-knowing position of the
present. This is not what Vogel offers us. Instead, the action of the scene
reinforces the notion that the scene is not being played out by a unified
younger self. Vogel drives a wedge between the characters' words and
actions. The stage direction that introduces the scene establishes this
separation of the characters from their bodies. The ostensible action of
the scene is of consensual sexual touch between Li'l Bit and Peck, but
Vogel directs the action as follows: *"the two sit facing directly front.
They do not touch. Their bodies remain passive. Only their faces emote"*
(8). As Li'l Bit assents to Peck's request to touch her breast, the direction
reads, *"Peck pantomimes undoing Li'l Bit's brassiere with one hand"*
(11). This bodily action divorced from each other's bodies continues, as
they each respond physically with their bodies but do so without touch-
ing each other:

> *(They sit, perfectly still, for a long moment of silence. Peck makes gentle,
> concentric circles with his thumbs in the air in front of him)*
>
> Peck: How does that feel? . . .
>
> *(Peck bows his head as if praying. But he is kissing her nipple. Li'l Bit, eyes
> still closed, rears back her head on the leather Buick car seat (12).*

The body that acts out the scene exists on two overlapping planes: it is at
once the body of the teenage Li'l Bit, reacting to the sexual stimulus of
her uncle, but at the same time it is the body of the adult Li'l Bit, whose
body can no longer be physically touched by Peck. She is simultaneously
inside and outside of her body, and that body is presented simultaneously
in the past and in the present. The refusal of touch stems from the fact
that Li'l Bit is split between past-self and present-self in this scene, and is
simultaneously outside of the character and inside it. She is constantly
oscillating between sujet de l'énonciation and sujet de l'énoncé. The double-
ness always remains, and it is in the gap created by that doubleness that

disruption can occur. Just as Li'l Bit's visual representation in the "mirror" image of the photographs cannot contain her, so neither can she be contained as a subject of discourse (sujet de l'énoncé). As a result, the audience, because it does not have a unified subject with whom to identify, also remains suspended between inner subject and subject of the énoncé. Unable to identify satisfactorily with the mirror-subject, the audience must open itself to the disruption and division.

This contradictory, overlapping, impossible split between Past-I and Present-I, between narrator and character, between sujet de l'énoncé and sujet de l'énonciation is taken a step further in the final scene. Whereas the prior scene saw the Past-I and Present-I embodied together in one body, Li'l Bit, in the opening scene, does not fully relive the past because of the lack of touch—thus, she is still disconnected from it. In the final scene, however, the single body's blurred representation of Past-I and Present-I is replaced by the simultaneous on-stage presence of two contradictory but, again, overlapping and blurring representations.

Li'l Bit is embodied by two bodies: the actress who has played her up until now in the play, and the Teenage Greek Chorus. Rather than any possible hierarchy between a sujet de l'énonciation/narrator/Present-I and a sujet de l'énoncé/character/Past-I, we are instead presented with side-by-side sujets de l'énoncé. Thus, division within the body is transformed into a multiplicity of body. Reversing the photo-scene, whose two simultaneously present images of Li'l Bit correspond to the inner subject and the co-opted outer image who are divided from each other, these two bodied Li'l Bits do not conform to the Lacanian division. This scene dismisses any possibility that one can ever get at that inner I, that I of the énonciation. Any single representation can only achieve one facet of the contradictory, énoncé-unified I; thus, it is necessary to represent her in multiple. Vogel challenges any possibility of a unified self, but discovers, in the process, a potential way of productively embodying the fragmented self on stage.

In this final scene, Peck and Li'l Bit are again in the car, an echo of the opening scene, but the scene has now shifted back to 1962: "On the back roads of Carolina: The First Driving Lesson" (88). Li'l Bit is eleven. In the opening scene, Li'l Bit's single body was a blurring of the two selves, Present-I and Past-I. In this scene, the split seems on the surface to be more complete (as two bodies are needed to represent it), but, instead, the past and present selves are more tangled than before, and thus impossible to separate. The Teenage Greek Chorus speaks the words of Li'l Bit, while Li'l Bit acts out the part bodily, but does not speak: *The Teen-*

age Greek Chorus member stands apart on stage. She will speak all of Li'l Bit's lines. Li'l Bit sits beside Peck in the front seat. She looks at him closely, remembering (88). That she is physically in the car while looking at him and remembering, places her simultaneously as outside of her past-self, as a detached observer, and as inside her past-self, as the participant in the scene. Peck invites her onto his lap to drive the car:

Teenage Greek Chorus:	Okay. (*Li'l Bit moves into Peck's lap, She leans against him, closing her eyes*). . . .
Peck:	Li'l Bit—I need you to watch the road— (*Peck puts his hands on Li'l Bit's breast. She relaxes against him, silent, accepting his touch.*)
Teenage Greek Chorus:	Uncle Peck—what are you doing?
Peck:	Keep Driving. (*He slips his hands under her blouse.*)
Teenage Greek Chorus:	Uncle Peck—Please don't do this—
Peck:	Just a moment longer. (*Peck tenses against Li'l Bit*)
Teenage Greek Chorus:	(*Trying not to cry*) This isn't happening (89-90).

The radical separation between voice and body that was evident in the first scene is realigned here, as Li'l Bit is multiplied into two actresses. In the opening scene, each body reacted, but there was no physical contact between Peck and Li'l Bit; that contact was confined to words. In this final scene, physical contact does occur between Li'l Bit and Peck, but with two layers of remove. The Li'l Bit that acts out the scene is the adult Li'l Bit, and the scene that she acts out is not identical to the one that the Teenage Greek Chorus experiences: the body is Li'l Bit accepting the caress, relaxing against him. The voice is afraid, rejecting the advances, but unable to act. In classic memory play format, the narrator would be the one standing to the side, watching the younger self—here it is the younger self that stands aside, and yet is not objective. If anything, it is the body that enacts the scene that is detached.

After playing out the scene, Li'l Bit steps out of the car, and speaks as her adult-self: "That day was the last day I lived in my body. I retreated above the neck, and I've lived inside the 'fire' of my head ever since" (90). And yet, by giving the bodily action to Li'l Bit as an adult, she relives the event bodily as an adult rather than as a child, and her body reacts quite differently to the stimulus of Peck's. She cannot stand aside and watch her younger self act out the past, remaining an objective observer, narrating the event. Both are equal participants in the scene. No hierarchy can be established between the two bodies on stage. One is not sujet de l'énoncé, to the other's sujet de l'énonciation. One is not past to the other's present, or korper to the other's lieb.

The acceptance of the doubled body leads to a power that can be taken up. Ironically, by reliving the past bodily, split into two, Li'l Bit achieves a fusion, a reattachment (through radical division and multiplication) to her body. By re-embodying the scene, and experiencing it both as her present self and her past self, she relives it both in the reality of how it occurred (thus not repressing the trauma of it, and accepting that it did happen), and in the present, as something that can no longer hurt her. The multiplication into two simultaneously present bodies yields a reattachment to her own body in the present, an acceptance of both facets. The need for such a multiplicity echoes the language of *Recollecting Our Lives*, whose authors state: "Many women also told us an essential part of dealing with the self-alienation that had plagued them from childhood was accepting the various aspects of themselves they'd discovered, and integrating these pieces into their sense of self" (WRC, 228). The form discovered by Paula Vogel for Li'l Bit's revelation of her secret affirms this multiplicity, and allows Li'l Bit to tell her story without being reduced to the fictitious unity that a realist form would enforce.

Learning to Drive

Li'l Bit has used the discovery of a way to tell/represent her story as a way of reclaiming and reconnecting with her body, and accepting her multiplicity. This can be seen in the bodily division of the final scene. The question that then arises is: Where does she go from there? The monologue that closes the play brings together bodily multiplicity and reattachment with Li'l Bit's recognition of herself as an inner subject, rather than determined by the outside. It is a rejection, in essence, of korper in favor of lieb, and of sujet de l'énoncé in favor of sujet de l'énonciation.

Li'l Bit exhibits a continued awareness that her physical body has been taken from her, and that her experience of it has been co-opted by Peck, and given a meaning that she does not want it to have—that of the object to be looked at/violated by Peck. She states:

> I still have never known what it feels like to jog or dance. Any thing that . . . "jiggles." I do like to watch people on the dance floor, or out on the running paths, just jiggling away. And I say—good for them. (Li'l Bit moves to the car with pleasure.) The nearest sensation I feel—of flight in the body—I guess I feel when I'm driving (91).

The "jiggling" of her breasts and its interference with her daily experience of life is a clear image of the intrusion of the korper on the lieb, the over-

awareness of the alienated thing body. She thus rejects this body in favor of a substitute: the car. The image of the car as a substitute for the body continues a thread that has been established throughout this work. The car is presented early on as a substitute for the female body. Li'l Bit situates the attraction to cars chronologically in the male's lifetime in terms of the woman's body: "Long after a mother's tits, but before a woman's breast" (46). The car is acknowledged as a fetishistic element of desire, established through the erotic associations of cars and pin-ups. During Li'l Bit's driving lesson, for instance, Vogel suggests:

> It would be nice to have slides of erotic photographs of women and cars: women posed over the hood; women draped along the sideboards; women with water hoses spraying the car; and the actress playing Li'l Bit with a Bel Air or any 1950s car one can find for the finale (46).

If the car is associated with the sexualized body (object body) of the woman, then there is a particular victory in reclaiming it for the woman's use. In reclaiming the car, transforming it from its erotic body association to a useful, lived-in experiential body, Li'l Bit goes far toward reclaiming her body itself.

The car bears a dual significance in the play, embedded in the title *How I Learned to Drive*. On the one hand, the car is presented as the site of her initial violation (and the section that features it is entitled "The First Driving Lesson"). In this final monologue, the car is presented as the escape, the "flight in the body," and hence, "learning to drive" is also learning to reclaim her body and her life. This double significance is evoked when, in the driving lesson (at age sixteen), Li'l Bit makes a tentative joke out of Peck's direction to grab the wheel with both hands, asking: "How will I defend myself?" Peck responds: "This is serious business. I will never touch you when you are driving a car. Understand?" (49). In the same lesson, he states: "I don't know how long you and I are going to live, but we're for damned sure not going to die in a car" (50). There is a terrible irony in the fact that the car is both the site of violation, the violated body, and subsequently delineated as a safe haven, a body that is free from harm. There is thus an inherent tension that is established between the car's association with female bodily objectification and the car as the means for the (female) character to escape, providing the means for "flight in the body" of the subject, which can stand in for Li'l Bit's physical body and which impedes that flight.

Elin Diamond, in a section of *Unmaking Mimesis* punningly entitled "autoeroticism," discusses the dual nature of the image of the car for

feminist performers. Exploring Peggy Shaw's celebratory vision of herself in a 1962 Corvette, a beautiful woman by her side, Diamond examines the complex dynamics between women and cars, commenting on the fetishistic association of the female body and car:

> from the 1949 motoramas, with dancing showgirls pointing ecstatically at the Cadillac fin, to the advertisements we'll see on television tonight, women's bodies sell the car (metonymically they are the phallus) to the men who want it (metaphorically they are the phallus) (163).

However, she continues, Shaw's appropriation of the car as a vehicle for her own desire, also "annex[es] American automophilia for a female imaginary, refiguring the lives of girls and women not in private spaces but on the erotic dream highways usually reserved for males" (164). Thus, the car is no longer a substitute for the woman's body as sexual other, but a functional added part, a vehicle that, unlike her physical body, gives her freedom.

Likewise, for Li'l Bit, the car's very femininity, annexed by the woman, is put to a very different use. In the driving lesson, Li'l Bit asks her uncle why he refers to the car as a "she." His response betrays a traditional erotic equation of the woman's body and car:

> Peck: It doesn't have to be a she—but when you close your eyes and think of someone who responds to your touch—someone who performs just for you and gives you what you ask for—I guess I see a 'she.' You can call her what you like.
> Li'l Bit: I closed my eyes—and decided not to change the gender (50).

By choosing to retain the car's female association for herself, Li'l Bit does not seem to be accepting a fetishized view of woman from a male perspective, but rather, she makes it into a part of herself and uses it as an escape. If the gender of this car is female, if this car is a substitute for the body, it is in the sense of lieb rather than korper, a lived-in-body rather than an object-body. Rejecting the "jiggling" breast, which represents to her the object status of her body, her body as determined by Peck's violation, she chooses this substitute, reclaiming it from the eroticized body of Peck's perspective to become a functional, lived-in one. She never fully re-unites with her physical body. That division, however, is mitigated by her unification with the car as a body substitute. Through the metonymic association with the car, she reclaims her body.

As the monologue continues, the doubleness and multiplication, embodied previously in the form of the two bodies on stage, is maintained,

rather than a desire for a fictitious unity. This multiplicity takes several forms, which echo the various forms of fragmentation of memory and body. Li'l Bit enters the car, locks the doors, turns the key and adjusts "the most important control on the dashboard: the radio." In overlapping static, the Greek Chorus repeats earlier lines from the play:

Female Greek Chorus (overlapping):	—"You were so tiny you fit in his hand—"
Male Greek Chorus (overlapping):	—"How is Shakespeare going to help her lie on her back in the—"
Teenage Greek Chorus (overlapping):	—"Am I doing it right?"
	Li'l Bit fine tunes the radio station (91–92).

The past is made present in the form of a kaleidoscope of lines, of memories, but Li'l Bit now has control of them, and can choose when to listen to them. She now has fully unearthed the memories, and can acknowledge their continued existence in her current self, but they no longer control her. As Li'l Bit continues to ready the car for its drive, the image of multiplicity shifts from memories to mirror-images, as Vogel ends the play with an image of mirrors. But rather than the unifying (and replacing) mirror of the mirror-stage, whose image of the body has been given meaning by Peck, the mirrors that Vogel leaves her audience with are multiple:

> Then I check the right side mirror—Check the left side. (*She does.*) Finally, I adjust the rearview mirror. (*As Li'l Bit adjusts the rearview mirror, a faint light strikes the spirit of Uncle Peck, who is sitting in the back seat of the car. She sees him in the mirror. She smiles at him, and he nods at her. They are happy to be going for a long ride together*) (92).

The image of three mirrors, each reflecting a different angle, adjusted (like the radio) by Li'l Bit to reflect what she chooses, creates a kaleidoscope of images to replace the fictitious coherence of the Lacanian mirror. Crucially, none of the mirrors directly reflect Li'l Bit. She is in the position of the self looking into the mirror, but there is no unifying image of herself with which to identify, to misrecognize as herself, and replace her inner self with. A final challenge to the false unification of the character in representation is contained in the last words of the monologue as the above excerpt continues, to end the play: "*Li'l Bit slips the car into first gear; to the audience:*) And then—I floor it. (*Sound of a car taking off. Blackout*)" (92). The combination of the look back into the rearview mirror and the acceleration forward provides a contradictory thrust, a movement that is simultaneously forward and backwards, an evocation of

Past-I and Present-I (not to mention future-I) at once, rejecting the tyranny of the past and memory.

In *How I Learned to Drive*, the fragmentation of the subject is represented through the fragmentation of body and memory. But the fragmented subject is antithetical to realist representation, which demands a fictional unity. How can the incest survivor represent the self without the detrimental fictitious unity that continues to enforce the repression of parts of the self? The alternative that Vogel provides is that of multiplicity, in which the fragments of body and memory and image (and hence of subject) can exist simultaneously. The kaleidoscopic representation of the subject accomplishes this because it allows contradictory pieces to co-exist and be represented. The Women's Research Center writes that they chose the phrase "Recollecting Our Lives" for the title of their book on survivors of child sexual abuse for its dual meaning, both of reclaiming the memory and of how the survivors "collect the pieces of their experience, reflect on them, try to fit the pieces together" (WRC 24). In this dual form of recollecting, the pieces of body, memory, and subject are gathered together. Recovering and accepting all the pieces leads to a productive kaleidoscope, in which the various aspects of the self are allowed to co-exist and thrive, rather than be subjected to a fictitious and repressive need for unity. The resultant "kaleidoscopic" subject allows simultaneously present, multiple perspectives to co-exist. As fragmentation is replaced by multiplicity, Li'l Bit reclaims her life, and her self.

Note

1. Eve Ensler, in the 1993 play *Floating Rhoda and the Glue Man* has dramatized this splitting of the abused subject, using a doubling of bodies on stage. As Rhoda is beaten by her boyfriend, it is her "stand-in," representing the shell of her body, that is in the bed (150). Watching her body suffer, Rhoda "swings over them on a trapeze . . . lights a candle and swings into the stars." This separation of inner self and outer body is shown to be dangerous, however, as it is Rhoda, and not her stand-in, who lies in the hospital bed, her face swollen, in the following scene. Rhoda explains her splitting (to Storm, who is her doctor):

 > *Rhoda*: It's somewhere what I want, what I've come to know. That's why I leave as soon as it begins. That's why I go.
 > *Storm*: Go?
 > *Rhoda*: Don't you ever leave yourself?
 > *Storm*: I wish I could.
 > *Rhoda*: You've never stepped aside or floated out or watched yourself? . . .
 > *Storm*: He wasn't hitting me.
 > *Rhoda*: That's the problem. Because it isn't you, you do not feel. And if you do not feel, it isn't real. So he could eventually kill you.

Works Cited

Aston, Elaine and George Savona. *Theatre as a Sign-System: A Semiotics of Text and Performance*. New York: Routledge, 1991.

Belsey, Catherine. *Critical Practice*. London: Routledge, 1991.

Blume, E. Sue. *Secret Survivors: Uncovering Incest and Its Aftereffects in Women*. New York: John Wiley and Sons, 1990.

Brecht, Bertolt. *Brecht on Theatre*. Ed. and Trans. John Willett. New York: Hill and Wang, 1964.

Diamond, Elin. *Unmaking Mimesis*. New York: Routledge, 1997.

Ensler, Eve. "Floating Rhoda and the Glue Man." In *Women Playwrights: The Best Plays of 1993*. Marisa Smith, ed.. Newbury, VT: Smith and Kraus, 1994.

Garner, Stanton B., Jr. *Bodied Spaces: Phenomenology and Performance in Contemporary Drama*. Ithaca: Cornell University Press, 1994.

Hall, Liz and Siobhan Lloyd. *Surviving Child Sexual Abuse: A Handbook for Helping Women Challenge Their Past*. Washington D.C.: Falmer Press, 1993.

Lacan, Jacques. *Ecrits: A Selection*. Trans. Alan Sheridan. New York: Norton, 1977.

Vogel, Paula. "How I Learned to Drive." *The Mammary Plays*. New York: Theatre Communications Group, 1998.

Women's Research Centre. *Recollecting Our Lives: Women's Experience of Childhood Sexual Abuse*. Vancouver: Press Gang Publishers, 1989.

Notes on the Contributors

Denise Bauer is the coordinator of women's studies at SUNY New Paltz. Currently, she is writing a book on the American painter Alice Neel and her portraits of women, to be published by Hudson Hills Press. She holds a Ph.D. in Culture and Communication from New York University, where she wrote on "The Representation of the Female Subject by Three American Women Artists: Painter Alice Neel, Poet Lucille Clifton, and Filmmaker Claudia Weill, 1963-1980."

Deborah Johnson is associate professor at Providence College in the departments of Art History, Black Studies, and Women's Studies, which she helped to found in 1994. She is the author of numerous scholarly articles and museum catalogues on these subjects, including two that won national awards, *Black Photographers 1760–1960*, and *Old Master Drawings from the Museum of Art, Rhode Island School of Design*. She received her Ph.D. in art history from Brown University, and currently specializes in cultural history since 1945.

Phillipa Kafka, Ph.D., professor emerita at Kean University, is the author of *The Great White Way: African American Women Writers and American Success Mythology* (1993) and *(Un)Doing the Missionary Position: Gender Asymmetry in Asian American Women's Writings* (1997). She has most recently edited the Holocaust segment of a memoir in *Women and the Holocaust: Narrative and Representation* (1999) and will shortly publish a volume on contemporary Latina writers.

Loretta Lorance is completing her dissertation, *Building Values: R. Buckminster Fuller's 1928–29 Dymaxion House in Context* at the City University of New York Graduate Center. She guest edited an issue

of the electronic journal *Part* on architecture which was selected for inclusion in the BBC Excellence in Education Web Guide. In addition, she served as co-director of the Feminist Art and Art History Conference at Barnard College in 1999.

Susan McClary is professor of musicology at the University of California, Los Angeles. She received her Ph.D. in musicology from Harvard University in 1976, and has published articles on music ranging from the sixteenth century to the present. She is also the author of several books, including *Conventional Wisdom: The Content of Musical Form* (2000) and *Feminine Endings, Music Gender and Sexuality* (1991). In 1995, she was awarded a MacArthur fellowship.

Wendy Oliver, Ed.D. Columbia University, M.F.A., Temple University, is associate professor of Dance and Women's Studies in the Theatre Department at Providence College. She is the editor of *Focus on Dance XII: Dance in Higher Education*, and has authored articles that have appeared in *JOPERD, Impulse, Kinesiology for Dance*, and the *Minnesota Daily*, where she served as a dance critic. She is also a choreographer and directs the dance company at Providence College.

William Osborne, Ph.D., Columbia University, is a composer who has lived for the past twenty years in Europe, where he and his wife have an ensemble devoted to the exploration of the identity of women through music theater. His articles about gender discrimination in symphony orchestras helped lead to protests against the Vienna Philharmonic, forcing them to open their doors to female musicians for the first time in their 150-year history. In 1997, he was given a special award by the International Alliance for Women in Music for his services to women in music.

Annie Perkins, professor of English at Norfolk University in Virginia, has also taught at Howard University and Georgie Tyler School. She is the co-editor of *Variations on Humankind: Introduction to World Literature*, published in 1996.

Maura Reilly received her Ph.D. in art history at the Institute of Fine Arts at New York University, writing her dissertation on the interface of photographic and painted pornography in nineteenth-century France. She has held positions at the Museum of Modern Art and Sotheby's auction house, both in New York, and was most recently studio assistant to Laurie

Anderson. She is assistant editor of Anderson's autobiographical catalogue, *Stories from the Nerve Bible*.

Sarah Lansdale Stevenson is a Ph.D. candidate at New York University, where she is currently writing a dissertation entitled "Embodied Voices/ Speaking Bodies: Bodily Interventions in American Drama by Women, from Elizabeth Robins to Paula Vogel." She previously studied English Literature at Harvard University, and Dramaturgy at the American Repertory Theatre Institute for Advanced Theatre Training at Harvard. She has written for the Cassell Companion to Twentieth Century Theatre, and is a theatre critic for *OOBR: the Off-Off-Broadway Review*.

Resource List

NOTE: Each of the works (or a facsimile thereof) discussed in this book can be found in the following places:

Anderson, Laurie. *Langue D'Amour.*
> On the videotape *Home of the Brave*, written & directed by Laurie Anderson, produced by Paula Mazur; color; 90 min., 1986, available through Warner Bros.
> CD: *Home of the Brave* soundtrack, 1987, Warner Brothers, ASIN B000002L9F

Brooks, Gwendolyn. Selected Poems.
> *To Disembark*. Chicago: Third World Press, 1981, ISBN 0883781026
> *Blacks*. Chicago: Third World Press, 1987, ISBN 0883781050

Campion, Jane. *The Piano.*
> Videotape of the 1993 film in VHS or DVD format, rated R, ASIN 630307362x with Holly Hunter

Chicago, Judy. *The Dinner Party.*
> Book with photos: *The Dinner Party*, Judy Chicago & Donald Woodman, Viking Press, ISBN 0140244379
> Slides available from: Through the Flower/Judy Chicago, 101 North 2nd St., Belen, New Mexico 87002
> 505-864-4080 (phone)
> 505-864-4088 (fax)
> Website: http://judychicago.com

Hadid, Zaha. *The Peak Club.*
> Websites with drawings and photos:
>> http://www.arabart.com/hadishow.htm
>> http://www.iit.edu/departments/pr/arch.comp/hadid.html
> Book with drawings, plans, models: *Zaha Hadid: The Complete Buildings and Projects,* by Zaha Hadid & Aaron Betsky, 1998, Rizzoli International Publications, ISBN 0847821331

Oliveros, Pauline. *Sonic Meditations.*
> Music score. Baltimore: Smith Publications, 1971.
> Pauline Oliveros Web Page, http://www.artswire.org/pof/peop_po.html

Rainer, Yvonne. *Trio A.*
> Black & white 16 mm film (1978), available at the Dance Film Archive, University of Rochester, Rochester, NY 14627. 716-275-5236. (Can rent or buy).
> Videotaped version available on The Judson Project Tapes, 1982. Contact Kitchen Center for Video, Dance & Music, 512 W. 19th St., New York, NY 10011, 212-255-5793.*
> Videotape available through ARC Video, 123 W. 18th St., 7th fl., New York, NY 10011, 212-206-6492, 1990*

Sherman, Cindy. *Untitled Film Stills.*
> Reproduced in a book, *Cindy Sherman Retrospective*, 1997, Thames & Hudson, ISBN 0500027987x.
> Slides available at: Metro Pictures, 519 West 24th St., New York, NY 10011.

Tan, Amy. *The Kitchen God's Wife.*
> A novel by Ivy Books, Reprint Edition 1992, ISBN 080410753x.

Vogel, Paula. *How I Learned to Drive.*
> This play can be found in a collection entitled *The Mammary Plays,* New York: Theatre Communications Group, 1997. ISBN 1-55936-144-1.

*May be viewed at the New York Public Library for the Performing Arts, Lincoln Center Dance Collection

Index

ERUPTIONS
New Thinking across the Disciplines

Erica McWilliam
General Editor

This is a series of red-hot women's writing after the "isms." It focuses on new cultural assemblages that are emerging from the de-formation, breakout, ebullience, and discomfort of postmodern feminism. The series brings together a post-foundational generation of women's writing that, while still respectful of the idea of situated knowledge, does not rely on neat disciplinary distinctions and stable political coalitions. This writing transcends some of the more awkward textual performances of a first generation of "feminism-meets-postmodernism" scholarship. It has come to terms with its own body of knowledge as shifty, inflammatory, and ungovernable.

The aim of the series is to make this cutting edge thinking more readily available to undergraduate and postgraduate students, researchers and new academics, and professional bodies and practitioners. Thus, we seek contributions from writers whose unruly scholastic projects are expressed in texts that are accessible and seductive to a wider academic readership.

Proposals and/or manuscripts are invited from the domains of: "post" humanities, human movement studies, sexualities, media studies, literary criticism, information technologies, history of ideas, performing arts, gay and lesbian studies, cultural studies, post-colonial studies, pedagogics, social psychology, and the philosophy of science. We are particularly interested in publishing research and scholarship with international appeal from Australia, New Zealand, and the United Kingdom.

For further information about the series and for the submission of manuscripts, please contact:

Erica McWilliam
Faculty of Education
Queensland University of Technology
Victoria Park Rd., Kelvin Grove Q 4059
Australia

To order other books in this series, please contact our Customer Service Department at:

(800) 770-LANG (within the U.S.)
(212) 647-7706 (outside the U.S.)
(212) 647-7707 FAX

Or browse online by series at:

www.peterlang.com